MARK ROTHKO, 1903–1970
A Retrospective

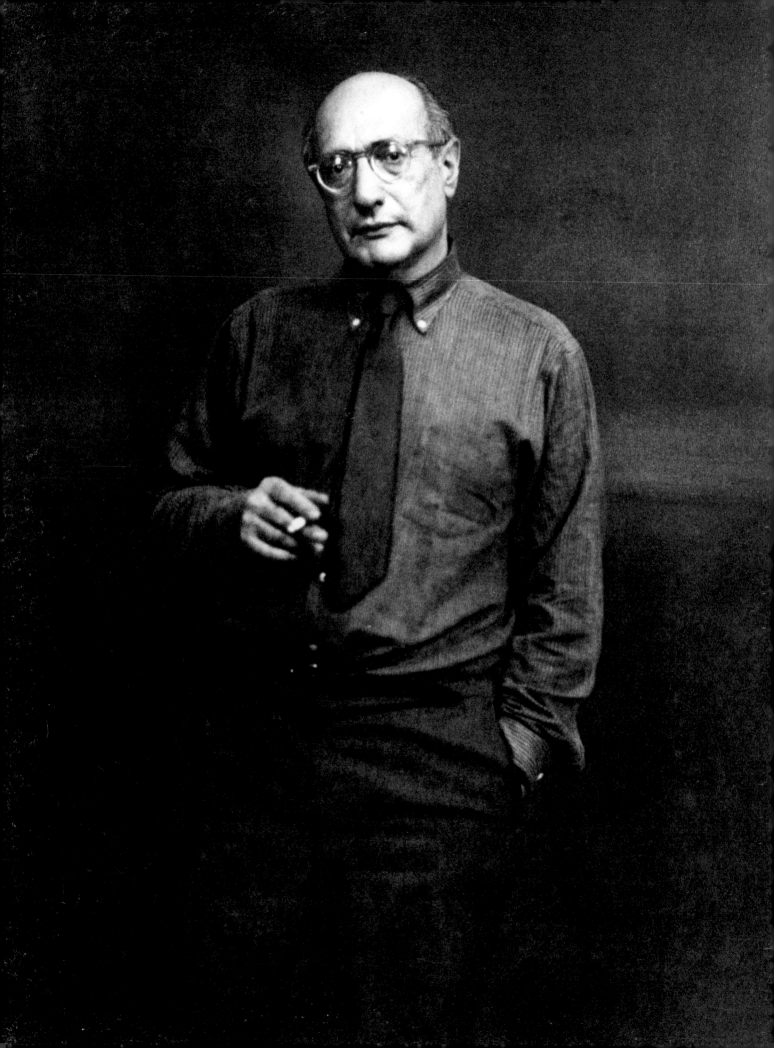

DIANE WALDMAN

Rothko, Mark

MARK ROTHKO, 1903–1970
A Retrospective

This project is supported by grants from
Atlantic Richfield Foundation and the National Endowment
for the Arts in Washington, D.C., a Federal Agency

Published by Harry N. Abrams, Inc., New York,
in collaboration with The Solomon R. Guggenheim
Foundation, New York, 1978

frontispiece
Mark Rothko on his birthday in
1960, 222 Bowery, New York.
Photo by Regina Bogat

The American Sublime
Copyright 1936 by Wallace Stevens and renewed
1964 by Holly Stevens. Reprinted from *The Collected
Poems of Wallace Stevens,* by permission of Alfred A.
Knopf, Inc.

The Solomon R. Guggenheim Museum, New York

in association with

The Museum of Fine Arts, Houston
Walker Art Center, Minneapolis
Los Angeles County Museum of Art

Book design: Nai Y. Chang
Editor: Carol Fuerstein

ISBN 0-8109-1587-1

Library of Congress Card Catalogue Number 78-58411

Printed and bound in Japan

Lenders to the exhibition

Mr. and Mrs. Donald Blinken
Leonard and Ruth Bocour
Honorable and Mrs. Irwin D. Davidson
Gerald S. Elliott, Chicago
Arnold and Milly Glimcher, New York
Graham Gund
Mr. and Mrs. Ben Heller, New York
M H Holdings Inc. (courtesy Mr. &
Mrs. Donald B. Marron)
Barbara and Donald Jonas
Mr. and Mrs. Robert Kardon
Mr. and Mrs. Michael Klebanoff,
New York
Mr. and Mrs. Oscar Kolin
Mr. and Mrs. Richard E. Lang,
Medina, Washington
Steingrim Laursen, Copenhagen
Dr. Paul Todd Makler
McCrory Corporation, New York
Mrs. Barnett Newman
Betty Parsons, New York
Mr. and Mrs. Gifford Phillips,
New York
Mr. and Mrs. Joseph Pulitzer, Jr.
Tiziana de R., Geneva
Estate of Mark Rothko
Estate of Mary Alice Rothko
Mrs. Hannelore Schulhof
Joseph E. Seagram & Sons, Inc.,
New York
Mr. and Mrs. Burton Tremaine,
Meriden, Connecticut
Frederick Weisman Family Collection
Mr. and Mrs. Bagley Wright

Albright-Knox Art Gallery, Buffalo,
New York
Art Gallery of Ontario
The Brooklyn Museum
Dartmouth College Museum and
Galleries, Hanover, New Hampshire
The Fort Worth Art Museum
Kunstsammlung Nordrhein-Westfalen,
Düsseldorf
Milwaukee Art Center
Munson-Williams-Proctor Institute,
Utica, New York
Museum of Art, Carnegie Institute,
Pittsburgh
Museum of Art, Rhode Island School of
Design, Providence
The Museum of Fine Arts, Houston
The Museum of Modern Art,
New York
The Phillips Collection, Washington, D. C.
The St. Louis Art Museum
Tehran Museum of Contemporary Art
The Toledo Museum of Art
University Art Museum, University of
California, Berkeley
Vassar College Art Gallery,
Poughkeepsie, New York
Whitney Museum of American Art,
New York

Galerie Beyeler, Basel
Gimpel & Hanover Galerie, Zürich
The Pace Gallery

Table of Contents

Acknowledgements

A retrospective of Mark Rothko's painting would be an event of significance in any circumstances. The current presentation, however, is unique in two respects: first, it is the most comprehensive survey of Rothko's work ever held and, second, the artist's tragic death in 1970 bestows upon it a finality which obviously would not obtain in an exhibition mounted during his lifetime. Furthermore, this is the first show of Rothko's painting after an almost decade-long hiatus caused by extensive litigation—court proceedings that made it impossible until now to realize an exhibition or even to gain access to a representative sampling of the artist's lifework from which a selection could be made.

Foremost among those who have extended their confidence to the Guggenheim Museum are the artist's daughter, Kate, and her husband, Ilya Prizel. Together with Edward J. Ross, of Breed, Abbott & Morgan, legal representative for the Estate of Mark Rothko, and Sally and William Scharf, the Prizels continued to extend their help and support in every aspect of the project. In addition, Herbert Ferber, Executor, Estate of Mary Alice Rothko, and Stanley Geller, of Butler, Jablow and Geller, attorney for the Estate of Mary Alice Rothko, have helped us with the extensive work relating to the estate of the artist's wife. We also wish to acknowledge favorable action recommended by the newly-appointed Board of the Mark Rothko Foundation comprised of Donald Blinken, Chairman, Dorothy C. Miller, Gifford Phillips, David Prager, Emily Rauh Pulitzer, William Scharf and Jack Tworkov.

Financing subsequently assumed great importance because of the exhibition's comprehensive scale and the high values of the works involved. The enormous interest shown by leading American museums from coast to coast resulted in a welcome pattern of collaboration. The Museum of Fine Arts, Houston, William C. Agee, Director; the Walker Art Center, Minneapolis, Martin Friedman, Director; and the Los Angeles County Museum of Art, Kenneth Donahue, Director, agreed to cosponsor the presentation with the Guggenheim, thereby assuming for all participants a double advantage: broadened national impact for the show and increased financial resources, as each of the four museums assumed basic costs during the retrospective's year-long circulation. But even with this collaboration, expenses would have outrun available finances had the enterprise not benefited from corporate as well as governmental support—the two principal sources of funding that have become increasingly important for cultural institutions in recent years. We therefore underline the appreciation of all the participating museums for

the equivalent sponsorship of the exhibition by the Atlantic Richfield Foundation and the National Endowment for the Arts. Both may take credit for helping to launch this significant event.

The selection, organization and staging of the exhibition, as well as the authorship of the catalogue which accompanies it were the responsibility of Diane Waldman, the Guggenheim's Curator of Exhibitions. Mrs. Waldman approached her task with exemplary thoroughness, seeking out primary sources of information and thus adding substantially to the existing fund of knowledge about the artist, his life and his work. In the process of her researches, she obtained much new and valuable information, often in the form of previously unpublished documentary material, from the following friends and colleagues of Mark Rothko: Mrs. Milton Avery, Jimmy Ernst, Mrs. Adolph Gottlieb, H. R. Hays, Buffie Johnson, Katharine Kuh, Mildred and Joseph Liss, Dorothy C. Miller, Dr. Max Naimark, Mrs. Barnett Newman; Wallace Putnam, Jon Schueler; Lee Sievan, Joseph Solman, Oliver Steindecker, Pat Trivigno, Jack Tworkov and Edward Weinstein. The following have helped us obtain photographs and gather information about Rothko's work: Ronnie Baer, The Museum of Modern Art, New York; Sidney Janis Gallery; Mayor Gallery; David McKee Gallery; Pace Gallery; Betty Parsons Gallery. The catalogue obviously has been greatly enriched by Mrs. Waldman's extensive essay and by the personal recollections of Bernard Malamud which shed new light upon the subject of this study.

An undertaking as far-reaching as the current exhibition and catalogue involves all levels of the Museum's organization. Therefore, the Guggenheim's staff as a whole should be thanked for their diligence and devotion. The following staff members were most directly concerned with the preparation of the exhibition and the catalogue: Clair Zamoiski, Curatorial Coordinator, who contributed to all aspects of the exhibition and publication; Carol Fuerstein, Editor, who edited the catalogue and saw it through the presses; Susan Hirschfeld, Curatorial Assistant, who helped with the publication's preparation and production; Maud Lavin, Curatorial Intern, who did research; Linda Shearer, Assistant Curator, who aided in the exhibition's preliminary stages.

Our last and in some ways most important acknowledgement is addressed to the lenders who, in a most tangible sense, have made this retrospective possible. Unless they wished to remain anonymous, their names are cited elsewhere in this catalogue, but our indebtedness to them and our gratitude for the confidence that their loans imply go far beyond such a perfunctory gesture.

Mark Rothko, 1903–1970: A Retrospective represents a mighty commitment by the participating museums—one that was realized only with the fullest aid and support of every kind. In Diane Waldman's name and on behalf of my colleagues, I therefore extend to all those who have helped so generously, our deeply felt gratitude.

Thomas M. Messer, Director
The Solomon R. Guggenheim Museum

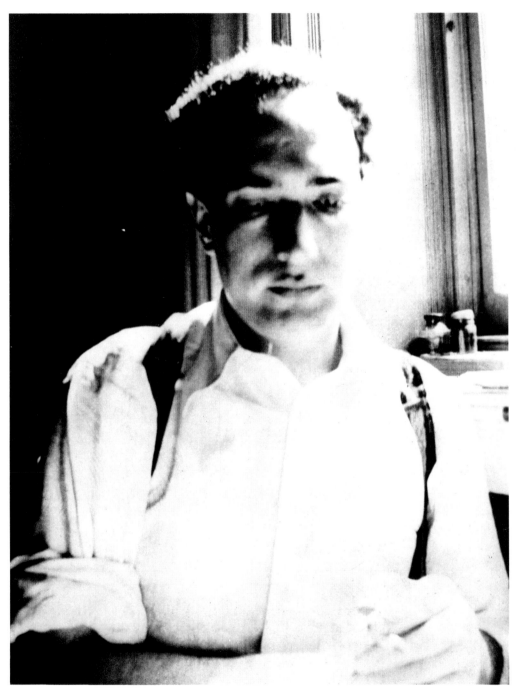

Ca. 1925

Preface

Mark Rothko shares with composers of music an absence of explicit imagery and a correspondingly developed capacity to evoke content by association; an ability to engage the responding organ (in his case, the eye) in a process that is akin to listening because it involves attention to consecutive passages; an interest in rhythmic structures (in his case, spatially articulated); and the use of color to achieve modulations that can be subtly chromatic or dramatically contrasted. Beyond this, Rothko's sensibility would seem to evoke the era of German Romanticism and with it the great names from Schubert through Brahms. Like them, Rothko is a creator of melodic surfaces rendered vital and sonorous by means of formal structures which are, for the most part, hidden. Also, like many of them, Rothko often creates for himself restricted formats which he then explores in a seemingly endless succession of rich variants. Finally, Rothko's orchestral propensities are, like those of the great Romantics, simultaneously ponderous and heroic, often lyrical in mood but never sentimental.

But music comes to mind here not only because Rothko uses devices analogous to those of the composers nor because he shares with them a broadly romantic sensibility. We think of music because Rothko's painting, so firmly structured, so rhythmically articulated and so subtly colored, has achieved a directness and force of expression rightly attributed to the tonal language more than to any other.

This comprehensive retrospective of Mark Rothko's lifework at the Guggenheim Museum and three American sister institutions should, therefore, envelop the visitor in an experience simultaneously intellectual and sensuous—an experience which reaches through eyes, deepened in their capacity, to the mind, the heart and the total being.

T. M. M.

The Aquamarine Sunrise: *a memory of Rothko*

Mark had been to John Kennedy's inaugural blast in 1961 and here he was, four years later, at Lyndon Johnson's, where my wife Ann and I met him and Mell. That night we were riding with two busloads of artists and performers from one pleasant entertainment to another. The company was exciting, the mood hilarious—Happy New Year still going on. Either on our bus, or at one party or another, I remember seeing or talking with people like Samuel Barber, Jasper Johns, Richard Wilbur, Anna Moffo, William Goyen and Edward Steichen. The buses were marked "Cultural Leaders" and led by sirening police cars at a fast clip through the streets of Washington. Mell Rothko, twenty years younger than her husband, was chatting from the seat behind us with Ann. Then Mark leaned forward and introduced himself. For a moment because of my associations with the Northwest I thought he had said Mark Tobey but he set me straight. We enjoyed being cultural leaders. Mark was beamish. Mell, in a happy mood, told my wife she had got him to propose by sitting in his lap and asking him to.

At dinner in the New State Department building, Mark and Mell, Ann and I, and, I think, Bill and Doris Goyen, sat together at a table with Henry Cabot Lodge, who was then Ambassador to South Vietnam, and his wife Emily. The Ambassador piled his plate and ate away: he said he hadn't eaten lunch. Mark, after cocktails, was high. He turned to Lodge and owlishly asked, "And what do you do?" Lodge told him. Mark, taking another look at him, got up on his feet and apologized. Lodge nodded courteously. They shook hands. Mark later told Ann the incident had embarrassed him.

After that we occasionally met Mark in New York City, usually at the home of Ilse and Karl Schrag, the painter and printmaker. They were neighbors who lived diagonally across the way from the Rothkos on East 95th. One day I was in town and coming to dinner at the Schrags. Ilse had gone across the street and lent Mark one of my books. He said he didn't read much but would have a go at it. She invited him to join us at dinner. He told her he liked being invited out at short notice, but he didn't think his wife would want to come. When he came over he told me he was familiar with the kind of people I'd written about in my book. He spoke of his Jewish immigrant family in Portland, Oregon, when he was a boy. I was very much interested in the Oregon connection because I had lived for a dozen years in Corvallis, a town south of Portland. Mark liked to reminisce: One night he told us how he had left his first wife. He had gone off for an army physical during World War II and they had turned him down. When he arrived home

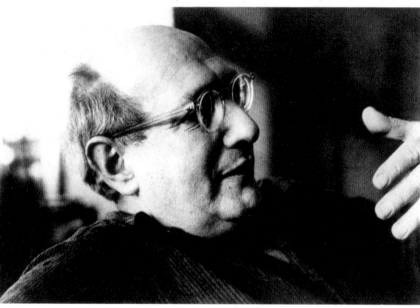

Photo by Consuelo Kanaga

Photo by Alexander Liberman

14

At the "Icehouse," Yorktown
Heights, New York, ca. 1949

Ca. 1964–66

and told his wife he was 4-F he didn't like the look that flitted across her face.
The next day he went to see his lawyer about a divorce.

Once, early in the winter of 1969, when we were subletting an apartment on Gramercy Park South, I stopped by to see Mark in his studio on East 69th Street. He wasn't working and seemed glad I had come. We spent most of the afternoon in the huge studio listening to Mozart and talking casually. On the coffee table was an open book on Shakespeare. He told me he had left Mell and talked about his depression. Mark recited his various troubles yet seemed content with himself. He had had a good summer, not at the beginning but good after a while. He had beaten out a severe depression and after a difficult time was able to work well in Provincetown. At first he'd

been given an antidepressant that tasted "brassy" and hadn't entirely relieved him so he went to another doctor, who had added or subtracted a pill, and thereafter he felt relief and could work. He'd had a prolific several months painting a flood of acrylics on paper. He said they had come to hundreds of paintings that summer and afterwards. He was in a period of wonderful productivity. It was a fine afternoon.

When I asked if I could see some of the summer's work he said he had already sold the best paintings. He dropped about ten or a dozen on the floor and said I could select from all but one, if I wanted. That was a black rectangle, about two feet by three, the black broken by a three or four inch jagged section in bright aquamarine. The aquamarine looked like light breaking through night. It was an uneven form, perhaps zigzag, unlike anything I'd seen in his work. I wondered if he was unwilling to part with it because it was a unique form for him; and I felt the picture held some special significance, which I interpreted to be symbolic of the dissolution of his black mood. I asked about that painting but he said he wouldn't part with it.

I wasn't much taken by the one-tone flat maroons and almost solid blacks on the floor but offered to show two of them to my wife. Mark said I could have the two for six-thousand dollars. He rolled the paintings into a cardboard cylinder which I brought home to Bennington. Ann and I examined them and decided they didn't represent Rothko to us. She returned them in the cylinder, insured, as Mark had requested, for twelve thousand dollars apiece. I sent a note saying that when he did some more acrylics on paper we hoped he would let us see them. There was no reply.

When we talked on the phone in December, when I was again spending the winter at Gramercy Park, I invited him to a party at our apartment and he said he would come and could he bring a friend. The night of the party he called to say he couldn't make it and would like to have a rain check. I said that for me where there was rain there were rain checks.

Shortly before he died in February, 1970, the Schrags saw Mark from their window, across the street. His long hair was lank. He looked haggard, pale, joyless.

That cold winter's night, one day after Mark Rothko had committed suicide, there was a small talky subdued crowd at the funeral home on Madison Avenue. Mark lay in his coffin with a pair of horn-rimmed glasses on his nose. He had been shaved and barbered and dressed in a dark suit. Standing there, I made my peace with him.

Karl Schrag thought he would not have taken his life if he hadn't been seriously ill.

Stanley Kunitz said that his death meant the end of an era in painting.

Mell, as I left, was glad I could come.

I said I didn't think I would be going to the funeral tomorrow.

She asked if I remembered the night in the bus when we were cultural leaders and everything was fine.

Bernard Malamud

15

The American Sublime

How does one stand
To behold the sublime,
To confront the mockers,
The mickey mockers
And plated pairs?

When General Jackson
Posed for his statue
He knew how one feels.
Shall a man go barefoot
Blinking and blank?

But how does one feel?
One grows used to the weather,
The landscape and that;
And the sublime comes down
To the spirit itself,

The spirit and space,
The empty spirit
In vacant space.
What wine does one drink?
What bread does one eat?

Wallace Stevens, 1935

MARK ROTHKO
The Farther Shore of Art

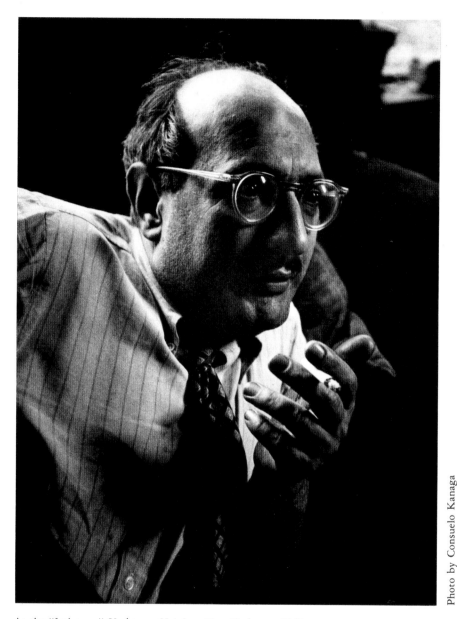

Photo by Consuelo Kanaga

At the "Icehouse," Yorktown Heights, New York, ca. 1949

The death of Mark Rothko on February 25, 1970, at the age of 67, brought to a close an era in which the myth of the artist as hero seemed as important as the period's now legendary paintings. Arshile Gorky, Jackson Pollock, David Smith, Franz Kline and others of the New York School had also met untimely ends, but it is Rothko's suicide that is the most disturbing, symbolically, of all these deaths. For it came in an age that values neither the hero nor the antihero and it demonstrated clearly, not a disbelief in art, but in the central role of the self in painting—a concept vital to Rothko and his contemporaries but antithetical to the ideas of a subsequent generation which views detachment on the part of the artist as essential.

Rothko's ambition was to rank with the greatest figures of Western art. This painter of genius wanted to achieve the grandeur of tradition and at the same time to rebel against tradition. The struggle to attain this paradoxical goal ultimately destroyed his confidence. The tragedy of Rothko's death, then, lies not only in its termination of a brilliant career, but in that it marked the end of an attitude towards the role of the artist and art itself.

18

fig. 1

Manifest of Alien Passengers for the United States Immigration Officer at Port of Arrival, August 17, 1913

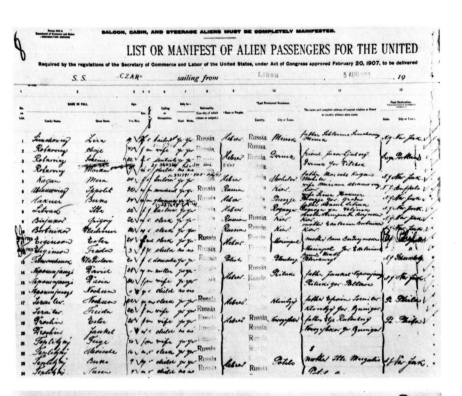

I

On August 5, 1913, the ten year old Marcus Rothkowitz sailed to America aboard the S.S. *Czar* from the Russian port of Libau with his mother, Anna, and his older sister, Sonia. His father, Jacob, a fairly well-to-do pharmacist in Russia, had emigrated to the United States in 1910. He traveled to Portland, Oregon, where his brother, Samuel Weinstein, had established himself some years earlier and founded a flourishing men's clothing business, the New York Outfitting Company.[1] Shortly after the senior Rothkowitz found employment as a pharmacist, he sent for his two eldest sons, Moise and Albert, and two years later for his wife, daughter and Marcus, the youngest child.

The latter three, listed in the Manifest of Alien Passengers (fig. 1) as "Markus," "Scheine" and "Chaje Rotkowicz," arrived in New York on August 17. As second-cabin passengers they did not have to enter the United States through Ellis Island. Instead, they disembarked in New York and then proceeded to New Haven, where they stayed with Weinstein cousins for ten days. Then they traveled by train to Portland, wearing badges indicating they did not speak English. In Portland, they settled in the Jewish section of the southwest part of town. Seven months after they arrived, Jacob died.

Life in Czarist Russia was very difficult for most Jews. Subject to extreme repression, they were unable to move about freely and were restricted to living in certain quarters. Advanced education was a privilege denied to all but a tiny minority. There was a quota system, with few Jews allowed into high school and even fewer into college. Nonetheless, Jacob Rothkowitz was able to provide a comfortable existence for his family and schooling for his children. Born on September 25, 1903, in Dvinsk, Marcus was considerably younger than his sister, who was fourteen at the time of his birth, and his brothers Moise and Albert, who were eleven and eight respectively. Like many Jewish boys in Eastern Europe in this era, Marcus was sent to Hebrew school and studied the scriptures and the Talmud. Despite these educational advantages, the family faced an uncertain future in Russia, and Jacob decided that they would fare better in America.

When Jacob died, the children were forced to go to work. Sonia, who had been trained as a dentist in Russia, became a bookkeeper and clerk at the New York Outfitting Company, while Moise and Albert also worked for the Weinstein family until they learned English well enough to pass the qualifying exams required to become pharmacists. Marcus worked as a delivery boy and took on a newspaper route.

fig. 2
Shattuck School, Portland, Oregon

20

fig. 3
Old Lincoln High School , Portland, Oregon

fig. 4
Newspaper clipping showing Naimark,
Director and Rothkowitz, September 18,
1921. Courtesy Dr. Max Naimark

LINCOLN HIGH GRADUATES LEAVE PORTLAND TO ENTER YALE.

Max Naimark. Harry Director. Marcus Rothkowitz.
BUSHNELL FINK. BUSHNELL

Three graduates of the Lincoln high school in the June '21 class left
Portland last week to enter Yale. They are Marcus Rothkowitz, Max
Naimark and Harry Director, three Russian boys, none of whom has been in
this country longer than seven years.

All three made brilliant records in scholarship during the time they were
in Lincoln high and passed their college entrance examinations soon after
graduation. They will stay at Yale four years. They intend to become
professional men, but have not yet decided upon their life work.

Max Naimark has been in the United States only four years. He spent
ne year in the elementary schools and three years in high school. All three
ok the college preparatory course in high school.

Marcus attended Shattuck Grade School and Lincoln High School, completing high school with an extraordinary record in only three years (figs. 2,3). While attending Lincoln, he worked in the shipping department of the family store. At this time, Marcus took drawing and painting classes at a local art school with two of his cousins and often sketched on the store wrapping paper.[2] His feeling for music emerged now, encouraged by his uncle, Samuel Weinstein, whose two daughters studied at Juilliard. Although Marcus had no formal music training, he taught himself to play the mandolin and later the piano. In high school, he was especially interested in social studies and literature and, despite his recent emigration, was fluent enough in English to be a proficient debater. Concerned with the labor movement and radical causes, he hoped to be a labor organizer, an ambition consistent with the liberal politics of many Russian Jews, born of the harsh realities of their situation. Many years later, the artist related:

> *While I was still in grade school . . . I listened to Emma Goldman and to the IWW orators who were plentiful on the West Coast in those days. I was enchanted by their naïve and child-like vision. Later, sometime in the Twenties I guess I lost all faith in the idea of progress and reform. So did all my friends. Perhaps we were disillusioned because everything seemed so frozen and helpless during the Coolidge and Hoover era. But I am still an anarchist. What else?*[3]

In September 1921, Rothkowitz left Portland for New Haven to attend Yale University—a Weinstein family tradition—with two former high school classmates and fellow Russian emigrants, Aaron Harry Director and Max Naimark (fig. 4). The dean of Yale, sent to Portland to recruit students, and Lincoln High School's chemistry teacher, a Yale graduate, had encouraged them to apply to the University. The three traveled across country by train. Marcus and Max shared a Pullman berth.

Naimark recounts their stay at the University as follows:

> *During our freshman year at Yale, Marcus and I roomed together in a third floor room . . . at 840 Howard Avenue, New Haven. . . . Marc and I didn't see much of each other except late in the evenings when we returned to our room. . . . Marcus didn't seem to need much studying and spent a considerable amount of time with his relatives in New Haven . . . the Weinsteins . . . who also lived on Howard Avenue. . . . The Weinsteins had two sons, architects, graduates of Yale and living in New Haven at the time. As far as I was concerned, Marc was brilliant. He did not have to study much, didn't pay much attention to some of the subjects or the professors he didn't particularly like.*

> *For the second year at Yale . . . Marc moved to the Yale dorms and roomed with Harry Director and another student.*

> *At no time have I seen Marc paint. He did much informal drawing and sketching which to me looked quite good but that's about all.*[4]

Although Marcus and his two friends had received full scholarships to the University, these were cancelled after one year. Nevertheless, all three stayed on. Marcus remained until 1923, studying English, French, history, mathematics, physics, biology, economics and philosophy. During his second year he took all his meals with the Weinsteins to save money and worked

at odd jobs in the Yale student laundry and at two different cleaners near the campus. He excelled in math and seriously considered becoming an engineer. In his sophomore year, Rothkowitz, Director and Simon Whitney, another student, published a short-lived weekly, the progressive *The Yale Saturday Evening Pest.* More a pamphlet than a newspaper, it contained articles, comments, editorials and criticism on subjects of interest to Yale students. The sheet's decidedly liberal point of view as well as its propagandist nature were quite unusual for Yale in the twenties.

Marcus left Yale—probably because he became bored with his studies, possibly also due to financial difficulties—in 1923, without receiving his degree, to "wander around, bum about, starve a bit."[5] Without any clear idea of what he wanted to do, he moved to New York and rented a room at 19 West 102nd Street. He seems to have become an artist by chance. "I happened to wander into an art class, to meet a friend who was taking the course," he explained. "All the students were sketching the nude model— and right away I decided that was the life for me."[6] He began taking anatomy courses at the Art Students League with George Bridgman. At this time, he supported himself by taking odd jobs, including work in the garment district. Rothkowitz worked for a while as a bookkeeper for a Weinstein relative, Samuel Nichtberger, a CPA and tax attorney with offices on Broadway. Naimark tells us:

> *Not too long after he left Yale I saw him in the Bronx [sic] where he lived in a one room apartment and I got the impression that he was earning a few dollars drawing patterns for some materials. I lost track of him after that, though I did hear that he hitchhiked to the West Coast once or twice but didn't know anything definite for some years. Then I began to hear and read about his accomplishments as a painter and artist.*[7]

He returned for a short period in 1924 to Portland and joined an acting company run by Clark Gable's first wife, Josephine Dillon. Gable was also in the company then and it is likely that they became acquainted before Gable left for Hollywood with Miss Dillon. In fact, the artist was to claim that Gable had been his understudy. Despite the brief duration of this experience, his fascination for theater continued. To some extent it influenced his choice of dramatic themes in his painting of the early 1940's. And as late as 1947-48 he said:

> *I think of my pictures as dramas; the shapes in the pictures are the performers. They have been created from the need for a group of actors who are able to move dramatically without embarrassment and execute gestures without shame.*[8]

Although Rothkowitz continued to make frequent visits to Portland during the 1920's, he returned to New York for good in 1925. He had reached a decision about his future dictated not by his love of math, music, literature, philosophy, engineering, radical causes or the theater, but by a compelling interest in art. Mozart, Schubert, Beethoven, Shakespeare, Nietzsche and Kierkegaard continued to sustain and nurture him throughout his life. He was fascinated by literature and had apparently once considered becoming a professional writer. But his commitment to painting prevailed, and from now on he devoted himself to it. Years afterward, he was to remark: "I became a painter because I wanted to raise painting to the level of poignancy of music and poetry."[9]

At the beginning of his career, he was still known as Marcus Rothkowitz. In 1940, however, he began to use the name Mark Rothko, first sporadically and with minor variations, such as Marcus Rothko, then consistently and without modifications. Although he became a United States citizen in 1938, he did not legally change his name until 1959. Exactly why he chose to shorten his name is unknown. Friends have variously explained that he was asked to change his name by a dealer, that it signalled a dramatic change in his style, or that the artist himself decided it was too cumbersome, too foreign and that a simpler one would be better for his career, citing the painter Arshile Gorky as a precedent.

His works of the late twenties, conventional but sensitive urban scenes, spontaneous landscapes and studies of nudes (cat. nos. 2, 6), are the products of a young and talented student. They reflect a realist trend dominant in American art in the 1920's that had little to do with the ongoing revolution in painting and sculpture taking place in Europe. Cubism, Futurism, Suprematism, Constructivism, Dadaism and Surrealism were alien to the experience of most artists in the United States at this time. As Rothko later said of realism, "that was what we inherited."[10]

Artists like Thomas Hart Benton set the standard for American painting during the 1920's and 1930's. Benton, like many others who had embraced avant-garde art, turned violently against abstraction after World War I. His reaction was symptomatic of the country's political, social and aesthetic conservatism, its isolationism and chauvinism, its mood of profound despair, born of the war and deepened by the Depression. Provincialism in the form of the Regionalism favored by Benton, Grant Wood and John Steuart Curry and the American Scene Painting of Reginald Marsh, Isabel Bishop, the Soyer brothers, the Social Realism of Ben Shahn and Philip Evergood and others, prevailed in the American artistic climate until World War II. Even artists like Georgia O'Keeffe, Marsden Hartley and Stanton MacDonald-Wright, who had been in the crowded vanguard of experimental abstraction, returned at least for a time to representation. Although a small number of Americans, Arthur Dove, Morgan Russell and Stuart Davis among them, and Europeans, like Josef Albers and Hans Hofmann, who came to the United States in the early 1930's, continued to work in advanced styles, the majority of painters concerned themselves with depicting the poverty and disillusionment of the downtrodden urban masses or celebrated rural life. Everyday reality was the subject of artistic comment, as painting often became topical, journalistic, illustrational.

The Regionalism or "realism" that Rothko and his generation inherited was to a certain extent offset by the teaching of Max Weber, in whose class Rothko worked when he re-enrolled in the Art Students League upon his permanent return to New York. Although Rothko studied with Weber for only a short time, from October through December of 1925 and again from March through May of 1926, his influence on the young painter was considerable. It is obvious that Weber's sophisticated knowledge of painting, his ardent admiration for Cézanne and his introduction of the more modern painters made a strong impression on his students. At an early stage of his career, Weber had rapidly absorbed the lessons of both Fauvism and Cubism. He had produced several superb Cubist paintings, foremost among them *Chinese Restaurant* of 1915 (fig. 5). Like the Cubists, Weber employed trompe l'oeil as an integral part of his work. The Cubists used these elements as decorative, additive accents, incorporating fragments of real or simulated

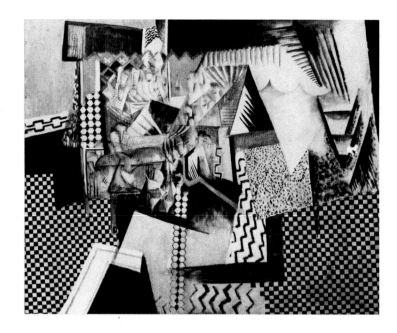

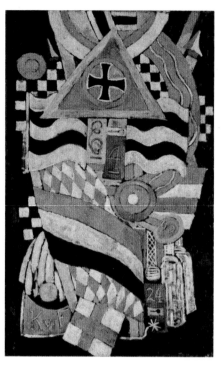

24

materials into their collages in order to question the nature of illusion and reality. Weber, however, insisted upon painting literal facsimile versions of textures and patterns with an attention to detail that often took precedence over formal order. This characteristic directly relates Weber to such nineteenth-century American masters of trompe l'oeil as William M. Harnett and John F. Peto. Later he adopted a form of Expressionism, derived from Soutine and Chagall, that he conveyed with enthusiasm to his students. Rothko's indebtedness to Weber's late style is readily apparent in both the choice of subjects and mood of his paintings of the 1920's. Less obvious but more meaningful is the imprint Weber's Cubist work was to leave on his later painting. *Gethsemane* and *Primeval Landscape,* both 1945 (cat. nos. 65, 66), for example, contain emblematic forms juxtaposed upon a flat backdrop in a manner that recalls Weber's combination of trompe l'oeil technique and collage-like images. Weber's spatial illusionism and play is, however, diminished in Rothko's canvases. Rothko's paintings are more frontal and two-dimensional, perhaps because they are in part inspired by Hartley's very flat, heraldic paintings of military symbols of 1914 (fig. 6). But the play has not altogether disappeared: remnants of the curiously shifting planes of *Chinese Restaurant* find their way into Rothko's spatially ambiguous works of the mid-1940's onward.

During the late 1920's, Rothko supported himself by drawing maps for a book on popularized biblical history written by Lewis Browne, a retired rabbi from Portland who was a relative of Rothko's schoolmate, Harry Director. He moved to 231 East 25th Street and took a job in 1929 teaching children part-time at the Center Academy, Brooklyn Jewish Center, a position he retained until 1952. Teaching, in fact, was to be his primary means of supporting himself until he became financially successful as an artist.

At the age of twenty-five, in 1928, Rothko was included in his first group exhibition at the Opportunity Galleries in New York. Bernard Karfiol chose several of his paintings for the show, together with works by Milton Avery, Louis Harris and others. His first one-man show in New York did not take place until 1933 at the Contemporary Arts Gallery. The review of the exhibition reads as follows:

fig. 5
Max Weber, *Chinese Restaurant,* 1915. Collection Whitney Museum of American Art, New York

fig. 6
Marsden Hartley, *Portrait of a German Officer,* 1914. The Metropolitan Museum of Art, The Alfred Stieglitz Collection, 1949

fig. 7
Pablo Picasso, *Two Nudes,* late 1906. Collection The Museum of Modern Art, New York. Gift of G. David Thompson in Honor of Alfred H. Barr, Jr.

fig. 8
Henri Matisse, *The Blue Nude (Souvenir of Biskra),* 1907. The Baltimore Museum of Art: Cone Collection

fig. 9
Henri Matisse, *Bathers with a Turtle,* 1908. Collection The St. Louis Art Museum, Gift of Mr. and Mrs. Joseph Pulitzer, Jr.

Our Odyssey ends with the Contemporary Art Gallery. Always engaged in fresh and unusual projects, such as the "Painting of the Month" club which is achieving great success, this gallery's repeated presentations of new artists are very exhilarating. The newcomer is Maurice Rothkowitz. No aid from the catalog is necessary to inform us of his art education. The ponderous structure of the "Nude" harks back to the "Eight Figures" of Max Weber. In other works, here is the full-fledged influence of Cézanne. Pigment modeling apparent in "Man Smoking" is not confined to oil, since "Portland" in watercolor shows the same tendencies. Of the black and white, "Riverside Drive" appears to be the most outstanding sketch.[11]

In all probability, the canvas referred to is the bulky nude of 1930 (cat. no. 10). While there is some evidence of Weber's influence on Rothko in the scumbled, heavily ladened brushwork of this painting, the apparent sources for the figure of the nude are Picasso's *Two Nudes,* late 1906, and Matisses such as *The Blue Nude (Souvenir of Biskra),* 1907, and *Bathers with a Turtle,* 1908 (figs. 7-9).

Many of Rothko's watercolors of the period refer specifically to Marin

25

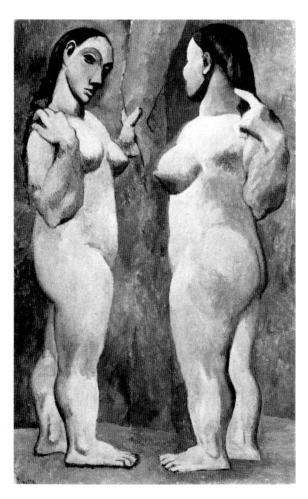

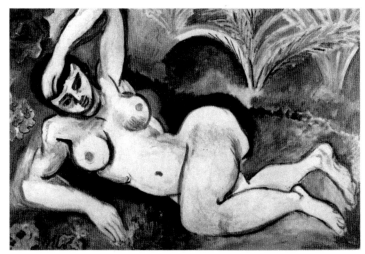

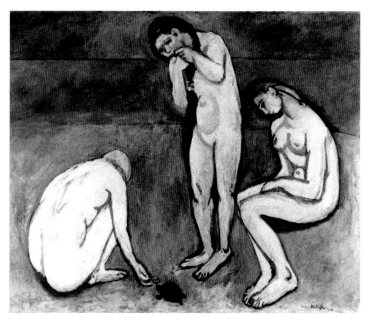

and through him to Cézanne. The triangular organization of a number of Rothko's paintings of this time recalls not only Cézanne but the art of the Renaissance, which the young artist very much admired. To be sure, the rational, harmonious order imposed by the classical device of the triangle is entirely at odds with Rothko's turbulent technique and expressionist color. Stylistic consistency was something he had yet to achieve.

As Rothko's experience broadened, he seized upon subjects other than the typical classroom still lifes, landscapes and nudes. He began to depict street and waterfront views, bathers, horses, portraits, the theater, religious themes and domestic subjects such as music lessons and women sewing (cat. nos. 9, 11, 12), in what seems to have been an attempt to make a diary of the world about him. He variously tried his hand at oils, watercolors and pen and ink or pencil drawings. His drawings and watercolors are extremely assured if not highly original. The oils are the most promising albeit least resolved work of these years. They are somber, ruggedly expressionist, heavily painted works in which figures with twisted heads alternate with contorted nudes and dark landscapes. Their brooding introspection and romantic feeling already reflect the sensibility that was to inform his dark paintings of the late 1950's and 1960's.

It is difficult to trace the evolution of Rothko's style and themes with exactitude because, for many reasons, the dating of the period of the twenties through the mid-forties is problematic. For one, Rothko rarely dated his paintings at this time—only many years later, when he made an inventory of his work, did he do so, without records and relying entirely upon his memory. Thus, his Avery-like figures on a beach, which are presently dated about 1925-27, could conceivably have been painted after 1928, the year Rothko and Avery first exhibited together. And the subway paintings, some of which are currently assigned to 1930, might more sensibly, on the basis of stylistic evidence, be reattributed to the mid or late 1930's. The work cannot precisely be dated on the basis of its appearance in particular exhibitions, as Rothko seems to have included paintings executed over a number of years in each show, well into the 1940's. (The idea of conceiving paintings especially for an exhibition or of showing only recent work did not gain currency until much later.) Moreover, many canvases have more than one title, more than one date and were oriented in more than one direction. Further confusion in dating arises because Rothko's thinking was often in advance of his painting. As early as 1936, for example, while working on the subway paintings, he began to write in his notebooks on the meaning of myth: he did not, however, start to paint mythic subjects until 1938, when he started *Antigone* (cat. no. 23), nor did he publish his fully articulated position on such themes until 1943. In the same year Rothko painted *Antigone,* he continued to work in a realist vein and produced the definitive subway canvas, *Subway Scene* (cat. no. 22). In fact, he often continued to work in one style while experimenting with another, more advanced formulation. The way Rothko's work was characterized by critics also contributes to misconceptions about his style: during the 1930's, for example, he was known as an Expressionist, when his subway paintings, expressive as they are, have little in them that is Expressionist.

Despite the strong effect Weber had on his work, Rothko was to maintain that he was largely self-taught and had "...learned painting from his contemporaries in their studios."[12] There was some truth in this assertion, for in the late 1920's, as a young artist just beginning to come into his own, he discovered that there were numerous alternatives to Weber's style.

The single most viable alternative was presented by Avery. In all probability, Avery and Rothko met in 1928, when both showed at the Opportunity Galleries. Later, it seems that the violinist Louis Kaufman, who, like Rothko, came from Portland, brought the young artist to Avery's home. Their friendship was immediate.

Rothko and a number of his colleagues looked to Avery for inspiration, even though he was only about ten years older than they. (Paradoxically, Avery did not arrive at his most successful statements until after Rothko developed his own mature style. Indeed, Rothko was an influence upon Avery by the early 1950's.) Avery's studio was open to many younger artists. His accessibility, his gentle manner, his willingness to engage in dialogue, were a refreshing change from the student-teacher relationships that artists of Rothko's generation had previously experienced. As Avery's wife, Sally, has remarked:

> [*Rothko*] *dropped in almost every day to see what Milton was painting.*
>
> *We spent summers together on Cape Ann where everyday we met at the beach for swimming and every evening we looked over the day's work. Adolph Gottlieb was there too and Barnett Newman joined us. Milton did a number of watercolors using these friends as models.* [13]

Among the portraits Avery painted of his young friends is a 1933 oil of Rothko (fig. 10). Rothko indicated Avery's importance in the moving eulogy he delivered upon his death in 1965:

> *This conviction of greatness, the feeling that one was in the presence of great events, was immediate on encountering his work. It was true for many of us who were younger, questioning and looking for an anchor....*
>
> *I cannot tell you what it meant for us during those early years to be made welcome in those memorable studios on Broadway, 72nd Street, and Columbus Avenue. We were, there, both the subjects of his paintings and his idolatrous audience. The walls were always covered with an endless and changing array of poetry and light.*
>
> *There have been several others in our generation who have celebrated the world around them, but none with that inevitability where the poetry penetrated every pore of the canvas to the very last touch of the brush. For Avery was a great poet-inventor who had invented sonorities never seen nor heard before. From these we have learned much and will learn more for a long time to come.*
>
> *But from these there have been fashioned great canvases, that far from the casual and transitory implications of the subjects, have always a gripping lyricism, and often achieve the permanence and monumentality of Egypt.* [14]

Avery's pastoral subject matter was, to be sure, alien to Rothko's urban sensibility. Rothko did, however, paint some figures in interiors, domestic and seaside scenes in a manner reminiscent of Avery (cat. nos. 4, 7). It was not Avery's themes—which were typical thirties genre subjects—but his refreshing style that opened doors for Rothko. His precisely delineated, Matisse-derived flattened form and soft, lyrical color became integral parts of

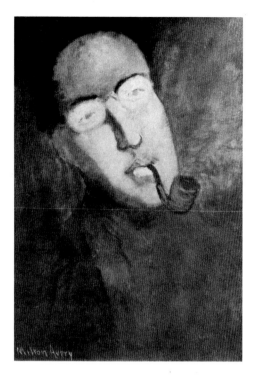

fig. 10
Milton Avery, *Portrait of Mark Rothko*, 1933.
Museum of Art, Rhode Island School of
Design, Providence, The Albert Pilavin
Collection; 20th Century American Art

Rothko's work and acted as antidotes to Weber's heavily painted, greyed hues and expressionistic manner. Avery's ability to minimize the numbers of shapes and colors he used and maximize their importance was of significance to younger artists like Rothko, as was the simplicity and directness of his figures. Avery was, in effect, the bridge between Matisse and Rothko. Rothko's *Subway Scene,* 1938 (cat. no. 22), reveals a number of parallels with Avery's work. Its scrubbed surface may be compared to Avery's painterly technique, and its figures are clearly derived from Avery's own forms. While there is an affinity between the stratified composition of *Subway Scene* and a canvas such as Avery's *Coney Island,* 1936 (fig. 11), Rothko's structure is much more overtly architectonic and geometric. Only rarely and in paintings closely modeled upon the older artist's did Rothko employ the diagonal compositions Avery favored as a means of reconciling the illusion of depth with the two-dimensional picture plane (fig. 12). It is notable that Rothko's mature preference for an inherently flat, frontal structure is already strikingly apparent in this painting.

Equally noteworthy here is Rothko's use for the first time of a single specific theme in a group of works, for *Subway Scene* is one of a number of subway canvases (cat. nos. 16, 18, 20) he executed in the 1930's. While these subway paintings are perhaps not sufficiently unified to constitute a true series, they do attest to an effort on Rothko's part to clarify his ideas in a number of related works and thus prefigure his mature series, the Seagram, Harvard and Houston chapel murals.

Rothko was attracted to the subject of the subway during the period of the WPA: its distinctly urban flavor and the opportunity it afforded to depict the dispirited masses dear to the artists of the Depression had obvious appeal at the time. It was a common enough theme during the thirties. A number of artists, Marsh, Bishop, Joseph Solman, Francis Criss among them, painted subway scenes in this era. Rothko, however, was the only one to endow the image with dignity, remoteness and a sense of dream-like suspension of motion, qualities more appropriate, perhaps, to the timeless formal order of Renaissance paintings than the contemporary, timely character of the subject.

The subway paintings are chalky, executed in "...wan, whitened color like frescoes from Herculaneum...."[15] Human form is attenuated until it almost ceases to exist; the bulky figures of the 1920's are pared down, as density is replaced by transparency. Formerly monolithic presences become shadowy, apparitional. Ghostly and unreal, these personages appear and disappear among the subway pillars. Even where several people are grouped together, there is a sense of silence, of distance and lack of communication that is extremely disorientating and recalls Edward Hopper or Giorgio de Chirico (figs. 13,14). Other paintings of the period are similarly disquieting—a nude seems hermetically sealed in a room with neither windows nor doors, an otherwise ordinary couple imbued with an impenetrable air of mystery or isolation confronts the viewer, a young boy is lost in contemplation (cat. nos. 13, 15, 21). In all instances, there is evidence of Rothko's need to compress space, if not flatten it. Whether or not Rothko's subways have symbolic meaning is open to conjecture, but certainly these paintings suggest a strange, nether region that re-emerges in his Surrealist-inspired subterranean fantasies of the mid-1940's. Although these far from fully resolved paintings are the efforts of a young artist struggling for clarity and identity, the otherworldly mood that infuses them is predictive of

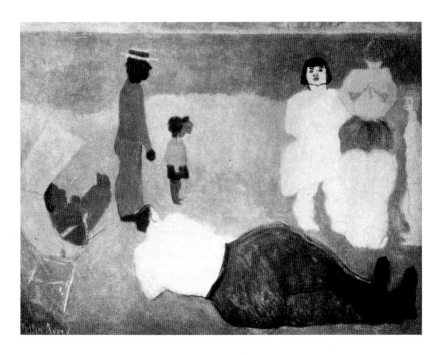

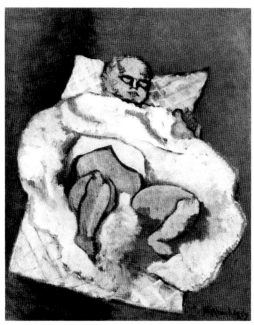

fig. 11
Milton Avery, *Coney Island*. 1936. Private Collection

fig. 12
Milton Avery, *Baby Avery*. 1932. Collection Mrs. Milton
Avery

fig. 13
Edward Hopper, *Early Sunday Morning*. 1930. Collection
Whitney Museum of American Art, New York

fig. 14
Giorgio de Chirico, *The Nostalgia of the Infinite*. 1913–14?
Collection The Museum of Modern Art, New York

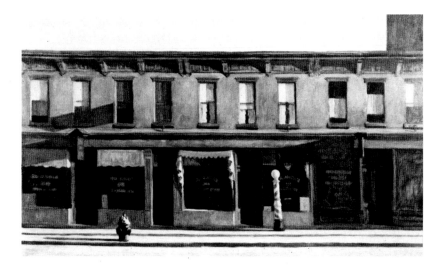

Rothko's mature expression. This mood is the emanation of a fragile, precarious and sensitive state of mind that is perfectly evoked by André Breton's words: "This summer the roses are blue; the wood is made of glass. The earth wrapped in its foliage makes as little effect on me as a ghost. Living and ceasing to live are imaginary solutions—Existence is elsewhere."[16] There is in these works an element of calm and a quality of palpable light. Later, of course, Rothko was to elevate these characteristics into transcendent spirituality.

The 1930's was a period of denial and stagnation rather than affirmative personal expression or social progressivism. The government sought to support art and artists during the Depression, but succeeded primarily in fostering provincial and conservative styles. There were two federal art programs administered by the Treasury Department in the early 1930's—the Public Works Art Project and the Section of Painting and Sculpture. Both organizations favored the representational styles generally associated with American Scene painting or Regionalism. Painters could have fulfilled a vital and forward-looking social role, but neither they nor the federal government understood this at the time. The forces of bureaucracy and individualism in art were in conflict. Like all minor artists, the painters encouraged by the government did not reach out towards the new but were satisfied to concern themselves with what was already known. Their attitude and the government's policy did not, however, satisfy the expectations of a young, politically active, primarily immigrant group of artists, Rothko among them, as is evident from the political and artistic events that took place during the decade of the thirties. The more progressive and militant artists formed a number of organizations which agitated for the creation of art projects for the unemployed and protested the conservative bias of the government's existing programs.

In 1934, one such group, the Artists' Union, was organized in New York, with local chapters elsewhere, to demand the establishment of new programs. Rothko was one of approximately two-hundred who participated in the inauguration of the Union. The Artists' Union did not confine itself to the problems of artists but was involved in different areas of labor as well; there was solidarity among the artists and other groups. As Solman has pointed out:

> *At this time the Artists' Union and the National Maritime Union (NMU) were two of the most active participants in aiding striking picket lines anywhere in New York City. If the salesgirls went out on strike at May's department store in Brooklyn a grouping from the above-mentioned unions was bound to swell the picket line. I recall some of our own demonstrations to get artists back on the job after a number of pink dismissal slips had been given out. At such times everyone was in jeopardy. Suddenly from nowhere a truckload of NMU workers would appear and jump out onto the sidewalk to join our procession. Cheers welled up from all sides. Those were spirited times indeed.*[17]

In August 1935, the Works Progress Administration, Federal Art Project (WPA/FAP) was formed with Holger Cahill as its director. It was the most extensive and most effective of all the New Deal art relief programs and engaged artists without bias in regard to style. Rothko, together with Harris, Solman, Jack Tworkov, Ad Reinhardt, William Baziotes and many others, was employed in the WPA's easel project. He was with the project

from 1936 to 1937, earning $95.44 per month. Small as this stipend was, it was the chief support for many of the artists of Rothko's generation.

Just as Rothko's rebellious nature had earlier drawn him to radical politics and an interest in trade unions, so now it led him to join the militant Artists' Union and, along with his fellow members, protest the economic and social conditions of the Depression, as well as the established order in both politics and art. However, it should be noted that, as the writer H. R. Hays, who was the artist's friend from 1935, has said, Rothko "had no objection to picketing for the immediate preservation of jobs but he strenuously opposed the injection of politics into art which he felt simply resulted in bad art."[18] The revolutionary attitudes that gave rise to these organizations continued to exist even into the fifties, when Rothko, Gottlieb, Willem de Kooning, Jackson Pollock, Newman, Clyfford Still and others protested the Metropolitan Museum's prejudice against advanced art.

In 1934, Rothko joined the newly established Gallery Secession in New York, but, in 1935, he and several other artists left it to form a group called *The Ten*. This circle rarely consisted of more than nine painters and was commonly referred to as "The Ten Who are Nine." It counted among its original members, besides Rothko, Gottlieb, Solman, Harris, Ben-Zion, Ilya Bolotowsky, Yankel Kufeld, Louis Schanker and Nahum Tschacbasov. Later additions were Lee Gatch, John Graham, Karl Knaths, Ralph Rosenborg and David Burliuk. They exhibited for five years, primarily at galleries in New York. Though *The Ten* was a group of independents with no declared program, the majority of its members painted representationally in a loose flat manner but were sympathetic to abstract art. Solman relates that at this time Rothko and Gottlieb "were both in the spontaneous expressionist or fauve traditions."[19] *The Ten* were much opposed to the conservative styles then dominant and interested in such Europeans as Picasso, Matisse and Soutine as well as the Americans Avery and Albert Pinkham Ryder. In Solman's words:

> *The modern concept of flat space, as in early Matisse, the 1922-26 still-life period of Picasso and the German Brücke group was also a clear force in the work of most of The Ten. We all admired Picasso, Matisse, Rouault, Klee and the German expressionists, many of whose works we first became acquainted with at J. B. Neumann's New Art Circle and later at Paul Rosenberg's and of course at The Museum of Modern Art.*[20]

The Ten were rebellious and progressive and in November 1938 they held an exhibition called *Whitney Dissenters* at the Mercury Galleries to protest the policies of the Whitney Museum of American Art. As Bernard Braddon of Mercury and Rothko wrote in the catalogue of the exhibition, "The title of this exhibition is designed to call attention to a significant section of art being produced in America. Its implications are intended to go beyond one museum and beyond one particular group of dissenters. It is a protest against the reputed equivalence of American painting and liberal painting. . . ." They repudiated both buckeye American painting and obsolete European traditions, expressing their intention to "see objects and events as though for the first time, free from the accretions of habit and divorced from the conventions of a thousand years of painting."[21]

The Ten met monthly at each other's studios. Solman says that Rothko was an extremely articulate participant in their discussions. "In argument he

was brighter than a lawyer and could almost wind out dialogues like a Talmudist."[22] The group broke up in 1940, primarily because it had outlived its usefulness, as most of the members were becoming more established and were now joining galleries on their own. *The Ten* parted company on friendly terms.

32

fig. 15
Mark Rothko, *Crucifixion,* before 1936.
Whereabouts unknown

fig. 16
Mark Rothko, *Woman Sewing,* before 1936.
Estate of Mark Rothko

fig. 17
Mark Rothko, *Street Scene,* before 1936.
Estate of Mark Rothko

II

In 1940, Rothko and Solman were given an unparalleled opportunity to participate in a three-man exhibition with Marcel Gromaire at the Neumann-Willard Gallery in New York. Both Rothko and Solman were delighted with the offer to exhibit on equal terms with a noted French painter. Although Rothko's work did not receive much critical attention prior to his one-man show at Peggy Guggenheim's Art of This Century in New York in 1945, a discerning review of the Neumann-Willard exhibition appeared:

> *Beside his depth of color, the light and singing hues of Mark Rothko's palette seem like a soprano part.* Entrance to Subway, *with its introduction of a green railing lightens a scene usually seen in its gloomy aspects, and the peace and quiet of* Contemplation *is arrived at because of the artist's translation of a mood to canvas. This artist has taught children for many years, and one feels that they in turn have helped to make him see and feel with their own simplicity and instinct for truth.* The Party *condenses the gaiety and high spirits of a children's celebration into a design of real structural beauty.*[23]

It is striking that the writer has noted the importance of both structural form and mood, the appearance of lyrical color and the coexistence of feelings of gaiety and contemplation, and thus has perceived salient features of Rothko's mature style in these paintings of the late thirties.

This three-man exhibition notwithstanding, Mark Rothko was virtually unknown as a painter at the outbreak of World War II. He had sold "...very few paintings, mostly to friends and other artists."[24] He and his first wife, Edith, whom he had married in 1932, lived on meager earnings from her jewelry designs and his teaching. Their apartment at 313 East 6th Street was both his studio and her shop. Despite Rothko's straitened circumstances, the late thirties and early forties were years of tremendous significance for his career, an era in which his thinking and his style underwent a dramatic evolution.

In Rothko's works of the thirties such as *Crucifixion, Woman Sewing, Street Scene* (figs. 15-17) and the subway paintings there is tension, doubt and striving, a confrontation between the subjects and the demands of the architectonic structuring of the compositions. This conflict is most fully resolved in the *Subway Scene* of 1938, but here, as in the earlier canvases,

Rothko still clings to figuration, unwilling as yet to express the theoretical positions he had already begun to crystallize in his notes. The intellectual struggle in which he was now engaged was ultimately to take him from these relatively conventional paintings to his infinitely more sophisticated style of the mid and late forties. As his former wife notes:

> *His work changed dramatically in the early 40's. He and a group of painters were much concerned about subject matter and these people met at our homes.... These meetings involved philosophical discussion... there were about four or five artists—Gottlieb, Newman, Bolotowsky and Tschacbasov.*[25]

A spirit of camaraderie developed among painters during this period, fostered to a large extent by their participation in the WPA. The easel and mural painting projects brought together people of very different backgrounds and temperaments who might otherwise never have become friends. Most of the artists whom Rothko knew around this time—Gottlieb, de Kooning, Pollock, Gorky, Newman, David Smith—were, like him, at unresolved stages in their development. Their limited resources, their need for community, their desire for change, led to friendship. They exhibited together, went to shows together, drank together, shared studios, fought with each other, picketed, protested and struggled for greatness. They admired the work of Miró and Klee well before these artists were accepted in Paris, went to see early Kandinsky at the Museum of Non-Objective Painting and were especially impressed with the Picassos reproduced in *Cahiers d'Art*. And they became intensely aware of the Surrealist movement, which was gaining increasing exposure in the United States in the thirties.

As early as 1931, the first important exhibition of Surrealism in the United States, *Newer Super-Realism*, had been staged by Arthur Everett Austin at the Wadsworth Atheneum in Hartford. This show traveled to the Julien Levy Gallery in New York the following year. Levy proselytized for the movement, showing Surrealist painters throughout the thirties and publishing an important anthology, *Surrealism*, in 1936. This same year, Alfred Barr presented the crucial *Fantastic Art, Dada, Surrealism* at The Museum of Modern Art.

None of their past experience, none of the one-man or group exhibitions they saw had prepared them for the revolution in aesthetics to which they now found themselves exposed. These young painters, who formed the core of the New York School and were later to be identified as Abstract Expressionists, now became conscious that American painting of the 1930's, whether the routine academicism of the regional scene painters or the Neo-Plasticist dogma of the American Abstract Artists, a group of adherents of geometric abstraction which had been established in New York in 1936, was extremely limited. Most of this pioneer generation of Abstract Expressionists had painted representationally during the Depression years, often under the auspices of the WPA. It was thus in a spirit of rebellion, against their own early efforts as well as the prevailing American art, that they began the search for a new means of expression. The arrival in New York of many major contemporary European painters at the time of World War II was the catalyst for their revolt. The Surrealists—Max Ernst, Yves Tanguy, Matta, André Masson and the poet laureate of the movement, André Breton—came en masse. Marcel Duchamp, of course, was already active here; Piet Mondrian, too, lived and

worked in New York during the War, as did Fernand Léger, who had already spent time in America. These expatriates brought with them an enormous vitality, a wealth of new ideas and a sense of the entire history of European painting.

A new awareness of European innovation on the part of Americans is indicated in the press release that accompanied the *Third Annual Exhibition of the Federation of Modern Painters and Sculptors* of June 1943, a show in which Rothko participated. The release reads in part:

> At our inception three years ago we stated, "We condemn artistic nationalism, which negates the world tradition of art at the base of modern art movements."
>
> Today America is faced with the responsibility either to salvage and develop, or to frustrate Western creative capacity. This responsibility may be largely ours for a good part of the century to come. This country has been greatly enriched, both by the recent influx of many great European artists, some of whom we are proud to have as members of the Federation, and by the growing vitality of our native talent.
>
> In years to come the world will ask how this nation met its opportunity. Did it nourish or starve this concentration of talent?
>
> Since no one can remain untouched by the impact of the present world upheaval, it is inevitable that values in every field of human endeavor will be affected. As a nation we are being forced to outgrow our narrow political isolationism. Now that America is recognized as the center where art and artists of all the world meet, it is time for us to accept cultural values on a truly global plane.

Of all the artists in exile in New York, the Surrealists were the most influential. Personal contact with the Surrealists, although limited, provided the Americans direct access to their work and assured the fledgling painters that the legendary Europeans were, after all, human. For all of them, it was an exhilarating time, a moment in history that gave them the freedom and challenge they needed to cut the cord that tied them to a provincial American art. From this alliance with European art and thought they created, in a monumental effort, a brilliant new American art.

Surrealism had been born in Paris in 1924, out of the ashes of Dada. According to the Surrealists, the function of the poet or artist was to select appropriate symbols, which corresponded in their power and magic to the myths, parables and metaphors of the past. These symbols stimulated or irritated the senses to arouse multiple associations and emotions, differing according to the sensibility of each viewer. Surrealism, like its parent, Dada, was antirational in character. The Surrealists developed an art in which the formal and rational order of Cubism was replaced by the fantastic, the accidental, the illogical. The unconscious was proclaimed as the essential source of art; the inner universe of the imagination, rather than the external world, became the wellspring of all inspiration. However, the Surrealists were not opposed to the reality of the external world as such, but only to reason and logic. In fact, they proposed that elements from the external world be retained in their work—but that they be unified with the dream to form one reality, "surreality."

In the researches of Freud and his exploration of the subconscious, the

fig. 18
André Masson, *Battle of Fishes*, 1926.
Collection The Museum of Modern Art,
New York

fig. 19
Max Ernst, *Blue and Pink Doves*, 1926.
Collection Kunstmuseum Düsseldorf

fig. 20
Max Ernst, *The Horde*, 1927. Collection
Stedelijk Museum, Amsterdam

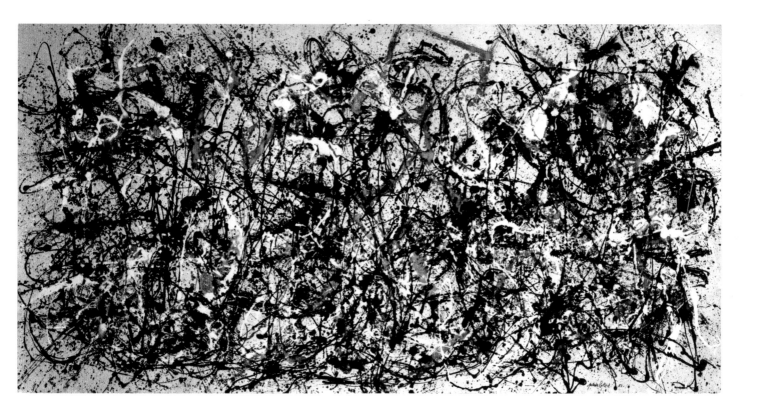

fig. 21
Max Ernst, *The Bewildered Planet*, 1942.
Collection The Tel Aviv Museum, Gift
of the artist

fig. 22
Jackson Pollock, *Autumn Rhythm*, 1950. The
Metropolitan Museum of Art, New York,
George A. Hearn Fund, 1957

Surrealists found some ideal tools for their own experiments. The Surrealists differed with Freud in their acceptance of dream images as significant realities in themselves, rather than as mere symbols of conscious life. His observations on the role of language in dream and dream interpretation were applied to their own ends. They found Freud's explorations of the mind and the investigations of dream imagery inspiration for their own experiments, and out of his theories they developed the technique of automatism, which they applied to both poetry and painting. In 1924, Breton first described Surrealism as "Pure psychic automatism, by which it is intended to express, verbally, in writing or by other means, the real process of thought. Thought's dictation, in the absence of all control exercised by reason and outside all esthetic and moral preoccupations."[26] The purpose of automatism was to free art of conscious control, and to liberate the imagination. Although much of Surrealism's imagery found its way into American painting in the 1940's, it was the technique of automatism that was of most crucial importance to the development of a revolutionary art in New York.

Ernst was an enigmatic and elusive figure who stayed in New York only briefly. But his charismatic personality, his reputation as a founder of both Dada and Surrealism, his marriage to Peggy Guggenheim and his link to her gallery, Art of This Century, attracted the attention of the impressionable Americans. He and Masson were among the most influential of the Surrealist emigrés. Both practiced a form of automatism characterized by all-over meandering lines and experimented with a number of unusual materials which in themselves suggested images. In Masson's *Battle of Fishes*, 1926 (fig. 18), and Ernst's *Blue and Pink Doves*, 1926, or *The Horde*, 1927 (figs. 19, 20), for example, images arise from the chance procedures employed. In 1942, when he was already in the United States, Ernst began two paintings in which he employed a drip technique, *Young Man Intrigued by the Flight of a Non-Euclidean Fly* and *The Bewildered Planet* (fig. 21). A comparison among

these Surrealist works and later paintings by Abstract Expressionists, such as Pollock's *Autumn Rhythm*, 1950 (fig. 22), reveals clear similarities. Ernst, of course, did not invent the drip technique, and Pollock's work was not necessarily based directly upon his example, but more probably upon the graceful arabesques of Masson's imagery. In any case, the inspirational force of the Surrealists upon the emergent New York School at this time is undeniable.

Ernst was important to artists like Pollock and Rothko, not only for his revolutionary procedures, but for his totemic figuration and relentless development of a series of related images. His example of stylistic consistency was extremely significant for the embryonic Abstract Expressionists. And Ernst had another, equally vital message for Rothko and his contemporaries: he reinforced the young painters' belief in the power of myth and the art of the primitive. Rothko's profound interest in archaic cultures, in the art of the Aegean and ancient Near East, had originated in the thirties. He was convinced that myth could be a source and inspiration, not for a literary style of painting as might be expected, but for abstraction. And, although Rothko was in no sense a literary painter, poetry and philosophy were among the fundamental sources of his thinking. Books such as Nietzsche's *Birth of Tragedy* both stimulated and reinforced his interest in myth while he was still painting figurative and socially-conscious canvases.

The form and mythic content of archaic art appeared in Rothko's work as early as 1938, when, as we have seen, he started *Antigone*. By 1941 he and Gottlieb were working closely together to develop and define an art based upon myth. Rothko's close friendship with Gottlieb had begun in the late 1920's. The two held a number of interests and attitudes in common. Both loved primitive art—Gottlieb collected, but Rothko did not, probably because he preferred not to acquire objects. Gottlieb, like Rothko, was active as an organizer of or participant in radical artists' groups. And each was intensely concerned with myth. For over a decade, from the mid-thirties to the mid-forties, they shared many aesthetic goals; the painting of each artist changed from a form of relatively realistic representation common to the

fig. 24
Adolph Gottlieb, *Eyes of Oedipus*, 1941.
Collection Mrs. Adolph Gottlieb, New Yo

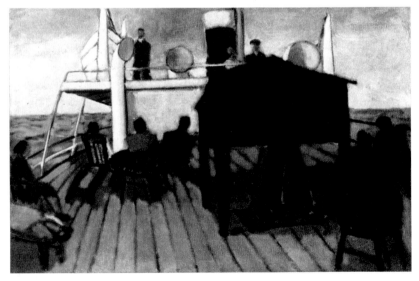

fig. 23
Adolph Gottlieb, *Sundeck*, 1936. Collection
University of Maryland Art Gallery, College
Park

thirties to a fully developed new language of archetypes. This often laborious evolution is reflected in the transition from paintings such as Rothko's *Subway Scene* of 1938 and Gottlieb's *Sundeck* of 1936 (fig. 23) to Rothko's *Antigone* and *The Omen of the Eagle*, 1942 (cat. no. 26), and Gottlieb's *Eyes of Oedipus*, 1941, or *Pictograph*, 1942 (figs. 24, 25).

Gottlieb's wife, Esther, has commented that both Rothko and her husband were extremely programmatic about their artistic direction and deliberately chose to concern themselves with myth so that they could break with what they considered stagnant in European tradition and with the provincial American past. Their ideas were reinforced by other artists like Gorky, Newman, Pollock and Still, who were also experimenting with myth at around this time. John Graham, whose *System and Dialectics of Art* was published in 1937, stated:

> *The purpose of art in* particular *is to re-establish a lost contact with the unconscious . . . with the primordial racial past and to keep and develop this contact in order to bring to the conscious mind the throbbing events of the unconscious mind.* [27]

Rothko and Gottlieb articulated their positions on art and myth in a now-famous letter of June 7, 1943, written, with the then unacknowledged assistance of Barnett Newman, to *The New York Times* critic Edward Alden Jewell. It was written in response to Jewell's largely negative review of the third annual Federation of Modern Painters and Sculptors exhibition, referred to above. Published in the *Times* of June 13, it reads in part:

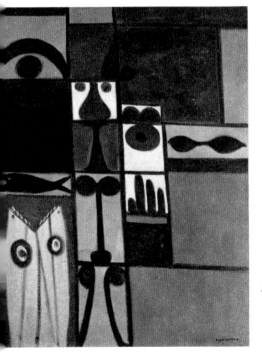

1. *To us art is an adventure into an unknown world, which can be explored only by those willing to take the risks.*

2. *This world of the imagination is fancy-free and violently opposed to common sense.*

3. *It is our function as artists to make the spectator see the world our way—not his way.*

4. *We favor the simple expression of the complex thought. We are for the large shape because it has the impact of the unequivocal. We wish to reassert the picture plane. We are for flat forms because they destroy illusion and reveal truth.*

5. *It is a widely accepted notion among painters that it does not matter what one paints as long as it is well painted. This is the essence of academicism. There is no such thing as good painting about nothing. We assert that the subject is crucial and only that subject matter is valid which is tragic and timeless. That is why we profess spiritual kinship with primitive and archaic art.*

Rothko and Gottlieb specifically referred to two of their paintings that had been included in the Federation annual, explaining Gottlieb's *Rape of Persephone*, 1943 (fig. 26), was "a poetic expression of the essence of the myth," and Rothko's *The Syrian Bull*, 1943 (cat. no. 28), was "a new interpretation of an archaic image. . . ." and that "significant rendition of a symbol, no matter how archaic, has as full validity today as the archaic symbol had

then."[28]

From 1941 until 1943, Rothko's paintings are stratified in composition, sometimes divided into sharply differentiated registers. Images are disposed in an orderly, geometric manner and at times are segregated into zones. Bird and animal forms, zigzags, disembodied facial features, anatomical parts, imagery drawn from archaic sculpture and from architectural motifs appear. Paintings such as *The Omen of the Eagle*, 1942, point directly to the art of Nineveh and Mesopotamia. Rothko fills his zones or registers with the part-men, part-beasts, part-gods of ancient legend. The ghostly figures of the subway paintings have taken on the relief-like qualities of Near Eastern friezes. The architectonic structure of these canvases derives from his own work of the thirties, but here it is clarified, compartmentalized and underscored by the registers, reinforced by the fragmented forms that fill each zone. Rothko wrote of *The Omen of the Eagle* as follows:

> *The theme here is derived from the Agamemnon Trilogy of Aeschylus. The picture deals not with the particular anecdote, but rather with the Spirit of Myth, which is generic to all myths at all times. It involves a pantheism in which man, bird, beast and tree—the known as well as the knowable—merge into a single tragic idea.*[29]

Although Rothko's symbol-laden imagery of the early 1940's was often ponderous, it is sometimes lightened by an element of surprise that derives from Surrealist automatism and exploration of chance. In addition, the seemingly random composition of paintings such as *Untitled*, 1939-40 (cat. no. 24), in which disparate kinds of images are incorporated in each register, may have been inspired by the Surrealists' *Cadavres Exquises* (exquisite corpses). These *Cadavres Exquises* were collaborative drawings, usually produced by three or four artists, each contributing a different kind of image to his separate zone of paper. The heavy symbolism and sculptural forms of the canvases of the period are mitigated also by Rothko's predominantly pastel palette and flat application of color, which continue to reflect Avery's sun-drenched hues.

Rothko's use of the eagle in his paintings of the period, such as *The Omen of the Eagle*, was probably inspired by Ernst's in part humorous and ironic identification of himself with the bird, Loplop. The specific symbolism of Ernst's birds as representations of power (the eagle is the national emblem of both Germany and the United States), of the intellect and freedom of the mind may also have influenced Rothko's choice of imagery. Jung, whom Rothko was very much interested in, points out that the totem of the bird is much used by artists to symbolize transcendence, release, liberation. But the painting derives from other sources as well, including motifs from his own earlier interiors. Solman mentions, in addition, that Rothko incorporated elements from the cornices of buildings and windows in his work at this time.[30] Indeed, there seem to be many echoes of thirties ornamentation in these paintings. It may also be that the structure of New York buildings reinforced Rothko's decision to divide many of his compositions into registers. Furthermore, the zones as well as the eyes, beaks, claws and wings clearly refer to Northwest Coast Indian art.

Although there is a close kinship among concepts and paintings of Rothko and Gottlieb, there are profound differences which are clear even in their relatively unresolved work of the 1930's. Despite important shared

goals, sensibility and intent separate Rothko and Gottlieb. Painting presented a philosophical dilemma to Rothko, as he came increasingly to question its terms and meaning. Gottlieb remained more concerned with the hedonistic qualities of his painting and decoration of surface than with problems of underlying significance.

The questioning and conflict that characterize Rothko's work of the late thirties are absent from Gottlieb's oeuvre, except in rare paintings such as *Still Life—Dry Cactus,* ca. 1938 (fig. 27), painted while he was living in the desert near Tucson. This canvas is atypical in that it is infused with a mood of enigma and foreboding arising from the attenuated shadows which seem to entrap the plant forms, and a sense of disorientation resulting from the presentation of a landscape as a still life and the endowing of plant forms with qualities of animal life. The Tanguy- or Dali-like forms that snake across the picture are flattened and quite abstract; they are, nevertheless, based on observed natural phenomena as well as on Surrealist prototypes.

Significantly, Gottlieb has chosen a title that might describe a naturalistic desert scene for his Surreal configurations. An artist like Dali would have given his painting a name that enhanced the mystery of its images, a title such as *Enigma of a Day,* for example. Gottlieb's choice of a descriptive title underscores his interest in both the natural and supernatural. This dichotomy is even more apparent in his later painting, *The Sea Chest,* 1942 (fig. 28). Despite the seemingly straightforward and more naturalistic presentation of specimens of marine life there is a pervasive, sinister, threatening spirit. However, the Gloucester, Massachusetts, coast inspired this canvas, just as the arid desert landscape had been the source of *Still Life–Dry Cactus.* Gottlieb was at this time, and remained, a naturalistic painter: his late, abstract burst canvases retain the sense of physical forces and phenomena. Gottlieb's basically Impressionist temperament did not allow him to pursue his experiments with myth as relentlessly as Rothko did into the forties. He continued to be interested in the external world; Rothko by the forties was already primarily concerned with inner states of existence.

Whereas Rothko sometimes segregated his images of this period into registers or zones, Gottlieb much more systematically compartmentalized his paintings, which he called pictographs, by drawing rather free-form grids across his surfaces. In each section of this grid he placed, seemingly at random, an image isolated to enhance its emotive powers, adding shape after shape until he was satisfied his painting had achieved its final form. Some of his images—eyes, faces, teeth, genitalia or other parts of the human anatomy—are the residual data of his earlier interest in the human figure. They are part of a repertory of image-symbols—others include snakes, birds, masks, eggs—that he discovered in past art forms which appeared to him to have a universal significance or, in Jungian terms, to form part of a "collective unconscious." Gottlieb continued to produce pictographs, however, as abstract forms devoid of mythic content, into the mid-1950's.

But myths as interpreted by Rothko, Gottlieb and other Americans in the forties did not convey universal meaning; the Americans failed to express through myth the truths of the collective unconscious or the brutalities of their own time. The master Picasso, alone among twentieth-century artists, was able to make mythology profoundly relevant in his monumental *Guernica,* 1937 (fig. 29). Here he draws upon both Surrealist and mythological prototypes, but endows them with genuinely modern form and content. *Guernica* is at once shocking in its contemporaneity and timeless in its references to the past

and thus stands not only for the Spanish Civil War but for all war. Past and present have been dramatically synthesized on a level of epic grandeur.

Picasso's achievement was unparalleled, however, and artists like Rothko and Gottlieb were unable to endow their paintings with the relevance they insisted was inherent in myth. Removed from their original culture, the symbols lose their context, the connective tissue which is crucial to their meaning and use; they become abstract signs without significant mythic content. Their entirely intellectual and programmatic approach was

42

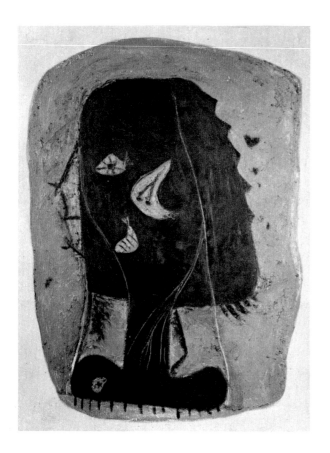

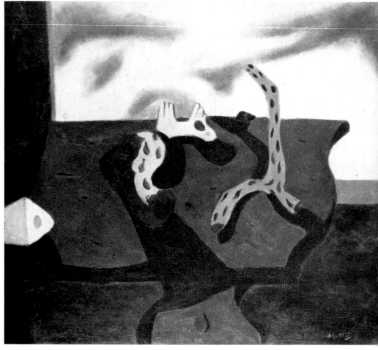

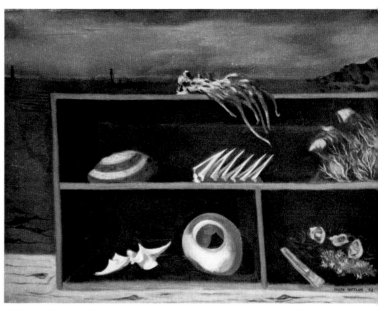

fig. 26
Adolph Gottlieb, *Rape of Persephone*, 1943.
Collection Mrs. Barnett Newman

fig. 27
Adolph Gottlieb, *Still Life—Dry Cactus*,
ca. 1938. Collection Adolph and Esther
Gottlieb Foundation, Inc.

fig. 28
Adolph Gottlieb, *The Sea Chest*, 1942.
Collection The Solomon R. Guggenheim
Museum, New York

fundamentally different from Picasso's deeply felt synthesis of emotion and intellect. Nevertheless, Rothko and Gottlieb sought to make myth the central focus of a new art form in their attempt to assert their linkage with European tradition as well as the coming of age and, finally, the primacy of American art. Their search for the "timeless" in art was in part a search for a new vocabulary. This new vocabulary was rooted in, but ultimately independent of, Surrealism, from which it drew its main inspiration. That the archaism of the art of the ancient Near East had little direct bearing on the search for the new did not seem to disturb Rothko at this time. Avant-garde painters working in New York in the forties were presented with an enormous range of possibilities and, in keeping with the catholic attitudes of twentieth-century artists, were able to use the primitive to break with the past. There was, however, a very real contradiction between what these artists saw as a "spiritual kinship" with primitive and archaic art and the new, as well as a conflict with what they achieved in their mature painting.

The Surrealists had combined ancient myth and Freudian symbolism, thus justifying their imagery in literary and scientific terms. For Rothko and his colleagues such subject matter was ultimately inhibiting. They drew upon it in an interim period, creating paintings that were poetic in their metaphors and transitional in form, as they progressed towards a new art. The Surrealists sought archetypal images to represent the highly charged world of their subconscious minds. But the future Abstract Expressionists developed a vocabulary of signs, not to symbolize the super-reality of the real world merged with dreams and the unconscious but to express the reality of a revolutionary abstract art. They released themselves from the past when they abandoned their commitment to the primitive and the literary and consecrated themselves to the realm of pure painting.

43

fig. 29
Pablo Picasso, *Guernica,* 1937. On extended
loan to The Museum of Modern Art,
New York, from the artist's estate

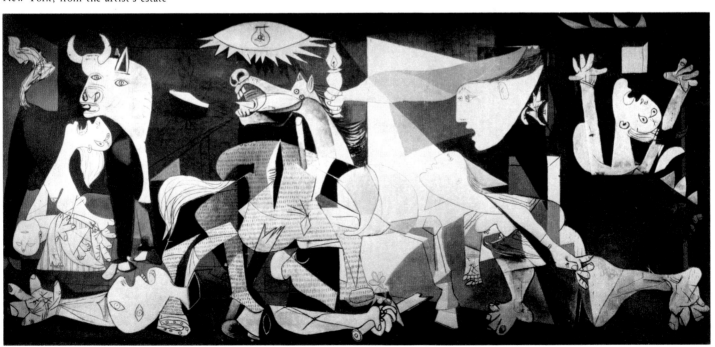

III

The last years of World War II were a time of great activity for Rothko and his colleagues. In 1944, Gottlieb was elected head of the Federation of Modern Painters and Sculptors, a position he retained until 1945. In December of 1944, the 67 Gallery, which Howard Putzel had opened in New York that fall, mounted an exhibition of *Forty American Moderns*, in which Rothko participated, showing an untitled Surrealist drawing. Putzel, Peggy Guggenheim's assistant from 1942-44, had advised her to represent Rothko, and in January of 1945 she gave him a one-man show at her gallery, Art of This Century. The catalogue preface reads:

> *Rothko's painting is not easily classified. It occupies a middle ground between abstraction and surrealism. In these paintings the abstract idea is incarnated in the image. Rothko's style has a latent archaic quality which the pale and uninsistent colours enforce. This particular archaization, the reverse of the primitive, suggests the long savouring of human and traditional experience as incorporated in the myth. Rothko's symbols, fragments of myth, are held together by a free, almost automatic calligraphy that gives a peculiar unity to his paintings—a unity in which the individual symbol acquires its meaning, not in isolation, but rather in its melodic adjustment to the other elements in the picture. It is this feeling of internal fusion, of the historical conscious and subconscious capable of expanding far beyond the limits of the picture space that gives Rothko's work its force and essential character. But this is not to say that the images created by Rothko are the thin evocations of the speculative intellect; they are rather the concrete, the tactual expression of the intuitions of an artist to whom the subconscious represents not the farther, but the nearer shore of art.* [31]

Among the fifteen paintings in this exhibition were *Sacrifice of Iphigenia*, 1942, *The Syrian Bull*, 1943, *Birth of Cephalopods, Slow Swirl at the Edge of the Sea* and *Poised Elements*, all of 1944 (cat. nos. 29, 28, 37, 63, 31). The titles of these works clearly indicate that Rothko's concern with myth and ritual, prehistoric forces, biological life in general, marine organisms in particular, was still very strong at this time.

There is, however, no consistent relationship between Rothko's titles and his imagery. Thus, the forms in paintings as variously named as *Slow Swirl at the Edge of the Sea, Birth of Cephalopods* and *Tiresias* are extremely similar to one another. *Poised Elements*, on the other hand, is much more

structured; its geometrically disposed forms seem to be derived from late Kandinsky and have little to do with the liquid grace and curvilinear shapes of the three other canvases, in which natural phenomena, mythic content, Surrealist automatic technique and subconscious imagery are successfully synthesized. The Ernst-like *Hierarchical Birds* (fig. 30) represents yet another direction Rothko was now exploring. In fact, he was still absorbing a multitude of influences—he himself said that Dali, de Chirico, Miró and Ernst attracted him at this time. Thus, *Entombment I*, 1946 (cat. no. 42), recalls Picasso's studies for *Crucifixion*, 1927 (for example, fig. 31), many gouaches resemble Ernst's *Shell Flowers*, 1929 (fig. 32), and others bring to mind the work of his contemporaries, such as Motherwell's *Indians*, 1944 (fig. 33). Therefore, it is incorrect to classify, as many critics have done, this phase of his oeuvre as biomorphic—although his best work of the period may be so categorized.

Just as the *Subway Scene* of 1938 represents the climax of Rothko's first mature work of the thirties, so *Slow Swirl at the Edge of the Sea*, *Birth of Cephalopods* and *Rites of Lilith*, 1945 (cat. no. 39), are the culmination of Rothko's search for the "middle ground between surrealism and abstraction." In these and related paintings of the mid-forties, Rothko creates a series of ritualistic or totemic images which vaguely suggest human figures, birds, animals, aquatic life. The animation of twirling or revolving forms, sensitivity to nuance of color, shape and detail and careful balance of large and small areas in these lyrical works are unexcelled. Rothko now achieves a synthesis of form, line and color which rivals that of the best Surrealist painting of the period.

Slow Swirl at the Edge of the Sea was painted during the artist's courtship of his second wife, Mary Alice Beistle (Mell), and thus had special meaning for him—it may, in fact, be a symbolic portrait of the couple. (Although it at one time belonged to the San Francisco Museum of Art it was traded back to Rothko in 1961 and remained in his home until his wife's death in 1970.)

The paintings of 1944-45 reveal that by now Rothko had begun to make important advances in a new direction. He starts now to enlarge his paintings—*Slow Swirl at the Edge of the Sea* is 75 by 84½ inches and *Rites of Lilith*, 84 by 108 inches. A comparison between *Slow Swirl* and the earlier *The Omen of the Eagle* (cat. no. 26) is illuminating and shows the extent to which Rothko's style had by now evolved. The forms of *The Omen of the Eagle* are divided into four clearly defined registers; the later work, however, contains semitransparent images that appear to float and merge with the soft, translucent ground like aquatic organisms in a liquid medium. Rothko has banished the bulging, bulky figures of *The Omen of the Eagle*, throwbacks to his expressionist work of the twenties and thirties, and employed instead weightless forms and a soft, light palette reminiscent of the subway paintings of the thirties.

Rothko's interest in myth lessened as the abstract possibilities inherent in Surrealism increasingly intrigued him. The Miró- and Masson-influenced *Slow Swirl at the Edge of the Sea* and *Rites of Lilith* are gracefully calligraphic, more markedly linear than the paintings that preceded them. Like Gorky, who was working in a similar direction at this time, as revealed in his *The Liver is the Cock's Comb*, 1944 (fig. 34), Rothko cultivated anthropomorphic forms within a generally diffused field. But Rothko, unlike Gorky, or for that matter, most of the Surrealists, uses little sexual imagery. The two painters undoubtedly were drawing upon common sources, but did not

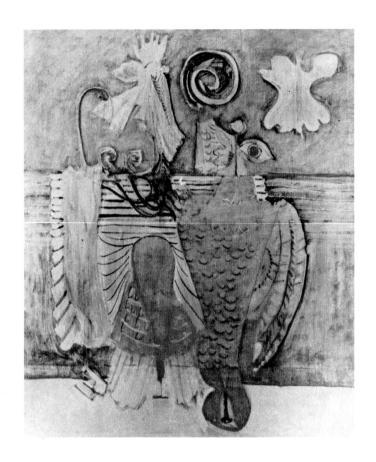

46

fig. 30
Mark Rothko, *Hierarchical Birds*, before 1945.
Estate of Mark Rothko

fig. 31
Pablo Picasso, *Study for Crucifixion*, 1927.
Whereabouts unknown

fig. 32
Max Ernst, *Shell Flowers*, 1929. Collection
Museum Ludwig, Cologne

fig. 33
Robert Motherwell, *Indians*, 1944.
Whereabouts unknown

fig. 34
Arshile Gorky, *The Liver is the Cock's Comb*,
1944. Collection Albright-Knox Art Gallery,
Buffalo, New York, Gift of Seymour H. Knox

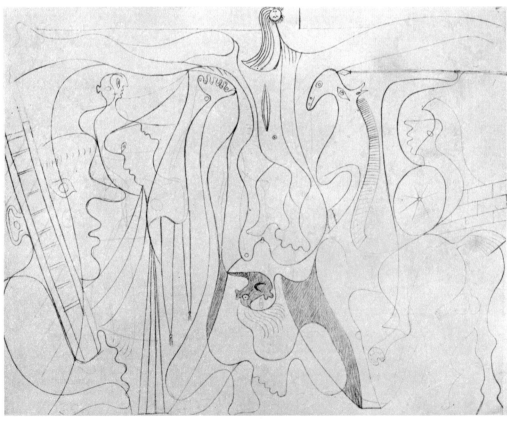

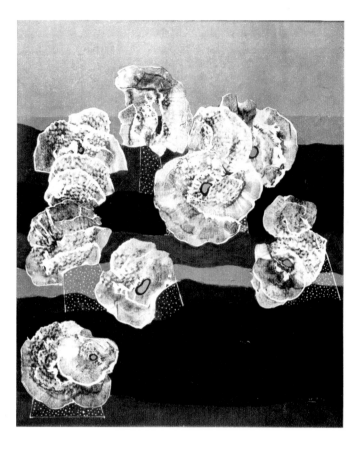

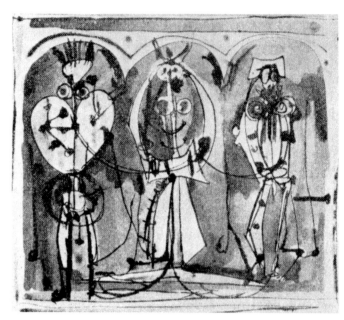

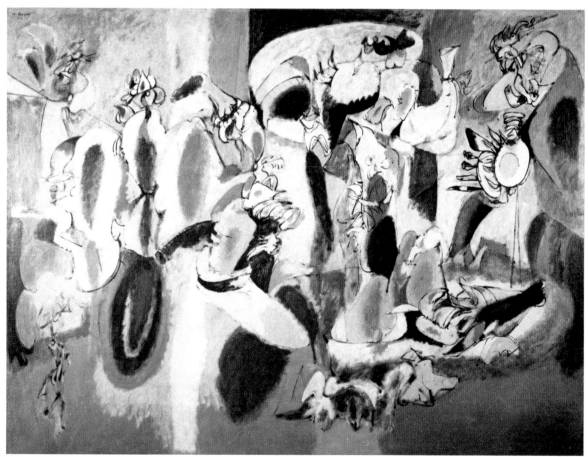

markedly influence one another. In most of his canvases of 1944 to 1946 Rothko uses an all-over ground, usually of a pale creamy color with a few bright accents. His images are generally flat and without real physical presence. Only rarely, as in the very Gorky-like *Aquatic Drama,* 1946 (cat. no. 59), do these shapes become overtly organic or three-dimensional. Nor is there any concession to the deep illusionistic space of Matta and Tanguy.

Rothko wished to establish light as an integral part of his painting. His use of oils, however, tended to dim the luminosity he sought, even in the otherwise masterful *Slow Swirl.* So disposed was he to effects of luminosity that he began to prefer watercolor and gouache to oil paints. And, in works of 1945 to 1947, such as *Entombment I* and *Entombment II,* both 1946 (cat. nos. 42, 43), Rothko returned to the smaller scale of his paintings prior to the 1940's and restricted his color range to the greys and earth colors typical of his canvases of the early forties. No doubt he found it easier to concentrate on developing effects of luminosity and loosening his imagery when working with this restricted scale and palette. The luminosity, flatness, frontality and close-value colors ascribed to the period of Rothko's great breakthrough in 1949-50 are already characteristic of these watercolors and pastels of the mid-1940's. Many of them are among his most beautiful works. Contrary to the opinion of some critics, who maintain that Rothko could not draw, and even of the artist himself, the calligraphy of this period is brilliant. Now, perhaps for the first time, he allows a Miróesque element of play, if not humor, to enter his heretofore solemn, even stern paintings. There is about them a decided air of confidence, accomplishment and quiet pleasure. Their forms, almost liberated from myth and referential imagery, border as never before on the totally abstract and are brought into perfect harmony with the formal requirements of the picture plane. Although Rothko's imagery of this period has often been characterized as aquatic, it is too ambiguous and complicated to be so defined. His forms are far less explicit than those of Baziotes, who, also influenced by Miró, truly did invent a vocabulary of aquatic, biomorphic imagery (fig. 35). Rothko's foreground and background are in a state of flux; nevertheless, the picture plane remains stable and constant. Rothko asserted this stability as well as the flatness of the picture plane by working with strictly horizontal-vertical axes, crossing his vertical canvases with horizontal bands upon which he placed vertically oriented shapes.

In these watercolors, Rothko no longer allows concern with symbolic meaning to stand in the way of abstract considerations, but he does not entirely renounce his fealty to myth or representational imagery. Rothko had now only to eliminate the last barrier, the vestiges of figuration that remained in his work, to create a revolutionary new art form. He was, however, not yet prepared to take this final step. As he said in 1945:

> *I adhere to the material reality of the world and the substance of things. I merely enlarge the extent of this reality, extending to it coequal attributes with experiences in our more familiar environment. I insist upon the equal existence of the world engendered in the mind and the world engendered by God outside of it. If I have faltered in the use of familiar objects, it is because I refuse to mutilate their appearance for the sake of an action which they are too old to serve; or for which, perhaps, they had never been intended.*
>
> *I quarrel with surrealist and abstract art only as one quarrels with his*

father and mother; recognizing the inevitability and function of my roots, but insistent upon my dissension: I, being both they, and an integral completely independent of them.

The surrealist has uncovered the glossary of the myth and has established a congruity between the phantasmagoria of the unconscious and the objects of everyday life. This congruity constitutes the exhilarated tragic experience which for me is the only source book for art. But I love both the object and the dream far too much to have them effervesced into the insubstantiality of memory and hallucination. The abstract artist has given material existence to many unseen worlds and tempi. But I repudiate his denial of the anecdote just as I repudiate the denial of the material existence of the whole of reality. For art to me is an anecdote of the spirit, and the only means of making concrete the purpose of its varied quickness and stillness.

Rather be prodigal than niggardly I would sooner confer anthropomorphic attributes upon a stone, than dehumanize the slightest possibility of consciousness.[32]

49

By 1947, however, Rothko had begun to formulate his mature style. He broke with Surrealism and purged the remnants of this style from his work. Many of his colleagues did the same, and by 1950 most of the leading members of the New York School had forged their own highly individualistic art forms. Nevertheless, Rothko continued to experiment with a variety of possibilities and still exhibited, even in 1948, earlier works characterized by biomorphic imagery. Thus *Archaic Fantasy* and *Rites of Lilith,* both of 1945, were seen in his first one-man show at Betty Parsons in 1947 and *Poised Elements,* 1944, *Phalanx of the Mind,* 1945, *Dream Imagery, Beginnings, Companionship* and *Solitude* were included in his 1948 show at this same gallery. However, as critics of the 1948 presentation noted, Rothko's newer works indicated a striking departure into pure abstraction. The writer in *Art News*

fig. 35
William Baziotes, *Aquatic,* 1961. Collection The Solomon R. Guggenheim Museum, New York

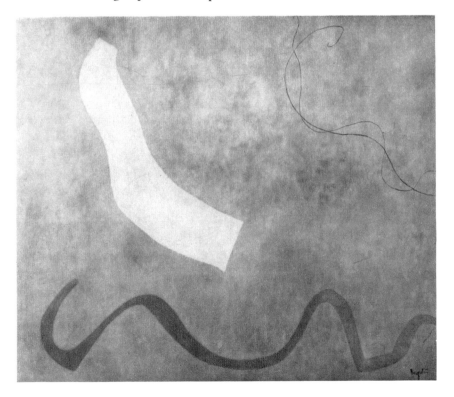

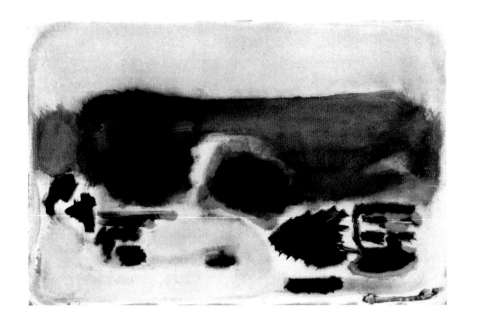

50

says, "Loose clouds of color appear to float on the surface; a palette opposing one intense hue with pastel modulations creates a spacious effect. Vaguely evoking the color patterns of Bonnard, Rothko achieves lovely textures and moods."[33] *The New York Times* reviewer notes that the paintings are mural-size, divested of content and identified with numbers rather than associative titles. He remarks that one is Redon-like in its color harmonies and that Rothko is attempting "to avoid arresting the raw life in the pigment or the flow of its movement by any kind of definition...."[34] Both critics considered the paintings unresolved, and the *Times* writer said Rothko had reached an "impasse of empty formlessness, an art solely of transitions without beginning, middle or end."[35]

Rothko experimented during 1947 with horizontal supports instead of using the near-square or pronouncedly vertical formats with which he had formerly seemed most at ease. Once again, oil replaces watercolor. Large color forms of diffuse but generally rectangular shape supplant the overtly biomorphic imagery of the previous years, as the artist attempts to purify his work of all associative elements. The Surrealist morphology of the 1944-46 paintings, which had displaced the mythic imagery of the preceding period, is now itself eliminated. In its stead is color, color as abstract shape, color in large and small units juxtaposed with one another. Despite Rothko's deliberate movement towards total abstraction, these are still clearly transitional works. In several canvases, the horizontal compositional orientation as well as the configurations of the color-shapes themselves are still referential and convey the distinct impression of landscape.

This is especially apparent in *Number 24*, 1948 (fig. 36), where the top edge of the middle block of color suggests a horizon line, and the gentle curves or sloping contours of the beach or countryside are alluded to, but not specifically depicted. While they may not be particularly successful or resolved, paintings of this kind reveal the confluence of a number of ideas and forces and thus offer a most interesting insight into Rothko's development. In *Number 24*, the residue of the past remains in echoes of Marin and, through him, Cézanne—the encircling border-within-the-frame, the use of oil in the manner of watercolor and the general, if ambiguous, reference to landscape.

There are reminders of Avery, too, in the pastoral ambience and flattening of form. Yet another, more contemporary artist has left his imprint on Rothko's work of this time: *Number 24* and other paintings of the period clearly call to mind Clyfford Still.

Rothko had expressed his admiration for Still in an introduction he wrote for the catalogue of this painter's one-man exhibition at Peggy Guggenheim's Art of This Century in 1946. Rothko's text reads in part:

> *It is significant that Still, working out West and alone, has arrived at pictorial conclusions so allied to those of the small band of Myth Makers who have emerged here during the war. The fact that his is a completely new facet of this idea, using unprecedented forms and completely personal methods, attests further to the vitality of this movement. Bypassing the current preoccupation with genre and the nuances of formal arrangements, Still expresses the tragic-religious drama which is generic to all Myths at all times, no matter where they occur. He is creating new counterparts to replace the old mythological hybrids who have lost their pertinence in the intervening centuries.*
>
> *For me, Still's pictorial dramas are an extension of the Greek Persephone Myth. As he himself has expressed it, his paintings are "of the Earth, the Damned and of the Recreated."*[36]

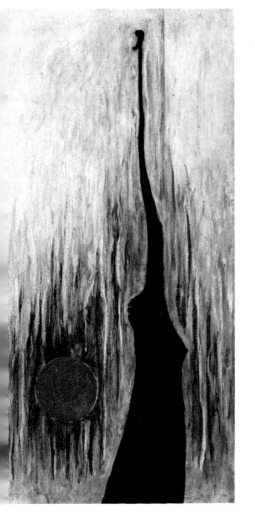

Still, like Rothko, was interested in ritualistic subject matter and archaic forms as early as 1938, as evidenced, for example, by his *Totemic Fantasy* of that year. And, although Rothko included him in the band of "Myth Makers" with which he himself was aligned, Still wished to remain independent of any group or movement and later repudiated this statement. In fact, Still was to maintain that the paintings in the show, which had titles like *Nemesis of Esther III*, *Buried Sun* and *Theopathic Entities*, had been named by someone other than himself. Still was an isolated figure, very much in the manner of Gauguin; the example he provided of an individual working alone, competing on the fringe of a peer group, without direct peer pressure, was as important to Rothko as the inspiration of his form, color and concept of painting. Certain of Still's works of the early 1940's, such as *Jamais*, 1944 (fig. 37), reflect Surrealist influence, particularly that of Miró. Later in the forties he rejected European influence, a renunciation that was extremely significant to Rothko. As Still said, "I have not 'worked over' the imagery or gimmicks of the past, whether Realist, Surrealist, Expressionist, Bauhaus, Impressionist, or what you choose. I went back to my own idioms, envisioned, created and thought through. And the insight gained and the momentum established altered the character of the whole concept of the practice of painting."[37] Still, whose individualistic temperament was ill-suited to the New York art world, returned after a brief stay during 1945-46 in this city to his teaching job at the California School of Fine Arts in San Francisco. However, in the short time he was in New York, he was undeniably an important catalyst and played a significant role in Rothko's liberation from Surrealism.

It was to Still that Rothko looked in 1946. The imprint of Still's style is apparent in the horizontal disposition of shapes with hooked and jagged contours in a number of Rothkos of 1946 and shortly thereafter, including the aforementioned *Number 24* and *Untitled*, 1946 (cat. no. 72). These elements may be traced to paintings such as Still's *1945-H* (fig. 38), which he showed to Rothko, Peggy Guggenheim and others in the fall of 1945 in New York in his

51

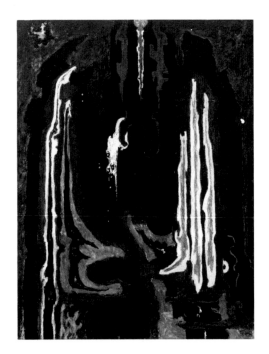

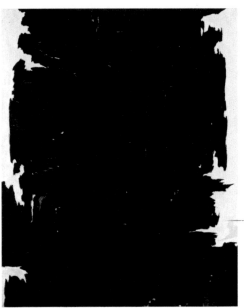

fig. 38
Clyfford Still, *1945-H*, 1945. Collection San Francisco Museum of Modern Art, Gift of the artist

fig. 39
Clyfford Still, *1947-8-W No. 2*, 1947. Albright-Knox Art Gallery, Buffalo, New York, Gift of the artist

Perry Street studio.[38] In addition, Still's skillful manipulation of color, shape and texture and his ability to create flickers of light by placing small areas of color at the edges of his canvas and scattered throughout the field must have impressed Rothko and certainly influenced his work of 1946-47. Still's later equation of color as space, as well as his commitment to stylistic consistency reinforced Rothko's own inclinations. And Rothko and Still shared a basically romantic attitude towards nature and painting itself—both spoke about their feelings of awe before the grandeur of nature and of their kinship with such artists as Turner and Matisse. There were facets of Still's style, however, that were inherently alien to Rothko's sensibility—Still's quite consistent use of large areas of black (a color Rothko generally avoided until the late 1960's) and the cavernous depths or void that it implied, his sharp and dramatic contrasts of positive and negative shapes and light and dark areas, the thick skin of his heavily encrusted paint surface. There is, in addition, a rawness and brutality in Still's work that aligns him with the gestural branch of Abstract Expressionism. These characteristics are very much at odds with Rothko's serene and orderly expression.

Rothko was undoubtedly a conduit of ideas from New York to Still. It is conceivable, therefore, that he may have acted, at least in part, as a catalyst in Still's stylistic quantum leap between 1945 and 1948. Still was a source of continuing inspiration for Rothko, and the two artists were in frequent contact. Rothko went to San Francisco to teach at the California School of Fine Arts during the summer of 1947. Still made a brief visit to New York in the spring of 1947 and again in the summer of 1948 to discuss the formation of The Subjects of the Artist School with Rothko, Baziotes, David Hare and Motherwell. Upon Still's recommendation, Rothko was invited to teach in San Francisco for a second time, during the summer of 1949. Still lent Rothko his studio that summer, and it was there that he saw Still's fully resolved painting *1947-8-W No. 2* (fig. 39). When Rothko returned to New York, he borrowed the painting and hung it in his New York apartment for six years. Although it has been stated that "Rothko developed his final style after seeing Still's large black *1947-8-W*,"[39] Rothko had, in fact, already formulated his mature style by that time.

Still crystallized his characteristic imagery some time before Rothko did. He did not, however, achieve the heroic proportions of his fully realized style until 1949, when Rothko was already on the verge of his own breakthrough. Still and Rothko remained close for many years, and, as we have seen, Still's painting clearly helped to liberate Rothko. However, Rothko's contemplative mature formulation derives not from the basically expressionist work of Still but from his own unique sensibility.

By 1947, Rothko begins to introduce larger color shapes (cat. no. 73). The size of the canvas itself generally remains modest, however, in this period of emerging abstraction. Rothko also starts to break away from the practice of confining images to zones. To release his patches of color and allow them to float, he sometimes renounces the vertical-horizontal grid structure and the division of the background planes into horizontal bands which had dominated his work from the time of the subway paintings. This abandonment of the balanced rectilinear structure to which he was so obviously drawn is a rather unexpected departure. However, even the quite freely disposed compositions of the period convey the sense of order and harmony we have come to expect of Rothko's expression.

Freed from Surrealist imagery, Rothko is now able to experiment with

numerous formal alternatives: he compresses a multitude of shapes and colors in the middle of large fields, reduces his compositions to relatively few blocks of color, allows his forms to merge with the grounds upon which they are placed and begins for the first time to achieve a wholistic image. The general atmosphere of freedom and the belief in limitless possibilities which prevailed in the New York art world in the 1940's must have encouraged Rothko to attempt such varied and sometimes uncharacteristic solutions.

Rothko's insistence in many of his paintings upon a horizontal-vertical structure was very much in keeping with the practices of a number of his New York School colleagues. As Meyer Schapiro has pointed out, "... Surrealist painting was infected with literature, and it was only in a milieu of artists who also admired the Cubists and Mondrian that abstraction could take over some of the functions that Surrealism assigned to imagery."[40] The preference for the grid that the Cubists and Mondrian espoused was not a restraining but a liberating influence in the development of Rothko and his contemporaries, in that it helped offset this "infection of literature." Mondrian's geometric abstraction affected figures as diverse as de Kooning and Rothko, Newman and Reinhardt. These younger artists were attracted to both the formal and metaphysical aspects of Mondrian's pure abstraction. Like the Surrealists, Mondrian sought a visual system to express inner states and transcendent meaning. Indeed, Mondrian once said to Max Ernst, "It is not you but I who am the Surrealist."[41] But unlike the Surrealists, Mondrian created his super-reality within the strictures of pure geometry.

Rothko's sensibility is in many respects close to Mondrian's. His attraction to order, stability, rectilinear structure and balanced asymmetry, his developing sense of the need to express a Platonic ideal, a higher spiritual or metaphysical truth through abstract form, are all clearly related to Mondrian's own goals. Despite Mondrian's personal asceticism and aesthetic purity, he expresses in his painting a rich, if highly controlled vein of emotion. Rothko recognized this and spoke of the "sensuousness of Mondrian," responding to the complex and often contradictory nature of his art.

Mondrian's grid divides the space of his surface plane into multiple units. His primary colors anchor the grid within the field but also, in interacting with the black lines that surround them, create spatial ambiguity. Thus, color and line perform dual roles and enhance rather than reduce the complexity of the image. Rothko, on the other hand, even in his paintings of 1947-48, diminishes the complicating effect of color relationships by eliminating black and white and either subduing the value contrasts among his colors or sensitively balancing his contrasting hues so that they all appear to hover on the same plane. Thus, unlike Mondrian's shapes, which seem to advance and retreat in space, Rothko's color forms achieve a uniformity of spatial play as they hold a single plane in a manner entirely consistent with his emphasis on the two-dimensional picture surface. Mondrian relied upon the black and white grid to contain his compositions and color, which he restricted to the primaries. Rothko, however, abandons all but the most minimal references to a rectilinear scaffolding and allows his widely varied and subtle color to act almost independently and at its maximum level of luminosity. Rothko's color is the substance of his art. Yet it is dematerialized and in this respect, too, most unlike Mondrian's dense color.

In addition, Mondrian establishes a frame—his grid—within a frame —the small rectangle of the canvas. His compositions are compartmentalized and consist of small discrete units. The viewer is forced to stand back

and examine the whole painting in order to understand how the forms and colors interact with one another. Rothko, on the other hand, enlarges and isolates small surface incidents, for example, patches of color. These enlarged details and, in the later work, the heroic proportions of the canvases engulf the viewer, immersing him in the totality of the overall image.

Newman, who became close friends with Rothko in the 1930's, had, like Rothko, been an ardent advocate of Surrealism in the mid-1940's. He produced a number of Surrealist drawings and watercolors, executing his automatic, frottage-like drawings first in black and white and, then, in 1944, adding color with grease and oil crayons as in *The Blessing* (fig. 40). Calligraphic, heavily textured and improvisational oils followed, featuring circular (female) forms and vertical (male) elements. Works such as *Pagan Void,* 1946, and *Genetic Moment,* 1947 (fig. 41), suggest creation and genesis.

Mondrian's influence on Newman was perhaps even more pronounced than on Rothko. In his writings, Newman developed a personal and highly intellectual concept of painting. This formulation of his ideology enabled him to achieve his characteristic mature style as early as 1948: solid color fields interrupted by vertical stripes or "zips" of another color or tone. By 1949, he had enlarged his canvases to heroic scale and he ultimately carried the idea of the expansive color field further than either Rothko or Still. Both Rothko and Newman focused upon a small section of the grid, enlarged it and utilized it to structure color and space. But, in contradistinction to Rothko's usual practice of working with horizontal bands of color within a vertical or near-square field, Newman chose, by about 1950, to orient his paintings horizontally and subdivide them vertically with one or more "zips." And in his mature painting, for example, *Vir Heroicus Sublimis,* 1950-51 (fig. 42), Newman eliminates much of the texture that had marked the grounds of his earlier canvases to produce neutral, wall-like fields most unlike Still's heavy impasto and Rothko's atmospheric surfaces.

Mondrian's effect on Newman is seen in his use of red and blue, with which he made some of his most majestic statements. To be sure, Newman experimented with many colors other than the primaries, and his colors are true only in late works such as *Who's Afraid of Red, Yellow and Blue, I–IV,* 1966-70. Newman may tint his colors so that they lose their precision, but he makes a statement about a field of a single, specific color. Rothko, on the other hand, is concerned with relationships among varied and modulated colors. Despite Newman's rejection of pronounced texture, his field is not entirely flat and unmodulated. He activates his surface with his brushstrokes and his "zips," which he creates by masking off a section of the canvas, painting over the tape and allowing the pigment to bleed or seep underneath. The pronounced frontality and verticality of the "zip" in contrast to the lateral expanse of the field creates a sensation of deep space and the void which brings him closer to Still than it does to Rothko, who chooses to keep his shallow color-space in flux.

Rothko, Newman and Still purify their art by rejecting the decorative qualities of paint, by ridding their canvases of complex relationships of color, form and structure. They reduce color to its essence and make it become volume, form, space and light. Having emptied their paintings of the superfluous, they are able to express both the material reality of abstract painting and the incorporeal reality of the sublime. Art for all of them becomes an act of revelation, of exaltation, an embodiment of universal truth.

54

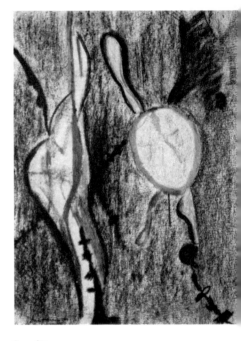

fig. 40
Barnett Newman, *The Blessing,* 1944.
Collection Mrs. Barnett Newman

fig. 41
Barnett Newman, *Genetic Moment,* 1947.
Collection Mrs. Barnett Newman

fig. 42
Barnett Newman, *Vir Heroicus Sublimis,*
1950–51. Collection The Museum of
Modern Art, New York. Gift of Mr. and Mrs.
Ben Heller

As Rothko increasingly simplified his painting, he freed himself from dependence upon the examples of other artists and approached the domain of his own hegemony, his unique, mature expression. Elements of this resolved style appear in the paintings of 1948-49 which Rothko designated as multiforms, but not until the winter of 1949-50 does he achieve a fully unified, consistent vision. Numerous works of 1949 (see cat. nos. 89, 92) reveal an artist liberated in terms of color. *Violet, Black, Orange, Yellow on White and Red,* of 1949 (cat. no. 90), for example, reflects Rothko functioning at the highest level of intuition and is predictive of his unsurpassed mature color statements.

In these multiforms, Rothko is inexorably moving beyond mythic subject matter and Surrealist forms to replace imagery with color. This is not to say that certain aspects of the painting of the preceding period are not carried over into the new work, for, in fact, traces of such elements, primarily in the form of a residual calligraphy, do appear in canvases such as *Multiform,* 1948, and *Number 22,* 1949 (cat. nos. 70, 91). These linear elements, which Rothko renounces entirely in his work of the 1950's, however, no longer carry the weight of representational or symbolic allusions but are largely formal in intent. In this transitional stage, Rothko cannot yet allow his color and shape to stand alone. He still feels impelled to define the picture plane and emphasize the importance of his surface with these markings. Thus, he places a series of short parallel strokes adjacent to a patch of color or he scores the paint surface with lines or outlines a block of pigment. Sometimes he draws with a thin line of color just inside the canvas edge to call attention to the picture plane and produce an effect of a strip of light—this border of light he was later able to create, without recourse to line, by juxtaposing areas of pure color. Dots, dashes, dragged lines, indeterminate contours, all are used to activate the surfaces of the multiforms, as Rothko more and more severely restricts their compositions and reduces the shapes in them to a few simple slabs of color.

The process of clarification has already started in *Multiform,* 1948 (cat. no. 70): here both horizontal and vertical, large and small shapes are disposed

55

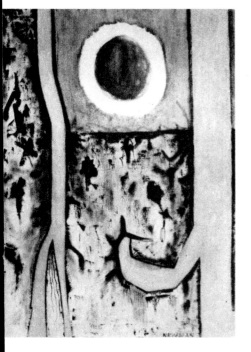

seemingly at random within the field. A number of colors act at once as discrete entities and merge together, unified, as they are reduced to a single intensity. Dashes and drips are the only reminders of Rothko's former fascination with Surrealist automatism. More advanced is the luminous *Number 19, 1949* (cat. no. 88), where the internal configurations are enlarged and simplified and the structural role of color increases in importance, as linear surface incident is diminished. Despite the general pattern of development that may be discerned in these paintings, Rothko's evolution is not absolutely consistent, his direction not entirely certain, as *Number 18, 1948-49* (cat. no. 77), indicates. In this canvas, he once again resorts to a multiplicity of lines, shapes and colors. And in another work of 1948 (cat. no. 84), he chooses a fairly simple format and uses relatively few colors and shapes, but he reveals that he is still unable to attain a complete formal resolution. Because this canvas is exaggeratedly narrow, the areas of color seem too large to be comfortably contained within it. The painting should be executed on a much larger scale, a scale Rothko was to successfully employ barely one year later.

The characteristics of Rothko's mature style emerge with increasing force in paintings of 1949 like *Untitled, Violet, Black, Orange, Yellow on White and Red* and *Number 22* (cat. nos. 89-91). The two latter works form an interesting comparison. *Number 22* is unusually large (it measures 9 feet 9½ inches by 8 feet 10¾ inches) for this date. It is quite unwieldy, as Rothko seems to have found it difficult to take command of the painting's space: the proportions of the internal rectangles are rather awkwardly adjusted to the dimensions of the canvas; the somewhat clumsy relationship of the internal shapes to one another is uncharacteristically out of balance and inharmonious. The painting is a field of abrasive yellow with a narrow stripe of a related, harsh hue inserted near its top; close to the center is a broader and wider band of deep red, which almost touches either side of the canvas. Within the red area, three white lines thread their way, lines which perhaps recall Miró, for example, his *The Hunter (Catalan Landscape)*, 1923-24 (fig. 43), and are among the last vestiges of Surrealist automatic calligraphy in Rothko's work. Curiously, these skeins probably also refer to that wizard of Dada, Duchamp, for in their disposition within the composition they recall the linear elements in works such as *Network of Stoppages*, Paris, 1914 (fig. 44). Although Rothko never acknowledged a debt to Duchamp, the Dada master may have influenced some of his early Surrealist-inspired works— Rothko's *Untitled*, 1945 (cat. no. 62), for example, has the quality of a mirror image and resembles Duchamp's the *Large Glass*, 1915-23 (fig. 45), in its general organization. And Duchamp capitalized upon chance in his art and was, in this, a precursor of Surrealist automatism. The existence of a link between Duchamp and Rothko remains an intriguing if hitherto unexplored possibility. *Number 22*, then, reflects the past and also, in its extreme reduction and large scale, points to the future.

The awkwardness and harshness of this transitional work are in direct contrast to the much more fully resolved *Violet, Black, Orange, Yellow on White and Red*. In this painting, the significant elements of Rothko's mature style are not only clearly in evidence but are unified: he employs a series of horizontals within a vertical format and harmony is achieved by means of precise adjustment of a drastically reduced number of shapes and colors. This order is in no sense mechanical or based upon predetermined calculation; it is exquisitely sensitive and intuitive.

fig. 43
Joan Miró, *The Hunter (Catalan Landscape)*, 1923-24. Collection The Museum of Modern Art, New York

fig. 44
Marcel Duchamp, *Network of Stoppages*, Paris, 1914. Collection The Museum of Modern Art, New York. Abby Aldrich Rockefeller Fund and gift of Mrs. William Sisler

fig. 45
Marcel Duchamp, *The Bride Stripped Bare by Her Bachelors, Even (the Large Glass)* 1915-23. Collection Philadelphia Museum of Art: Bequest of Katherine S. Dreier

In *Violet, Black, Orange, Yellow on White and Red,* Rothko reveals one of the supreme features of his genius—his ability to hold on a single plane colors that advance and retreat. He achieves this through relatively simple means. The large violet shape in the uppermost portion of the canvas is far heavier than the smaller bands of orange and yellow below it. Rothko prevents this rectangle from toppling because of its weight by anchoring it with the thin band of black directly below it and with two vertical red bars which, despite their narrowness, effectively counter the strength of the violet mass. Furthermore, the soft yellow and white ground lends added density to the lower half of the painting and reinforces an otherwise recessive area.

Rothko by now had enlarged and neutralized his forms, allowing color to breathe. Color does not allude to landscape, as it had only a few years before, nor is it any longer a secondary element which supports shape. Color has come to stand for form. Absolutely crucial to his color expression is Rothko's paint handling, which evolved from his Surrealist watercolors. It is basically a watercolor technique translated into oil. Paint is soaked into the very fiber of the canvas, so that color seems dematerialized, a characteristic effect of Rothko's most successful late work. The intensity and warmth of hues (he often favors yellow, orange, violet, red) and an extreme sensuousness of pigment would seem to be at odds with this quality of dematerialization. But Rothko's color is full of contradictions. He frequently remarked he did

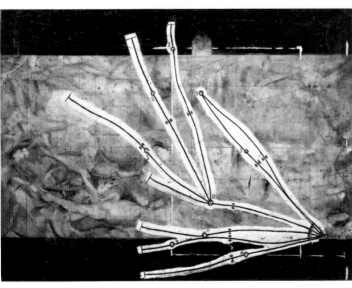

not wish color to be accepted at face value, asserting that dark paintings could be more cheerful than light ones, bright color more serious than deep hues. Rothko's goal was to make color both area and volume, emotion and mood, at once palpable and disembodied, sensuous yet spiritual. For color represents something larger than its own sheer physical presence. Rothko has come to think of color as the doorway to another reality.

Rothko himself said that he was not interested in color for its own sake. Nor did he want to be labeled—and limited—as an abstract painter. "I'm not interested in relations of color or form.... I'm not an abstractionist."[42] He explained that color was important to him as a vehicle to express "...basic human emotions—tragedy, ecstasy, doom....The people who weep before my pictures are having the same religious experience I had when I painted them. And if you, as you say, are moved only by their color relationships, then you miss the point."[43] Rothko had always sought to convey these basic emotions—but he had formerly done so through expressionist figures, dream-like subway scenes and, finally, mythic and Surrealist imagery. But it is only in his painting of the 1950's and 1960's that he achieves "the simple expression of the complex thought" as he distills the meaning of his earlier work into color; color which is the vessel for transcendental meaning.

Red fascinates Rothko above all colors as a carrier of emotion. No other color appears so insistently in his oeuvre from the time of the multiforms. It dominates Rothko's work of the fifties and sixies and, in fact, was the color of his last painting. Red is so potent optically that it overwhelms or obliterates other hues unless it is diluted or controlled by juxtaposing it, as Mondrian did, with equally strong colors, such as black and white or the other primaries, yellow and blue. But Rothko frequently uses it alone, altering its tonality according to the emotion he wishes to express. Perhaps Rothko was so drawn to red because of its powerful and basic associations: it is identified with the elements and ritual—with fire and with blood—and thus with life, death and the spirit. The Existentialist philosopher, Kierkegaard, whom Rothko and his friends deeply admired, wrote movingly of red, in terms that call to mind Rothko's painting:

> *The result of my life is simply nothing, a mood, a single color. My result is like the painting of the artist who was to paint a picture of the Israelites crossing the Red Sea. To this end, he painted the whole wall red, explaining that the Israelites had already crossed over, and that the Egyptians were drowned.* [44]

Rothko belongs very much in the tradition of such metaphysicians of painting as Mondrian, Paul Klee and Vasily Kandinsky, for whom color was the key to the realm of the spirit. The paintings and writings of Mondrian and Kandinsky, particularly the latter's *On the Spiritual in Art,* received much attention in New York in the 1940's. However, Rothko's commitment to the expression of the spiritual rather than the physical was inspired not by their aesthetic theories, but by the evidence of their painting. Moreover, magic and mysticism, myth and ritual were integral to late nineteenth- and twentieth- century art movements as diverse as Symbolism, Surrealism, Cubism and Suprematism. And Rothko's own youthful religious background must surely have fostered and supported his concern with the spiritual aspects of art.

It is important to reiterate that Rothko did not consider himself, even in his mature phase, an abstract artist. He said: "I do not believe that there was ever a question of being abstract or representational. It is really a matter of ending this silence and solitude, of breathing and stretching one's arms again."[45] For Rothko abstract form and pure color had significance only insofar as they represented a higher truth. Thus, he rejected as far too limiting the restricted goals of pure geometric abstraction just as he renounced the literary content of Surrealism.

Though Rothko limited his forms and restricted his number of colors, his intention was to enhance rather than reduce the expressive possibilities of his painting. To suggest multiple levels of meaning he had first to strip away extraneous detail, just as the Surrealist poets and painters divested the object of conventional associations. Once this purification has taken place and imagery has been renovated, the viewer is permitted new kinds of associations, in Apollinaire's words, "numerous interpretations that sometimes contradict each other."[46] In these often contradictory layers of interpretation, Rothko expresses rich content. Formal reductivism thus gave rise to expanded meaning for Rothko as for other artists of his generation.

In a painful, often tortuous process of transformation, Rothko purified his painting by purging it of many of the European models he admired and learned from. He now expressed the metaphysical meaning of his Surrealist works without any recourse to the forms, symbols or allusions of his earlier canvases. References to the external world are subsumed into disembodied color, as Rothko attains a synthesis of the physical and spiritual. In this respect, it is interesting to note Rothko's admiration for the Italian Primitives, in particular Fra Angelico, who represented the beauty of both spiritual and physical worlds in their religious paintings. That Rothko was able to achieve this synthesis with the rigorously limited means he allowed himself is all the more remarkable. In these pure, reduced, transcendent works, Rothko makes the concrete sublime.

IV

Rothko banishes entirely any hint of representational imagery from his painting and resolves his mature, fully integrated style by 1950. He has arrived at his characteristic formulation: two or three horizontal, relentlessly frontal rectangles of disembodied color stacked one above another almost fill the canvas field in which they seem to hover or float. The support is either long and narrow, as in *Green and Red on Orange,* 1950 (cat. no. 93), or near-square, as in *No. 8,* 1952 (cat. no. 105). Gone are the few vestiges of linear elements that remained in the paintings of 1949. Gone, too, are the layers of color bands and contrasting horizontal and vertical forms that had marked the multiforms.

Spatial illusionism always played a part in Rothko's work—from the Renaissance windows of his first paintings to his Surrealist dream-landscapes and, finally, to the Mondrian-inspired complex spatial play of the multiforms. But this illusionism was extremely limited as early as the subway paintings. In a work like *Subway Scene,* 1938 (cat. no. 22), for example, although recession into depth is indicated, one tends to read the image from top to bottom, on the flat canvas surface. Rothko always creates a figure-ground relationship but, in virtually all his work from the time of the subway paintings, he modifies it by dividing his canvas into horizontal bands. These bands emphasize the canvas surface and therefore flatten the composition. This sectioning is an underlying, if often subliminal, unifying factor throughout Rothko's oeuvre.

By 1950, this stratification is stressed further. Because Rothko's rectangles of color are utterly frontal, spatial illusionism is even more limited than before. But the paintings are not resolutely flat: Rothko has diminished the figure-ground relationship but has not abandoned it, and his forms float ever so slightly above the color field upon which they are placed. This depth is restricted, not only by means of frontality, but through feathery paint application which renders the rectangles almost transparent: the ground is revealed through the color forms and appears to merge with them. In addition, Rothko often uses a band or accent of stronger color to reassert the picture plane. Despite the emphasis on the picture plane and the sense of shallow depth, there is in these paintings a curious, paradoxical fluctuation in space—the color forms seem not only to hover on the canvas surface but actually to move forward. Because these veils of color are so weightless, because there is about them a sensation of mist and atmosphere, they advance and appear to exist somewhere between us and the picture, somewhere

between what we know to be true and what we perceive.

In these paintings, which are the essence of simplicity, Rothko expresses his ideas with increased clarity and directness. As he had said somewhat earlier:

The progression of a painter's work, as it travels in time from point to point, will be toward clarity: toward the elimination of all obstacles between the painter and the idea and between the idea and the observer. As examples of such obstacles, I give (among others) memory, history or geometry, which are swamps of generalization from which one might pull out parodies of ideas (which are ghosts) but never an idea in itself. To achieve this clarity is, inevitably, to be understood. [47]

Rothko's commitment to reduction and clarity filled him with self-doubt and was achieved at great emotional cost. But this commitment endows his paintings with a nobility and monumentality which place him among the foremost artists of his generation, perhaps even among the greatest of the twentieth century and thus enables him to attain his grand ambition. He later came to question his single-minded direction and often told his friends that he felt trapped in it; he nevertheless produced an astonishing body of work which, especially from 1950 to 1956, was at once remarkably consistent and extraordinarily varied. For, while he severely limits the general format of his compositions, rigorously restricting the number, kind and orientation of his shapes, he uses canvases of different sizes and an enormous range of colors, combining them in seemingly infinite ways, and exquisitely adjusts the relationships of rectangles whose proportions are slightly altered from painting to painting. Through this rich and subtle formal variety, Rothko gives expression to an unparalleled range of emotions, moods and sensations, a range and a sensibility that neither his contemporaries nor the younger generation of color-field painters of the later 1950's and early 1960's were able to approach.

In these paintings, Rothko is clearly creating a set of rules for himself, but he would not or could not remain within them. Constantly exploring, reshaping and re-evaluating form and color, he seems to have established these principles only to break them. Reinhardt shares with Rothko the sense of need for perfection, the desire to express a utopian order, a metaphysical truth with his abstract form and color. And, like Rothko, he reduces his painting to its essence. But Reinhardt adheres obsessively to the series of aesthetic principles he formulated for himself. By 1960 he had established a fixed module of a five-by-five-foot canvas and limited his color to black, his imagery to a cruciform structure of nine squares. The color painters of the sixties, too, felt the need to remain within a system. They, however, dispense with metaphysics in favor of the pragmatism of pure color painting.

Rothko perfected a technique of dyeing (or staining, as it later came to be called) with his paint which enabled him to saturate the threads of his canvas with his medium so that pigment and canvas become one. By applying many thin washes of paint, one over another, and often allowing some of the colors in the bottom layers to appear through the top coat of pigment, Rothko achieves the effect of a hidden light source. In most of the paintings of this period, Rothko creates a quality of inner light which seems to emanate from the very core of the work, a quality that calls to mind the palpable and spiritual light of Rembrandt, an artist whom he very much admired. Rothko often enhances this effect of inner light by floating a thin

seam or sliver of another color through his rectangles or around their edges. Thus, in *Green, White, Yellow on Yellow* of 1951 (cat. no. 102), fleeting glimpses of pink underpainting punctuate the large green upper mass, which is partially surrounded by a narrow border of softly brushed white. There is a layer of green underpainting in the yellow block at the bottom of the canvas: it shines through the yellow, emphasizing the sense of suffused light and also balancing the composition. The yellow field behind the two rectangles provides yet another border of light and further unifies the painting.

Rothko's mastery of both coloristic and formal nuance is revealed in painting after painting of the 1950's. A comparison of *Brown, Blue, Brown on Blue*, 1953, and *Homage to Matisse*, 1954 (cat. nos. 108, 107), demonstrates his supreme ability to achieve astonishingly different results within his severely restricted format. The former painting, roughly square in shape, is illuminated by an electric blue in its midsection. So powerful is this blue that it must be offset by two darker and larger brown forms to prevent it from destroying the stability and balance Rothko seeks. Because the blue is more intense in value than the other colors, it would burst out of the rectangle if the heavier and denser masses of brown above and below it did not press in upon it to hold it in place. The blue field which surrounds the three bands (and is also behind them) locks them together in a single plane. Contradictions between foreground and background, flatness and shallow depth emerge and coexist in tenuous and ever-shifting relationships. This canvas indicates that Rothko could exploit blue to powerful effect, yet it is a color he worked with less often than red—perhaps because it had come to be identified with Newman, who had used it so early and so well. The richness of *Brown, Blue, Brown on Blue* certainly derives in large part from Rothko's successful use of the several blues disposed throughout it, but also depends upon the variety and textures of the surrounding browns. Extraordinary balance, a superb handling of scale and proportion and the tension between emphatic frontality and flatness and an effect of shallow space also contribute to the painting's majesty.

Despite the large size of *Brown, Blue, Brown on Blue* and the other paintings of this period, Rothko's work is refined and subtle and thus remains, despite its majestic proportions, intimate and emotionally accessible. As Rothko said:

> *I paint very large pictures. I realize that historically the function of painting large pictures is painting something very grandiose and pompous. The reason I paint them, however—I think it applies to other painters I know—is precisely because I want to be very intimate and human. To paint a small picture is to place yourself outside your experience, to look upon an experience as a stereopticon view or with a reducing glass However you paint the larger picture, you are in it. It isn't something you command.*[48]

A special, intensely personal relationship is achieved between the viewer and the canvas and, by extension, Rothko. Acutely aware of the need for this relationship, the artist noted:

> *A picture lives by companionship, expanding and quickening in the eyes of the sensitive observer. It dies by the same token. It is therefore a risky act to send it out into the world. How often it must be impaired by the eyes of the*

unfeeling and the cruelty of the impotent who would extend their affliction universally![49]

The words that describe the qualities and components of Rothko's art—measure, balance, shape, texture, tonality—cannot adequately express its breathtaking beauty. Indeed, *Brown, Blue, Brown on Blue* and other mature paintings elicit a sense of awe on the part of the viewer and convey a feeling of mystery, a harmony and meaning that is magical and larger than the sum of the parts of each canvas. In these transcendent works, Rothko creates the contemporary spiritual equivalent of the great Renaissance paintings he revered, paintings which were meant to inspire the beholder, not merely with their formal perfection but also as reminders of an order beyond man and nature.

The ultimate effect of *Homage to Matisse* is completely unlike that of *Brown, Blue, Brown on Blue.* This difference is in part produced by Rothko's use of a long narrow canvas, the one alternative he allows himself to the squarish format of *Brown, Blue, Brown on Blue.* Once again he employs blue, here in the form of a rectangle at the bottom of the composition. It is surmounted by a floating, vaporous yellow square. The misty yellow and the red beneath it behave in an unexpected way. The red that peers through from underneath the yellow overlay has a bluish tinge. This is curious, because when red and yellow interact they normally produce orange. To create this unusual effect, Rothko must have made the square an extremely bluish-red. But the uncovered portion of it is a true red: in all probability Rothko overpainted the band with this color. Therefore, in a quite inexplicable way, the veiled red, which should be more orange than the uncovered band, is actually bluish. The result is a sense of coherent shape and implausible color. Rothko refuses to accept proven rules about the behavior of color—that is, that red and yellow make orange. Here he creates his own rules and reinvents

63

fig. 46
Henri Matisse, *The Red Studio*, 1911.
Collection The Museum of Modern Art,
New York. Mrs. Simon Guggenheim Fund

color, and this is his homage to Matisse.

Matisse was profoundly important to Rothko and his contemporaries. His *The Red Studio,* 1911 (fig. 46), and *The Blue Window,* autumn 1911, without doubt inspired the artists of the New York School. To be sure, Rothko did not find relevant Matisse's rather straightforward representation of objects in such paintings. But his radical use of unifying planes of sensuous color which flatten space into the two-dimensional surface of the canvas had enormous impact on Rothko.

There is also a symbolic and spiritual dimension in *Homage to Matisse.* In his choice of scarlet and true red, Rothko perhaps makes reference to Catholic vestments. The dense blue rectangle is emphatically, intensely physical; it contrasts with and acts as a foil for the evanescent, incorporeal form of the golden square. This shimmering halo-like form calls forth associations with religious imagery. Thus, the painting speaks of form and space, of the real and immaterial, the physical and sensual yet disembodied presence of paint.

During the course of the 1950's, Rothko experiments in a number of · ways: the size of the field and the interior configuration differ in relationship to one another and from painting to painting, the widths of the spaces between colors vary, colors range from bright to dark, from gay to sober, but are rarely somber, small amounts of black are introduced, although this color does not figure prominently until the late 1960's. Paint is handled in a loose, brushy manner, feathered out so that the edges of forms are never clearly defined. The canvas is stretched and then painted not only on its front surface but on its sides as well. The works are left unframed so that the depth of the stretchers and the entire painted surface are revealed. Although his compositions are generally weighted towards their tops, Rothko occasionally concentrates his darkest, heaviest colors at the bottom of the canvas, as, for example, in *Light, Earth and Blue,* 1954 (cat. no. 116). *Light, Earth and Blue* is one of the few paintings of this time with a title that enhances its meaning. Rothko had no fixed system for naming his canvases: most are either left untitled or identified with numbers or colors, since he probably felt that more interpretive or descriptive names would restrict their meanings. Sometimes he bleeds the edges of rectangles so they appear unfinished—he then completes their forms by enclosing them within another color area, as in *Number 8,* 1952 (cat. no. 105), or he leaves part of the rectangle so well defined that the viewer can read it as a totality and complete the shape himself, as in *Yellow, Orange, Red on Orange,* 1954 (cat. no. 110).

Rothko minimizes the tactility of his paint by dyeing it into the canvas; as we have seen, his color, despite its intensity, becomes disembodied and seems to hover somewhere in front of the paintings. Because by now the canvases are larger than life-size—and are often very large indeed—the spectator is encompassed by these floating color shapes, drawn into space that exists somewhere between himself and the picture plane and is engulfed in an overwhelming emotional experience. Rothko's commitment to creating this exalted emotional experience, to art as an act of revelation, shared by Still and Newman, contrasts markedly with the attitudes of painters like Pollock or de Kooning and Franz Kline, for whom the physical rather than the spiritual aspects of painting were of central importance. For these artists who emphasized the gestural elements of Abstract Expressionism, the canvas must reflect the very act of painting. Pollock, pouring paint, walking around and in his canvas, using his entire body as he worked, was the quintessential action painter. Because his canvases were so large, Rothko probably had to

expend as much physical energy when he painted as Pollock did. But Rothko's approach was contemplative rather than physical; unlike Pollock, who worked intuitively, rapidly and spontaneously, Rothko proceeded from long periods of meditation to the physical act of painting.

As the 1950's advance, Rothko's canvases grow larger, the edges of his forms become more concrete, the colors more opaque, the mood of the work more somber. This shift in direction was clarified and emphatically reflected in a mural series Rothko executed for the Four Seasons restaurant in the Seagram Building in 1958. Rothko had never before received a mural commission nor had he ever painted a formal and unified series. He worked on them for nearly a year and actually completed three separate sets of murals before he was satisfied. Each set became progressively darker: the first were primarily orange and brown, the last, deepest maroon and black. In them, Rothko abandons solid color-forms in favor of rectangles with open centers that reveal the field behind them and therefore suggest doorways. For the first time he employs a horizontal support with a vertical configuration and restricts his palette more severely than ever before, using only two colors in each panel. Rothko explained that the panels were inspired by Michelangelo:

> *After I had been at work for some time, I realized that I was much influenced subconsciously by Michelangelo's walls in the staircase room of the Medicean Library in Florence . . . he makes the viewers feel that they are trapped in a room where all the doors and windows are bricked up, so that all they can do is butt their heads forever against the wall.*[50]

For the first time, the work is brooding, forbidding, tragic.

Rothko completed the commission but did not deliver the paintings: when he saw the space for which they were intended, he said he was offended and returned the sum he had been paid for them. In fact, this was not the only time Rothko refused to sell his work or accept patronage. He would not allow certain museums to buy his paintings in the 1950's and returned the Guggenheim International Award prize money he won in 1958. These actions no doubt depended upon deep-seated emotional and moral attitudes. By this time famous and financially secure, he must still have been outraged by social injustice, as he had been in his impoverished youth. The radical, liberal Jewish immigrant probably felt guilty because he was himself rich and had accepted a commission for a commercial establishment that served the wealthy. It is well known that Rothko's success brought him at least as much torment as comfort. Whether or not Rothko was ever really satisfied with the Four Seasons murals is open to conjecture. He did consent to sell the first group as separate paintings. The second set was abandoned and the third, completed in 1959, Rothko gave to The Tate Gallery in London (figs. 47, 48).

In 1960, The Phillips Collection in Washington, D.C., opened a new wing and set aside a room in it to display their three Rothkos, which included *Green and Tangerine on Red*, 1956 (cat. no. 131). A fourth painting, *Ochre and Red on Red,* 1954 (cat. no. 118), was acquired in 1964 and added to the room at that time. The idea was conceived by Duncan Phillips, who was moved by the artist's profound use of light and color. The windows in the room were darkened, and thus was born the first "Rothko Chapel." This installation undoubtedly affected Rothko's thinking about future presentations of his work.

Rothko was given his first important one-man museum exhibition by

figs. 47, 48
The Tate Gallery, London, installation view

The Museum of Modern Art in New York in 1961. He directed the installation himself and made radical decisions about lighting and placement. When he participated in the *15 Americans* show at The Museum of Modern Art in 1952, Rothko had asked that his paintings be hung in blazing light and placed so close together that they touched one another. Some time later, however, when one of his canvases was installed in the Modern's collection galleries, Rothko indicated that he wanted the lighting dimmed. Now he had all of the works hung very close to one another and drastically reduced the lighting, so that the paintings appeared to glow in the dark. The effect produced was one of an intimate environment, of a dark space in which the paintings, instead of existing as individual entities, constituted a series although they ranged in date from 1945 to 1960 and varied considerably in style.

Rothko was commissioned to execute a series of murals in 1961 for Harvard University by Professor Wassily Leontief, Chairman of the Society of Fellows and Professor of Economics of Harvard University, and John P. Coolidge, Director of the Fogg Art Museum. They were slated to be installed in the penthouse of Holyoke Center, designed by José Luis Sert, but were ultimately placed on permanent view in the faculty dining room at the Center. Completed in 1962, the Harvard murals were exhibited at the Guggenheim Museum in the late spring of 1963 before they were sent on to Cambridge. The series consisted of five monumental panels which were intended to be hung in two distinct but interrelated groups (cat. nos. 175-177). For the Guggenheim installation, Rothko flanked a wide panel with two narrower ones; these formed a triptych. The remaining panels, one wide, one narrow, were hung on separate walls adjoining the triptych.

Rothko's configurations in these murals are made up of post and lintel forms—single ones in the narrower panels, double ones merged together in the wide ones. The plinth-like masses are linked at top and bottom by very narrow bands and by small discrete rectangles. The ground is dusky plum-purple, one of Rothko's favorite colors, which is offset by black, deep alizarin and creamy yellow columns. The relationship of the pillars to the picture plane creates the illusion of space, while the saturated pigment and brushwork assert the two-dimensionality of the canvas surface. The murals, more impetuously painted than his earlier canvases, are replete with tempestuous strokes and aggressive blocky forms. The somber colors and massive shapes create at once a sense of architecture, silence and stasis. The cumulative effect of the installation at the Guggenheim was a feeling of a sanctuary within a public space.

The Museum of Modern Art installation may have influenced an increasing bias on Rothko's part in favor of dimly lit presentations and the evolution of ever-darker paintings throughout the sixties. This development must also be attributed to a change in Rothko's personality, for as his fame grew, so did his uneasiness, and he became increasingly depressed as the years passed. Internal and external pressures mounted. The strain of The Museum of Modern Art exhibition took its toll—he produced very little in 1962 and 1963. He attended more and more ceremonial events—such as the Kennedy and Johnson inaugural festivities and a state dinner celebrating the arts at the White House—and painted less and less. Although highly acclaimed in the fifties, he was barely earning enough then to support his wife, Mell, and his daughter, Kate, born in 1950. Now he was able to travel abroad extensively with his family and visit the cities and monuments he must have yearned to see. In 1963, his son, Christopher, was born. He should have been happy and confident but he was deeply troubled. Friends relate that he spoke of being trapped and feared his work had reached a dead end.

But by 1964, Rothko was preoccupied with a major undertaking, a commission from Dominique and John de Menil to execute murals for a chapel in Houston (figs. 49, 50). This chapel, originally intended to be Roman Catholic and part of the University of St. Thomas, was finally realized as an interdenominational chapel affiliated with the Institute of Religion and Human Development at Rice University. The octagonal floor plan was designed by Philip Johnson; the final design was executed under the supervision of Howard Barnstone and Eugene Aubrey. Rothko accepted the project with great enthusiasm and began to work on the murals shortly after

he moved into his last studio, a converted carriage house on East 69th Street. The commission gave Rothko the opportunity to fulfill one of his life's ambitions—to create a monument that could stand in the great tradition of Western religious art. He placed a parachute over his skylight to adjust the natural light that filtered in during the daytime, preferring to keep the studio relatively dark. Rothko became obsessed with the chapel. He started the panels in the winter of 1964 and continued to work intensively on them until 1967, when they were basically complete. Yet even after 1967 he returned to them from time to time to make minor changes.

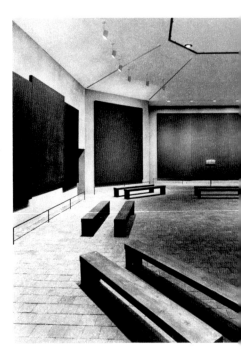

Tragically, Rothko did not live to see this project realized, and it was dedicated almost one year to the day after he committed suicide. Rothko designed three triptychs, five single panels and four alternatives for the chapel (figs. 49, 50). His theme was the Passion of Christ and he had, at one point, planned to place the numbers of the fourteen Stations of the Cross on the exterior of the building to indicate the location of each panel inside the structure. Two triptychs and one single panel are comprised of black hard-edged rectangles on maroon fields; one triptych and four single panels are entirely black, veiled with a wash of maroon. Variations in the thickness of paint produce nuances of color. In these murals on the Passion of Christ, Rothko evokes with his red and black his belief in the passion of life, the finality of death, the reality of the spirit. Red, so often the principal carrier of Rothko's emotions and ideas, is now accompanied by black, which symbolizes his state of mind and the character of his existence in the latter part of his life. Black, however, does not signify only death. It is one of the richest colors in the artist's palette. Rothko had reduced his painting in the fifties by restricting it to the simplest shapes and to color; now he was purifying it even of colors, limiting himself to red and, finally, black. These reds and blacks do not any longer seem to exist as physical color, but rather, as tranquil, tragic, twilit dreams of color. Even more than the Four Seasons or Harvard murals, the Houston paintings create a total environment, a unified atmosphere of all-encompassing, awe-inspiring spirituality.

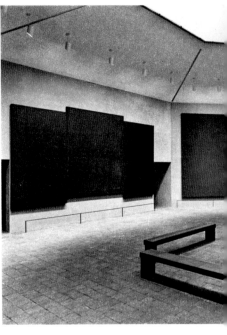

figs. 49, 50
The Rothko Chapel, Houston

In 1968, Rothko suffered an aneurysm of the aorta. This condition was aggravated by other ailments, by heavy drinking—common among artists of his generation—and by family problems. Nevertheless, in the last two years of his life Rothko produced an astonishing and prolific body of work. These were in acrylics, a medium which Rothko chose because he was attracted to their fast-drying qualities—he was able to make one painting a day. Some were canvases but the majority were extraordinary paper pieces, among the most exquisite work he had done. He had, of course, worked on paper in the forties and he executed small-scale paper versions of his oils on canvas in 1958. Rothko had his assistant roll out a length of paper on the floor as he watched. Once he decided on the size he wanted, he had a series of ten to fifteen sheets cut to approximately the same dimensions. Then he tacked the papers on the wall in a row and worked on them one at a time.

The new acrylics are simplicity itself: in most of them two dark planes—either brown or black on grey—are surrounded by a narrow white border. The borders were of extreme importance to Rothko, who constantly readjusted their proportions in relation to the inner configurations. Imagery, mood and meaning are vastly different from his work of the 1950's and early 1960's. The glowing colors of the earlier paintings are replaced here by deeper, quieter hues; the rectangles, which formerly floated, are denser, more stable, because of the more opaque quality of the acrylics. Rothko's

fig. 51

69

preference for horizontal divisions within vertical canvases and configurations is replaced by an insistence upon horizontal divisions of horizontal supports. Where the vertical called to mind architecture, the horizontal alludes to landscape. The doorways to a higher reality created before the Houston Chapel were still redolent with sensuous color and form: there was in them an equilibrium between two states of existence, the spiritual and the physical. The new works, however, speak entirely of another, transcendent world, of a painter who has crossed a threshold into the far side of reality.

These landscapes of the spirit bear a certain resemblance to paintings by Caspar David Friedrich, such as *Monk by the Sea* (fig. 51). Both artists stand in awe of the spirit, both use nature to express that spirit. Friedrich, of course, felt it necessary to incorporate a human element in the figure of the monk; Rothko has long since banished all allusions to the human form. Specific references to beach, sea and sky are also unnecessary for Rothko. He conveys all of his meaning through gesture and in the way the darker, heavier top mass meets the lighter, usually smaller area of grey below. The two planes are painstakingly adjusted and readjusted; between them is a band which appears to be a flicker of light. Often, especially in the paper pieces, this luminosity is Inness-like. The weight and texture of the canvas create a heavier, darker presence than the paper does. In both paper pieces and canvases, however, Rothko is moving towards darkness. "... the abstract idea is incarnated in the image. ... But this is not to say that the images created by Rothko are the thin evocations of the speculative intellect; they are rather the concrete, the tactual expression of the intuitions of an artist to whom the subconscious represents not the farther, but the nearer shore of art," wrote the author of the preface to the catalogue of Rothko's one-man exhibition at Art of This Century in 1945. By the end of his life Rothko had moved beyond such concepts in his painting. No longer is his art earthbound, sensual, corporeal. He had attained a harmony, an equilibrium, a wholeness, in the Jungian sense, that enabled him to express universal truths in his breakthrough works, fusing the conscious and the unconscious, the finite and the infinite, the equivocal and the unequivocal, the sensuous and the spiritual. Now he had left behind all that spoke of the carnate, the concrete. He had reached the farther shore of art.

Diane Waldman

FOOTNOTES

1. Interview with Edward Weinstein, January 24, 1978. According to Weinstein, there were numerous variants of the name, such as Rothkovich, adopted by different family members. One branch of the family changed its name to Weinstein and another to Nagel.

2. Letter from Weinstein, February 24, 1978.

3. John Fischer, "The Easy Chair: Mark Rothko: portrait of the artist as an angry man," *Harper's*, vol. 241, no. 1442, July 1970, p. 17.

4. Letter from Dr. Max Naimark, February 14, 1978.

5. *Current Biography Yearbook*, Charles Moritz, ed., New York, 1961, p. 398.

6. Fischer, "The Easy Chair," p. 22.

7. Letter from Naimark, December 27, 1977.

8. "The Romantics were Prompted," *Possibilities 1*, Winter 1947/8, p. 84.

9. Quoted in Brian O'Doherty, *American Masters: The Voice and the Myth*, New York, ca. 1973, p. 153.

10. Quoted in "A Certain Spell," *Time*, vol. lxxvii, no. 10, March 3, 1961, p. 75.

11. Jane Schwartz, "Around the Galleries," *Art News*, vol. xxxii, no. 9, December 2, 1933, p. 16.

12. Quoted in O[scar] C[ollier], "Mark Rothko," *The New Iconograph*, no. 4, Fall 1947, p. 41.

13. Letter from Sally M. Avery, December 14, 1977.

14. Eulogy for Milton Avery, delivered January 7, 1965, New York Society for Ethical Culture.

15. L[awrence] C[ampbell], "Reviews and Previews: Painting from the WPA," *Art News*, vol. 60, no. 5, September 1961, p. 14.

16. André Breton, *What is Surrealism*, London, 1936, p. 65.

17. Joseph Solman, "The Easel Division of the WPA Federal Art Project," *The New Deal Art Projects: An Anthology of Memoirs*, Francis V. O'Connor, ed., Washington, D.C., 1972, p. 120.

18. Letter from H. R. Hays, December 27, 1977.

19. Leter from Solman, November 15, 1977.

20. *Ibid.*

21. Mercury Galleries, New York, *The Ten: Whitney Dissenters*, November 15, 1938.

22. Letter from Solman, November 15, 1977.

23. J. L., "Three Moderns: Rothko, Gromaire and Solman," *Art News*, vol. xxxviii, no. 16, January 20, 1940, p. 12.

24. Joseph Liss, "Portrait by Rothko," unpublished, n.d. On deposit in Rothko file, Whitney Museum of American Art, New York.

25. Letter from Edith S. Carson, January 5, 1978.

26. Breton, *What is Surrealism*, p. 59.

27. John D. Graham, *System and Dialectics of Art*, New York, 1937, p. 15.

28. Marcus Rothko and Adolph Gottlieb with unacknowledged collaboration of Barnett Newman [letter], in Edward Alden Jewell, "The Realm of Art: A New Platform and Other Matters: 'Globalism' Pops into View," *The New York Times*, June 13, 1943, p. x9.

29. Sidney Janis, *Abstract and Surrealist Art in America*, New York, 1944, p. 118.

30. Interview with Solman, March 3, 1978.

31. Art of This Century, New York, *Mark Rothko: Paintings*, January 9-February 4, 1945, n.p.

32. "Personal Statement" in David Porter Gallery, Washington, D.C., *A Painting Prophecy—1950*.

33. "Reviews and Previews," *Art News*, vol. xlvii, no. 2, April 1948, p. 63.

34. Sam Hunter, "Diverse Modernism," *The New York Times*, March 14, 1948, p. 8x.

35. *Ibid.*

36. "Clyfford Still" in Art of This Century, New York, *Clyfford Still*, February 12-March 7, 1946.

37. Quoted in San Francisco Museum of Modern Art, *Clyfford Still*, January 9-March 14, 1976, pp. 108-109.

38. *Idem.*, opposite pl. 10.

39. *Idem.*, p. 52.

40. Meyer Schapiro, "The Younger American Painters of Today," *The Listener*, vol. lv, no. 1402, January 26, 1956, p. 147.

41. Quoted in Morton Feldman, "After Modernism," *Art in America*, vol. 59, no. six, November-December 1971, p. 72.

42. Selden Rodman, *Conversations with Artists*, New York, 1957, p. 93.

43. *Idem.*, pp. 93-94.

44. Søren Kierkegaard, *Either/Or*, trans. David F. Swenson and Lillian Marvin, Princeton, New Jersey, 1971, vol. I, p. 28. This is "A," an aesthete, speaking.

45. "The Romantics were Prompted," *Possibilities 1*, Winter 1947/48, p. 84.

46. Quoted in Anna Balakian, *Surrealism: The Road to the Absolute*, New York, 1959, p. 64.

47. "Statement on his Attitude in Painting," *The Tiger's Eye*, vol. 1, no. 9, October 1949, p. 114.

48. "A Symposium on How to Combine Architecture, Painting and Sculpture," *Interiors*, vol. cx, no. 10, May 1951, p. 104.

49. The Museum of Modern Art, New York, *15 Americans*, March 25-June 11, 1952, p. 18.

50. Quoted in Fischer, "The Easy Chair," p. 16.

Ca. 1964—66. Photo by Alexander Liberman

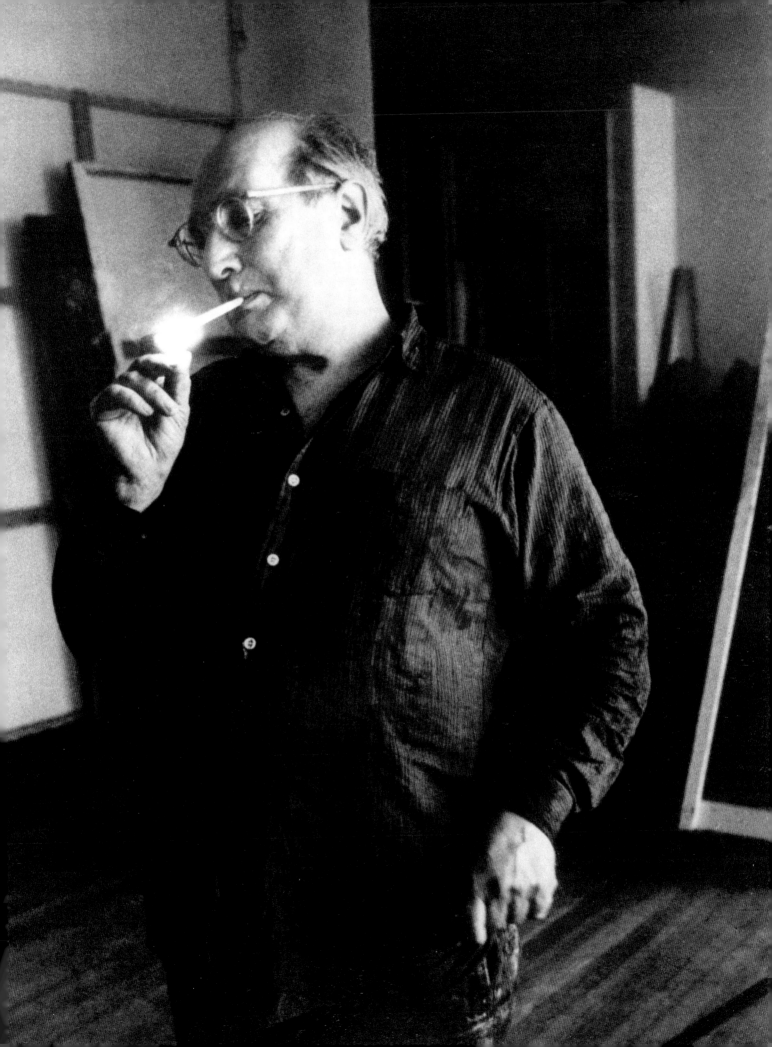

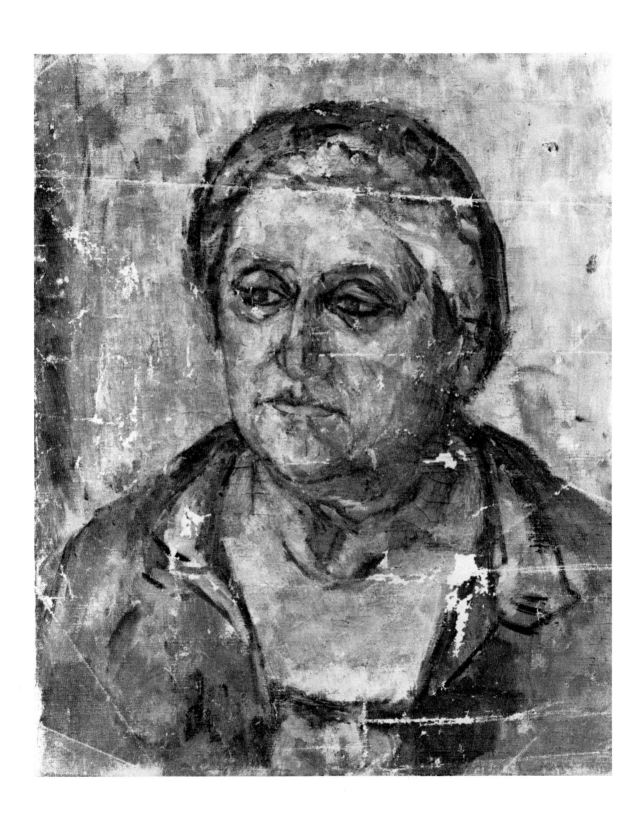

1. *Portrait of Rothko's Mother.* n.d.
 Oil on canvas, 20 x 16¼"
 Estate of Mark Rothko

2. *Untitled.* late 1920's
 Watercolor on paper, 15 x 22″
 Lent anonymously

3. *Untitled.* late 1920's
 Watercolor on paper, 15 x 21¼"
 Estate of Mark Rothko

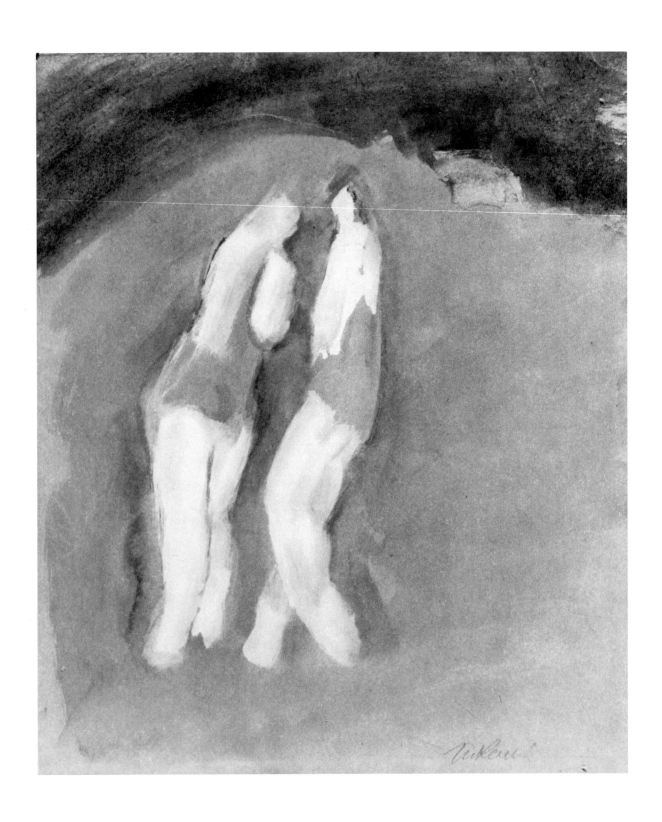

4. *Untitled.* late 1920's
 Watercolor on paper, 15 x 12⅜"
 Estate of Mark Rothko

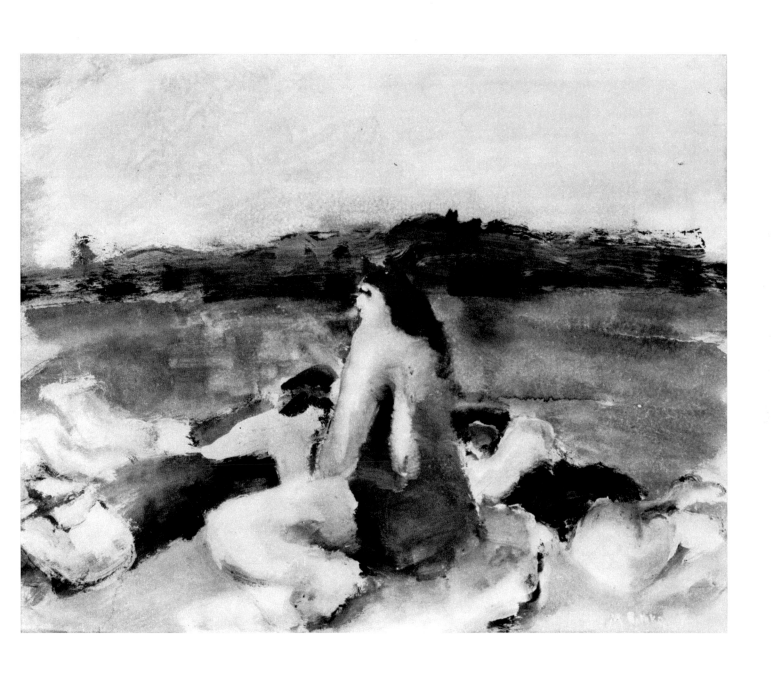

5. *The Bathers.* late 1920's
 Watercolor on paper, 12¼ x 15"
 Estate of Mark Rothko

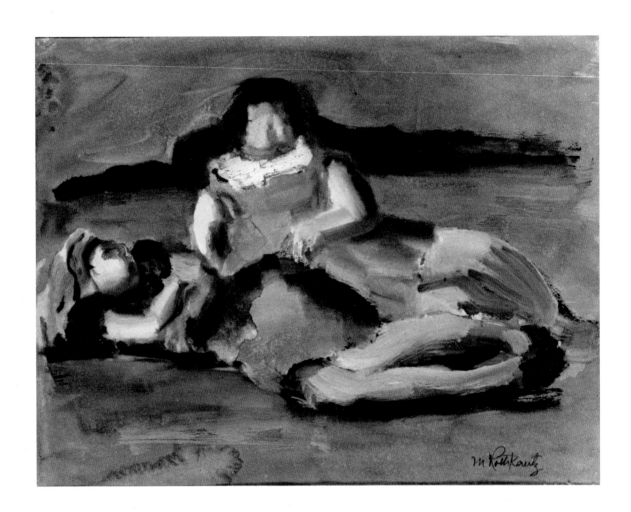

6. *Untitled.* late 1920's
 Watercolor on paper, 12¼ x 15″
 Estate of Mark Rothko

7. *Untitled.* late *1920's*
 Watercolor on paper, 12⅜ x 15″
 Estate of Mark Rothko

8. *Pasture.* late 1920's
 Watercolor on paper, 10⅜ x 15⅜″
 Estate of Mark Rothko

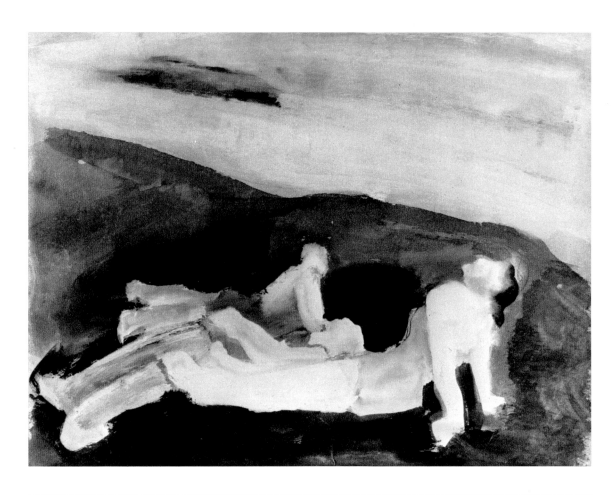

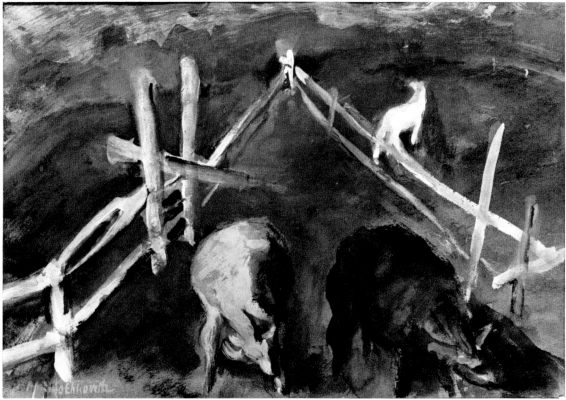

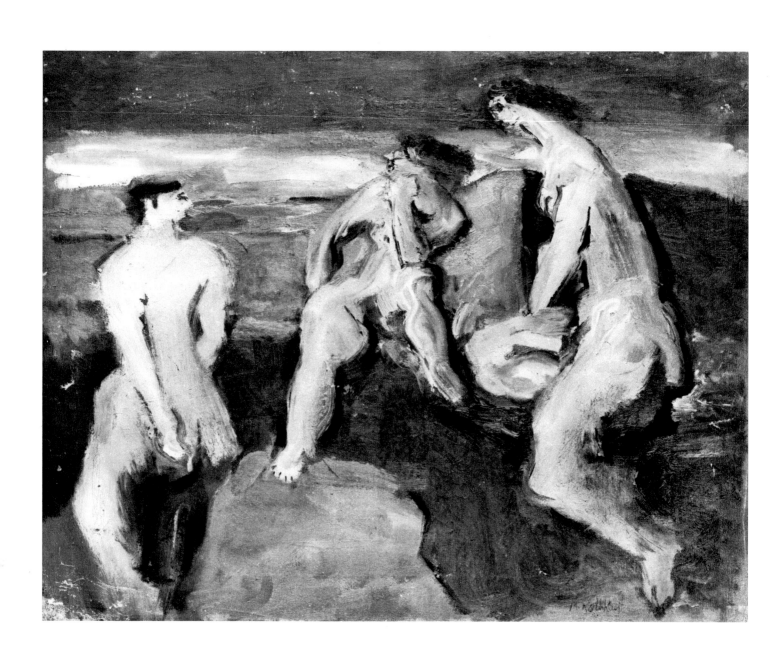

9. *Untitled.* 1930
 Oil on canvas, 21 x 27″
 Estate of Mark Rothko

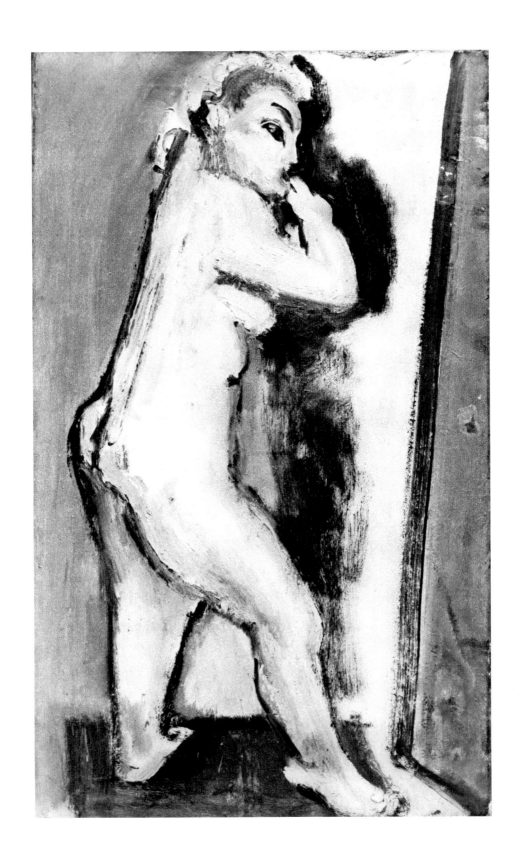

10. *Untitled.* 1930
 Oil on canvas, 28 x 17″
 Courtesy The Pace Gallery

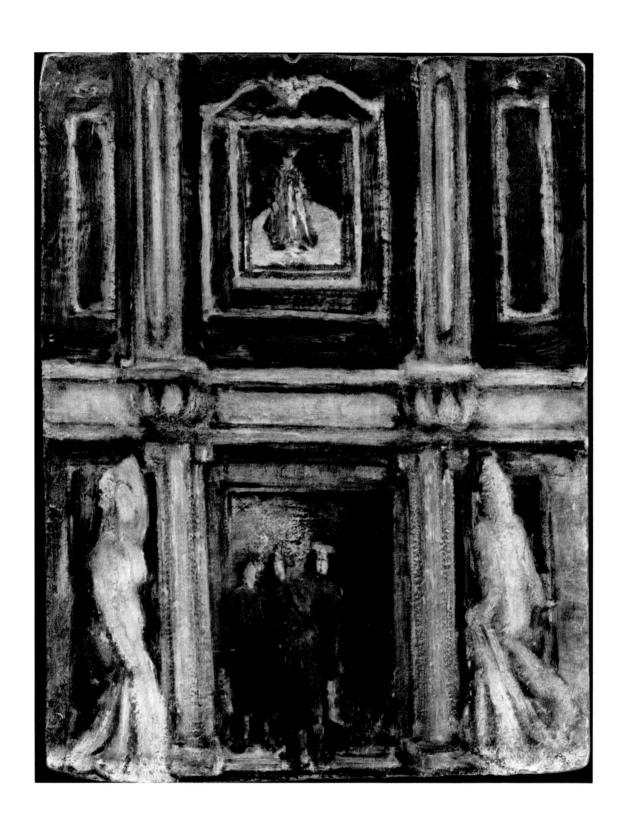

11. *Interior.* 1932
 Oil on masonite, 23⅞ x 18"
 Estate of Mark Rothko

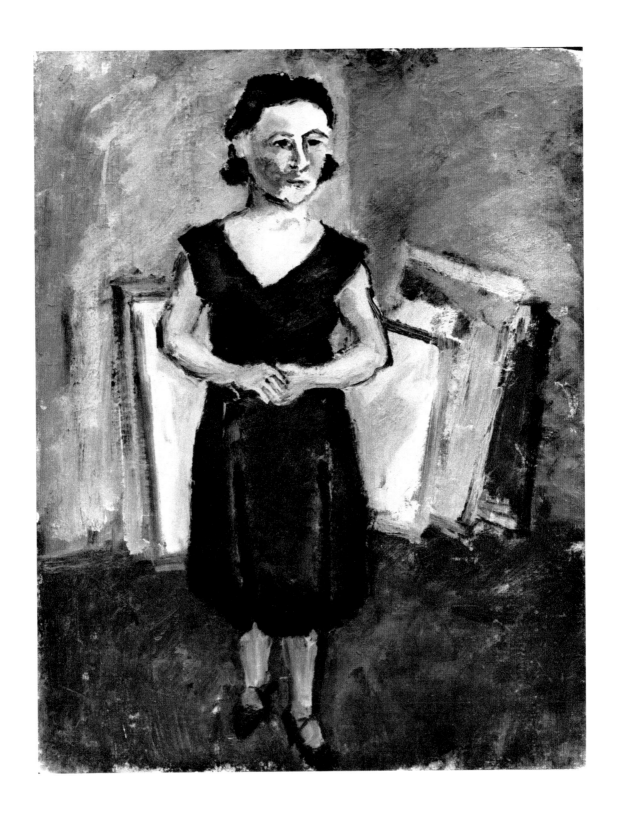

12. *Untitled.* 1932
Oil on muslin mounted on
canvas board, 26⅞ x 20¾"
Estate of Mark Rothko

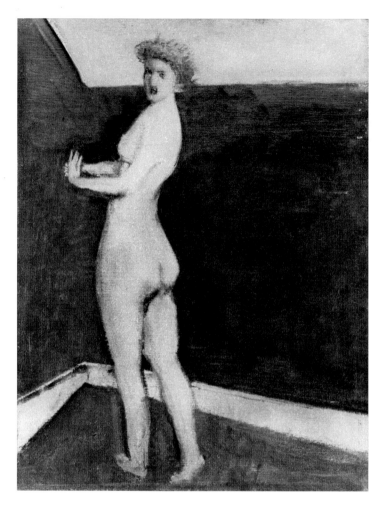

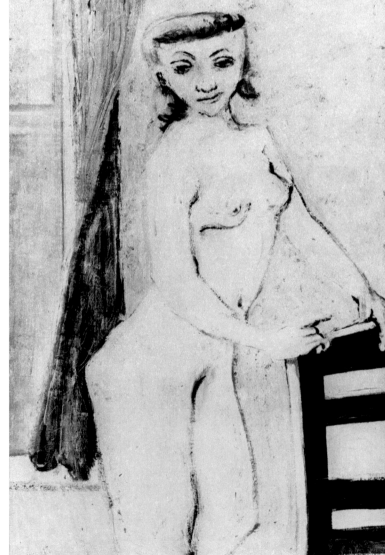

13. *Untitled.* 1936–37
 Oil on canvas, 24 x 18″
 Courtesy The Pace Gallery

14. *Nude.* 1936
 Oil on canvas, 36 x 24¼″
 Estate of Mary Alice Rothko

15. *Untitled.* 1938
 Oil on canvas, 49¾ x 37″
 Estate of Mark Rothko

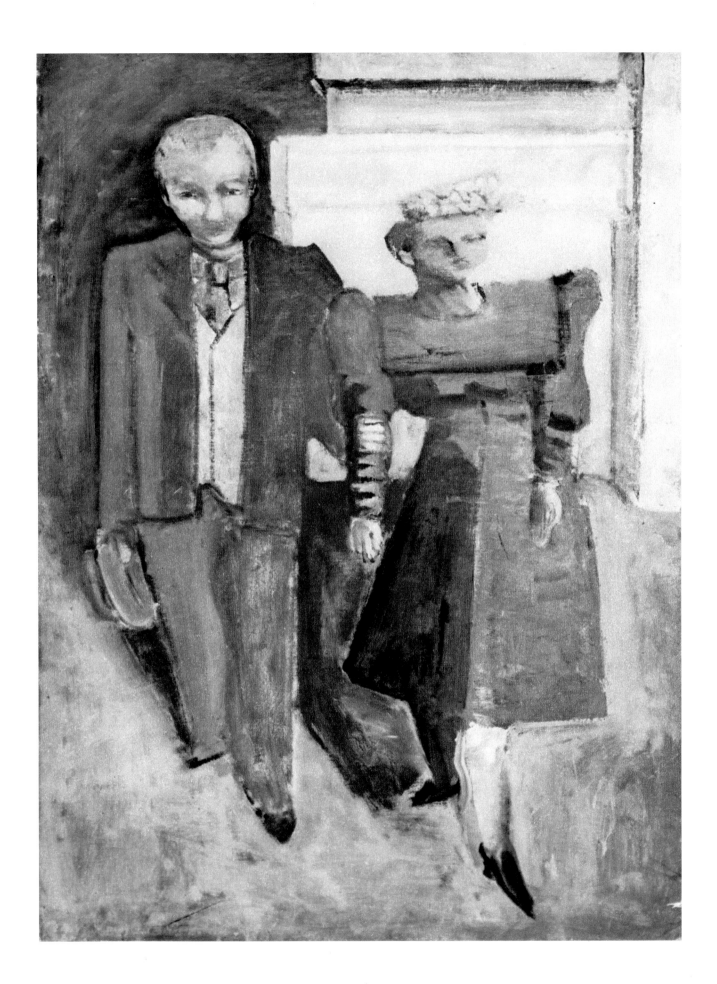

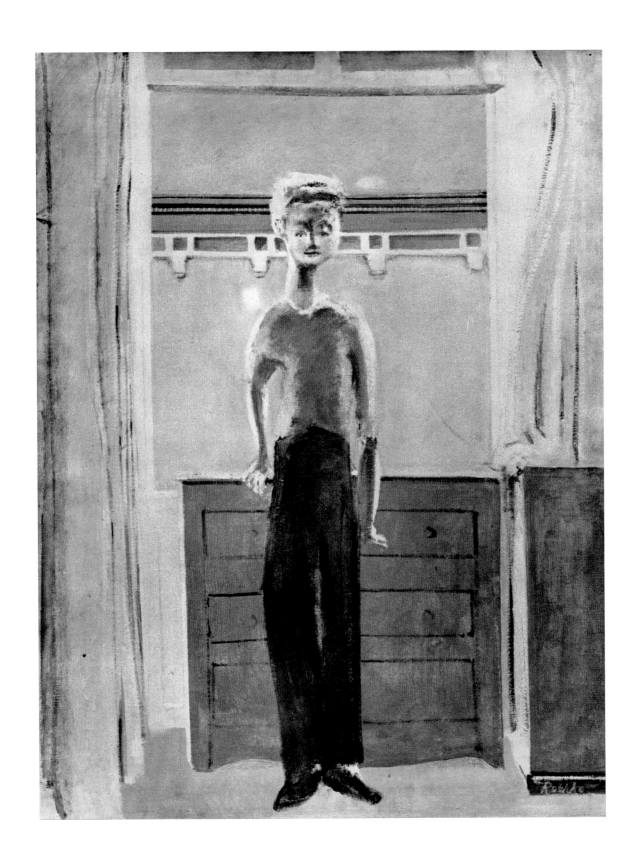

16. *Untitled.* 1936–38
 Oil on canvas, 40⅛ x 30⅛"
 Lent anonymously

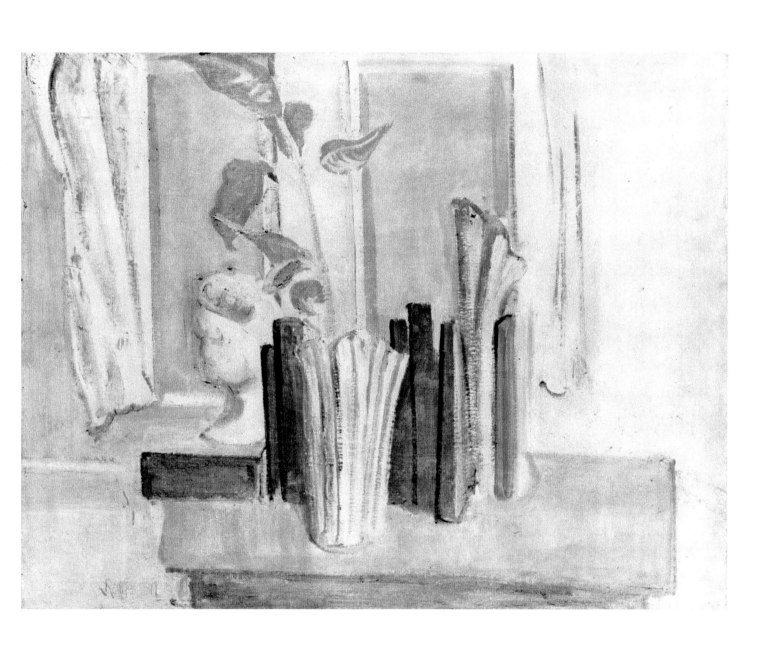

17. *Untitled.* 1936–38
 Oil on canvas, 28 x 36″
 Estate of Mark Rothko

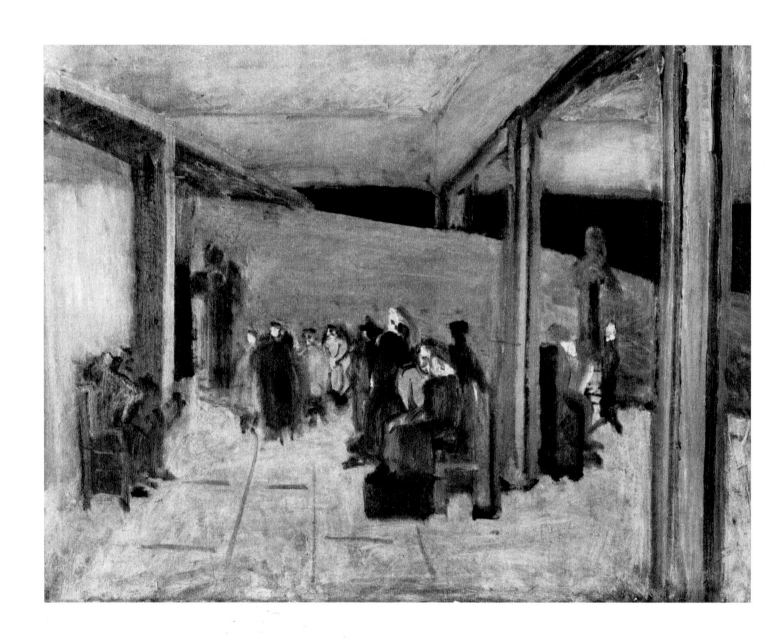

18. *Untitled.* ca. 1936
 Oil on canvas, 32 x 42"
 Estate of Mark Rothko

19. *Self Portrait.* 1936
 Oil on canvas, 32¼ x 26"
 Estate of Mary Alice Rothko

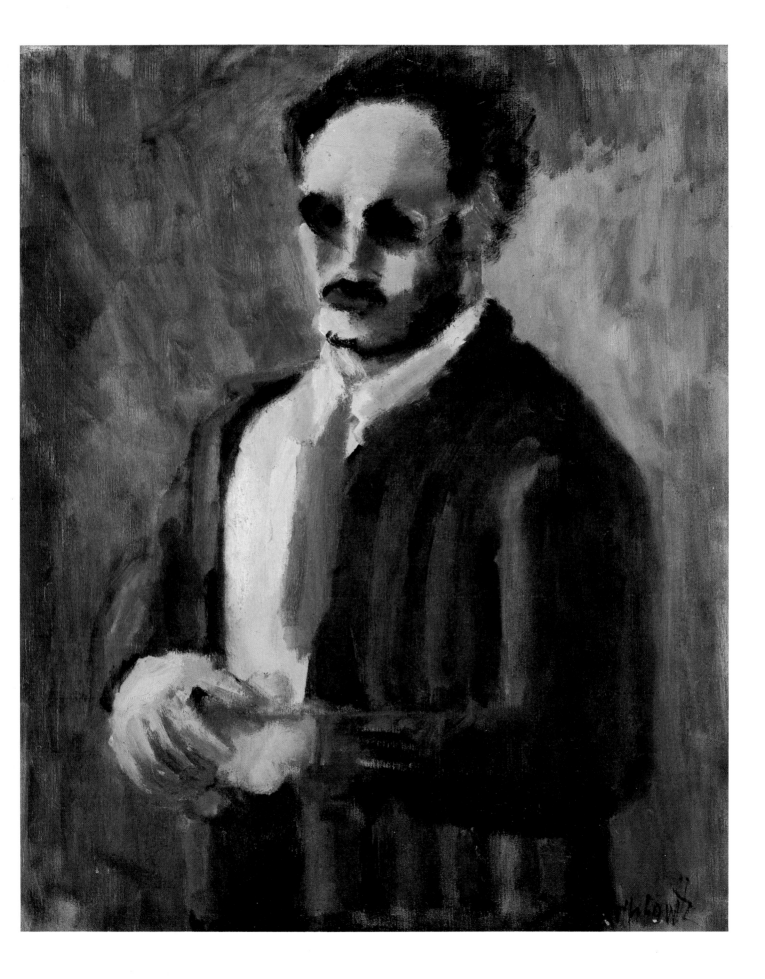

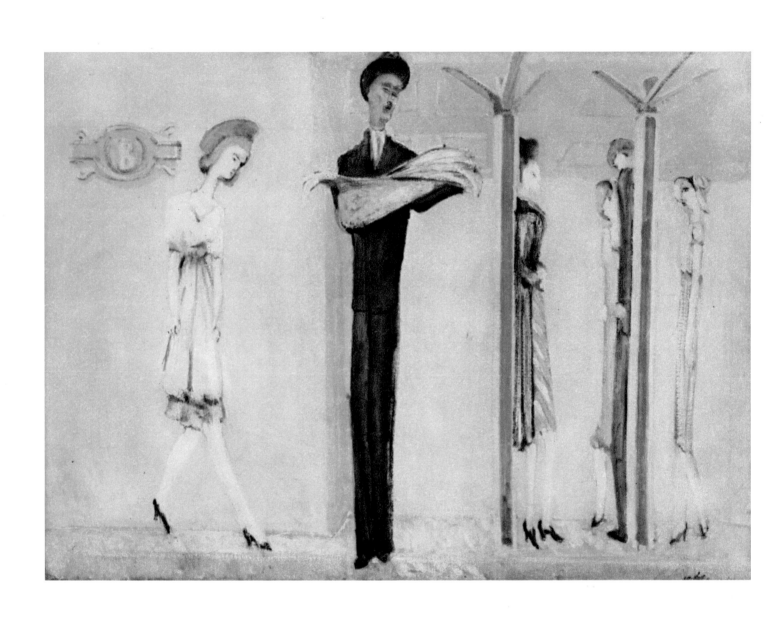

20. *Subway (Subterranean Fantasy)*. ca. 1936
 Oil on canvas, 33¾ x 46"
 Estate of Mark Rothko

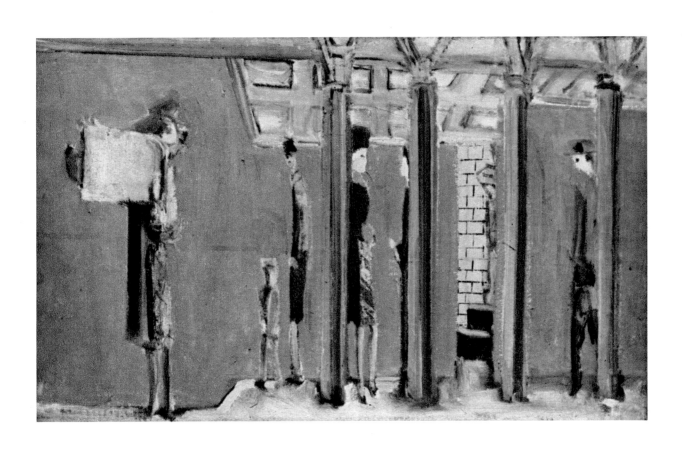

21. *Untitled.* 1936–38
 Oil on canvas, 20¼ x 30″
 Estate of Mark Rothko

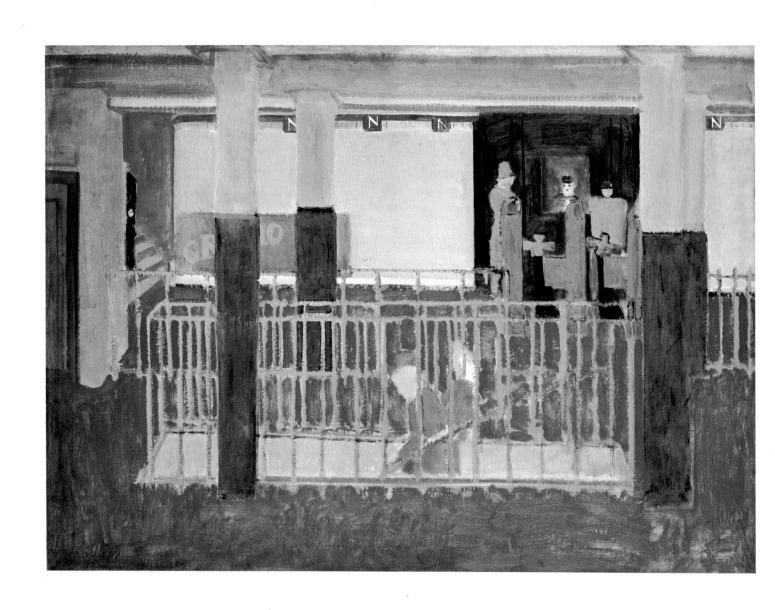

22. *Subway Scene.* 1938
Oil on canvas, 35 x 47¼"
Estate of Mark Rothko

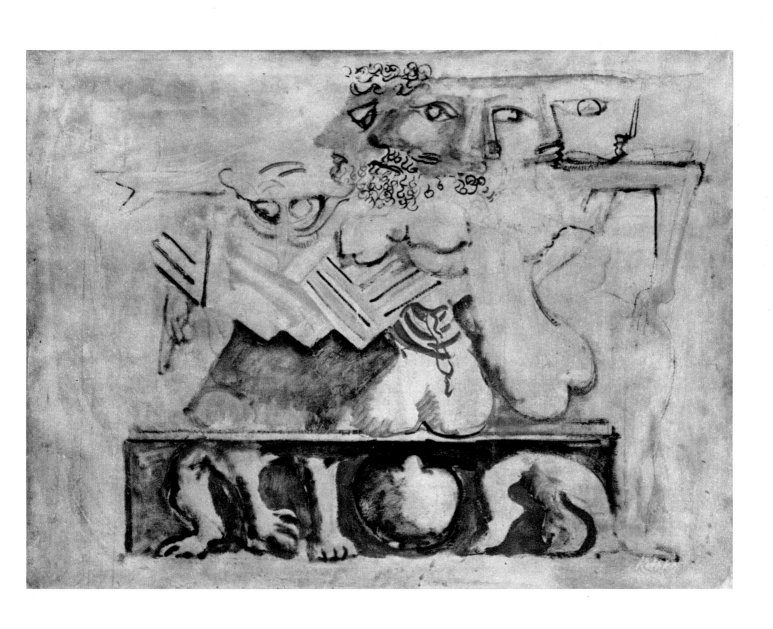

23. *Antigone.* 1938
 Oil on canvas, 34 x 46"
 Lent anonymously

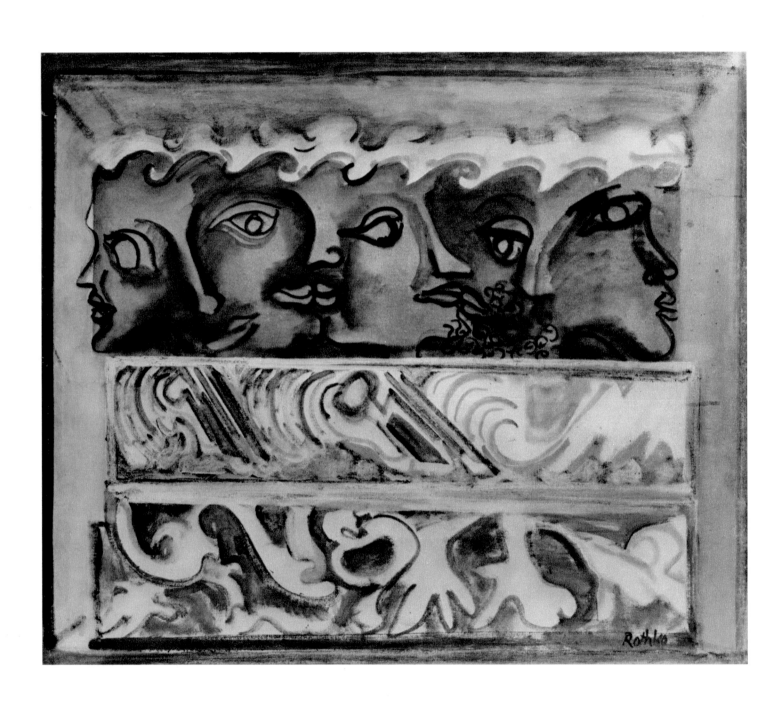

24. *Untitled.* 1939–40
Oil on canvas, 29¾ x 36"
Estate of Mark Rothko

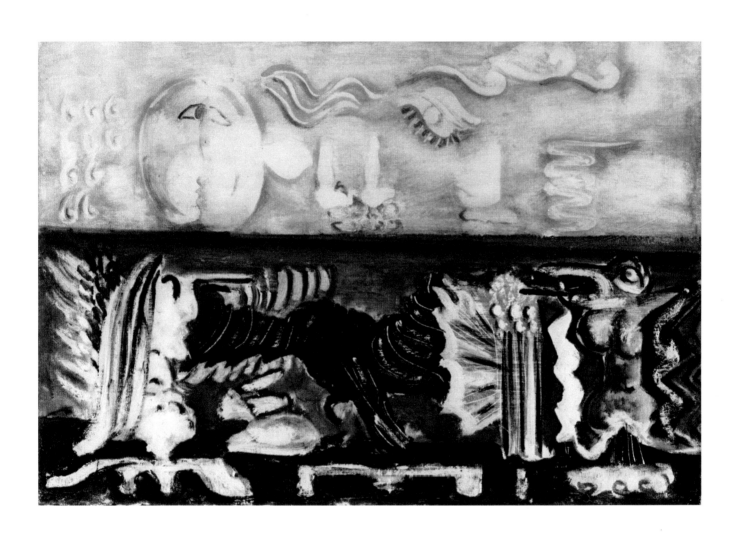

25. *Untitled.* 1940–41
 Oil on canvas, 17¾ x 25½″
 Estate of Mark Rothko

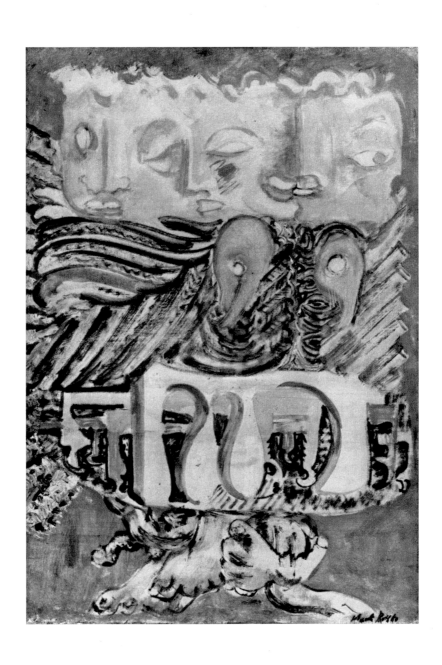

26. *The Omen of the Eagle.* 1942
 Oil on canvas, 25½ x 17¾"
 Estate of Mark Rothko

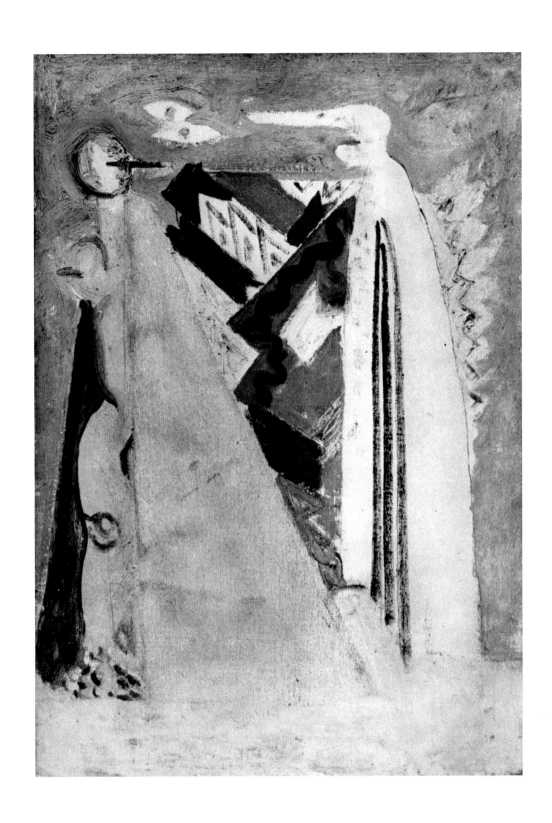

27. *The Omen*. 1942–43
 Oil on canvas, 19 x 13″
 Estate of Mark Rothko

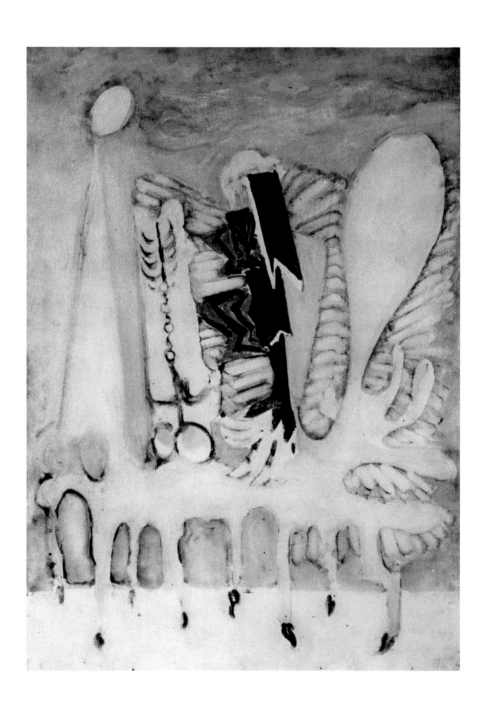

28. *The Syrian Bull.* 1943
 Oil on canvas, 39½ x 27½"
 Collection Mrs. Barnett Newman

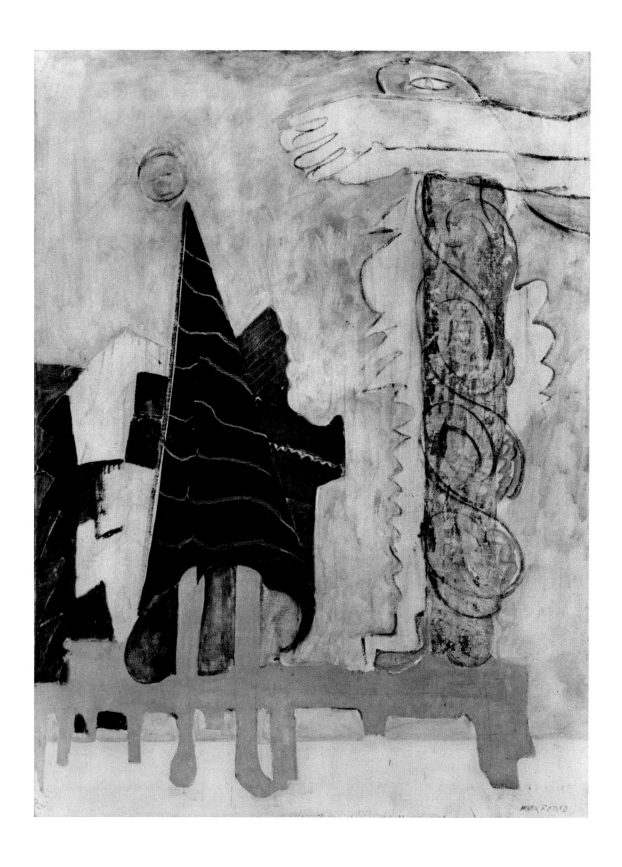

29. *Sacrifice of Iphigenia*. 1942
 Oil on canvas, 50 x 37″
 Lent anonymously

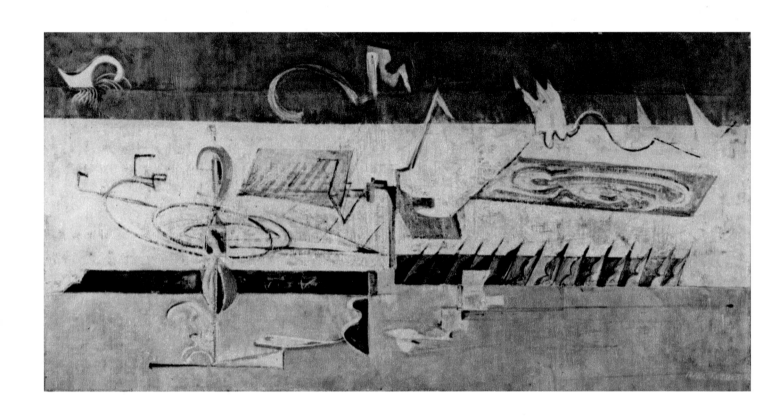

30. *Horizontal Procession*
 (Gyrations on Four Planes). 1944
 Oil on canvas, 23⅞ x 47⅞"
 Lent anonymously

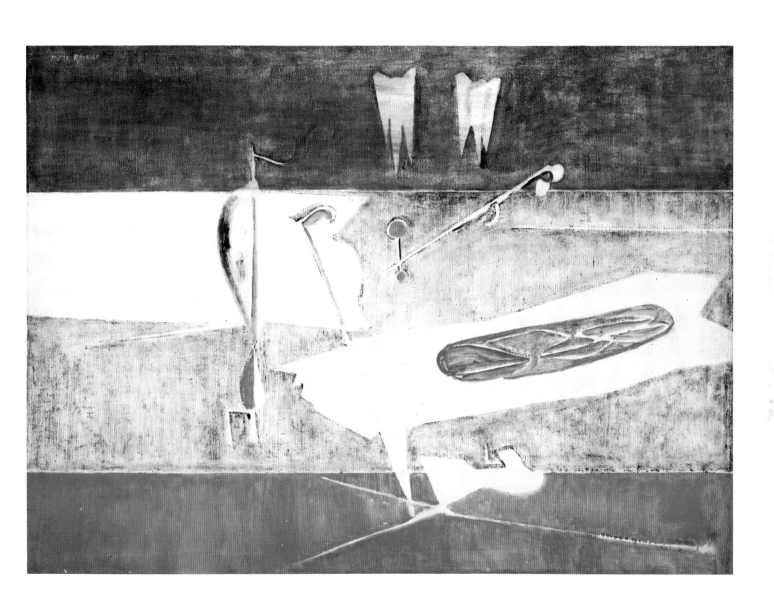

31. *Poised Elements*. 1944
Oil on canvas, 37 x 49″
Courtesy The Pace Gallery

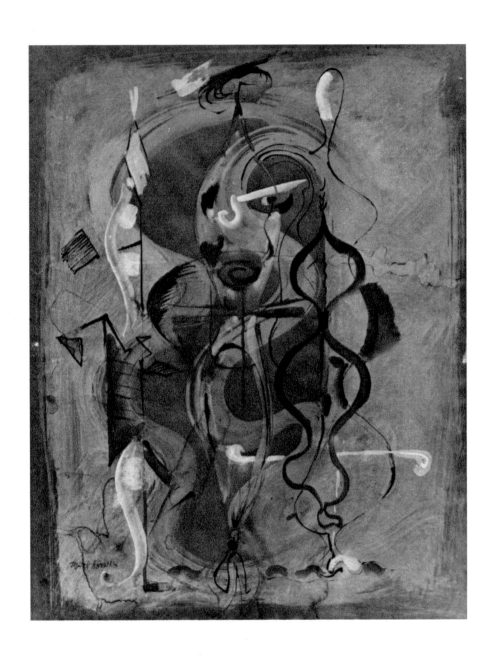

32. *Untitled.* 1944
 Watercolor on paper, 26 x 19¾"
 Lent anonymously

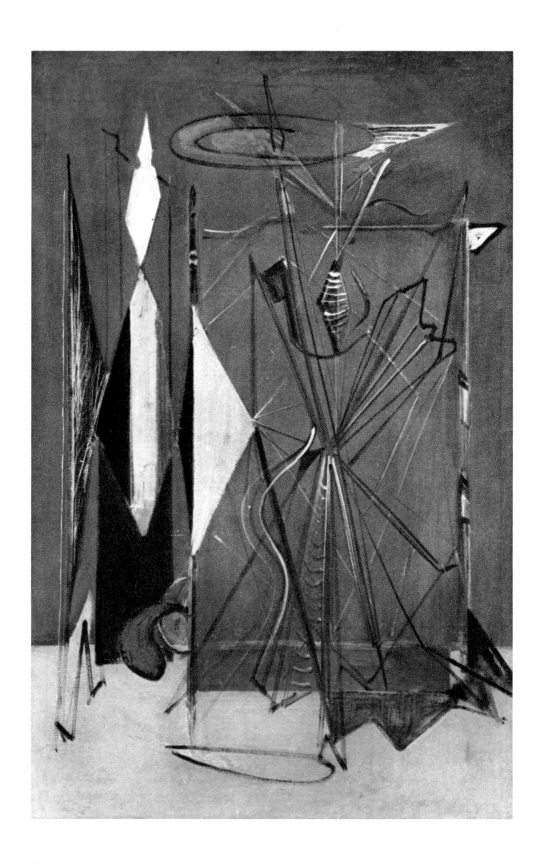

33. *Phalanx of the Mind.* 1944
 Oil on canvas, 54 x 35¾"
 Estate of Mark Rothko

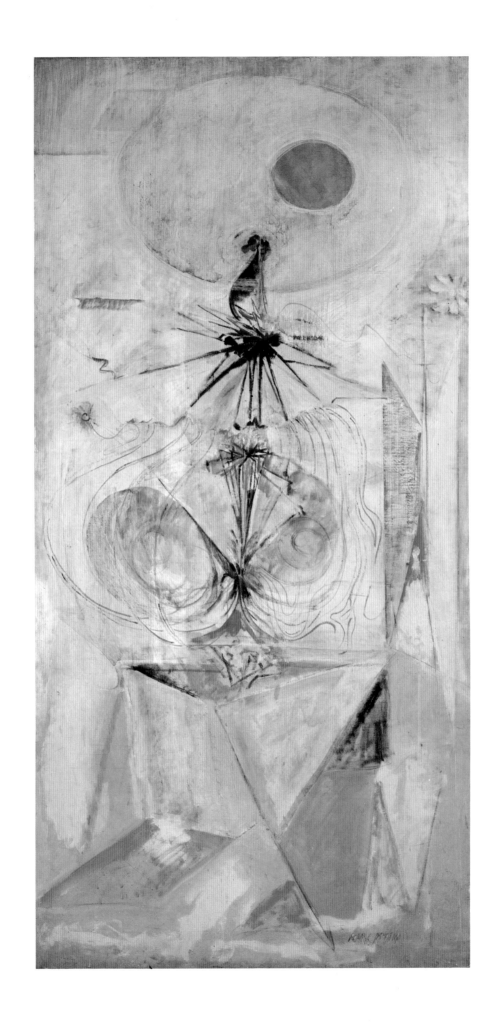

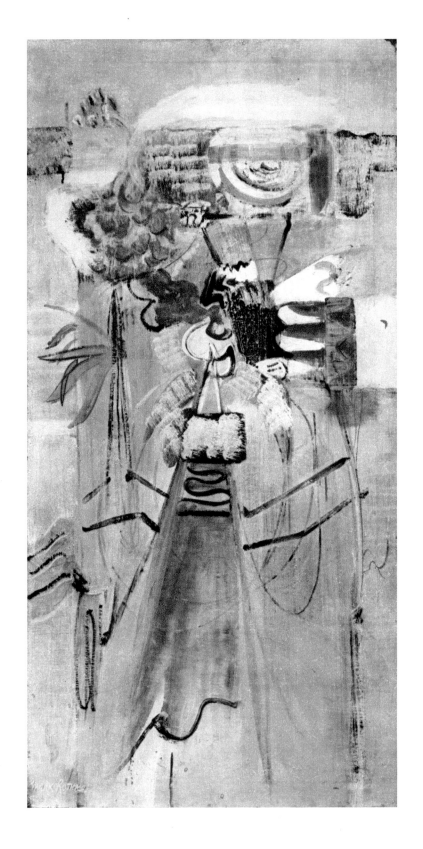

34. *Tiresias.* 1944
 Oil on canvas, 79¾ x 40″
 Estate of Mary Alice Rothko

35. *Archaic Phantasy.* 1945
 Oil on canvas, 48 x 24″
 Courtesy The Pace Gallery

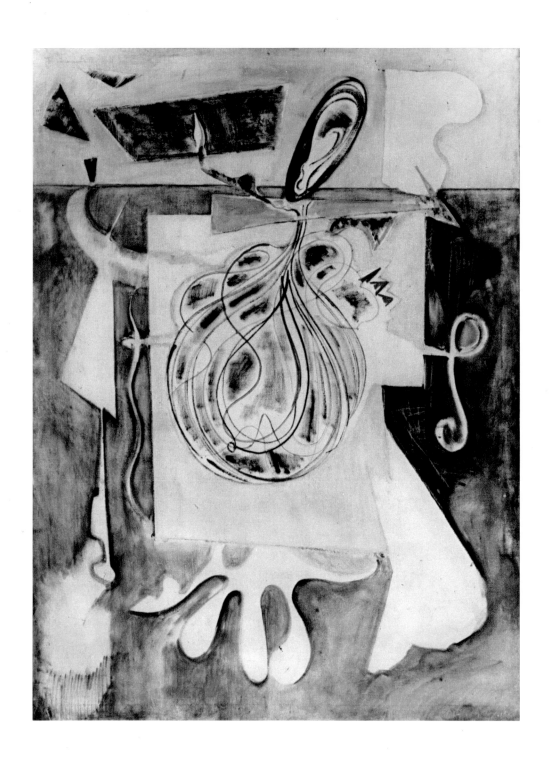

36. *Ritual.* 1944
 Oil on canvas, 53½ x 39½"
 Courtesy The Pace Gallery

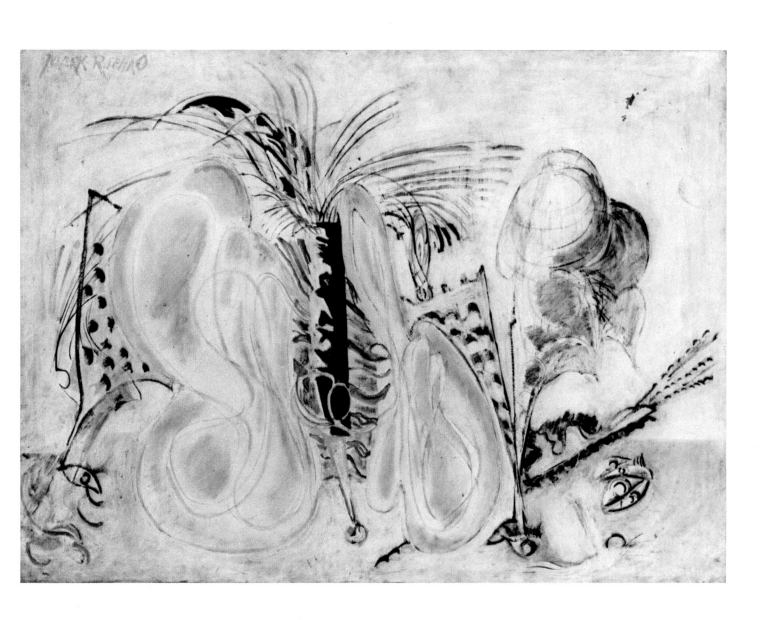

37. *Birth of Cephalopods.* 1944
Oil on canvas, 39¼ x 53½"
Estate of Mark Rothko

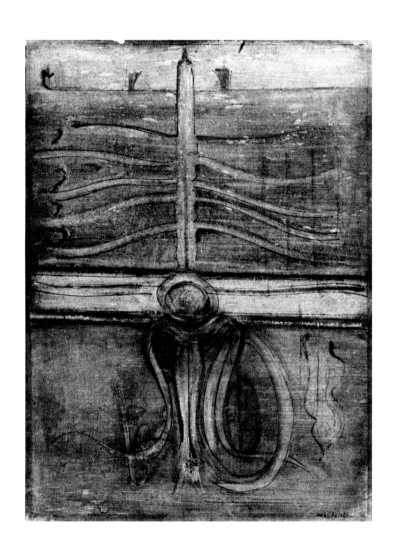

38. *Totem Sign.* 1945–46
 Watercolor on paper, 29½ x 21¼"
 Courtesy The Pace Gallery

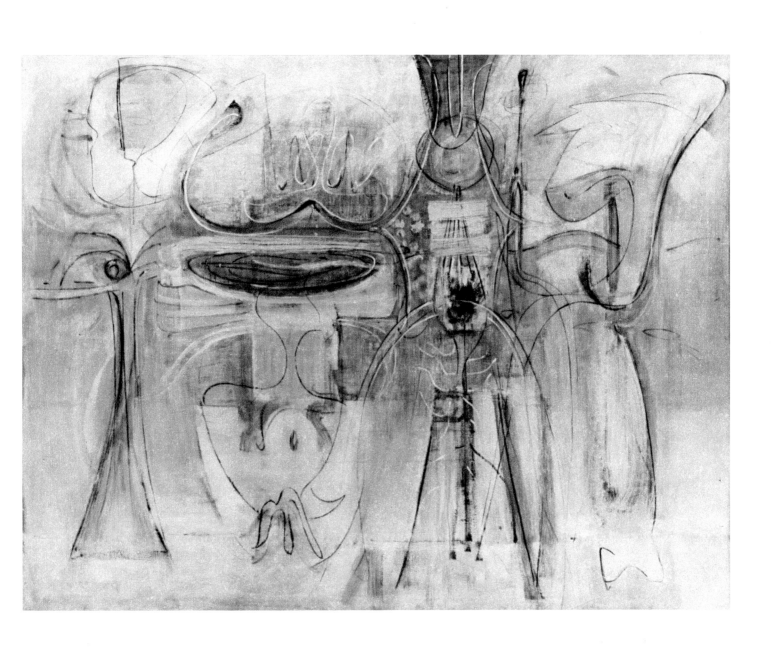

39. *Rites of Lilith.* 1945
 Oil on canvas, 81⅛ x 100⅝"
 Estate of Mark Rothko

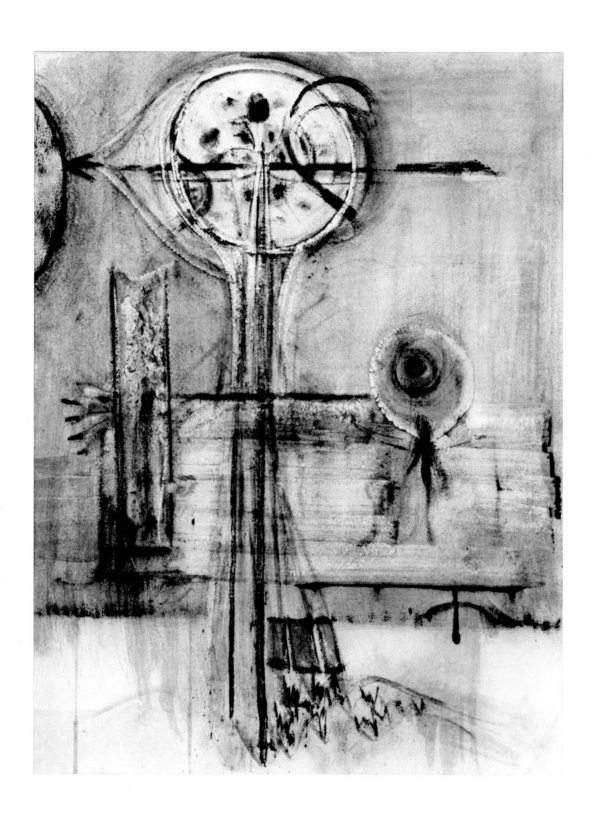

40. *Untitled.* 1945–46
 Watercolor on paper, 27½ x 20⅜″
 Courtesy The Pace Gallery

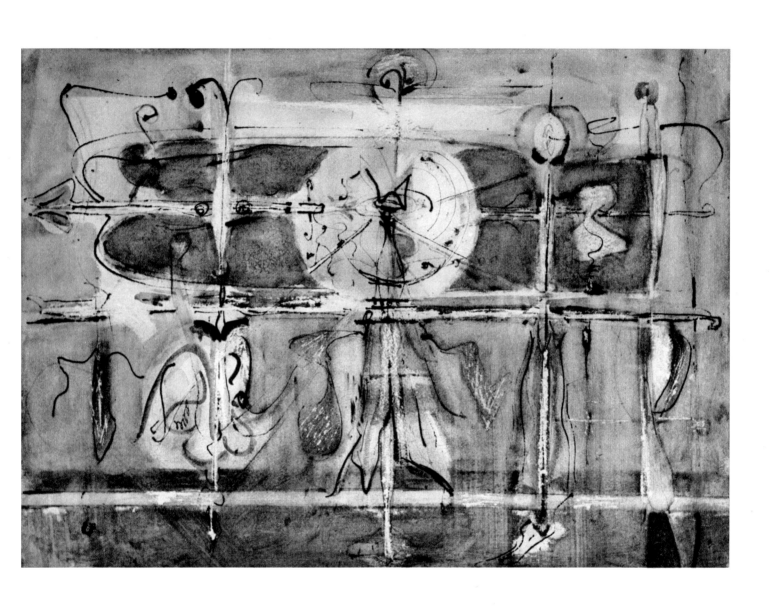

41. *Untitled.* 1944–45
 Watercolor on paper, 22⅜ x 30⅝″
 Estate of Mark Rothko

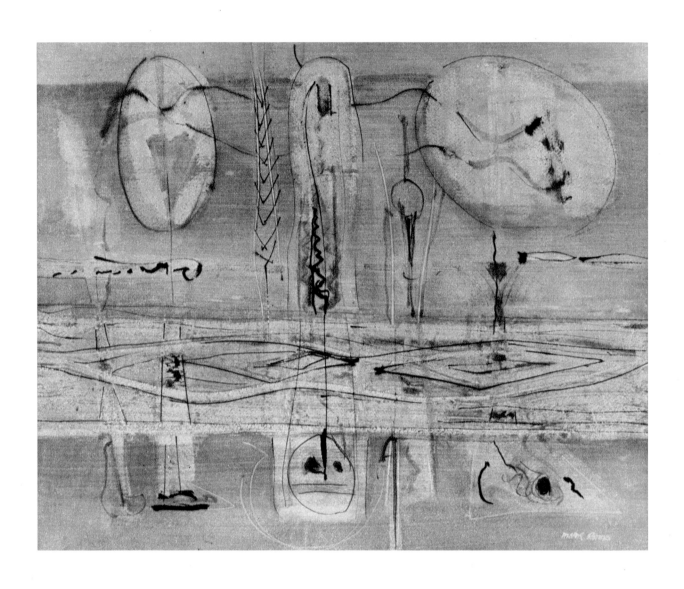

42. *Entombment I.* 1946
 Gouache on paper, 20⅜ x 25¾"
 Collection Whitney Museum of American Art, New York

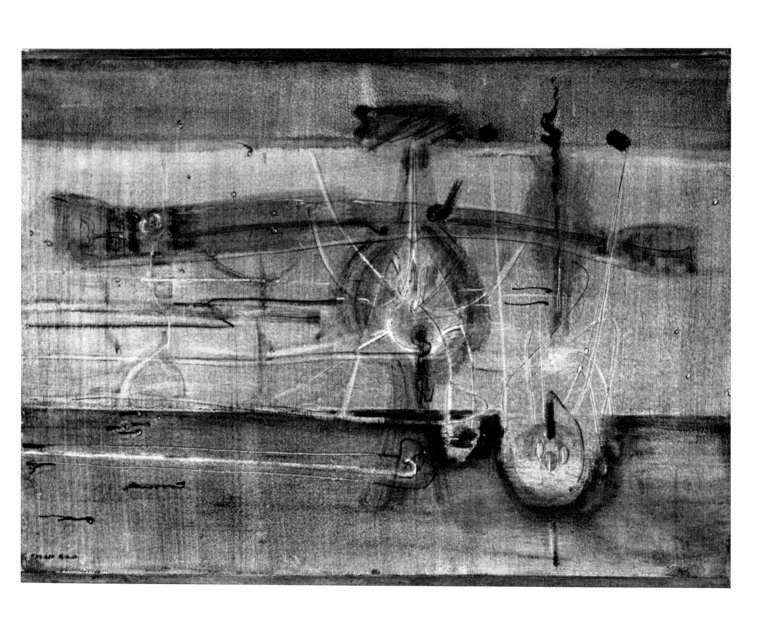

43. *Entombment II*. 1946
 Watercolor on paper, 30 x 38″
 Private Collection

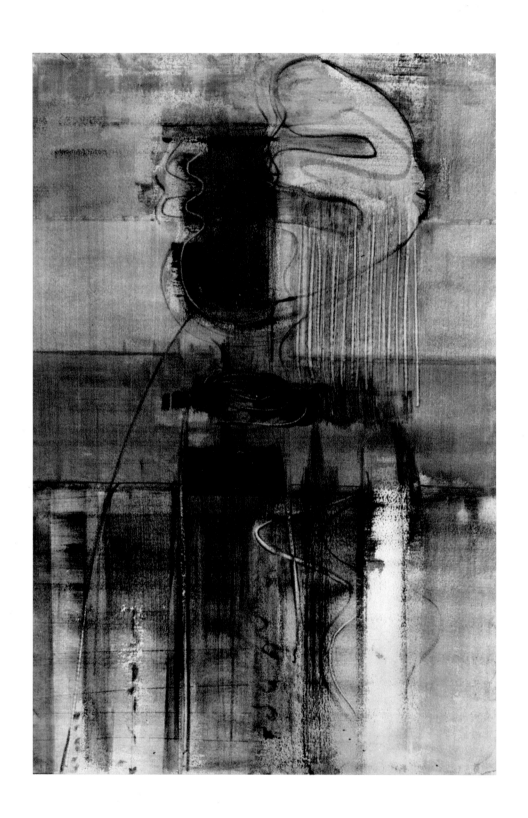

44. *Untitled.* 1945–46
 Watercolor on paper, 40¾ x 27¼″
 Lent anonymously

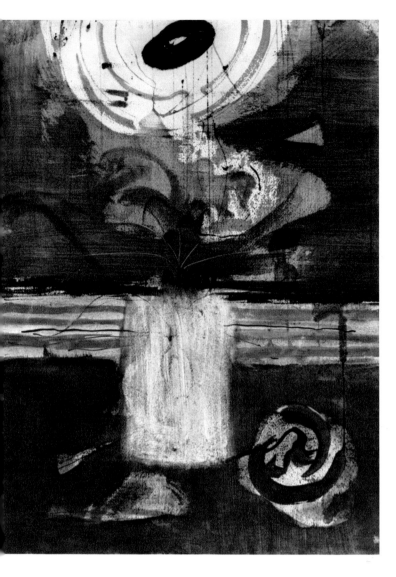

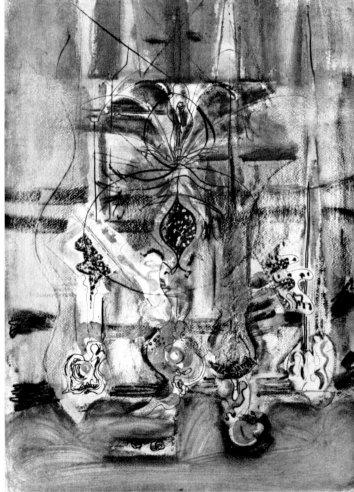

5. *Untitled.* 1945–46
 Watercolor on paper, 29⅛ x 21¾"
 Lent anonymously

6. *Untitled.* 1944–45
 Watercolor on paper, 29¾ x 21⅝"
 Estate of Mark Rothko

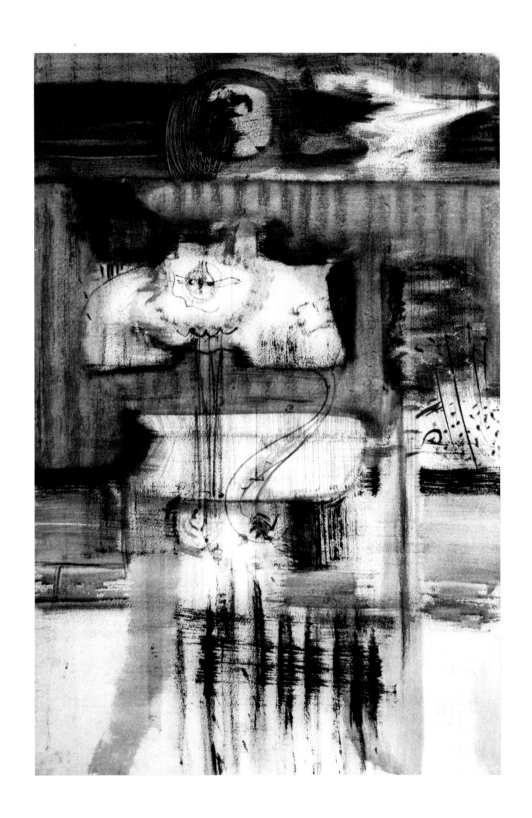

47. *Untitled.* 1945–46
 Watercolor on paper, 40½ x 27"
 Estate of Mark Rothko

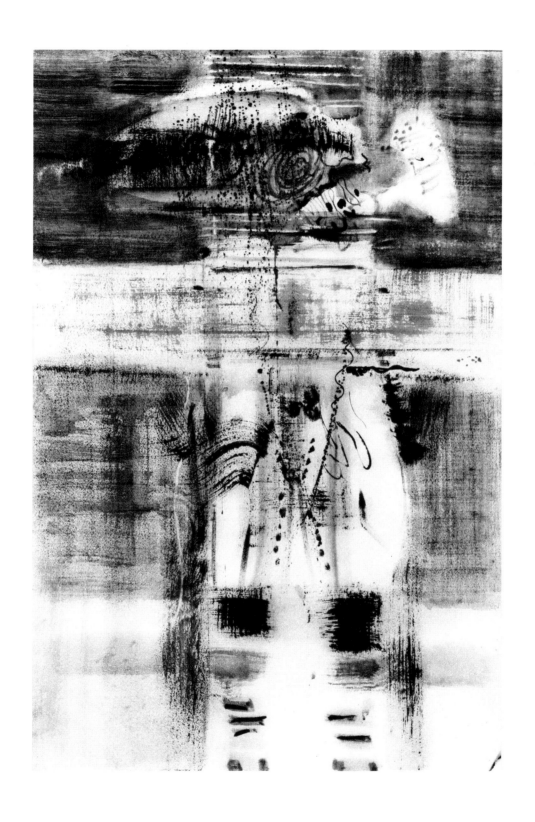

48. *Untitled.* 1945–46
 Watercolor on paper, 40½ x 27⅛"
 Estate of Mark Rothko

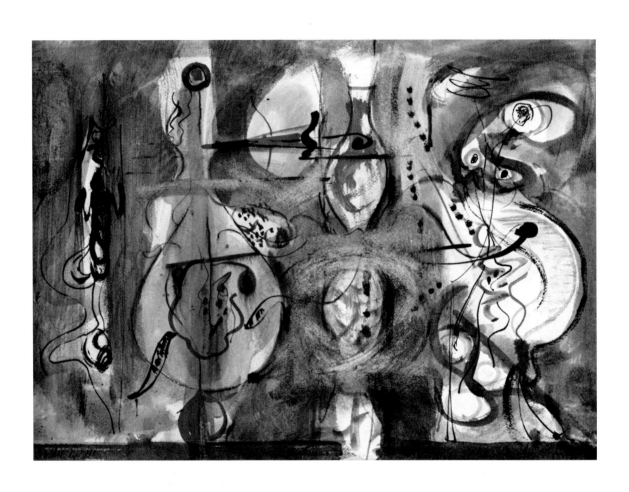

49. *Untitled.* 1944–45
Watercolor on paper, 20⅝ x 28¼″
Estate of Mark Rothko

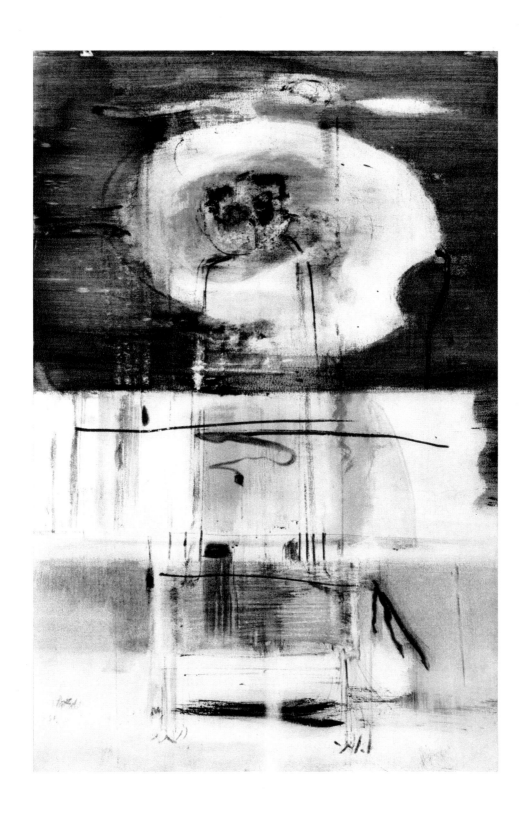

50. *Untitled.* 1945–46
 Watercolor on paper, 39⅝ x 26⅜"
 Estate of Mark Rothko

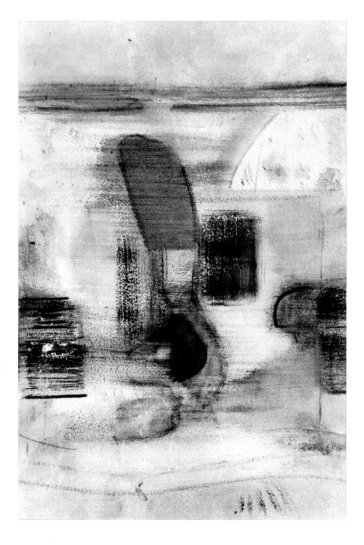

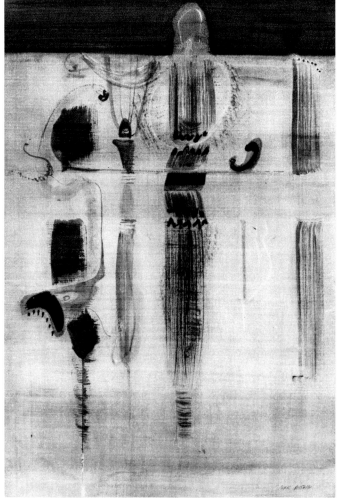

51. *Untitled.* 1945–46
 Watercolor on paper, 22 x 15¼"
 Estate of Mark Rothko

52. *Vessels of Magic.* 1946
 Watercolor on paper, 38¾ x 25¾"
 Collection The Brooklyn Museum

53. *Untitled.* 1946
 Oil on canvas, 38½ x 54¼"
 Courtesy The Pace Gallery

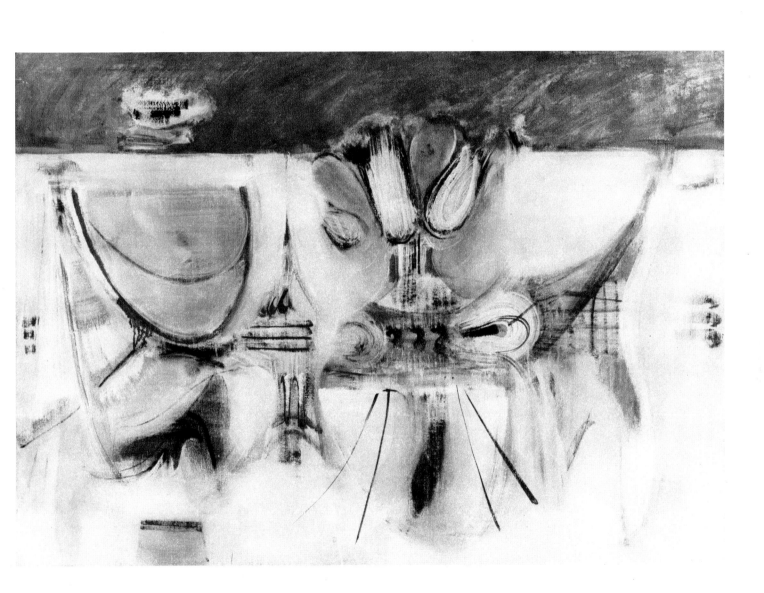

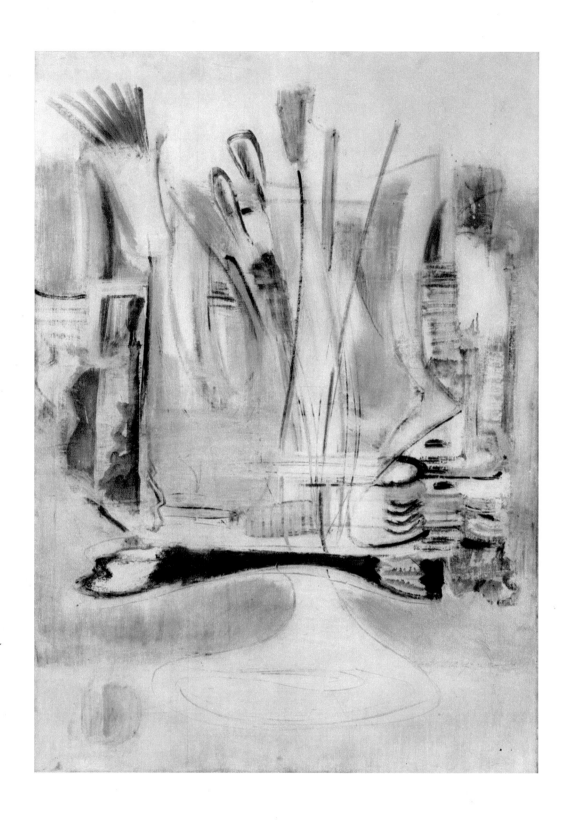

54. *Figure in Archaic Sea.* 1946
 Oil on canvas, 54¼ x 38⅝"
 Estate of Mark Rothko

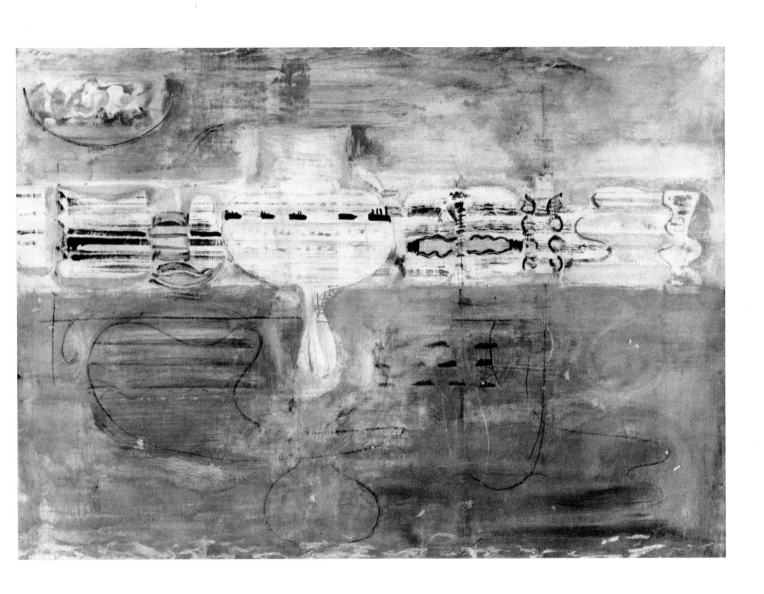

55. *Horizontal Vision*. 1946
Oil on canvas, 38⅞ x 54½"
Lent anonymously

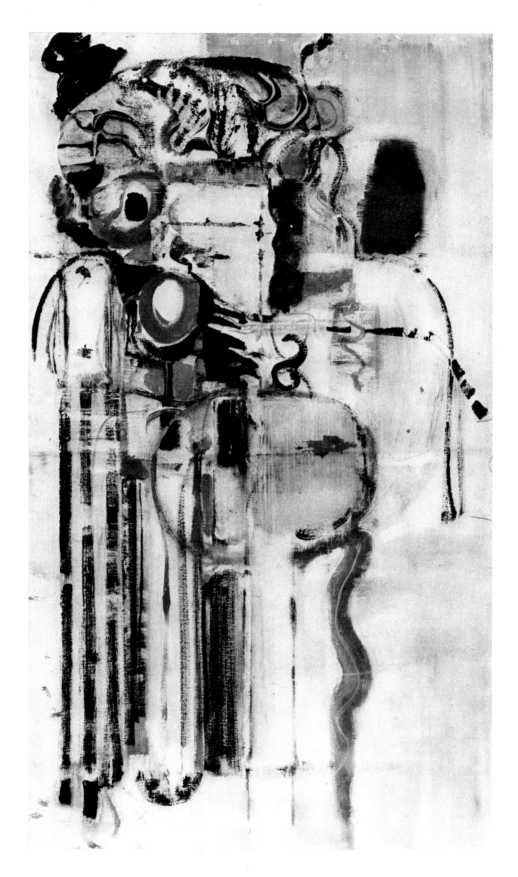

56. *Personage Two*. 1946
 Oil on canvas, 55¾ x 32″
 Estate of Mark Rothko

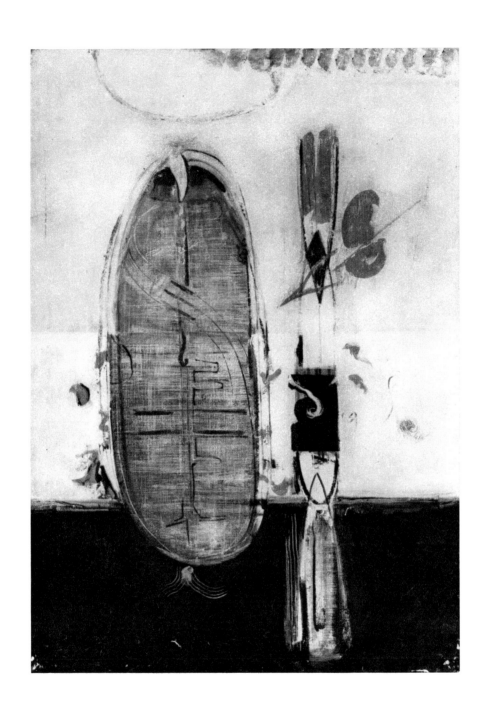

57. *The Source.* 1945—46
 Oil on canvas, 39¼ x 27¾"
 Estate of Mark Rothko

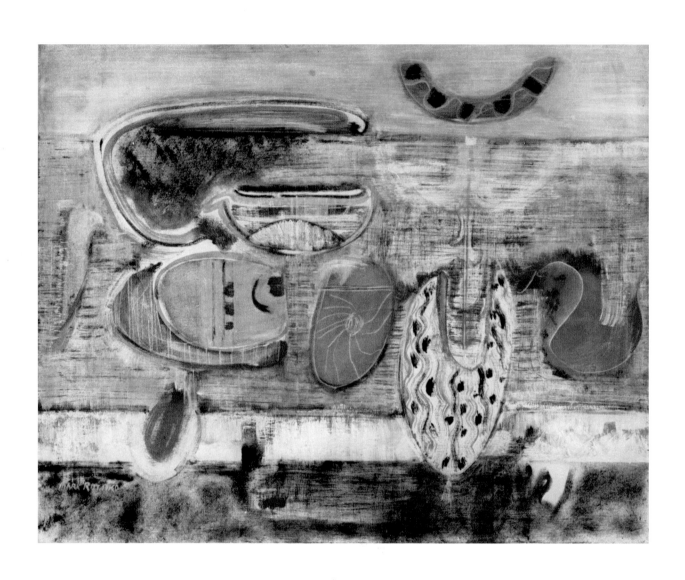

58. *Untitled.* 1945–46
 Oil on canvas, 31½ x 39¼"
 Courtesy The Pace Gallery

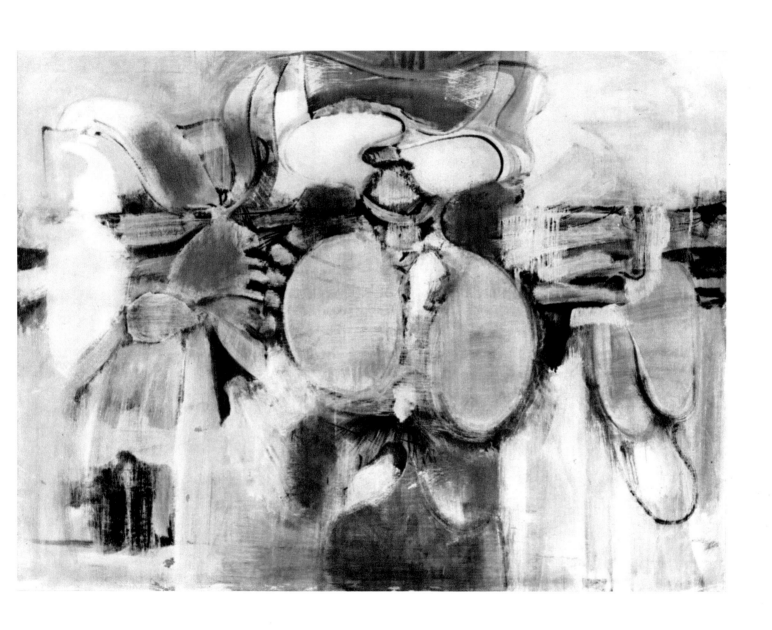

59. *Aquatic Drama.* 1946
 Oil on canvas, 36 x 48″
 Courtesy The Pace Gallery

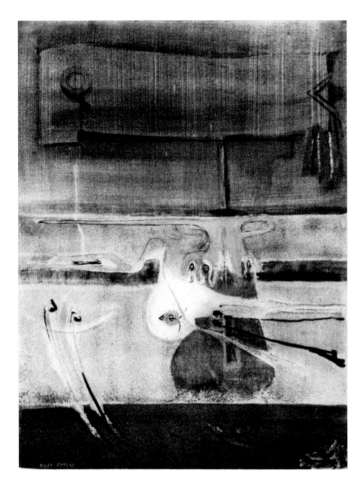

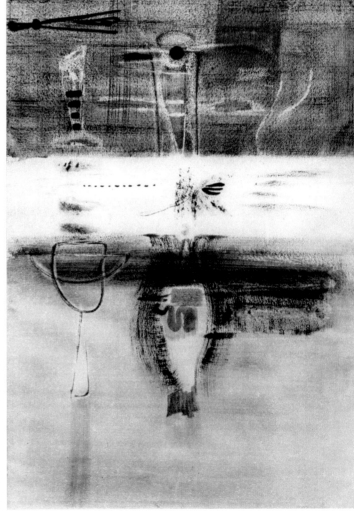

60. *Prehistoric Memory.* 1946
Pastel on paper, 25¾ x 19⅜"
Collection Steingrim Laursen, Copenhagen

61. *Untitled.* 1946
Watercolor on paper, 38¾ x 25½"
Collection Mr. and Mrs. Donald Blinken

62. *Untitled.* 1945
Oil on canvas, 22 x 30"
Courtesy The Pace Gallery

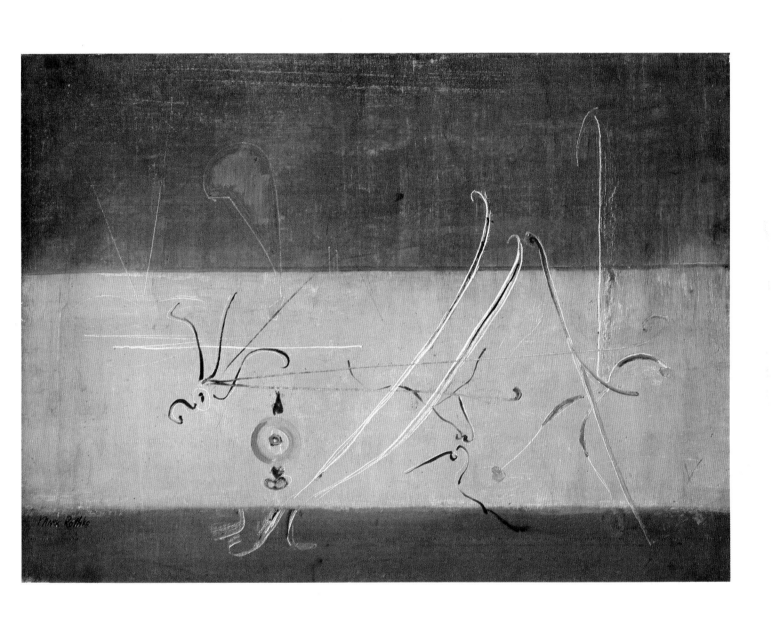

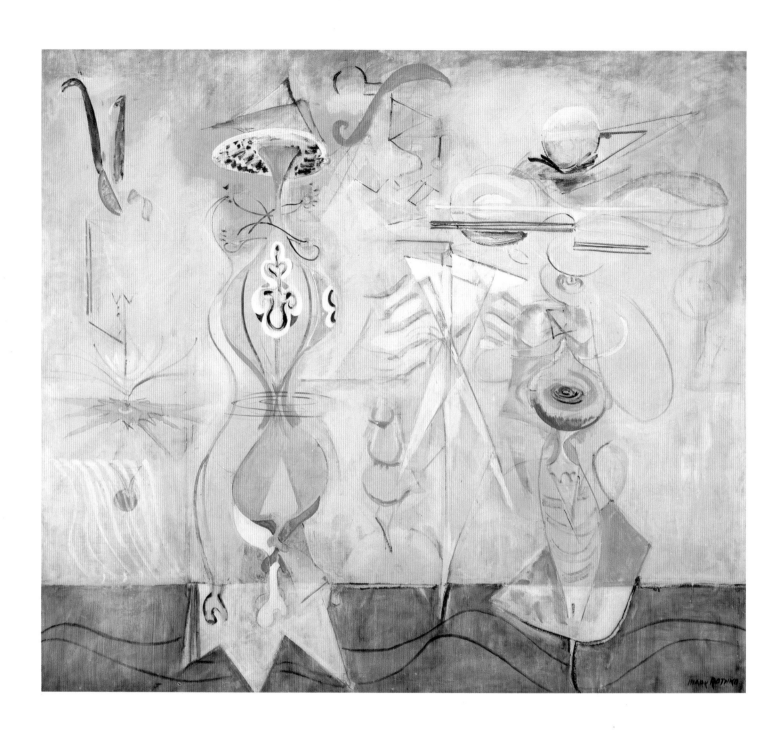

63. *Slow Swirl at the Edge of the Sea*. 1944
 Oil on canvas, 75 x 84¾"
 Estate of Mary Alice Rothko

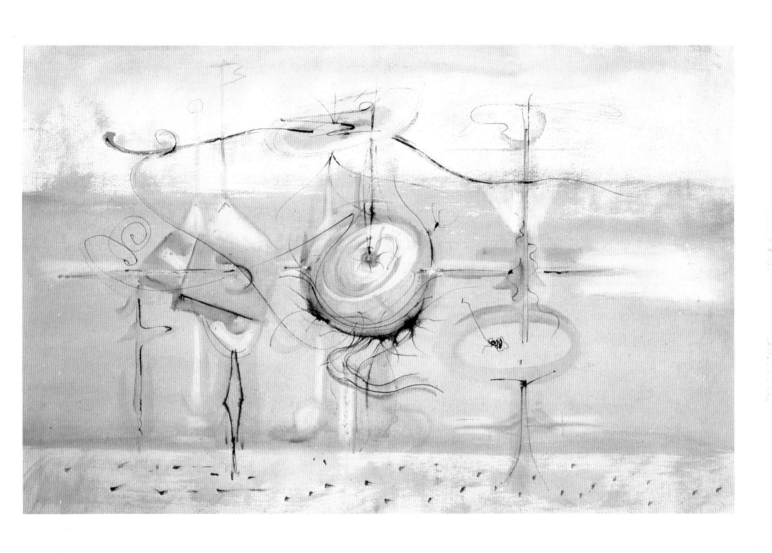

64. *Untitled*. 1945
 Watercolor on paper, 27 x 40½"
 Estate of Mark Rothko

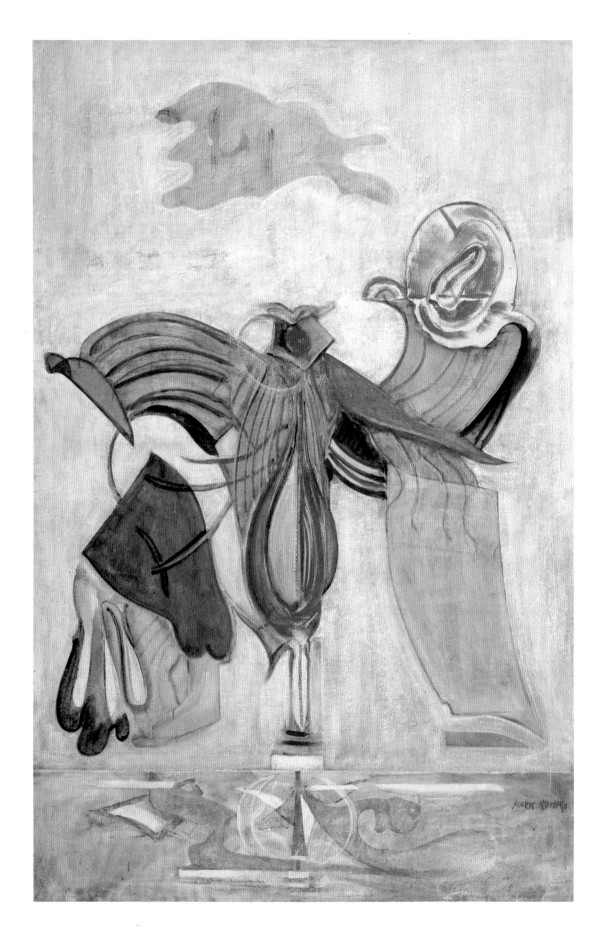

65. *Gethsemane.* 1945
Oil on canvas, 54⅜ x 35⅜"
Lent anonymously

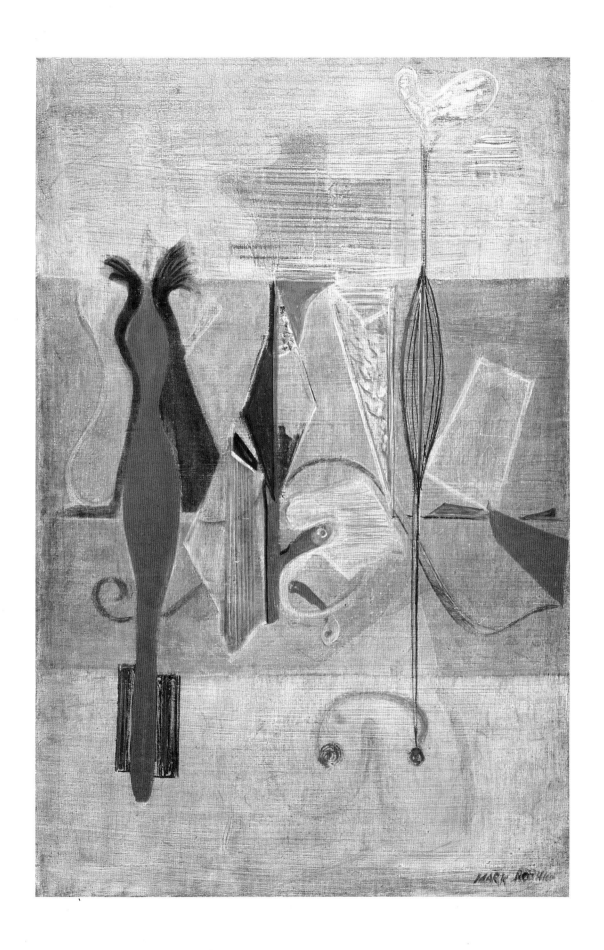

66. *Primeval Landscape.* 1945
 Oil on canvas, 54⅜ x 35″
 Estate of Mark Rothko

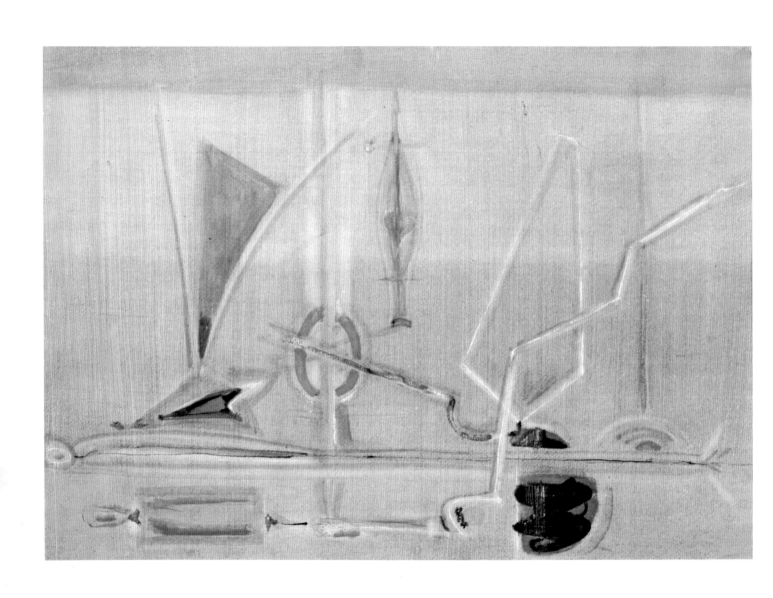

67. *Untitled*. 1945
 Watercolor on paper, 21¾ x 30″
 Courtesy The Pace Gallery

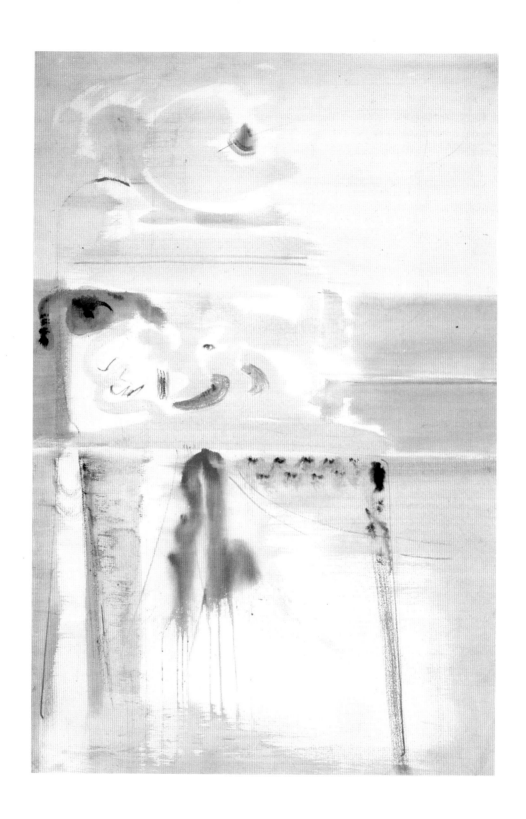

68. *Untitled.* 1945
 Watercolor on paper, 40½ x 27½"
 Estate of Mark Rothko

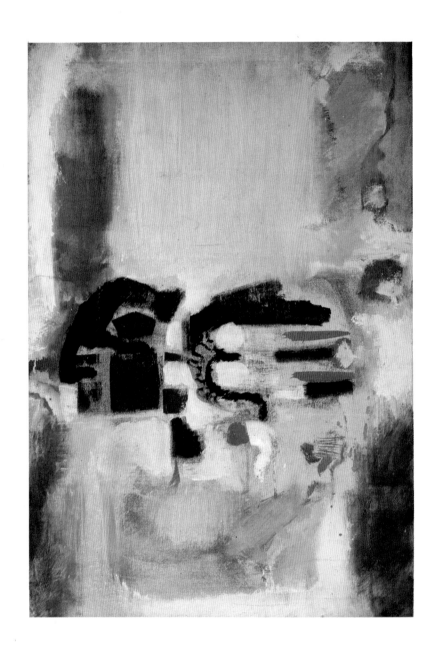

69. *Composition*. 1946
 Oil on canvas, 27⅜ x 18⅝″
 Private Collection

70. *Multiform*. 1948
 Oil on canvas, 89 x 65″
 Estate of Mark Rothko

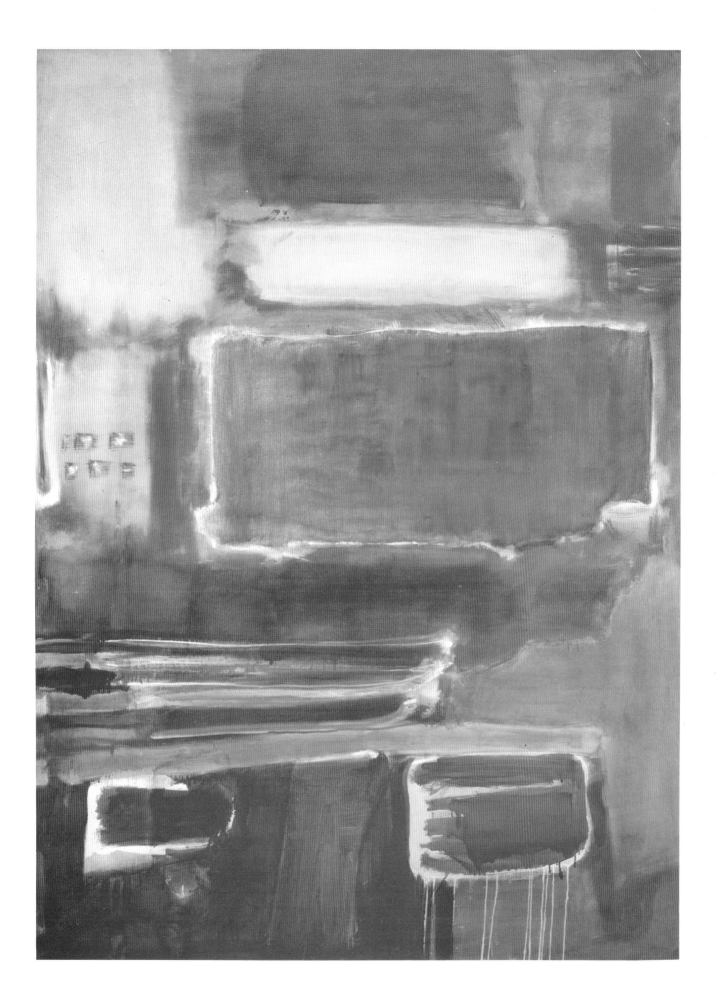

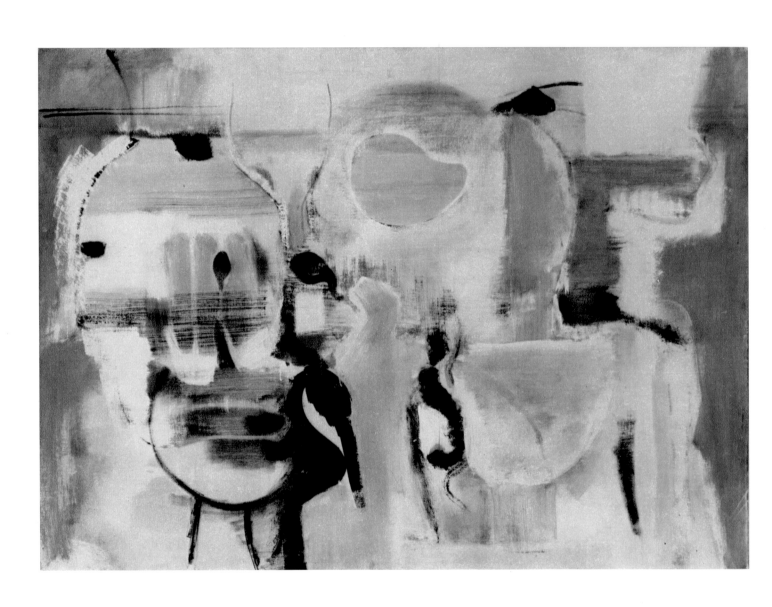

71. *Untitled.* 1946
 Oil on canvas, 39½ x 54½"
 Estate of Mark Rothko

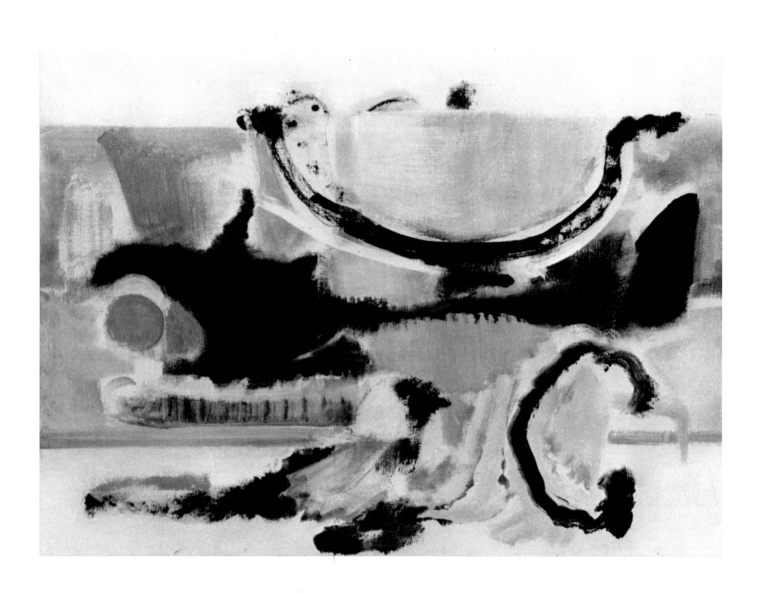

72. *Untitled.* 1946
 Oil on canvas, 27¾ x 38″
 Estate of Mark Rothko

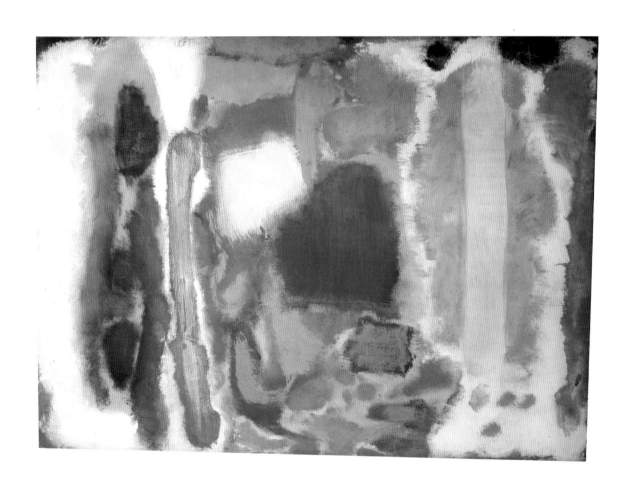

73. *Number 26.* 1947
 Oil on canvas, 33¾ x 45¼"
 Collection Betty Parsons, New York

74. *Untitled.* 1947
 Oil on canvas, 61 x 46½"
 Courtesy The Pace Gallery

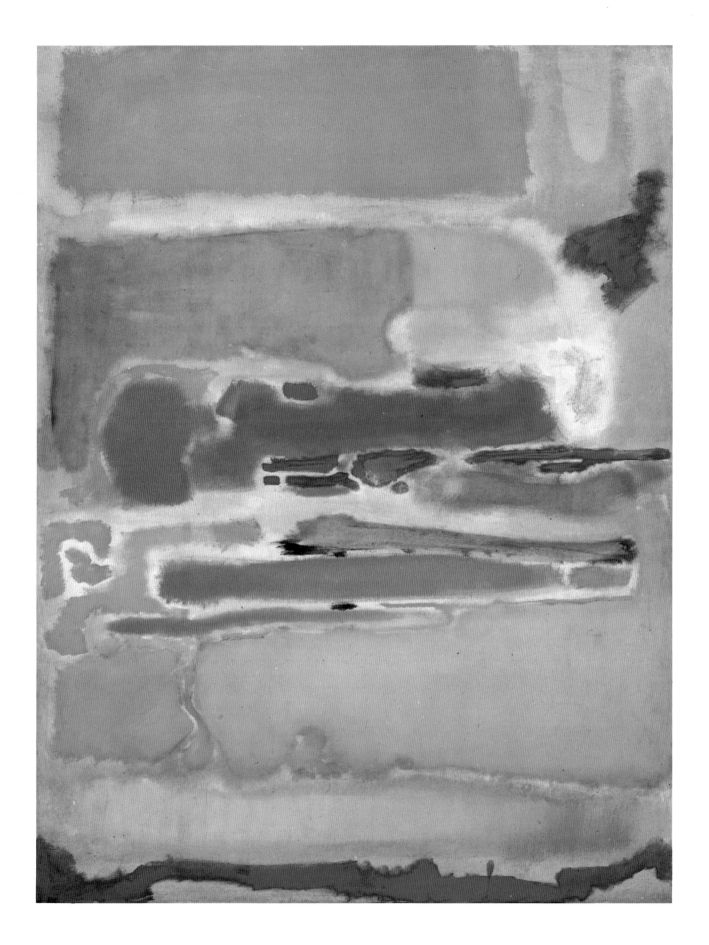

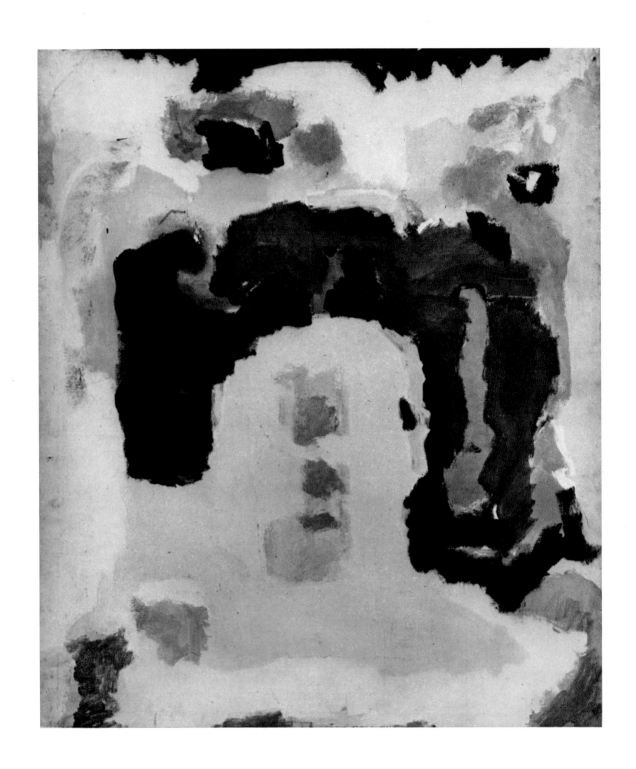

75. *Untitled*. n.d.
 Oil on canvas, 48 x 40"
 Lent anonymously

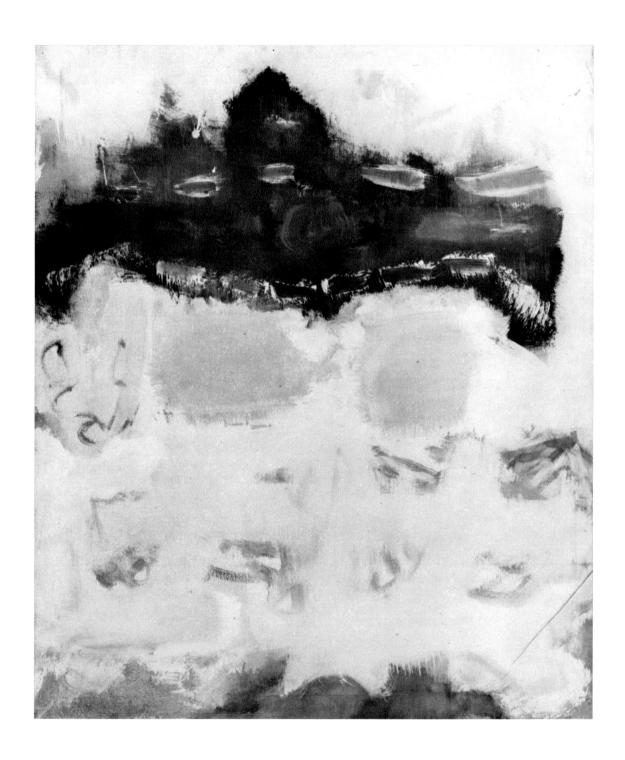

76. *Untitled.* 1947
 Oil on canvas, 39¾ x 33″
 Estate of Mark Rothko

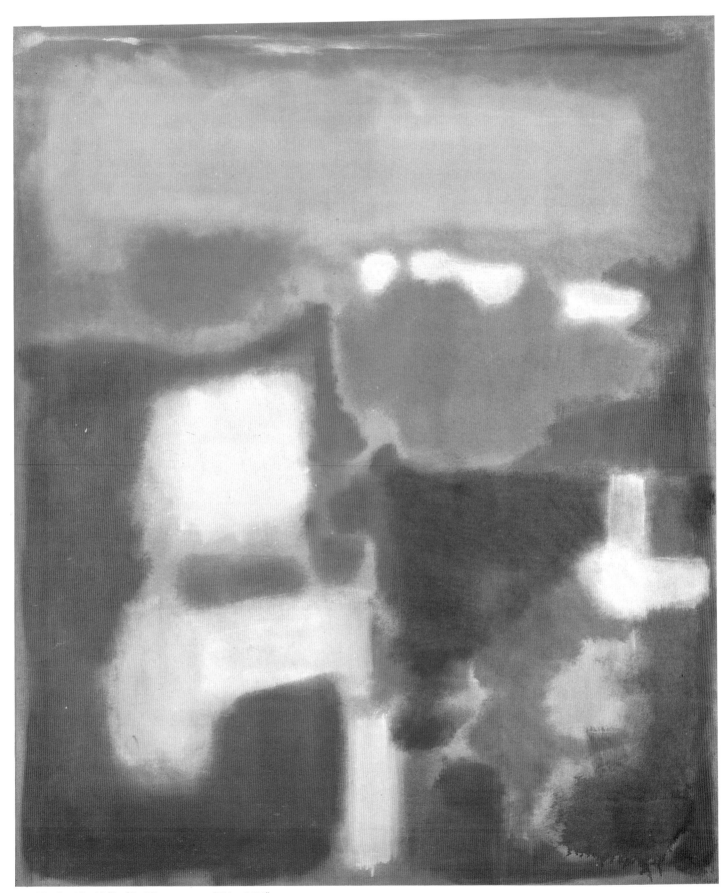

77. *Number 18*. 1948–49. Oil on canvas, 67¼ x 55⅞"
Collection Vassar College Art Gallery, Poughkeepsie, New York, Gift of Mrs. John D. Rockefeller, III

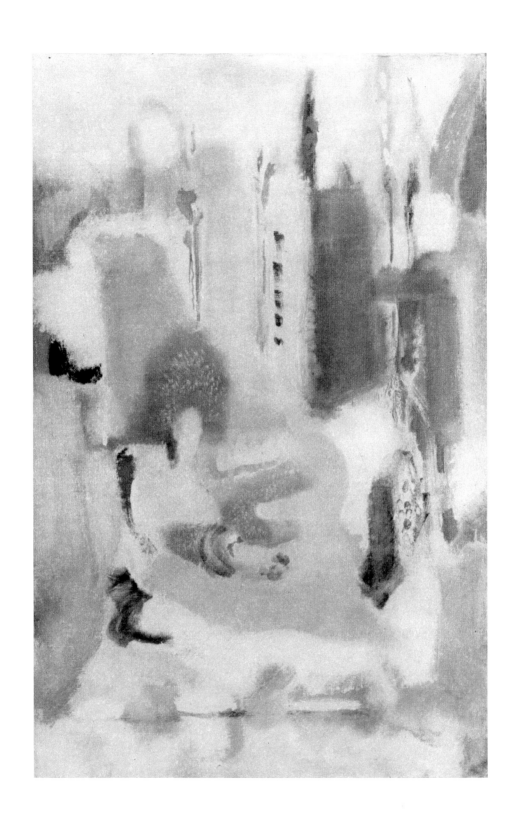

78. *Untitled.* 1947
 Oil on canvas, 54½ x 35¼"
 Estate of Mark Rothko

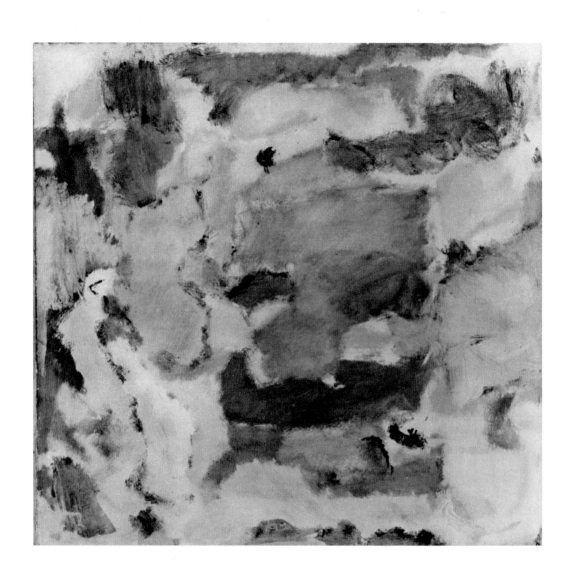

79. *Untitled.* 1947
 Oil on canvas, 38⅝ x 39¼″
 Estate of Mark Rothko

80. *Untitled.* 1947
 Oil on canvas, 61 x 43″
 Estate of Mark Rothko

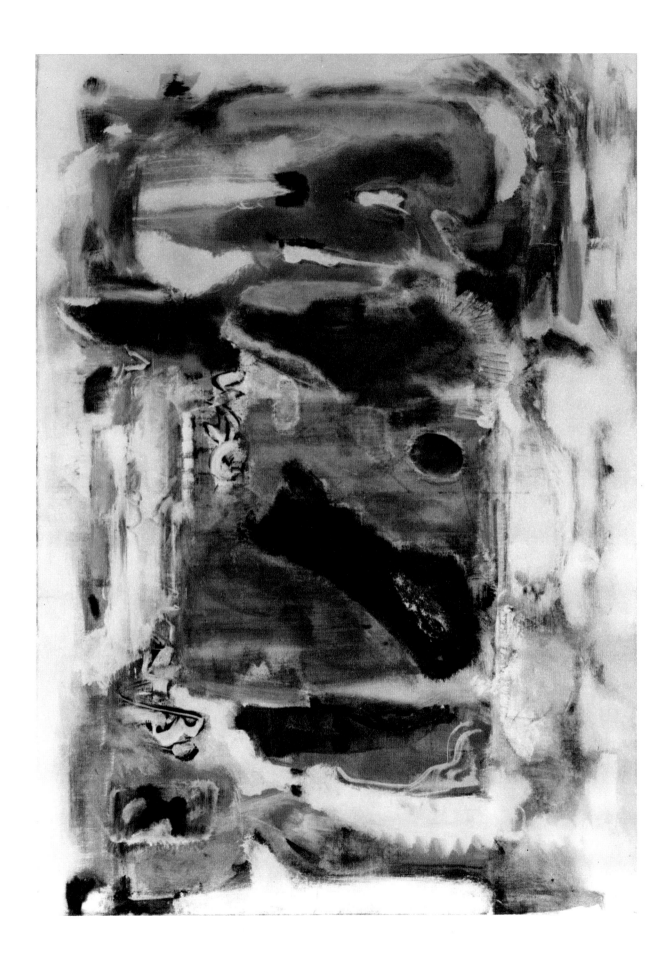

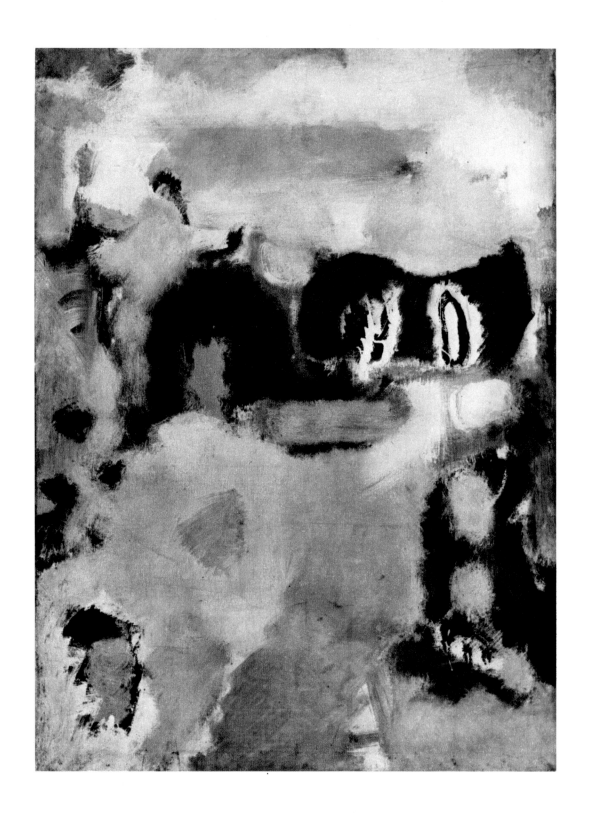

81. *Untitled.* 1947
 Oil on canvas, 38½ x 27½"
 Estate of Mark Rothko

82. *Untitled.* 1947
 Oil on canvas, 47⅝ x 35"
 Courtesy The Pace Gallery

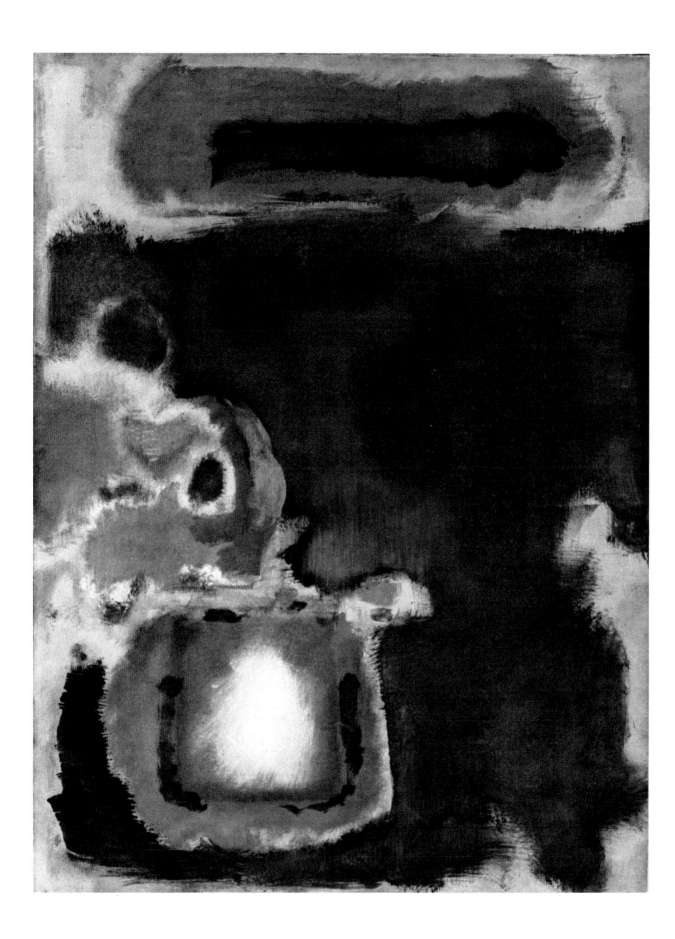

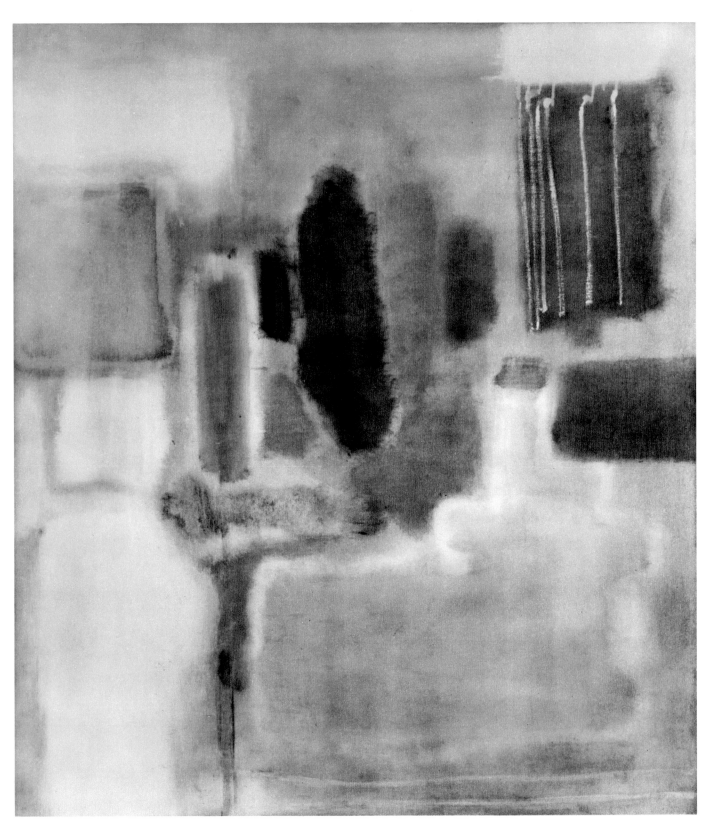

83. *Multiform.* 1948
 Oil on canvas, 53⅛ x 46⅝"
 Courtesy The Pace Gallery

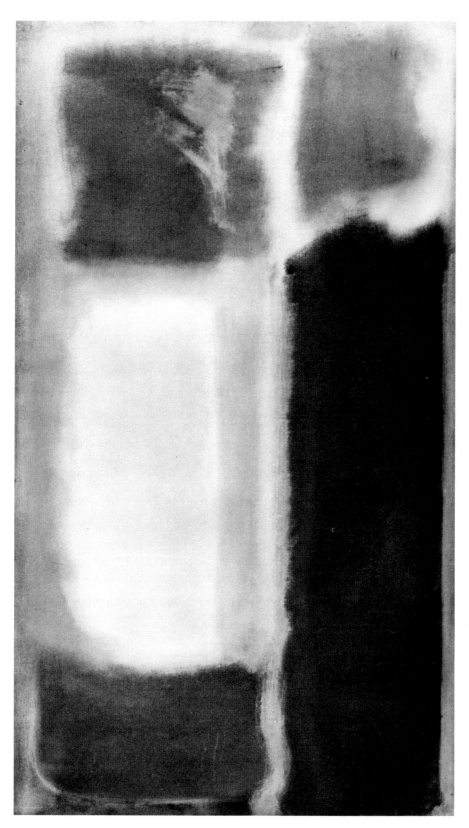

84. *Number 15.* 1948
 Oil on canvas, 52 x 29"
 Lent anonymously

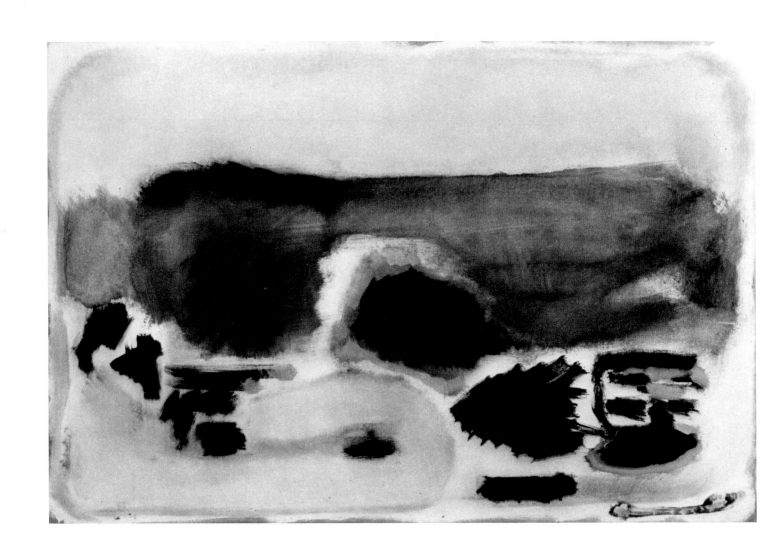

85. *Number 24*. 1948
 Oil on canvas, 34 x 50¼"
 Collection The Museum of Modern Art, New York.
 Gift of the artist

86. *Multiform*. 1949
 Oil on canvas, 80 x 39¼"
 Lent anonymously

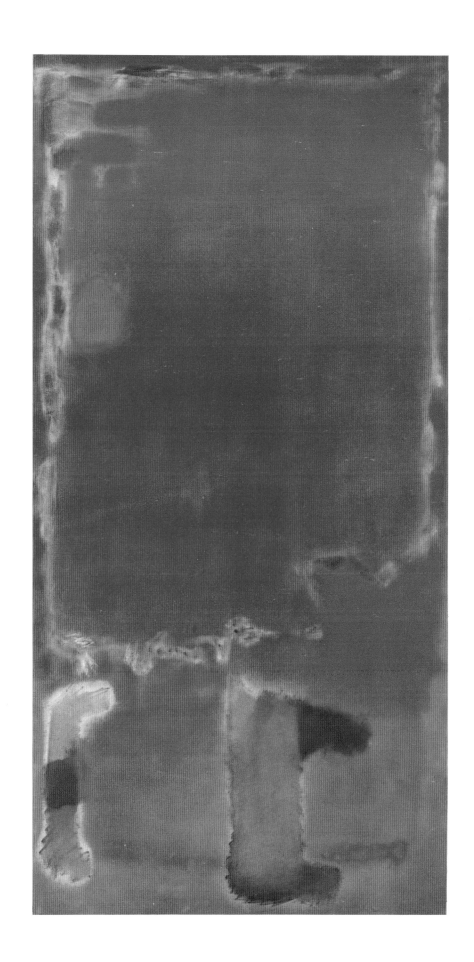

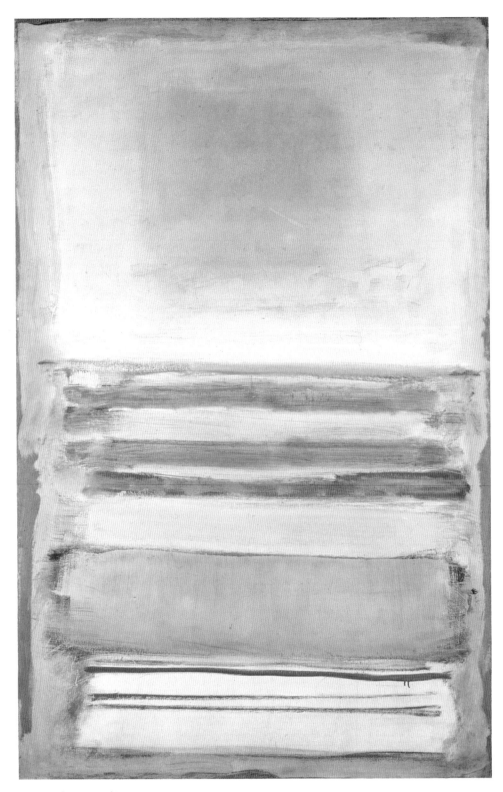

87. *Number 11.* 1949
 Oil on canvas, 68 x 43¼"
 Lent anonymously

88. *Number 19.* 1949
 Oil on canvas, 68 x 40"
 Collection The Art Institute of Chicago, Anonymous Gift

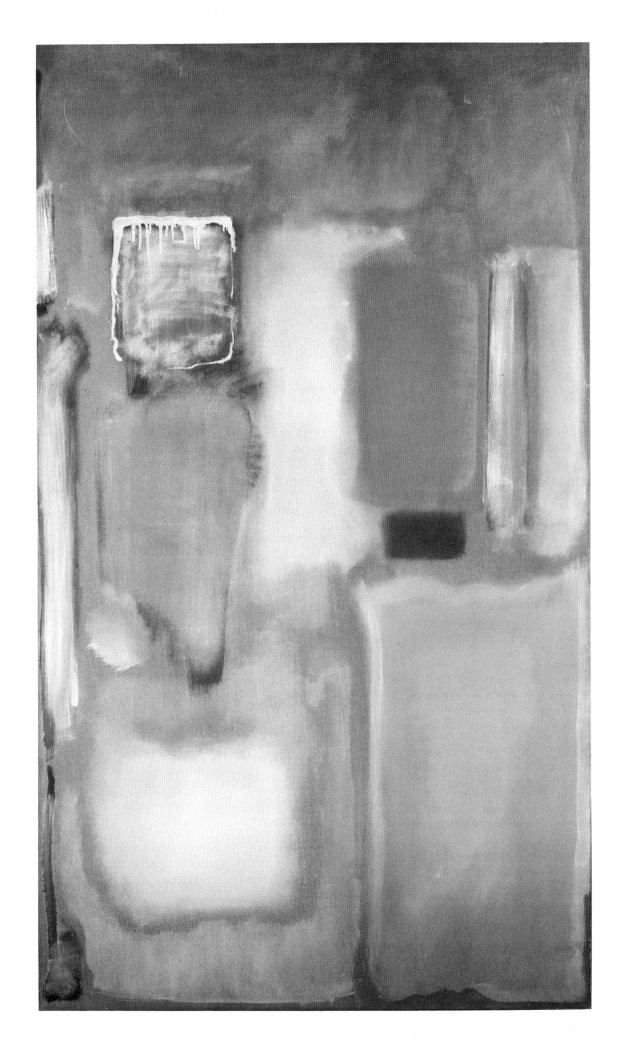

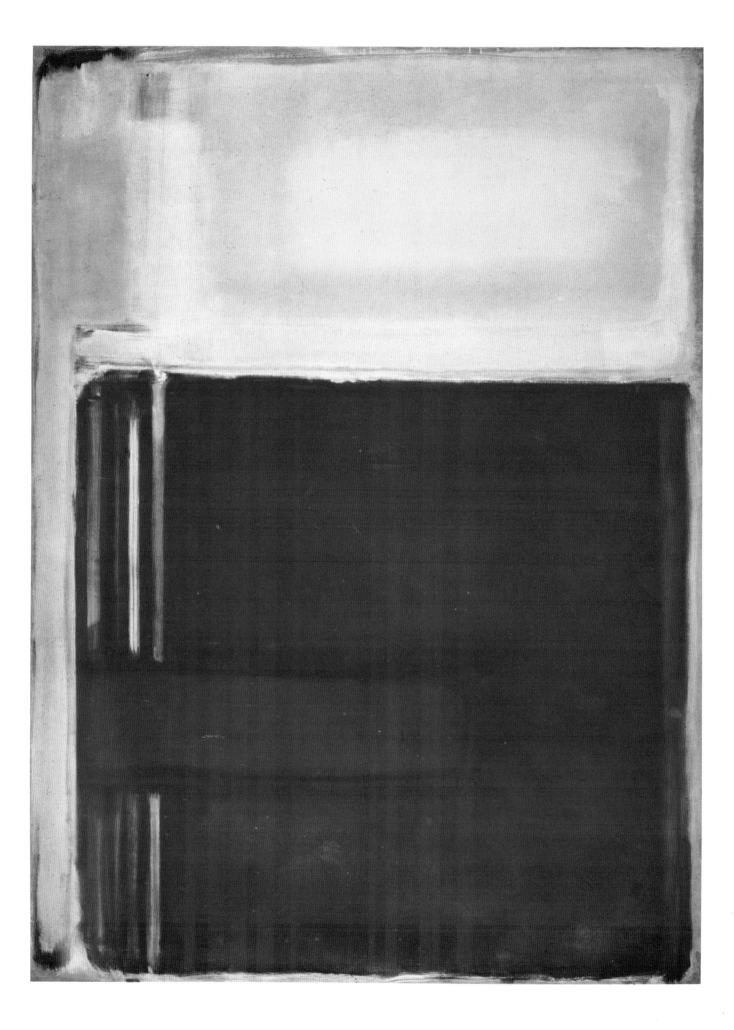

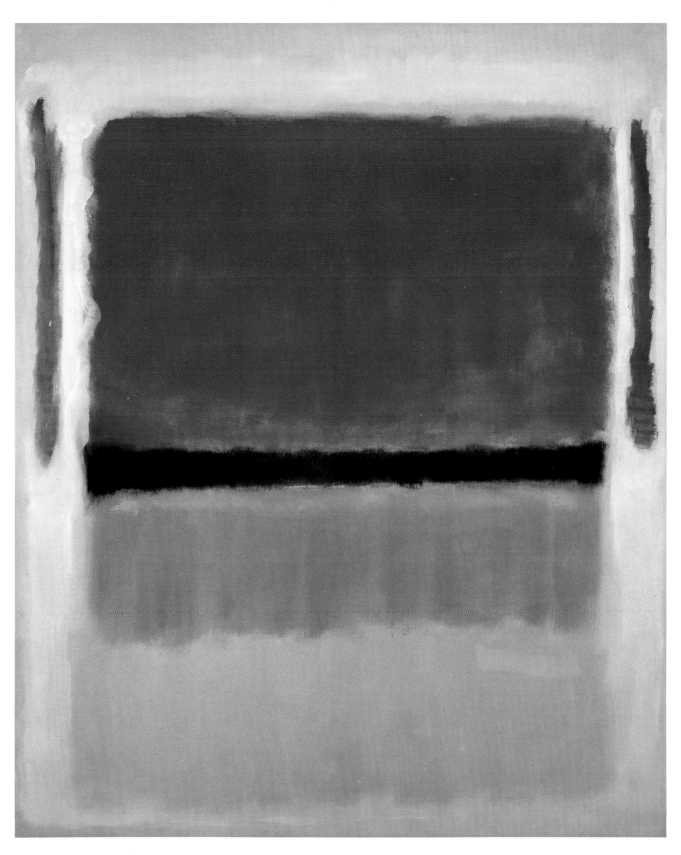

89. *Untitled.* 1949
 Oil on canvas, 98 x 65″
 Courtesy The Pace Gallery

90. *Violet, Black, Orange, Yellow on White and Red.* 1949
 Oil on canvas, 81½ x 66″
 Estate of Mark Rothko

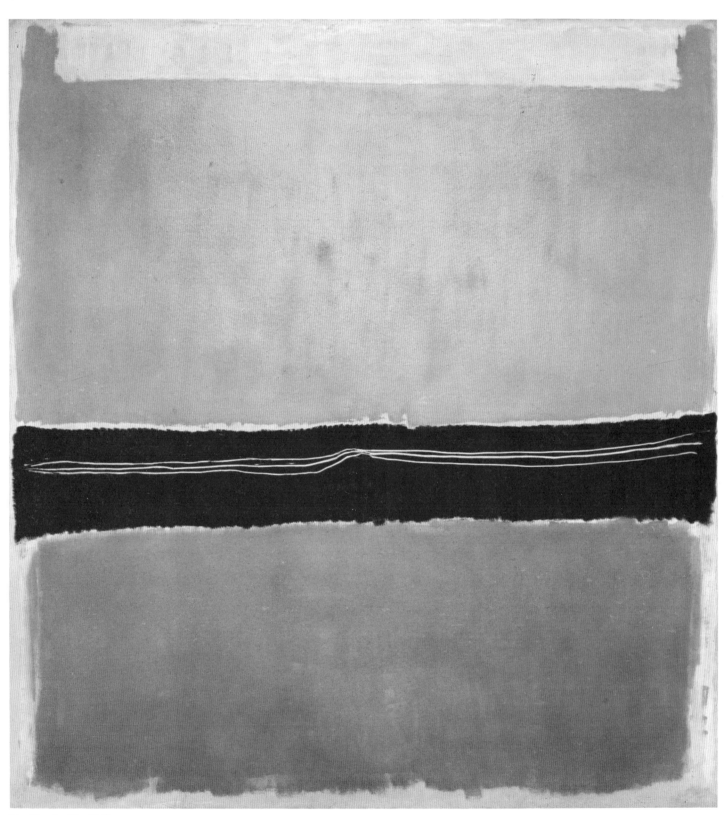

91. *Number 22.* 1949
Oil on canvas, 117 x 107⅛"
Collection The Museum of Modern Art, New York.
Gift of the artist

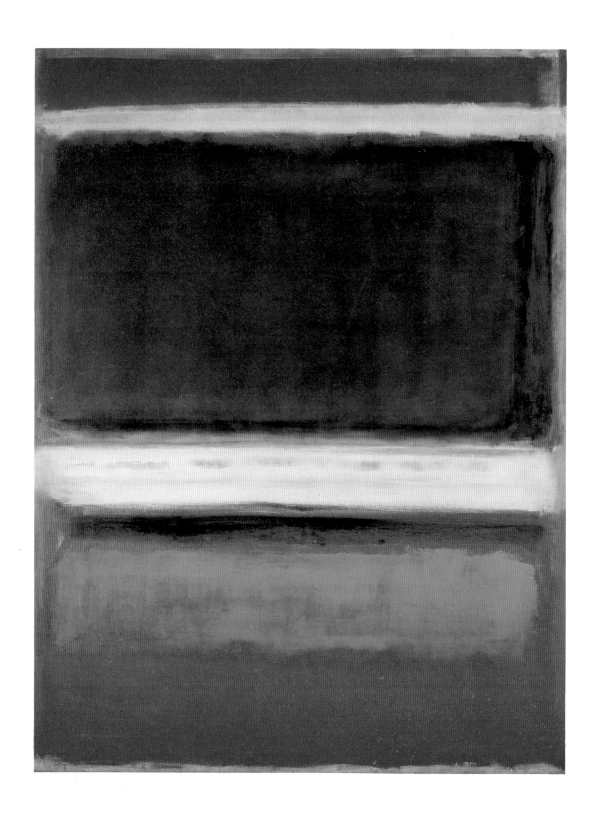

92. *Magenta, Black, Green on Orange.* 1949
 Oil on canvas, 85⅜ x 64½″
 Estate of Mary Alice Rothko

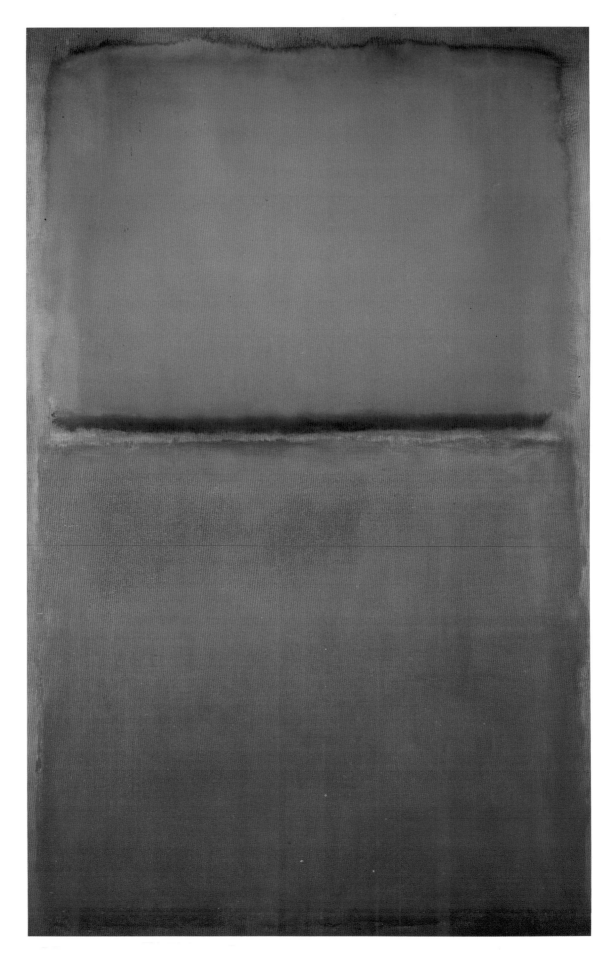

93. *Green, Red on Orange.* 1950
 Oil on canvas, 93 x 59″
 Courtesy The Pace Gallery

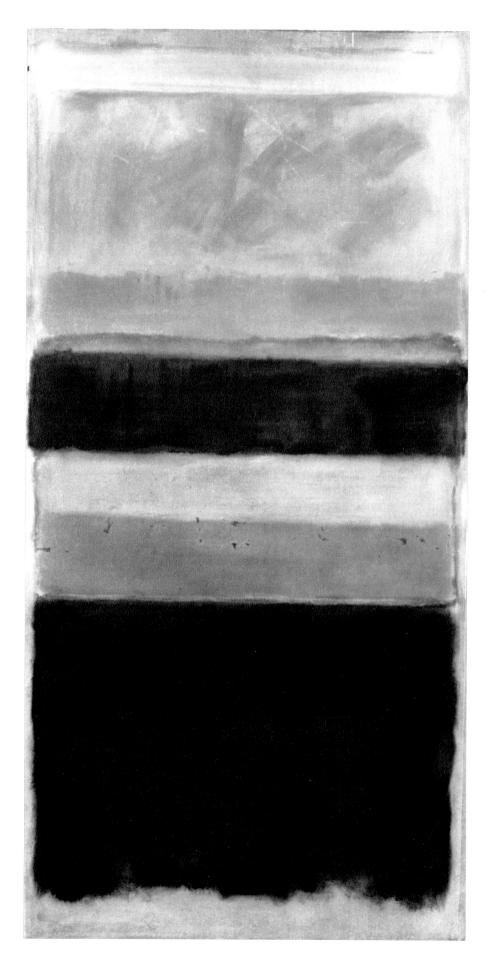

94. *Untitled.* n.d.
 Oil on canvas, 90 x 43¾"
 Estate of Mark Rothko

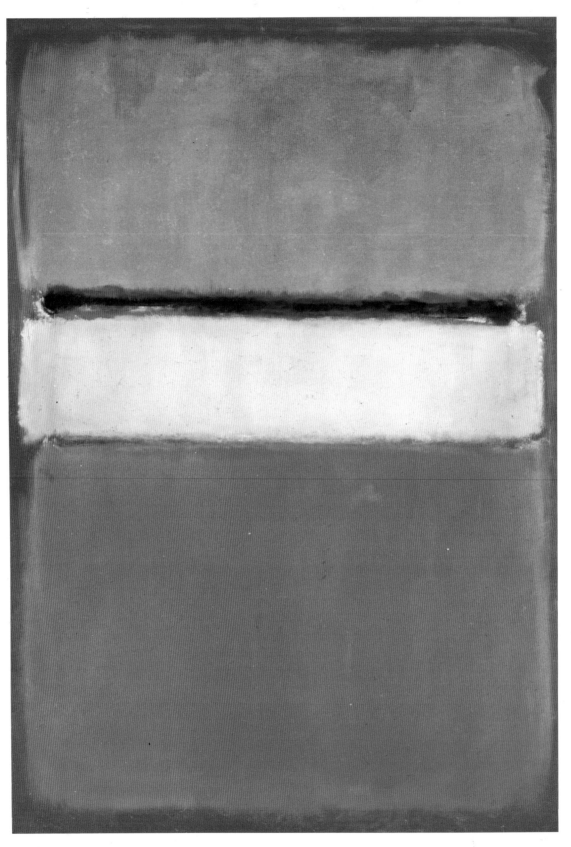

95. *White Center.* 1950
 Oil on canvas, 81 x 55½"
 Private Collection, New York

96. *Untitled.* 1951
 Oil on canvas, 93 x 57"
 Collection Mr. and Mrs. Gifford Phillips, New York

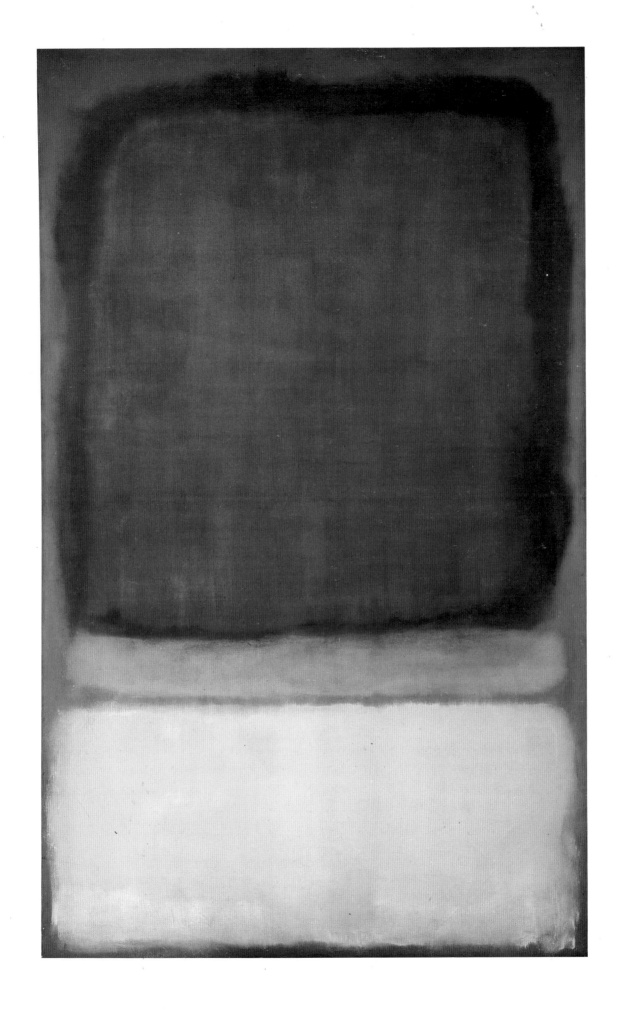

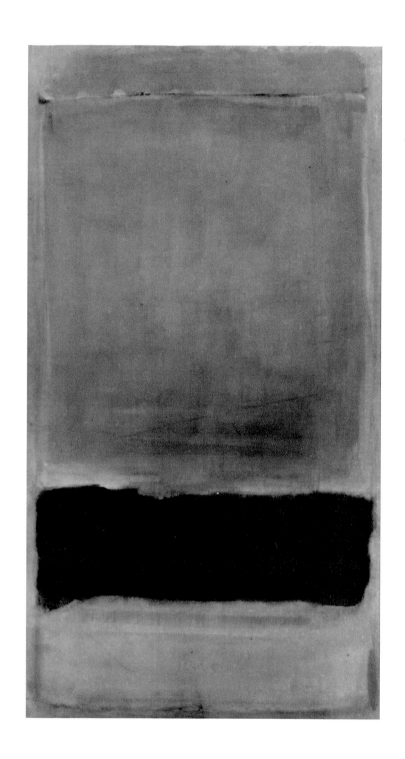

97. *Untitled*. 1949
 Oil on canvas, 56 x 30¼″
 Courtesy The Pace Gallery

98. *Number 10*. 1950
 Oil on canvas, 90⅜ x 57⅛″
 Collection The Museum of Modern Art, New York.
 Gift of Philip Johnson

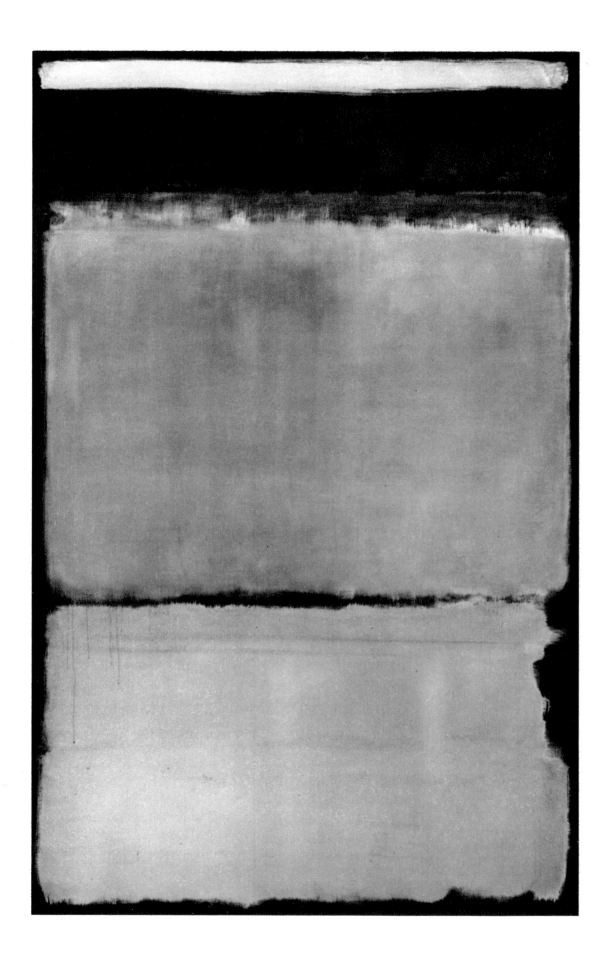

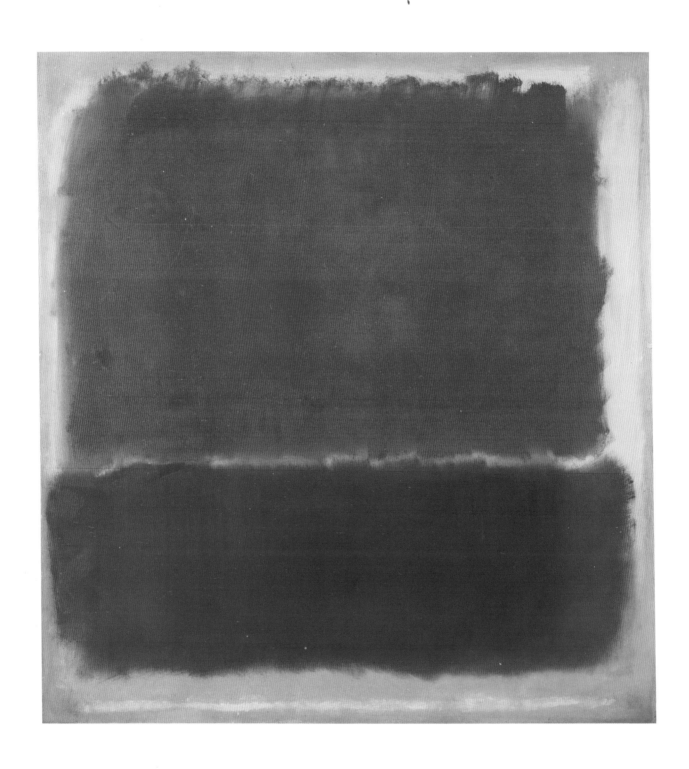

99. *Number 12.* 1951
 Oil on canvas, 57¼ x 52⅞"
 Estate of Mary Alice Rothko

100. *Number 18.* 1951. Oil on canvas, 81¾ x 67"
 Collection Munson-Williams-Proctor Institute, Utica, New York

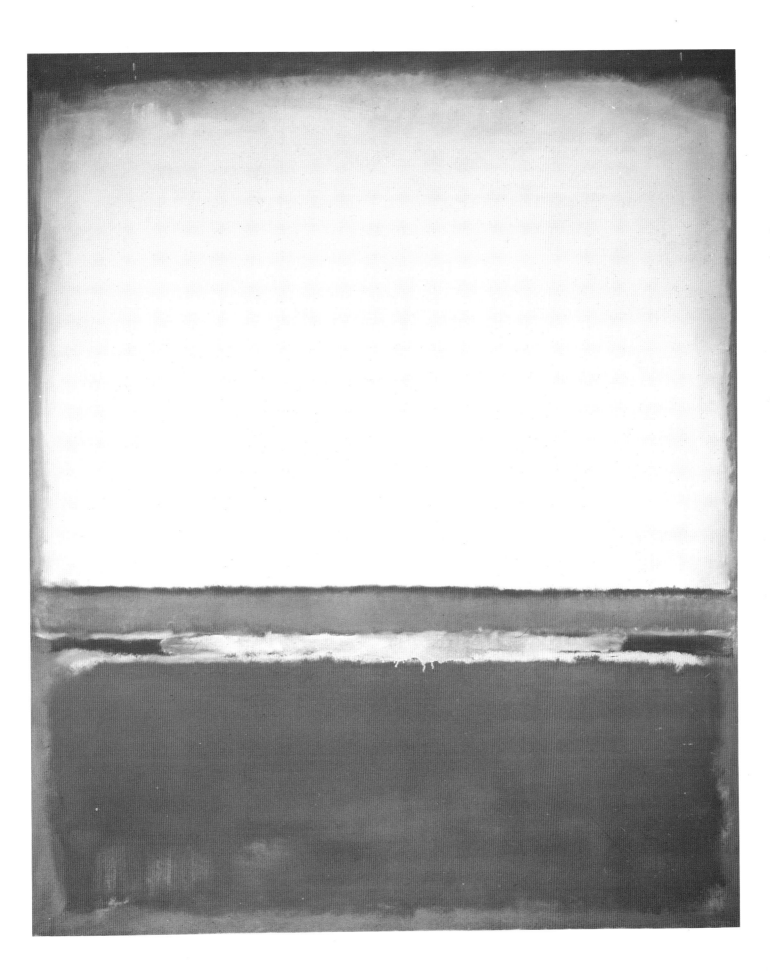

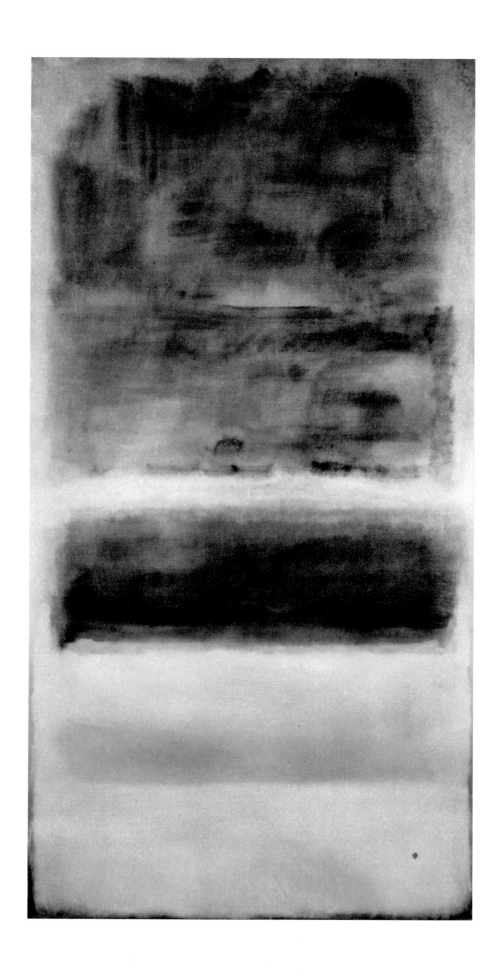

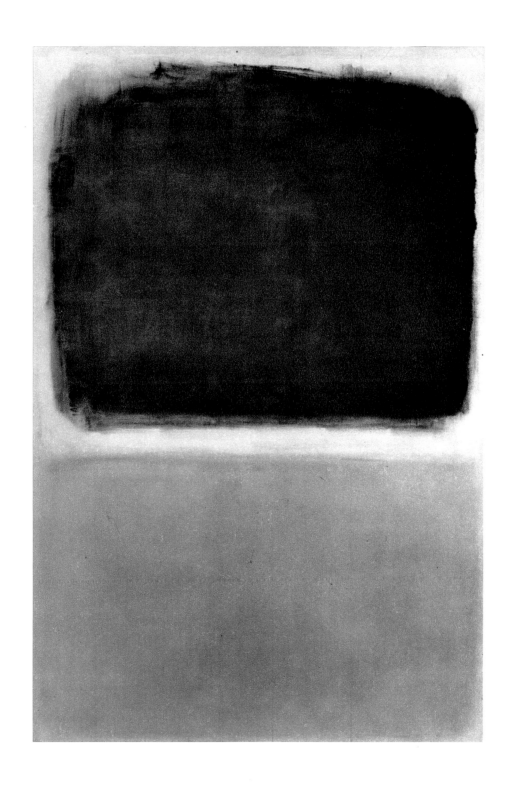

101. *Untitled.* 1950
 Oil on canvas, 81¼ x 42¼″
 Lent by Galerie Beyeler, Basel

102. *Green, White, Yellow on Yellow.* 1951
 Oil on canvas, 67½ x 44½″
 Lent anonymously

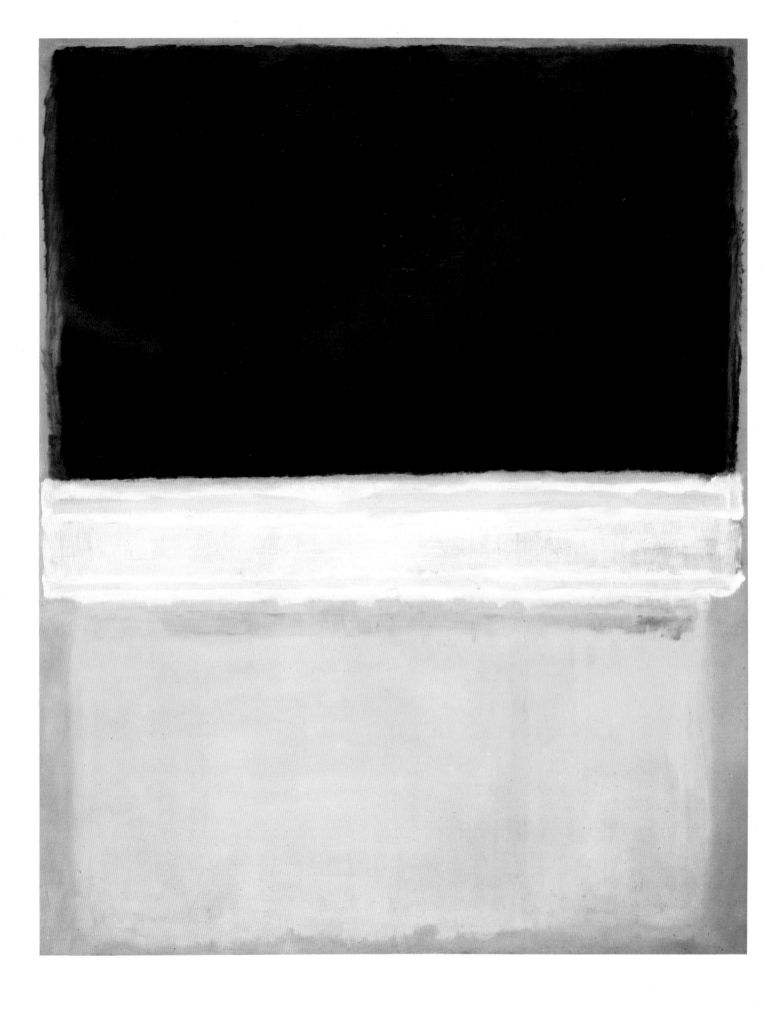

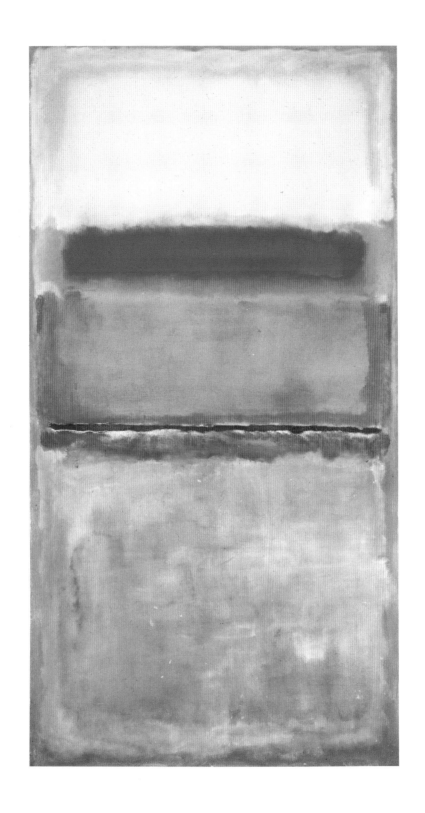

103. *Black, Pink and Yellow over Orange.* 1951–52
Oil on canvas, 116 x 92¼"
Collection Graham Gund

104. *Number 10.* 1952
Oil on canvas, 81½ x 42¼"
Collection Mr. and Mrs. Bagley Wright

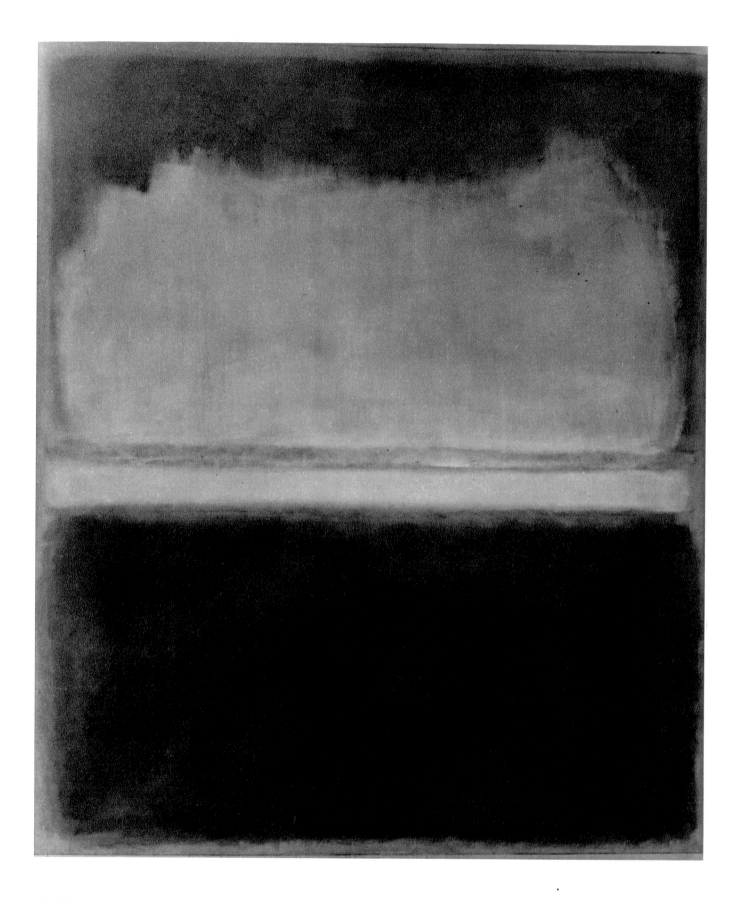

105. *Number 8*. 1952 .Oil on canvas, 80½ x 68″
 Collection Mr. and Mrs. Burton Tremaine, Meriden, Connecticut

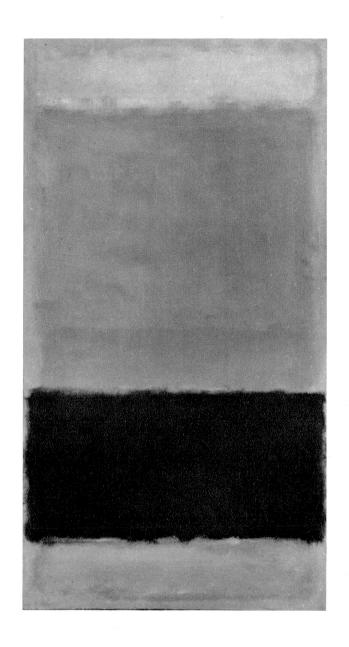

106. *Untitled.* 1952
Oil on canvas, 55¾ x 30⅜″
Lent anonymously

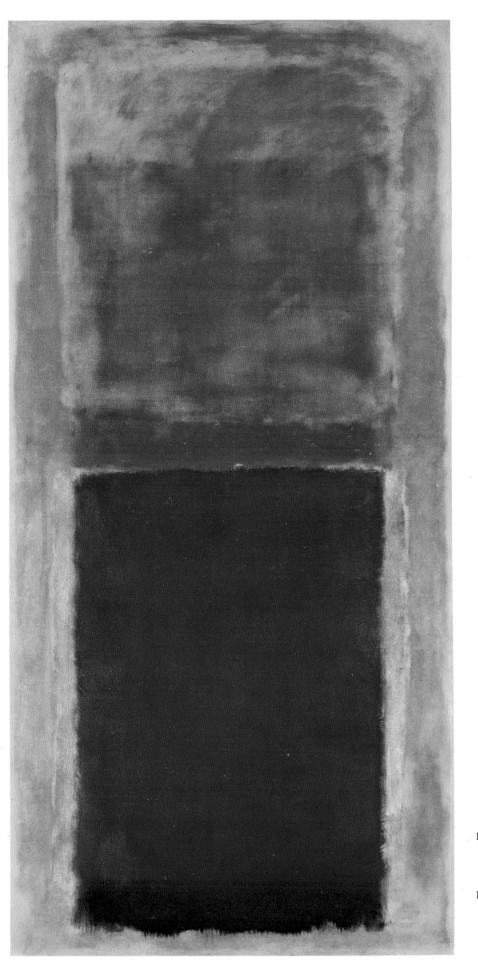

107. *Homage to Matisse*. 1954
 Oil on canvas, 105½ x 51″
 Collection McCrory Corporation, New York

108. *Number 61 (Brown, Blue, Brown on Blue)*. 1953
 Oil on canvas, 116½ x 92″
 Collection Panza di Biumo

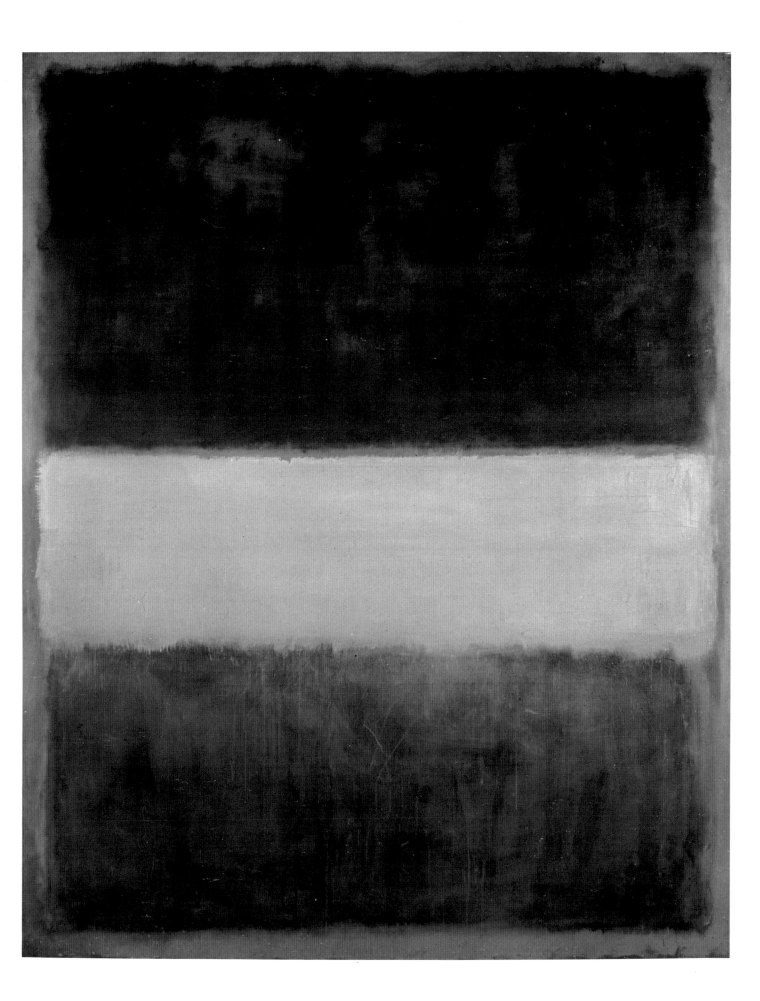

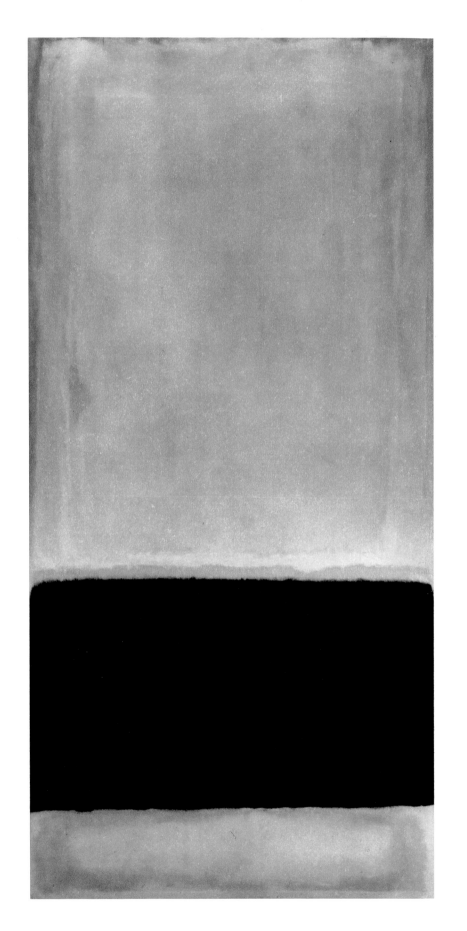

109. *Yellow, Black, Orange on Yellow.* 1953
Oil on canvas, 106 x 51"
Lent anonymously

110. *Yellow, Orange, Red on Orange.* 1954
Oil on canvas, 115 x 90¾"
Lent anonymously

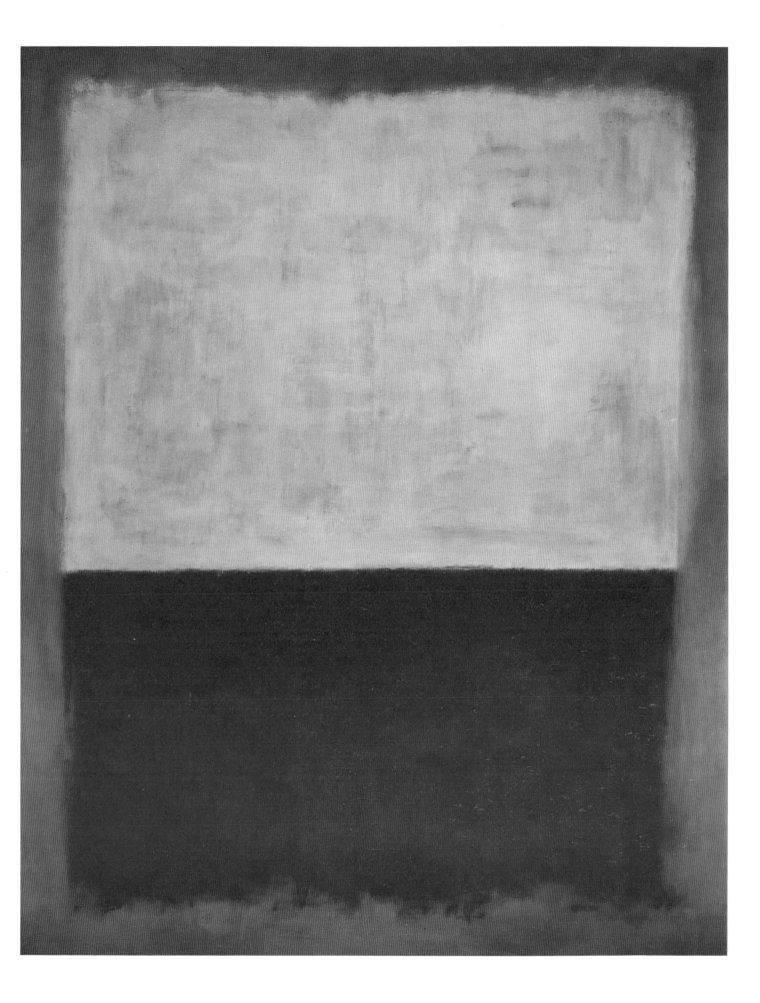

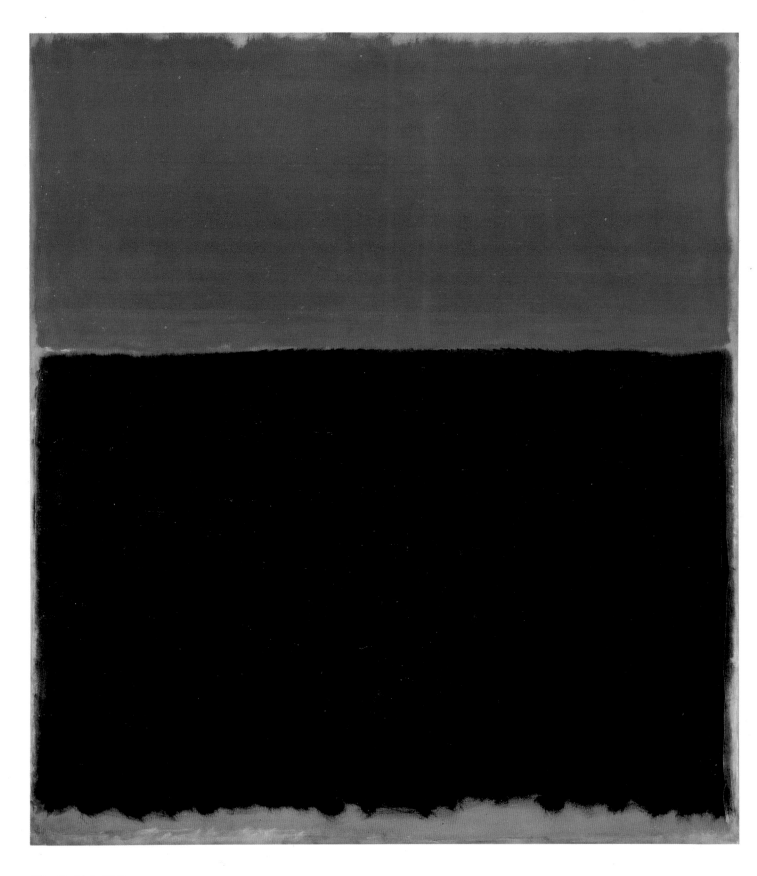

111. *Untitled.* 1953
Oil on canvas, 76½ x 67½"
Lent anonymously

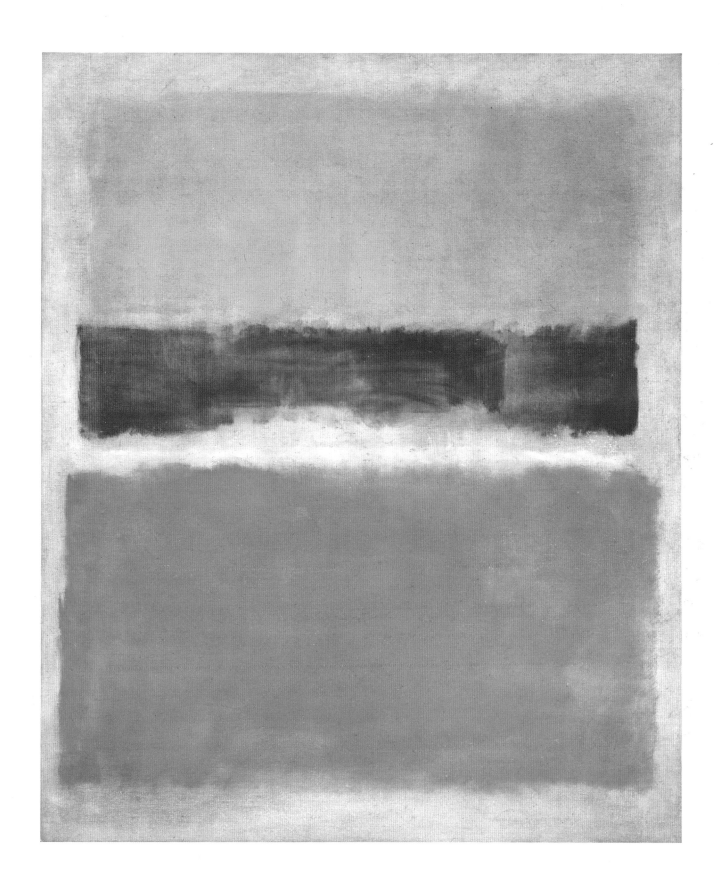

112. *Untitled.* 1953
 Oil on canvas, 74 x 61″
 Collection Mr. and Mrs. Robert Kardon

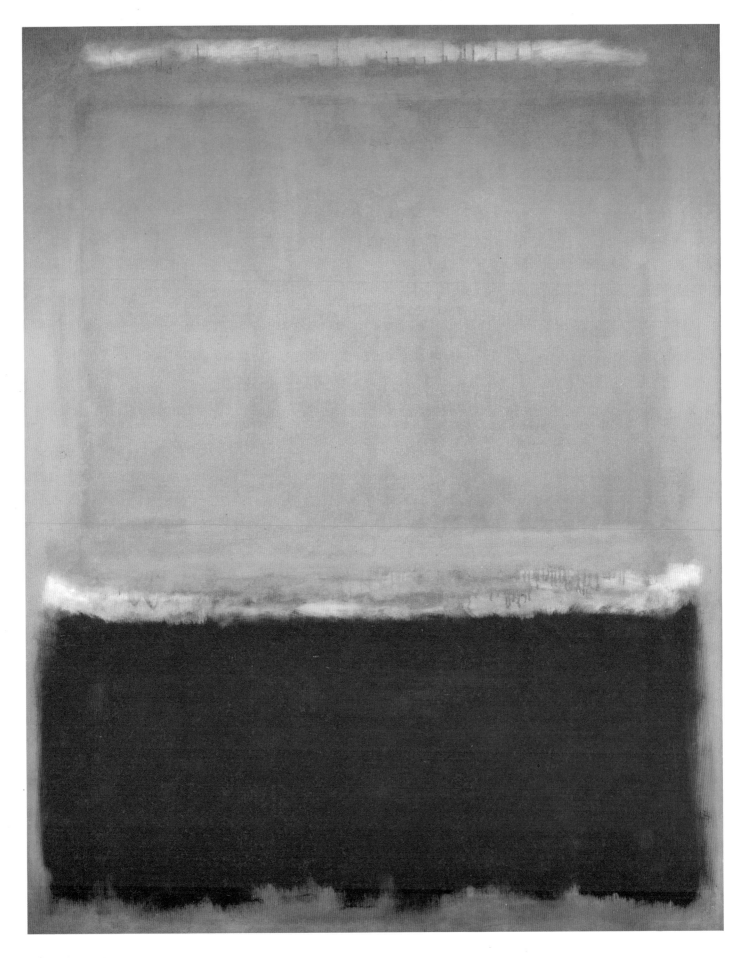

113. *White, Yellow, Red on Yellow.* 1953
Oil on canvas, 90¾ x 71"
Courtesy The Pace Gallery

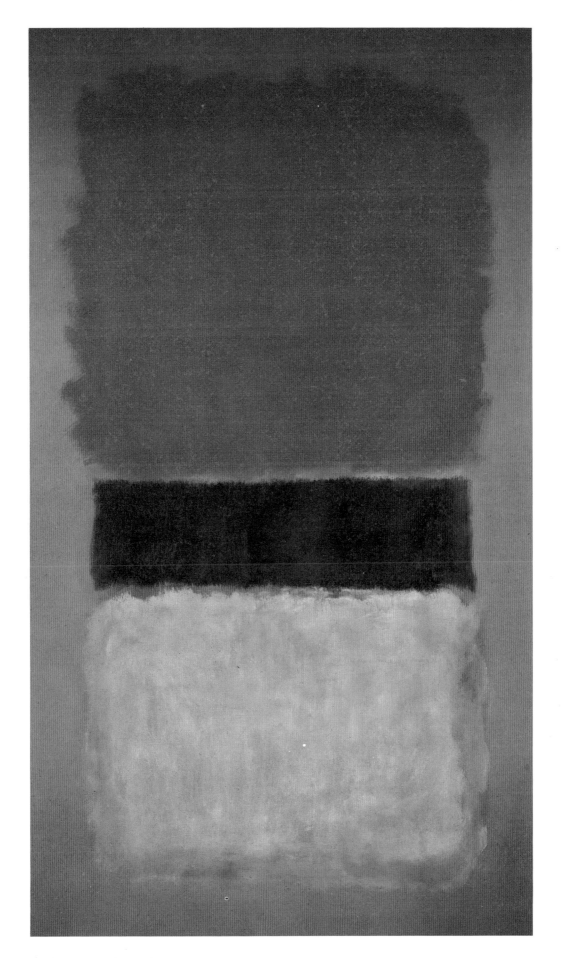

114. *Orange, Gold and Black.* 1955
 Oil on canvas, 89½ x 38¼"
 Collection Honorable and Mrs. Irwin D. Davidson

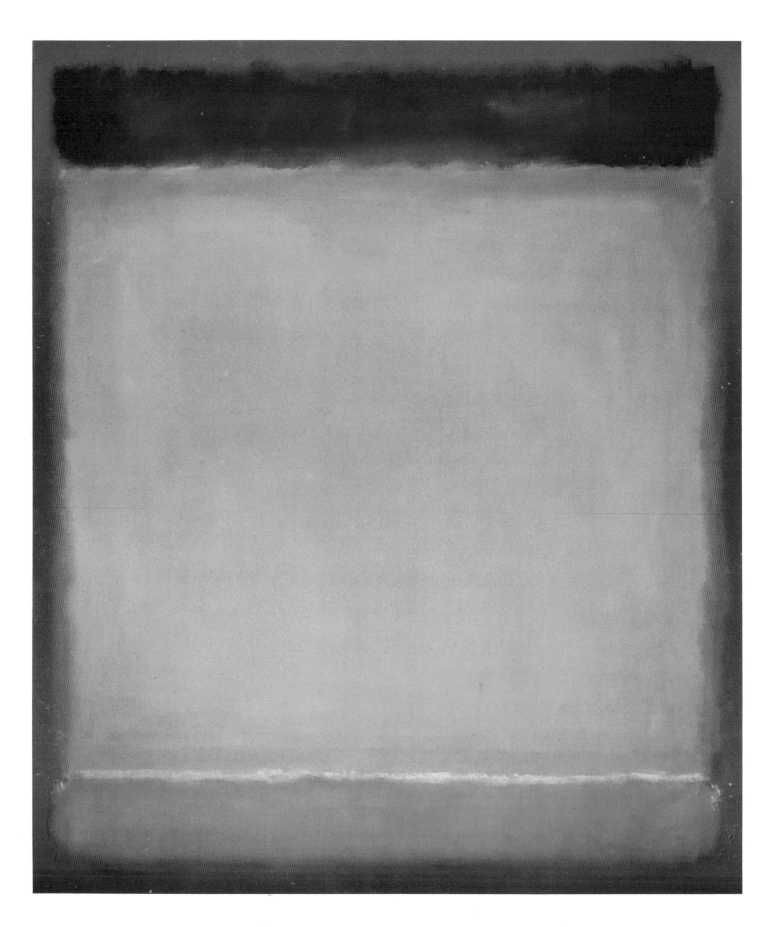

115. *Blue, Yellow, Green on Red.* 1954
Oil on canvas, 77¾ x 65½"
Collection Mr. and Mrs. Oscar Kolin

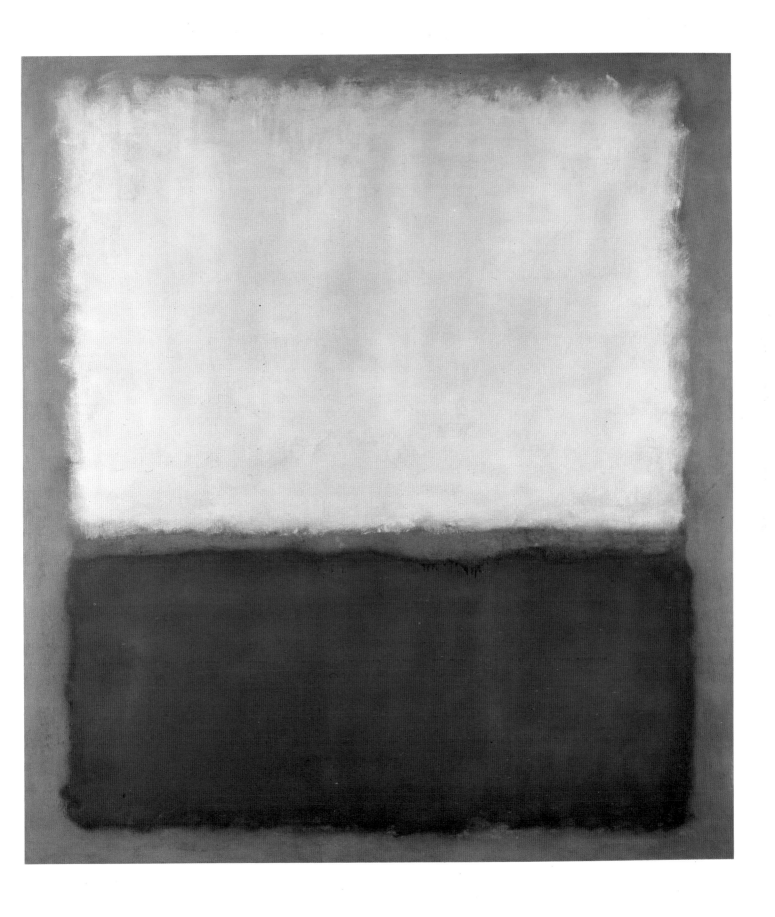

116. *Light, Earth and Blue*. 1954
 Oil on canvas, 76 x 67"
 Private Collection

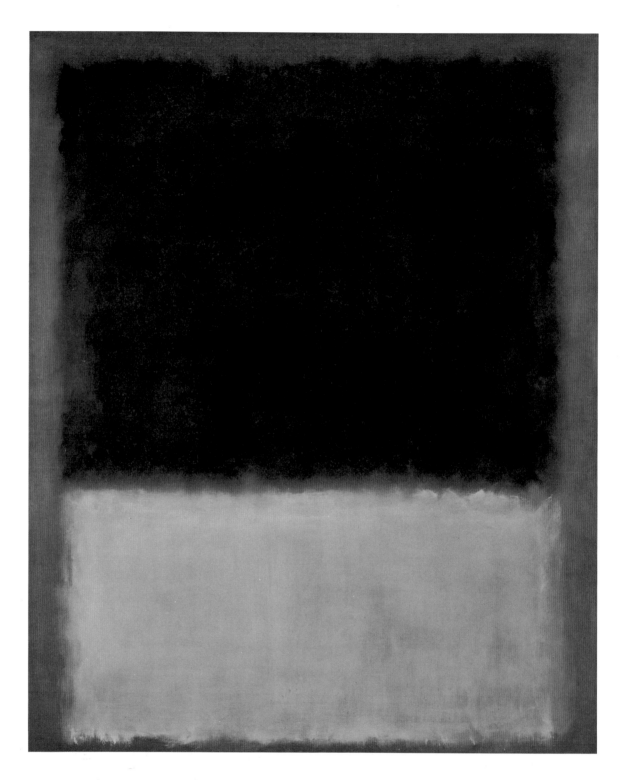

117. *Number 203*. 1954
 Oil on canvas, 84 x 68"
 Estate of Mary Alice Rothko

118. *Ochre and Red on Red*. 1954
 Oil on canvas, 90 x 69"
 The Phillips Collection, Washington, D.C.

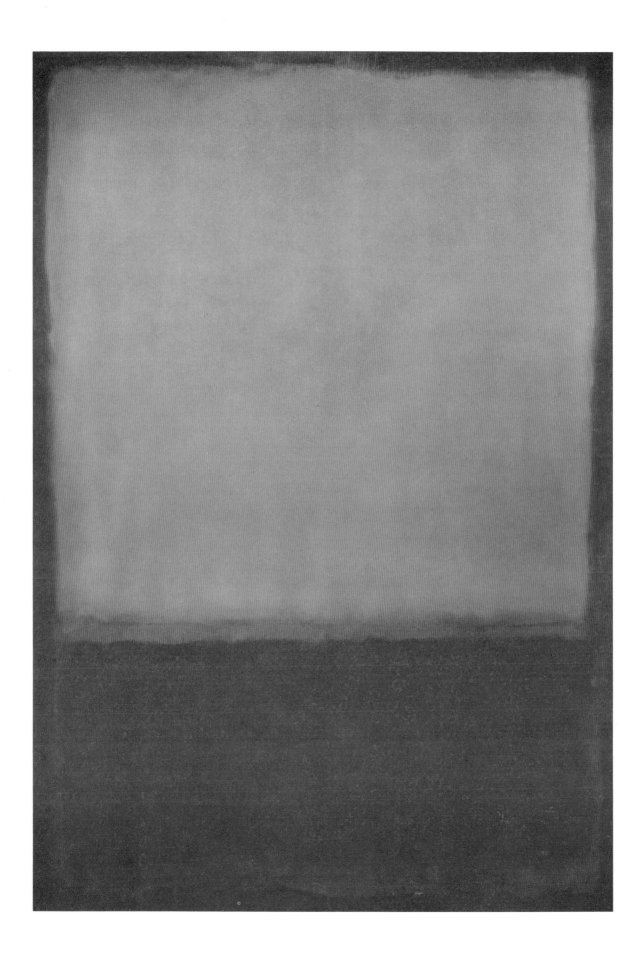

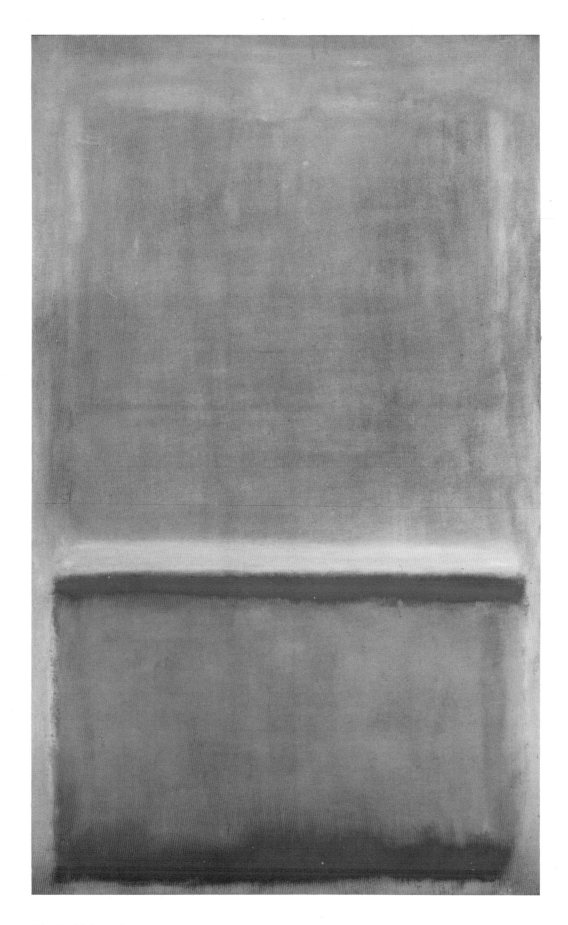

119. *Untitled.* 1954
 Oil on canvas, 93 x 56¼"
 Private Collection

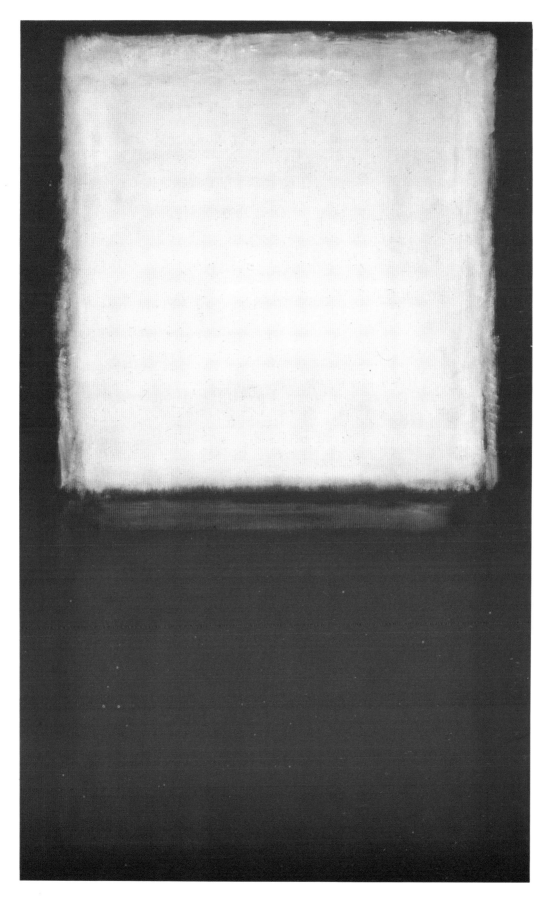

120. *Untitled.* 1954
Oil on canvas, 93⅜ x 56¼"
Collection Museum of Art,
Rhode Island School of Design,
Providence. Purchased in honor of Daniel Robbins

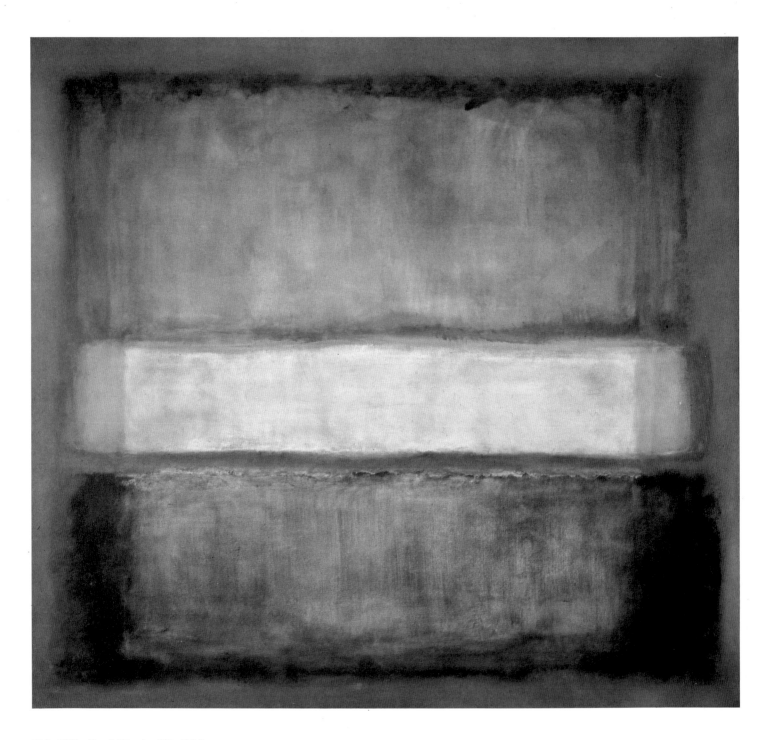

121. *White Band (Number 27).* 1954
Oil on canvas, 86⅜ x 81″
Collection Mr. and Mrs. Ben Heller, New York

122. *Untitled.* 1955
Oil on canvas, 91¾ x 69″
Collection Graham Gund

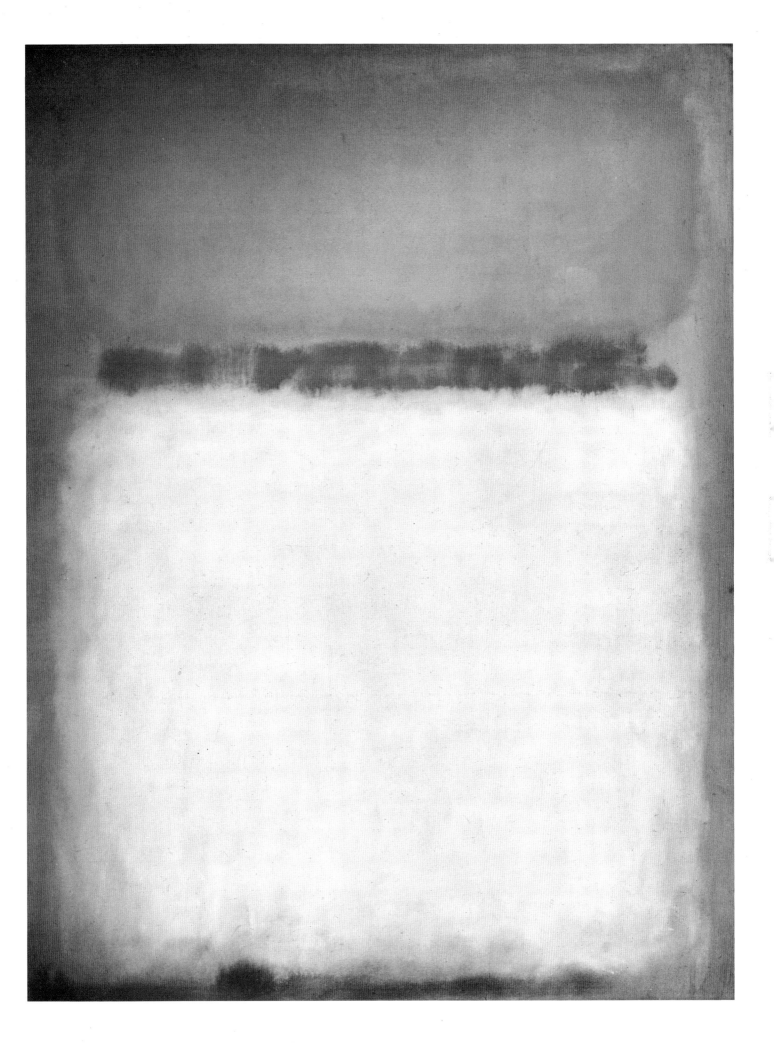

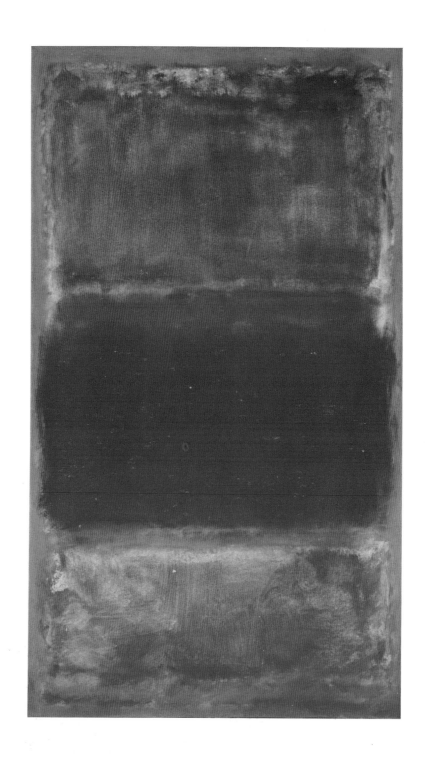

123. *Three Reds*. 1955
Oil on canvas, 68 x 38½"
Collection Mr. and Mrs. Donald Blinken

124. *Yellow, Blue on Orange*. 1955
Oil on canvas, 102¼ x 66¾"
Collection Museum of Art, Carnegie Institute, Pittsburgh

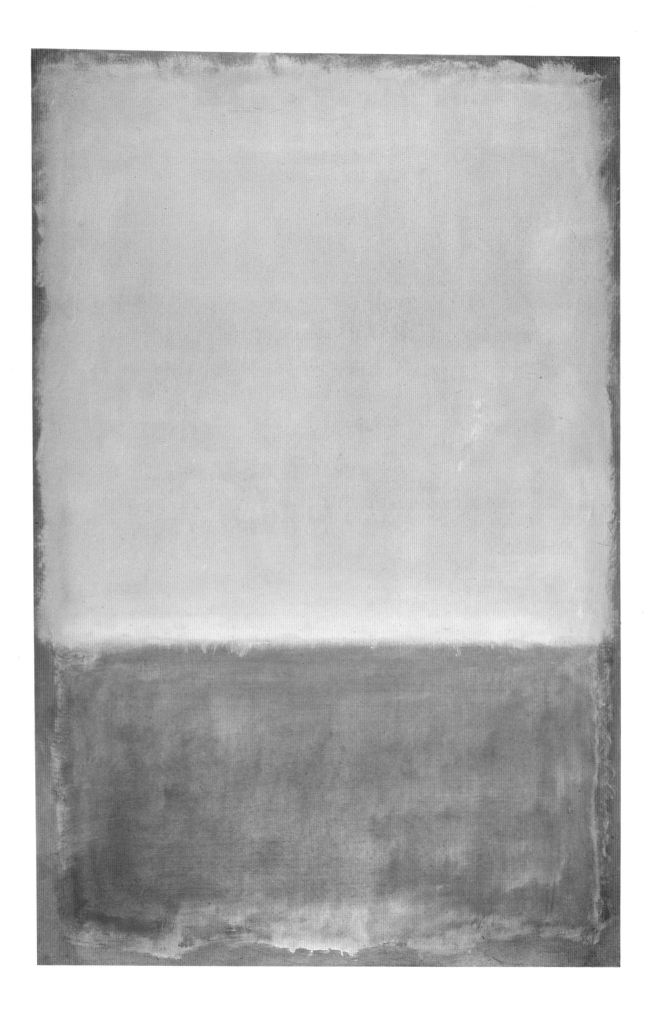

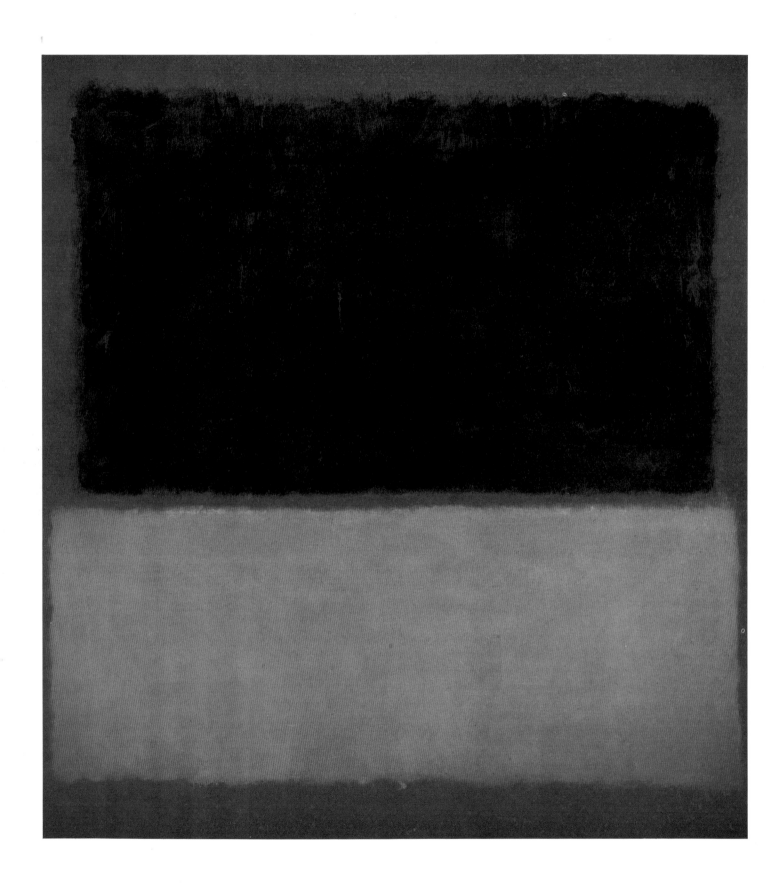

125. *Blue over Orange.* 1956
 Oil on canvas, 86 x 79″
 Collection Mr. and Mrs. Donald Blinken

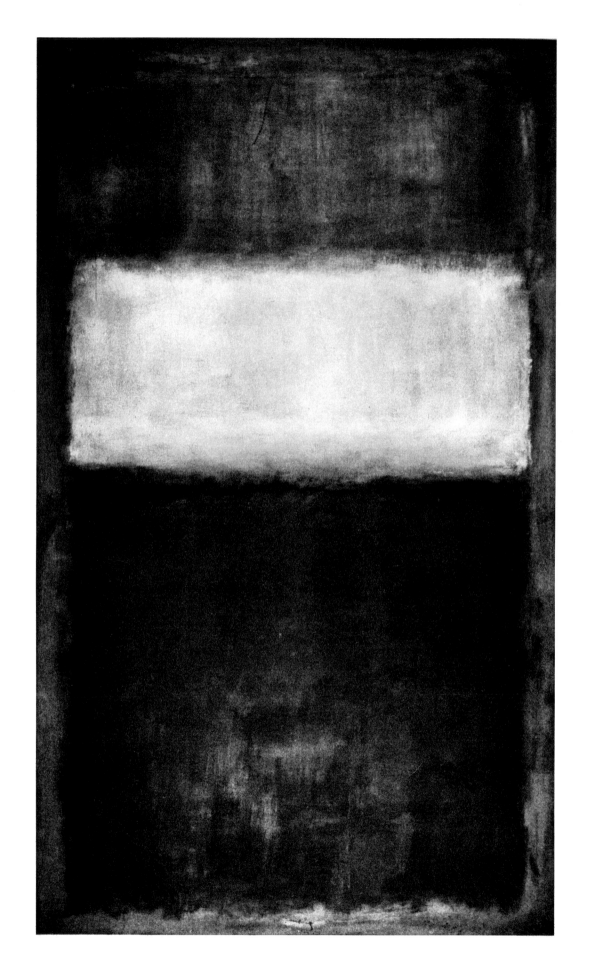

126. *Number 2.* 1954
 Oil on canvas, 113½ x 68½″
 Collection Tehran Museum of Contemporary Art

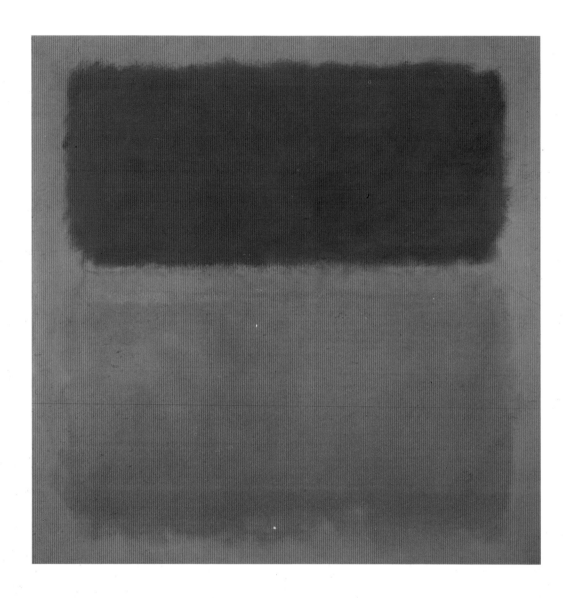

127. *Blue Cloud.* 1956
 Oil on canvas, 54½ x 53"
 Lent by Gimpel & Hanover Galerie, Zürich

128. *Blackish Green Tone on Blue.* 1957
 Oil on canvas, 103 x 116¾"
 Estate of Mark Rothko

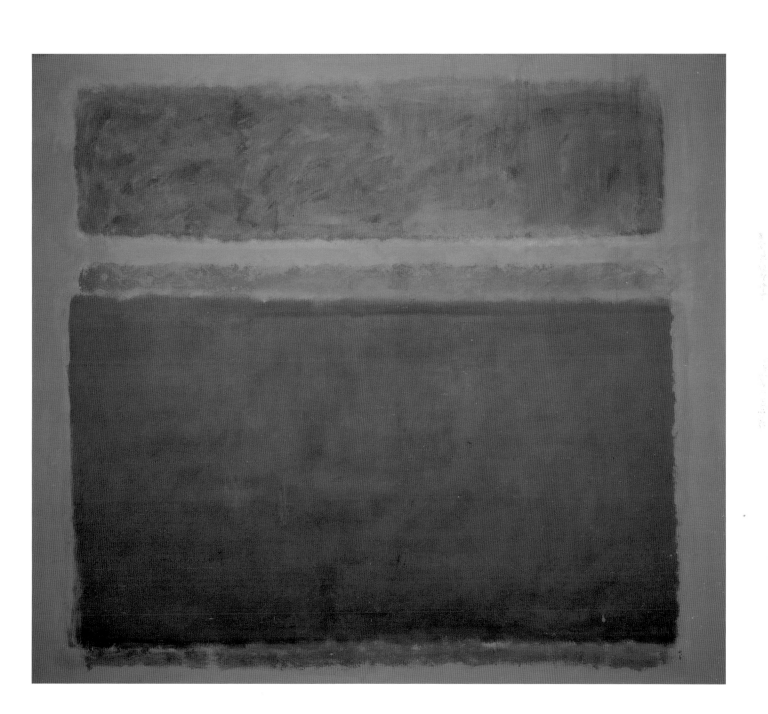

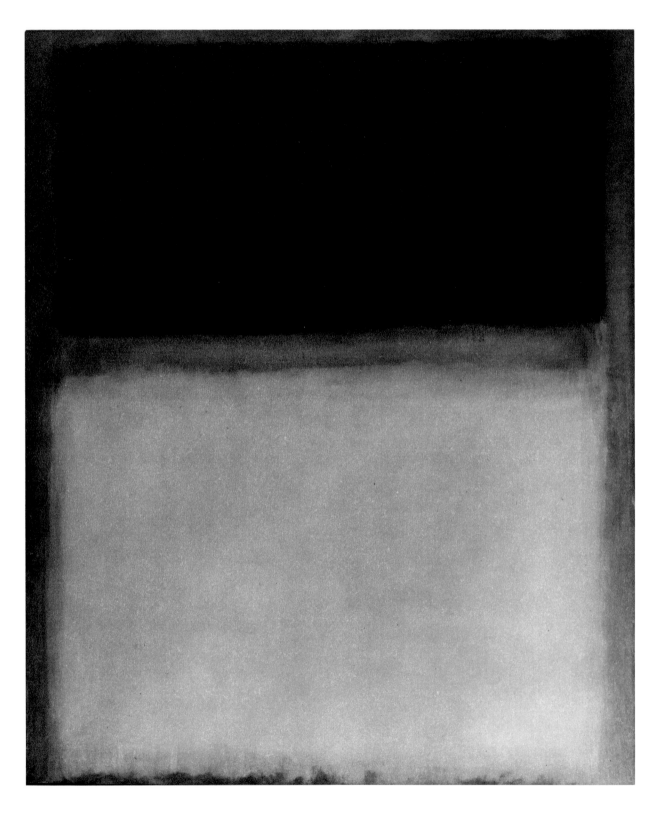

129. *Violet and Yellow on Rose.* 1954
 Oil on canvas, 84 x 67¾"
 Collection Panza di Biumo

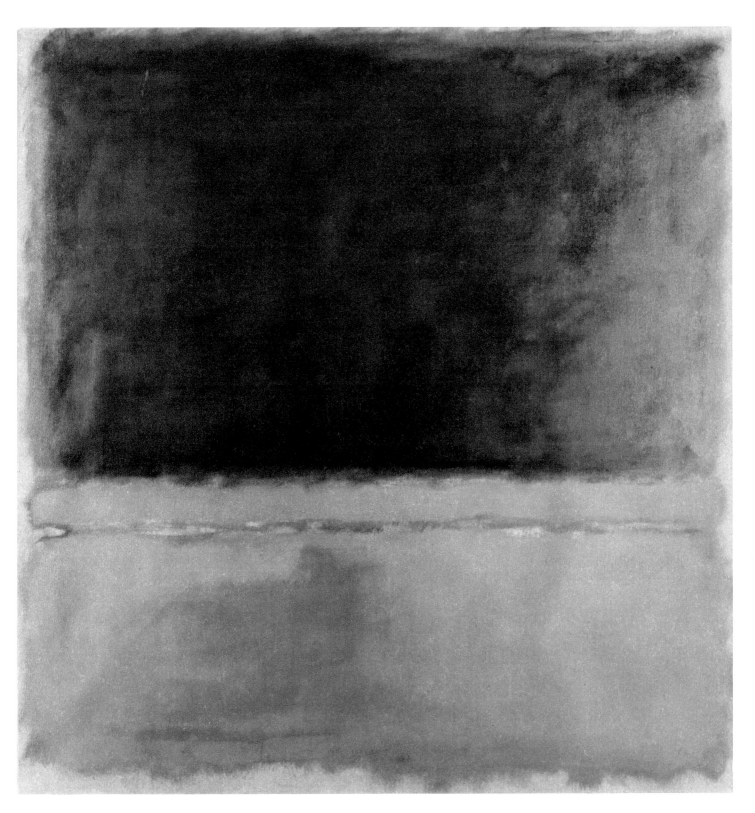

130. *Green, Red, Blue.* 1955
 Oil on canvas, 81½ x 77¾″
 Collection Milwaukee Art Center.
 From the Collection of
 Mrs. Harry Lynde Bradley

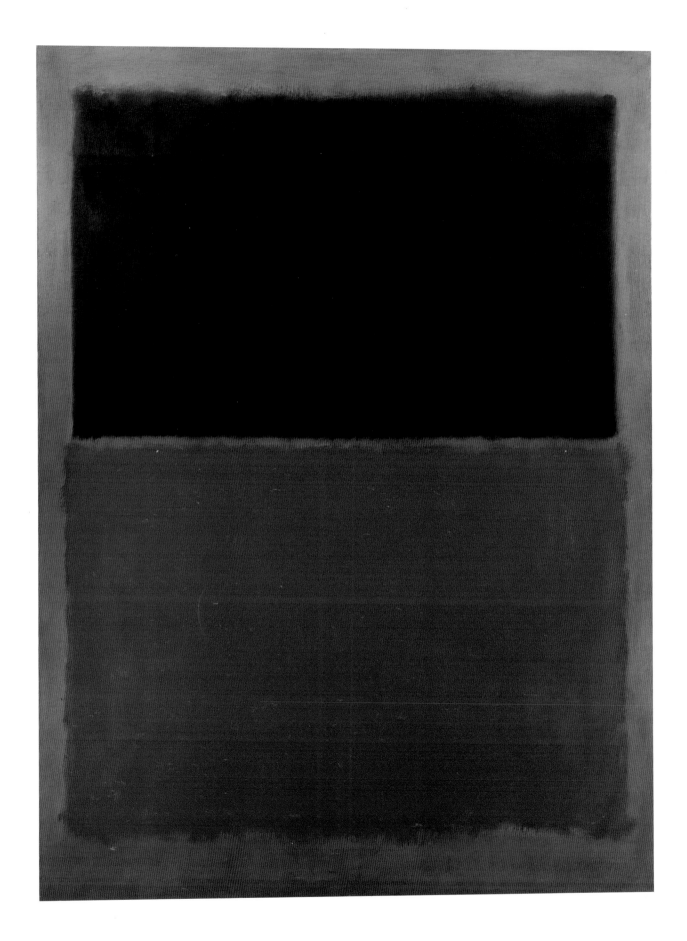

131. *Green and Tangerine on Red.* 1956
Oil on canvas, 93½ x 69⅛"
The Phillips Collection, Washington, D.C.

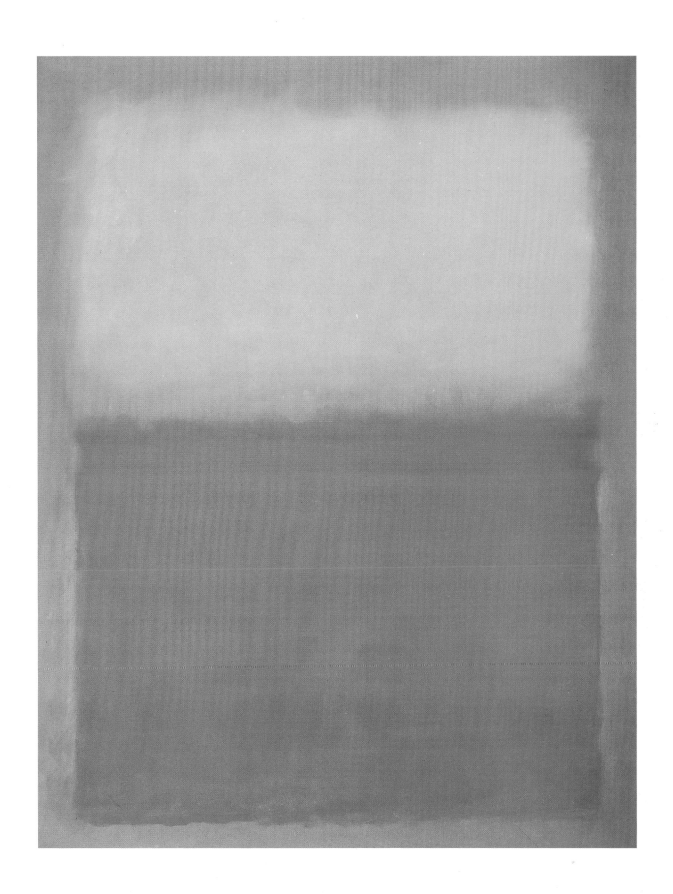

132. *Orange and Yellow.* 1956
Oil on canvas, 91 x 71"
Collection Albright-Knox Art Gallery,
Buffalo, New York, Gift of Seymour H. Knox

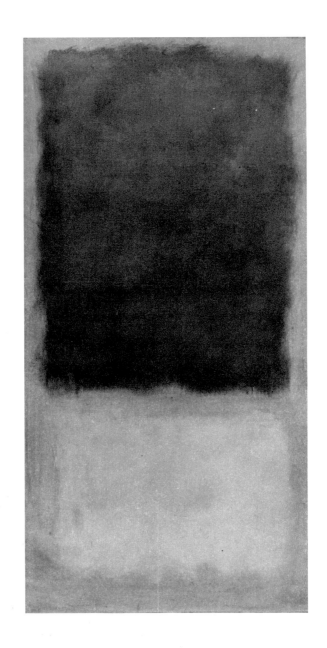

133. *Untitled.* 1955
 Oil on canvas, 53⅞ x 27¼"
 Estate of Mark Rothko

134. *Untitled.* 1956
 Oil on canvas, 79⅜ x 69"
 Collection Mr. and Mrs. Lee V. Eastman

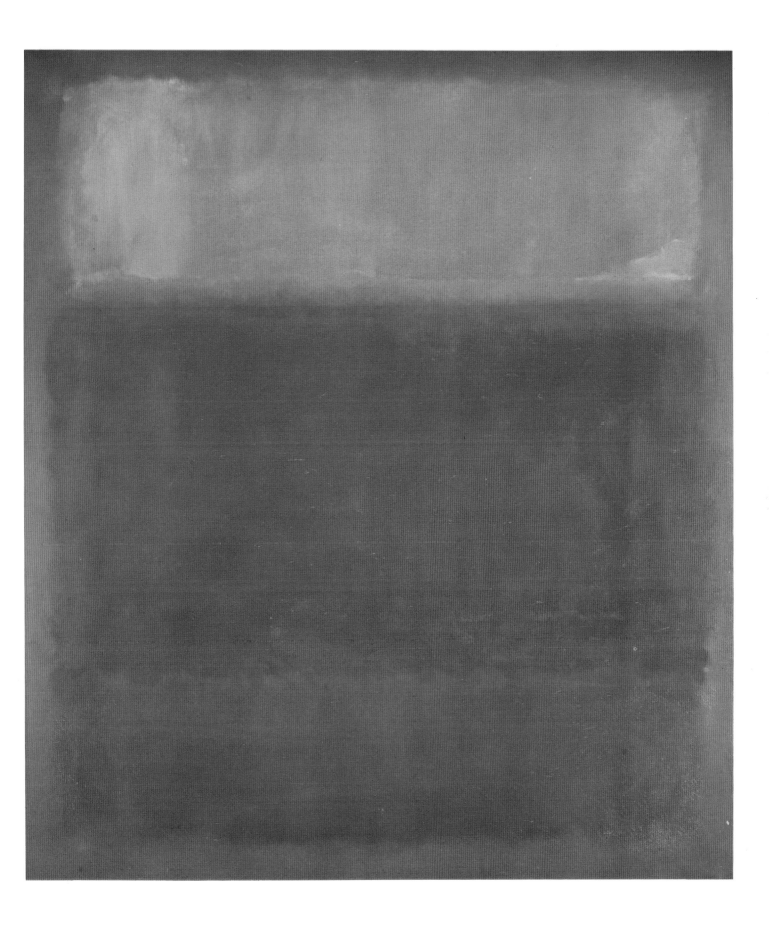

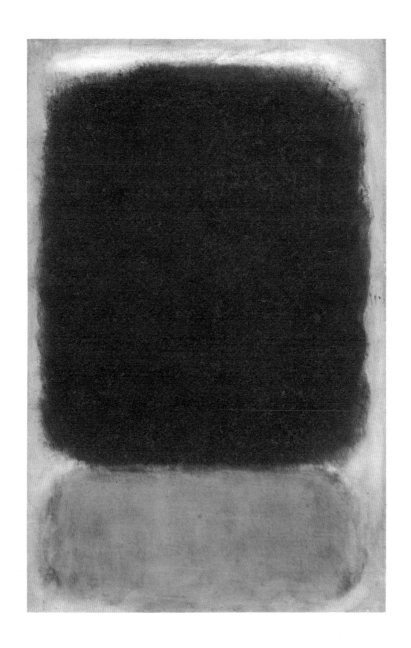

135. *Red and Pink on Pink*. 1953
 Tempera on paper, 39⅝ x 25¼″
 Courtesy The Pace Gallery

136. *White Cloud*. 1956
 Oil on canvas, 66½ x 62½″
 Private Collection

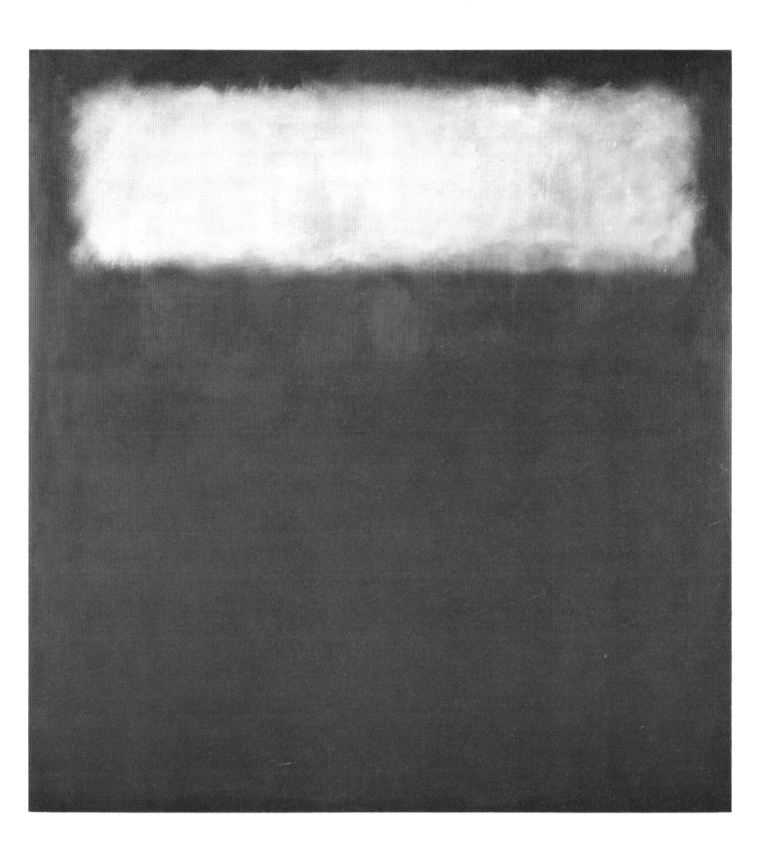

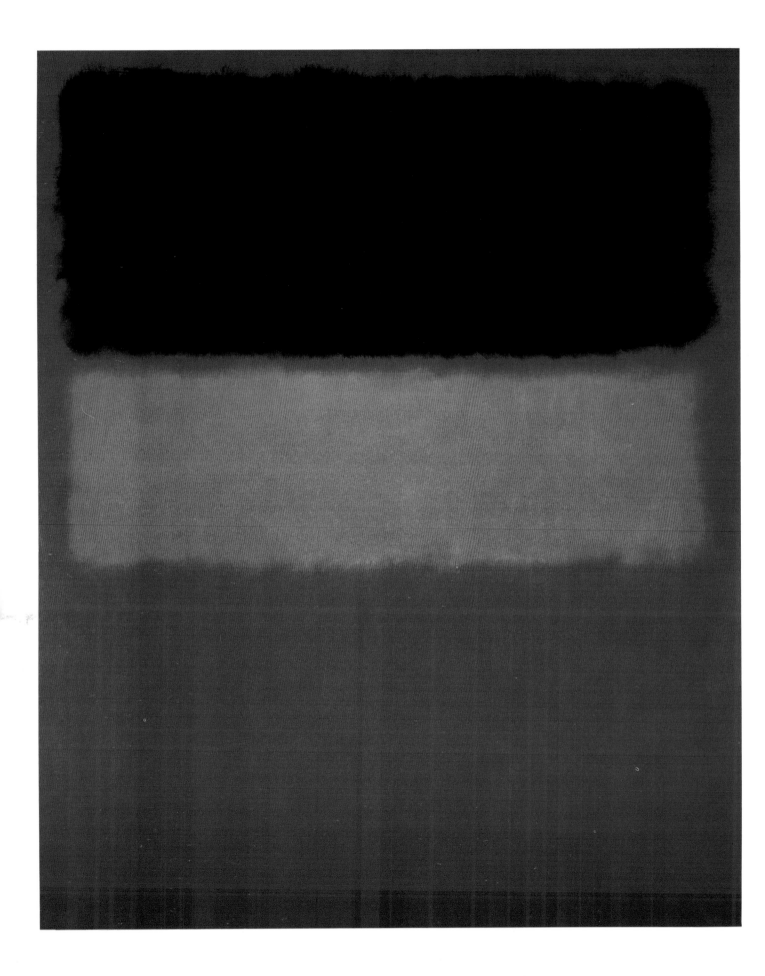

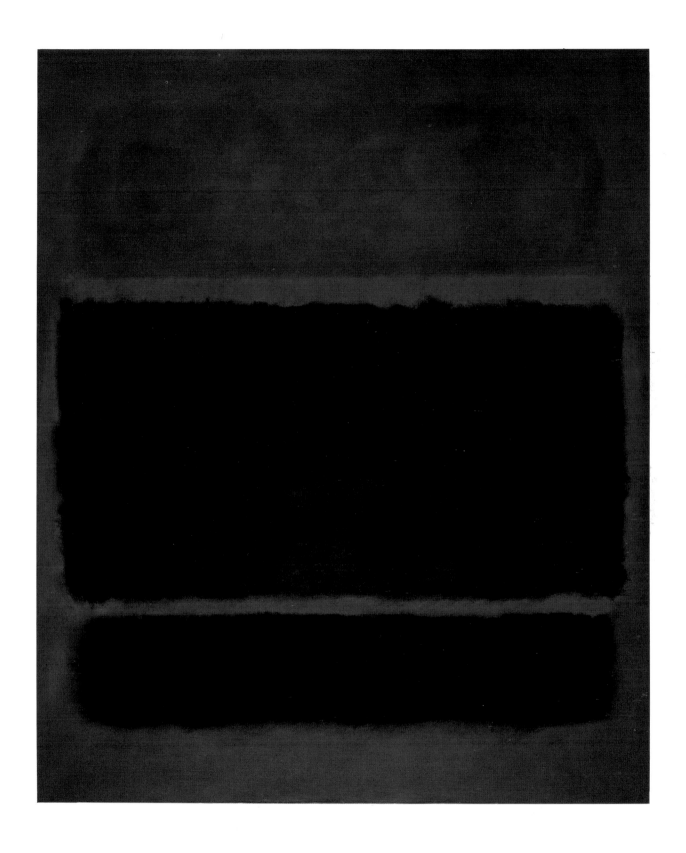

137. *Black, Ochre, Red over Red.* 1957
Oil on canvas, 100 x 82¼"
Collection Panza di Biumo,

138. *Brown, Black on Maroon.* 1957
Oil on canvas, 91½ x 76"
Estate of Mark Rothko

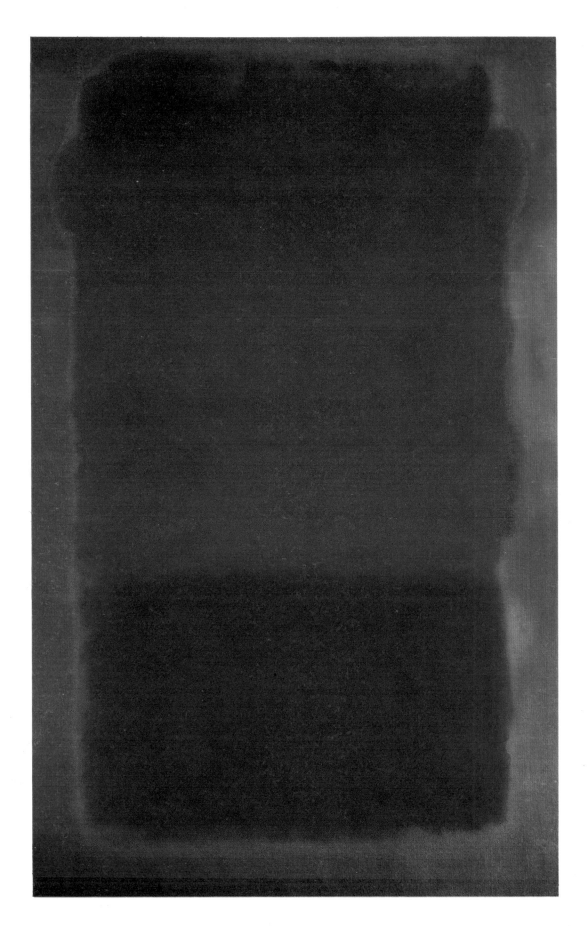

139. *Four Reds.* 1957
Oil on canvas, 81 x 50"
Collection Mr. and Mrs. Daniel Schwartz

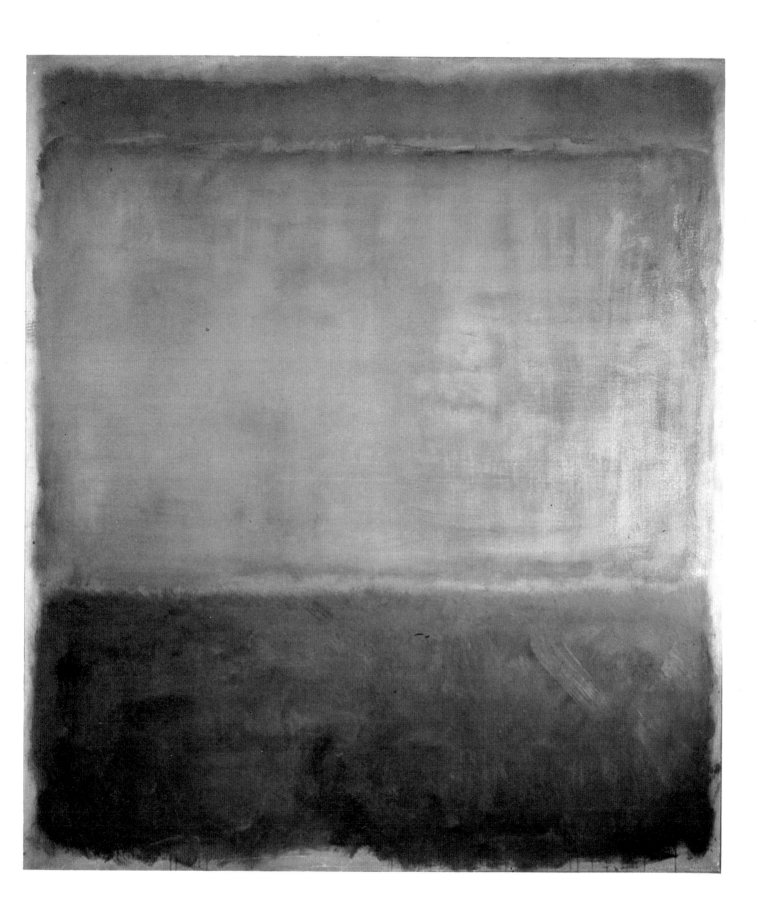

140. *Untitled.* 1957
Oil on canvas, 79½ x 69½″
Frederick Weisman Family Collection

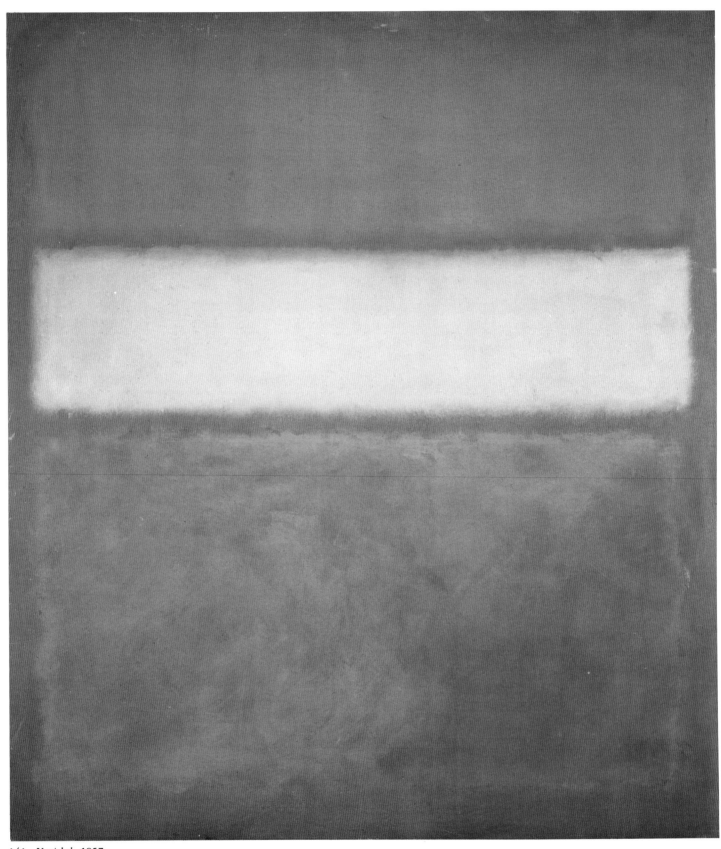

141. *Untitled.* 1957
Oil on canvas, 79½ x 69¾"
Private Collection, Zürich

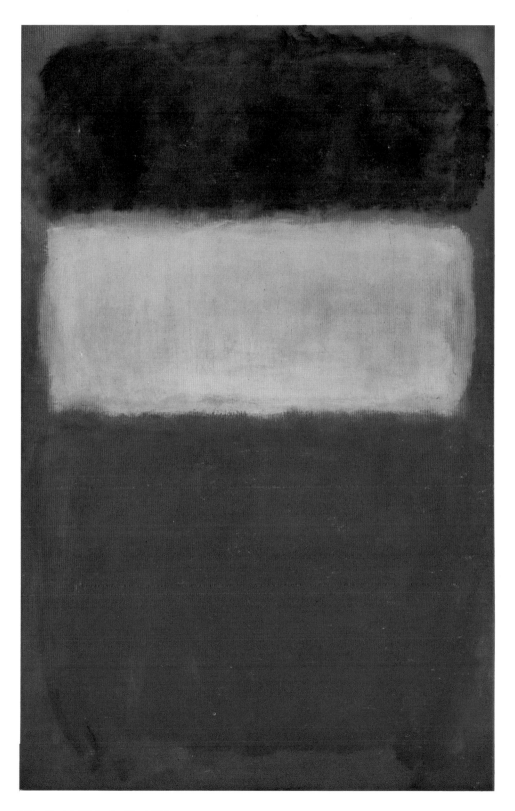

142. *Untitled (Number 7).* 1957
Oil on canvas, 69½ x 44″
Estate of Mary Alice Rothko

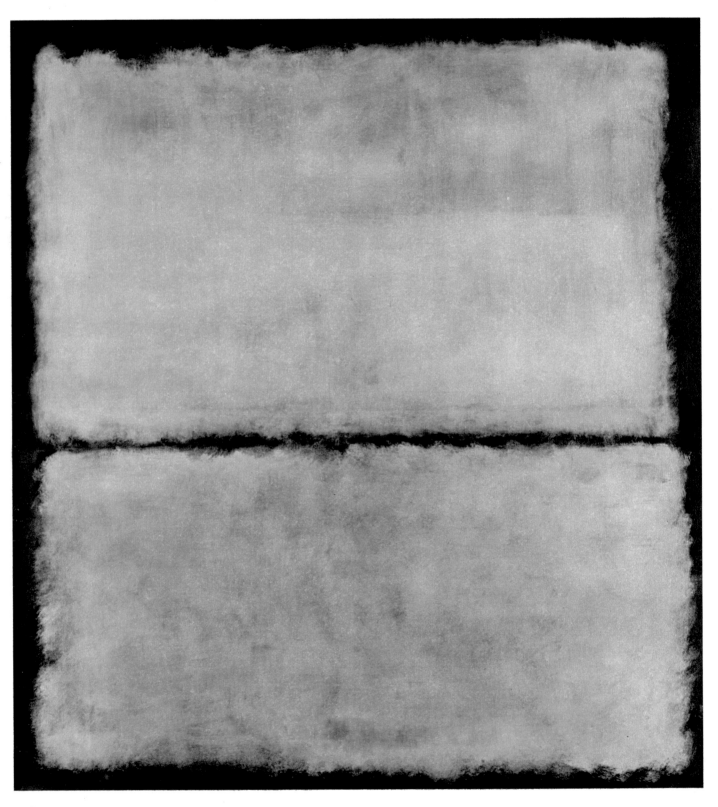

143. *Untitled.* 1955–56
 Oil on canvas, 64 x 58″
 Collection Gerald S. Elliott, Chicago

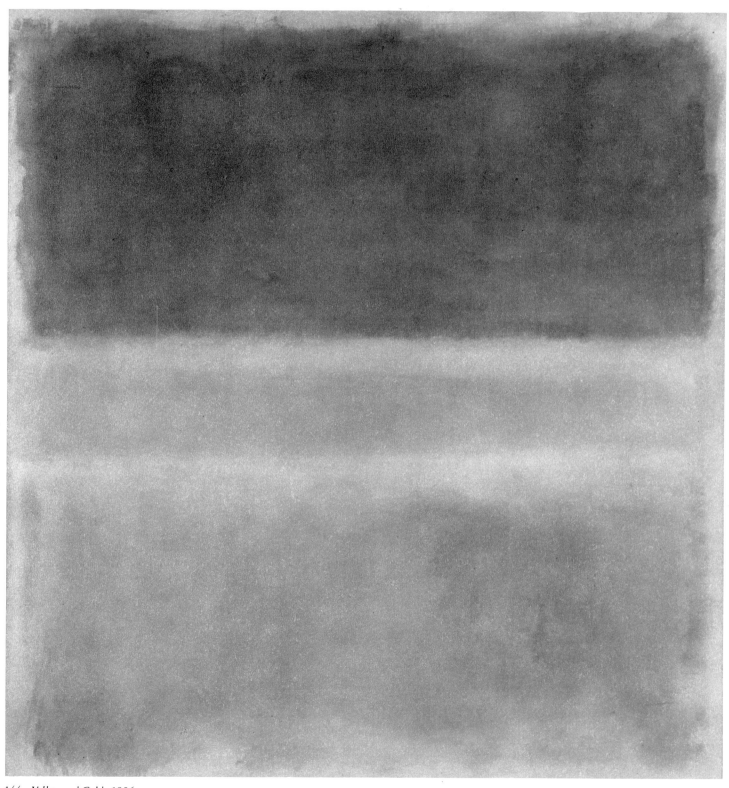

144. *Yellow and Gold.* 1956
Oil on canvas, 67⅛ x 62¾"
Collection The Museum of Modern Art, New York.
Gift of Philip Johnson

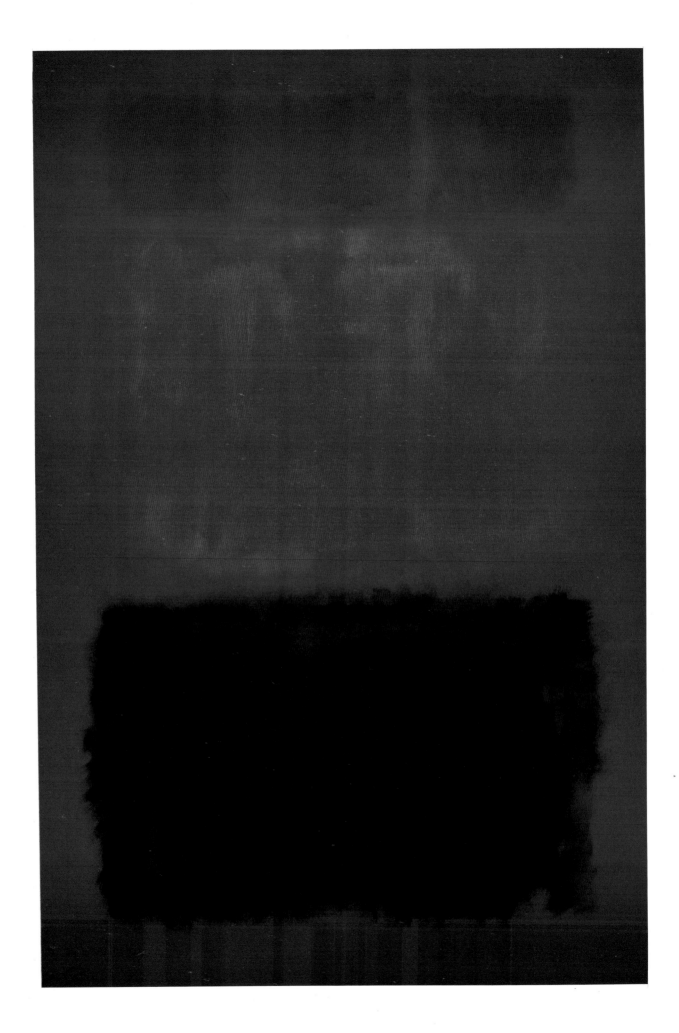

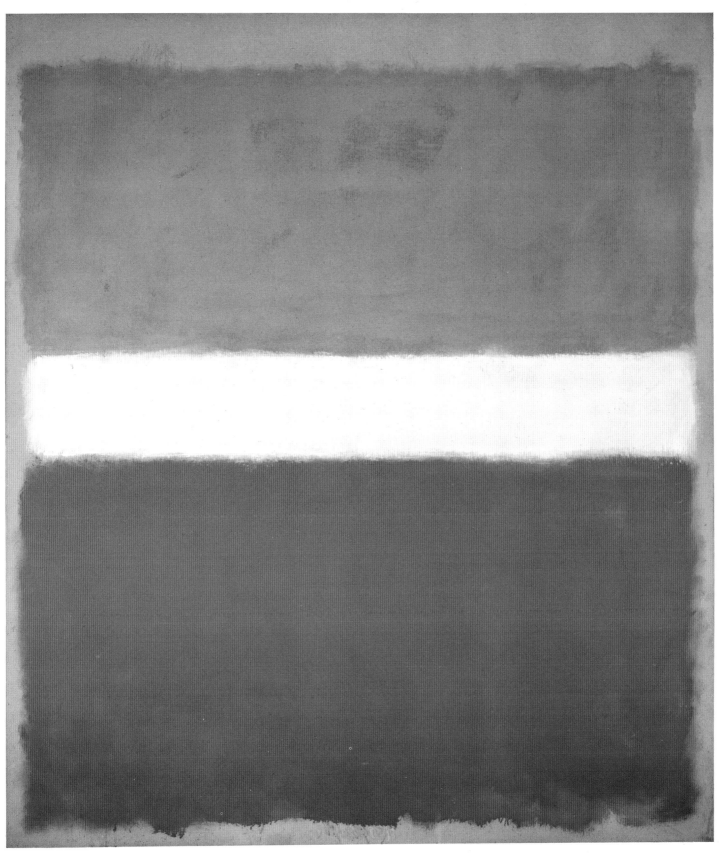

145. *Brown and Black in Reds.* 1958
Oil on canvas, 91½ x 60″
Collection Joseph E. & Seagram Sons, Inc.

146. *Number 16.* 1958
Oil on canvas, 79¾ x 69″
Estate of Mary Alice Rothko

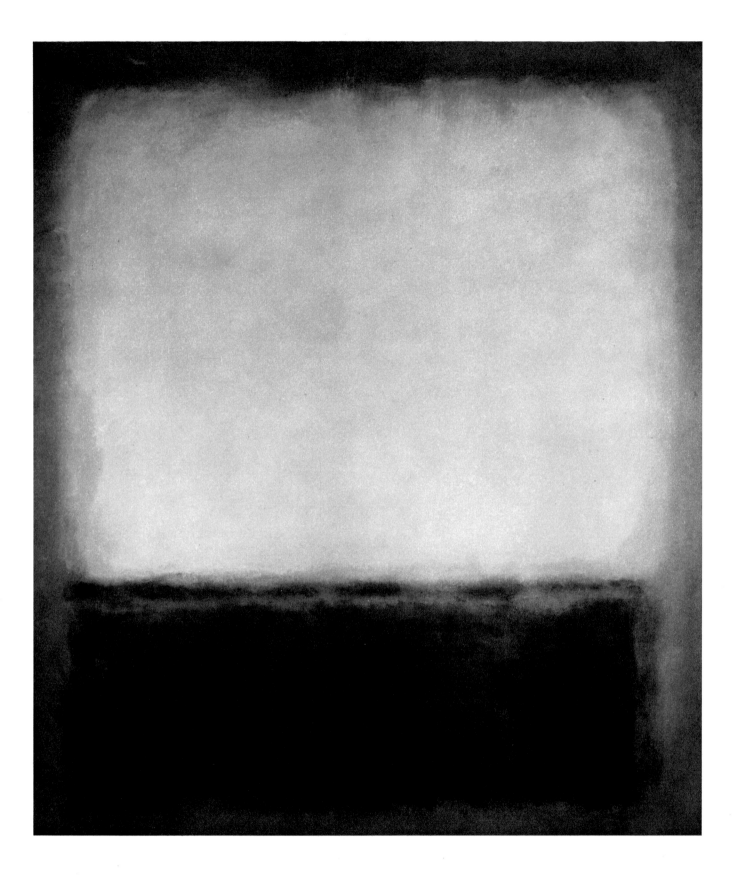

147. *Yellow over Purple.* 1956
 Oil on canvas, 69½ x 59¼"
 Morton Neumann Family Collection

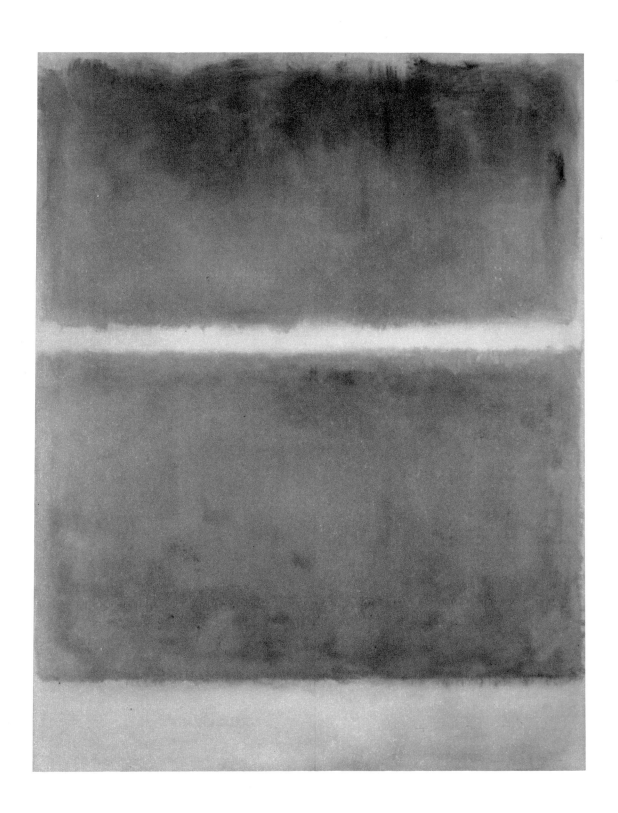

148. *Saffron*. 1957
Oil on canvas, 69¼ x 53½"
Collection Mr. and Mrs. Ralph I. Goldenberg, Chicago

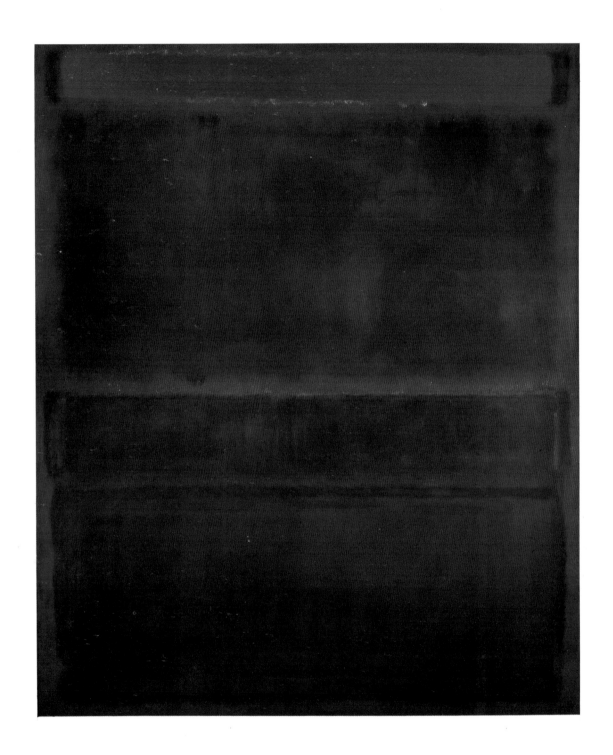

149. *Number 9.* 1958
Oil on canvas, 101 x 82″
Collection Mr. and Mrs. Donald Blinken

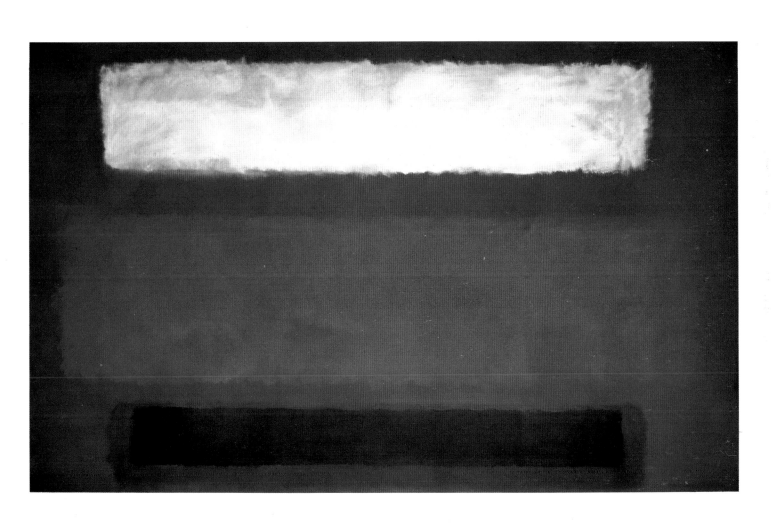

150. *Black, Maroons and White*. 1958
 Oil on canvas, 105 x 166″
 Collection Mr. and Mrs. Ben Heller, New York

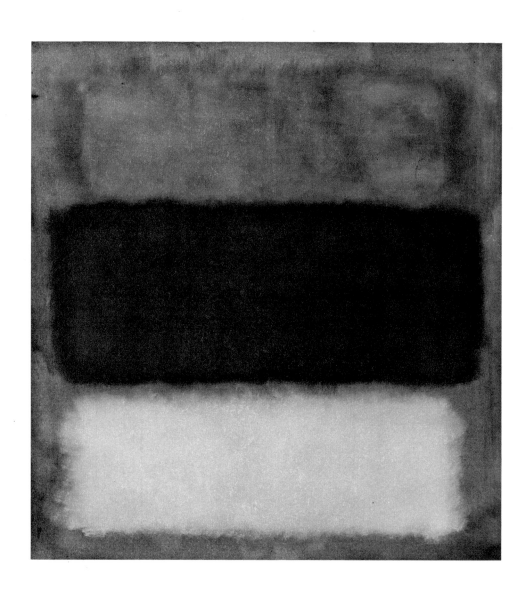

151. *Light Cloud, Dark Cloud.* 1957
Oil on canvas, 66¾ x 62½"
Collection The Fort Worth Art Museum , Benjamin J. Tillar Trust Fund

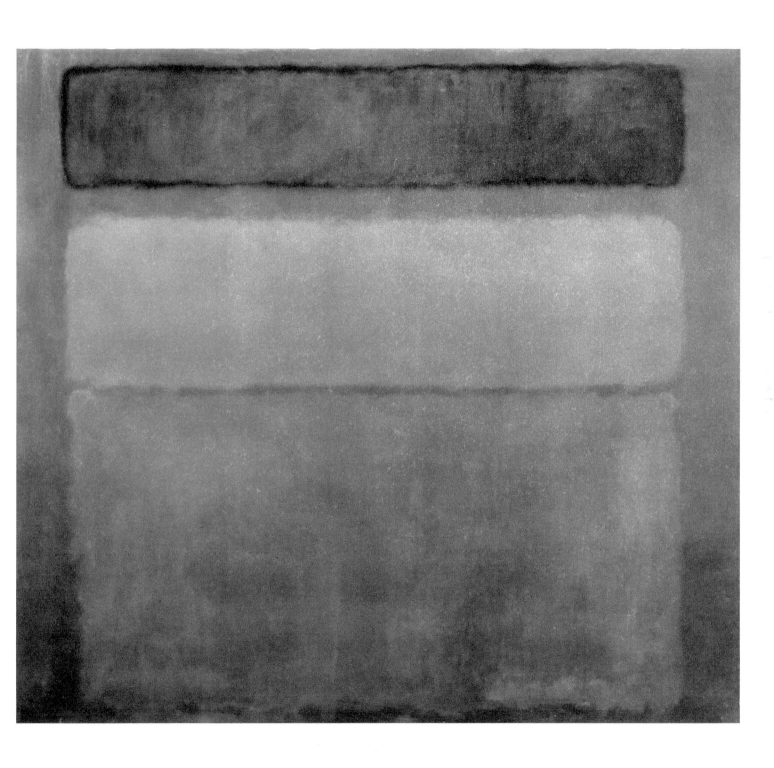

152. *Red, Brown and Black.* 1958
 Oil on canvas, 106⅝ x 117¼"
 Collection The Museum of Modern Art, New York.
 Mrs. Simon Guggenheim Fund

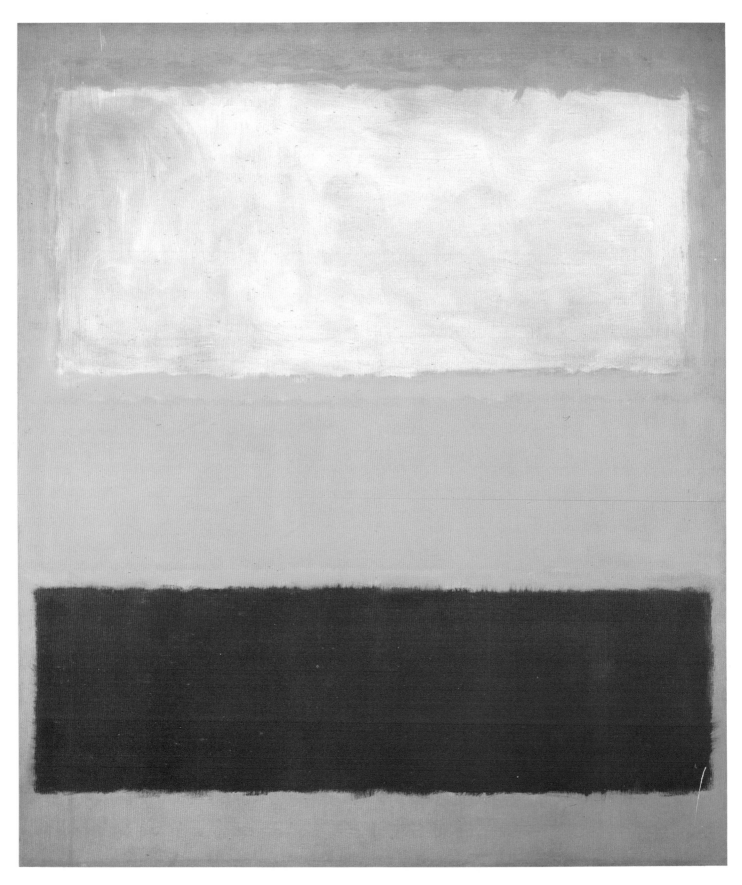

153. *White, Red on Yellow.* 1958
Oil on canvas, 95 x 81½″
Lent anonymously

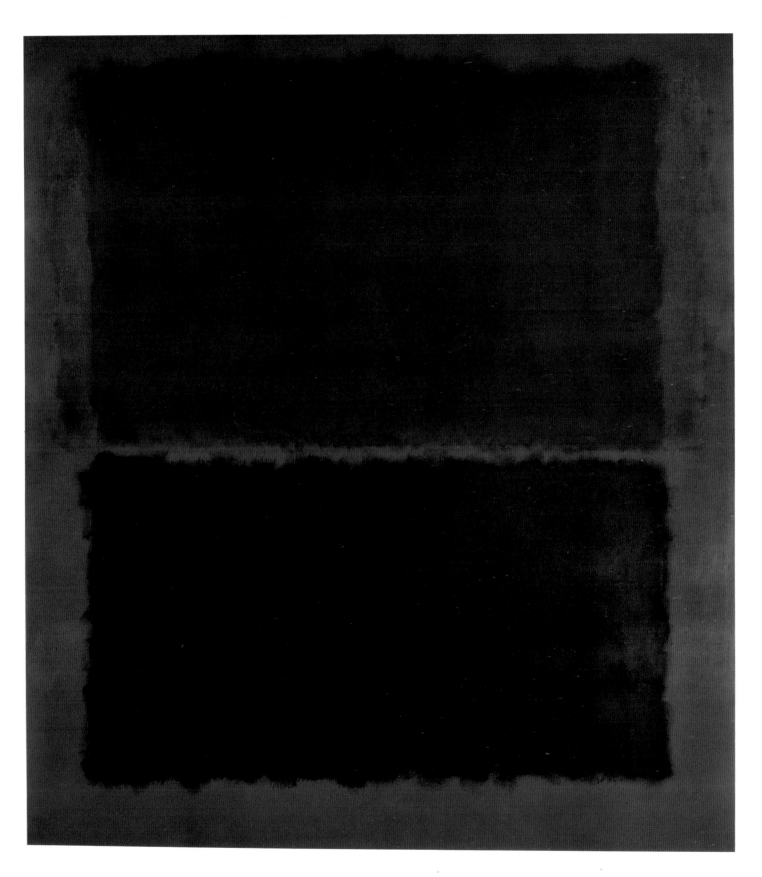

154. *Untitled.* 1961
 Oil on canvas, 105 x 83″
 Collection Arnold and Milly Glimcher, New York

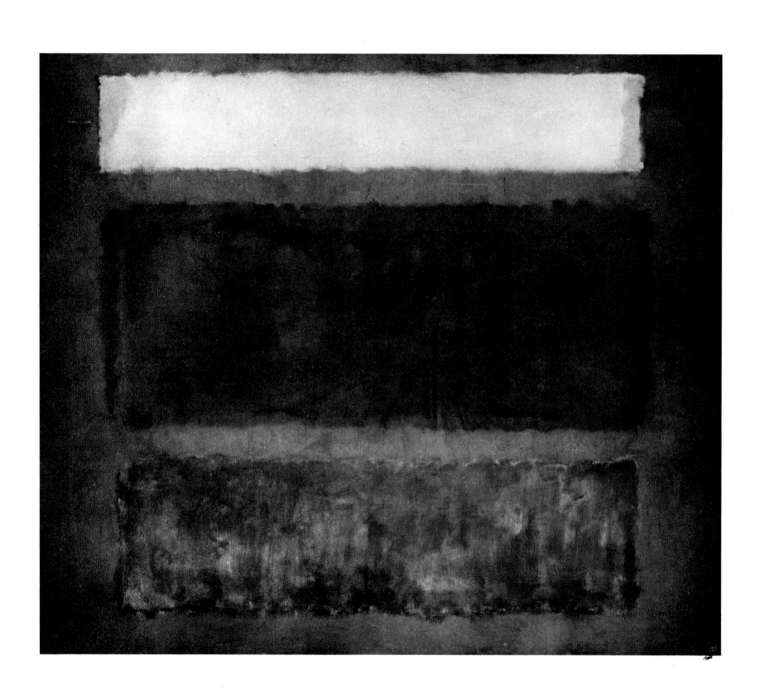

155. *Reds, Number 16.* 1960
 Oil on canvas, 102 x 119½"
 Collection The Metropolitan Museum of Art,
 New York, Purchase, Arthur A. Hearn Fund,
 George A. Hearn Fund, Hugo Kastor Fund, 1971

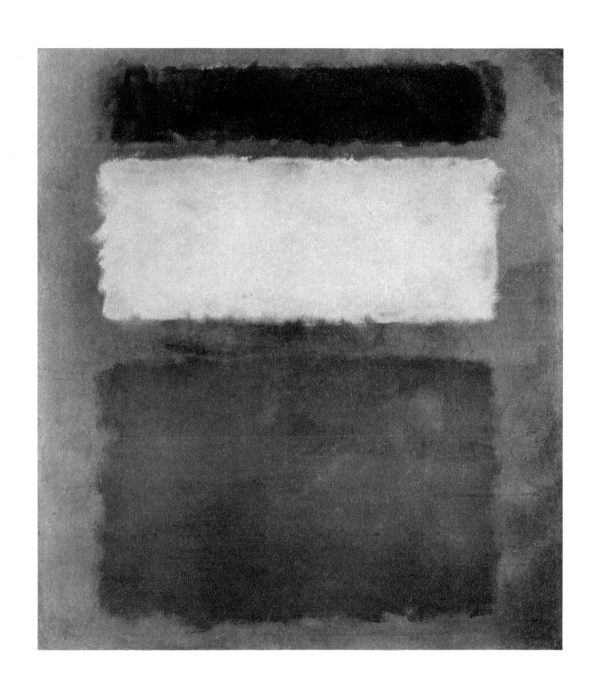

156. *Untitled.* 1960
Oil on canvas, 92⅞ x 81"
Collection The Toledo Museum of Art.
Gift of Edward Drummond Libbey

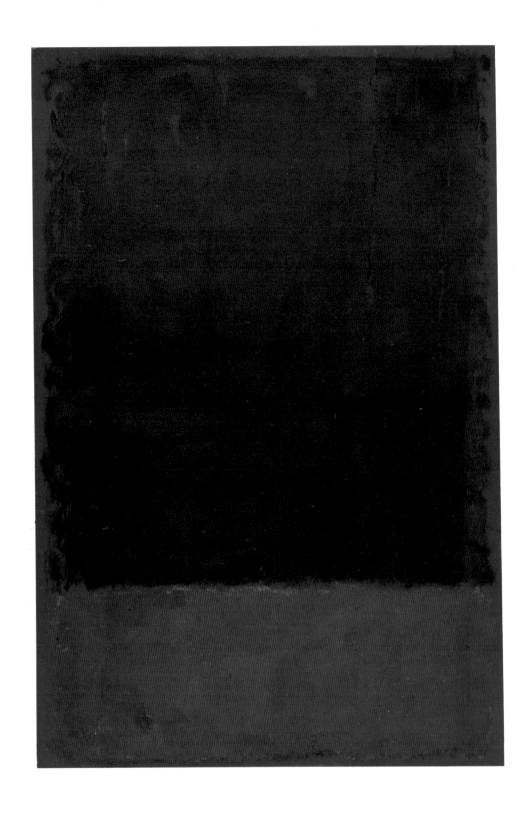

157. *Untitled.* 1959
Acrylic on paper, 38⅛ x 25"
Estate of Mary Alice Rothko

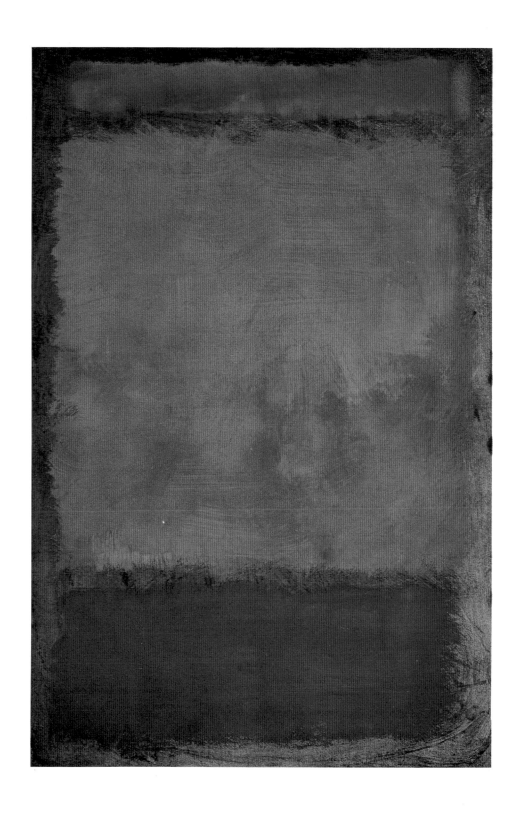

158. *Untitled.* 1959
 Acrylic on paper, 38 x 25″
 Estate of Mary Alice Rothko

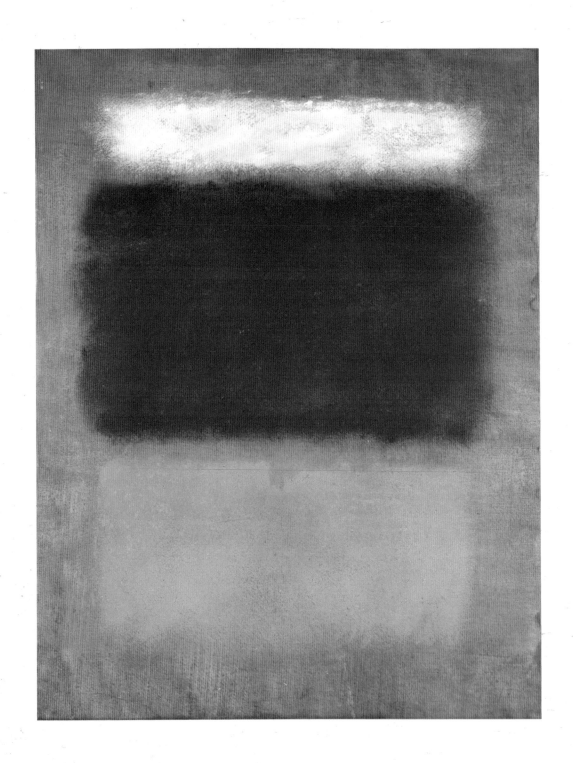

159. *Untitled.* 1960
 Oil on paper mounted on canvas, 25½ x 19½″
 Collection Mr. and Mrs. Lee V. Eastman

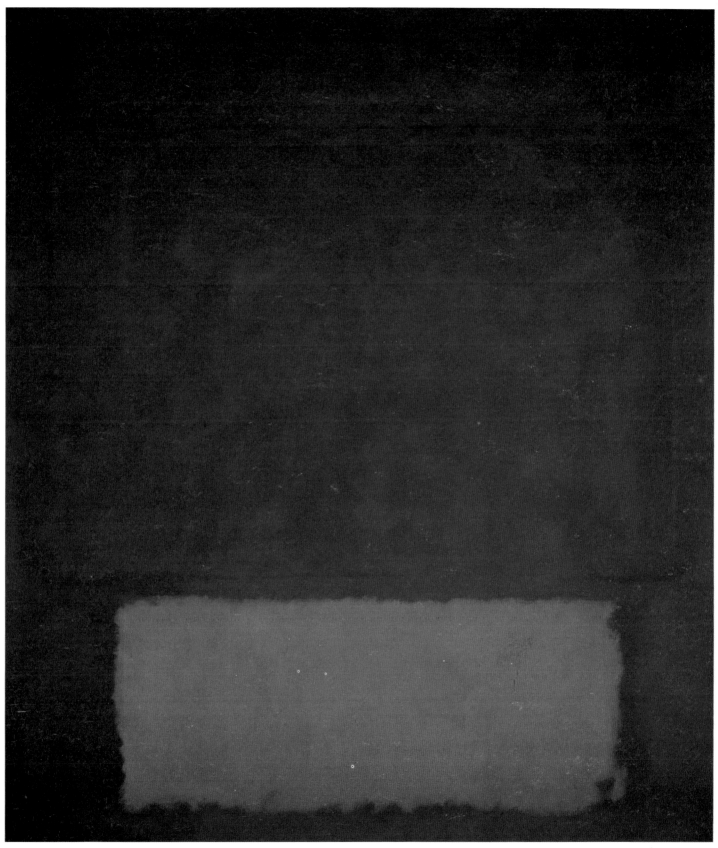

160. *Greyed Olive Green, Red on Maroon.* 1961
Oil on canvas, 101⅝ x 89½"
Lent anonymously

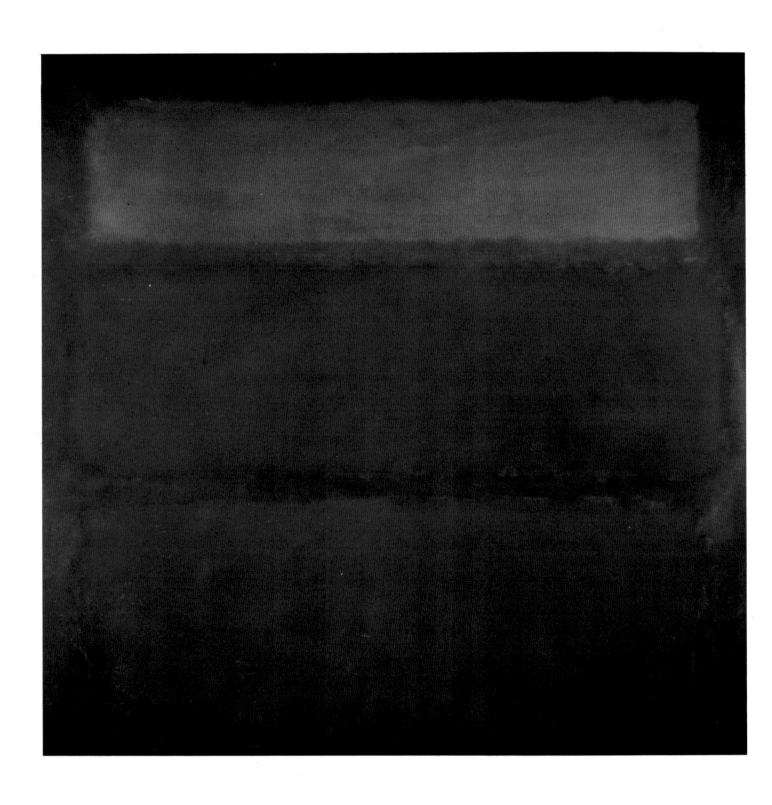

161. *Number 101.* 1961
 Oil on canvas, 79 x 81"
 Collection Mr. and Mrs. Joseph Pulitzer, Jr.

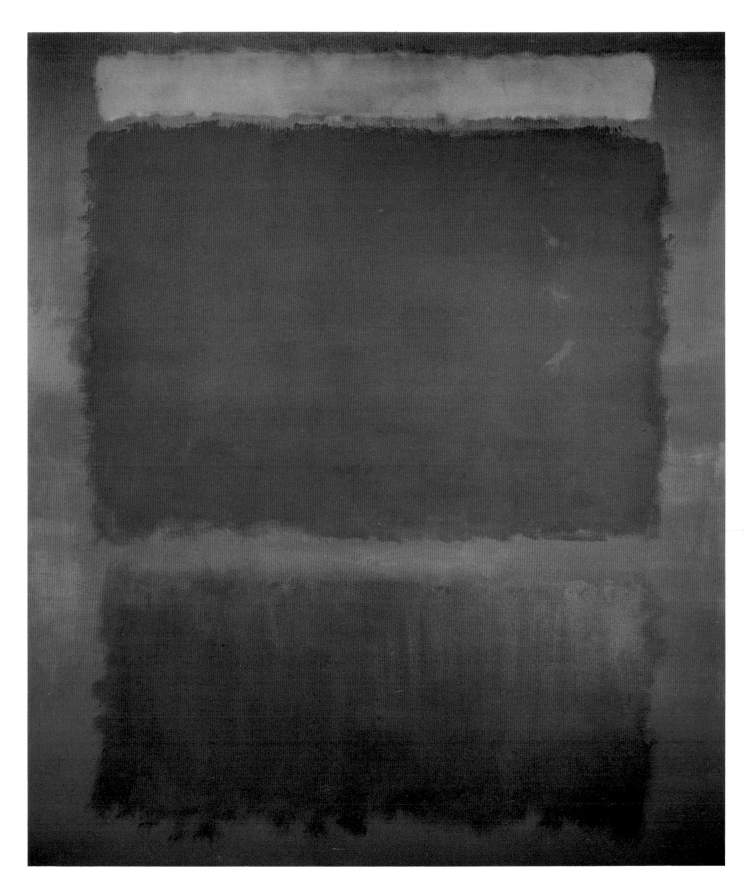

162. *Number 117*. 1961
Oil on canvas, 93 x 81"
Collection Mr. and Mrs. Donald Blinken

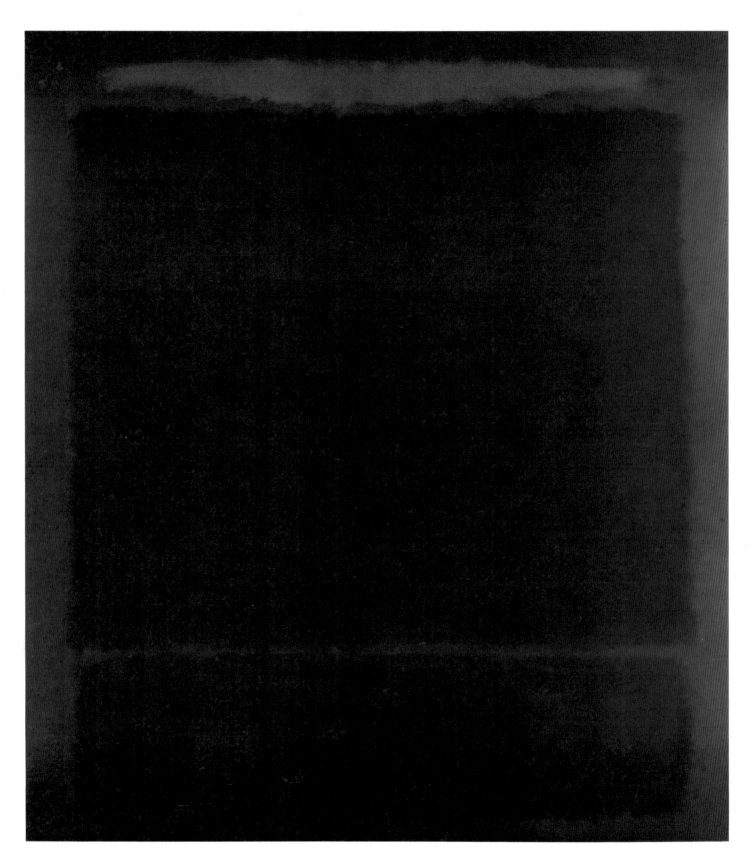

163. *Number 118.* 1961
Oil on canvas, 115 x 102½"
Collection Kunstsammlung Nordrhein-Westfalen, Düsseldorf

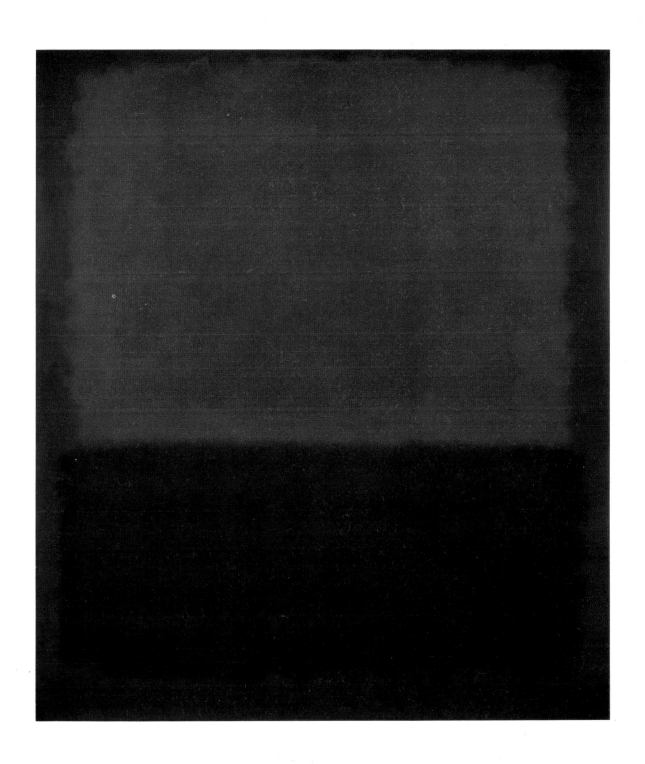

164. *Number 207 (Red over Dark Blue on Dark Grey).* 1961
 Oil on canvas, 92¾ x 81⅛"
 Collection University Art Museum,
 University of California, Berkeley

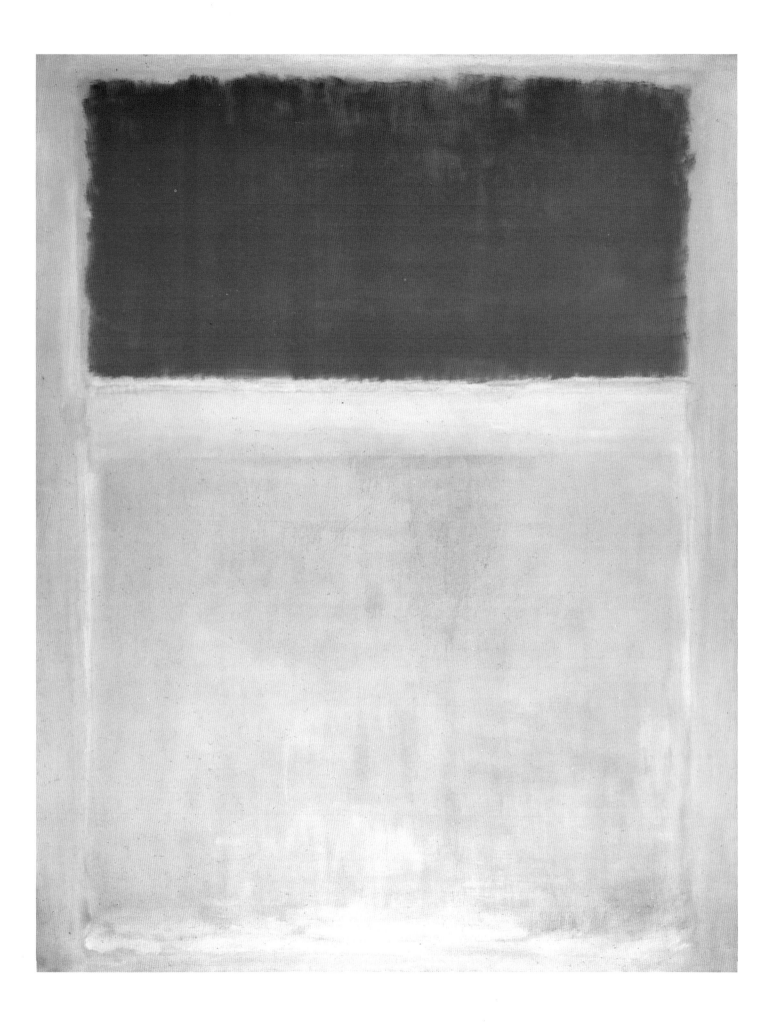

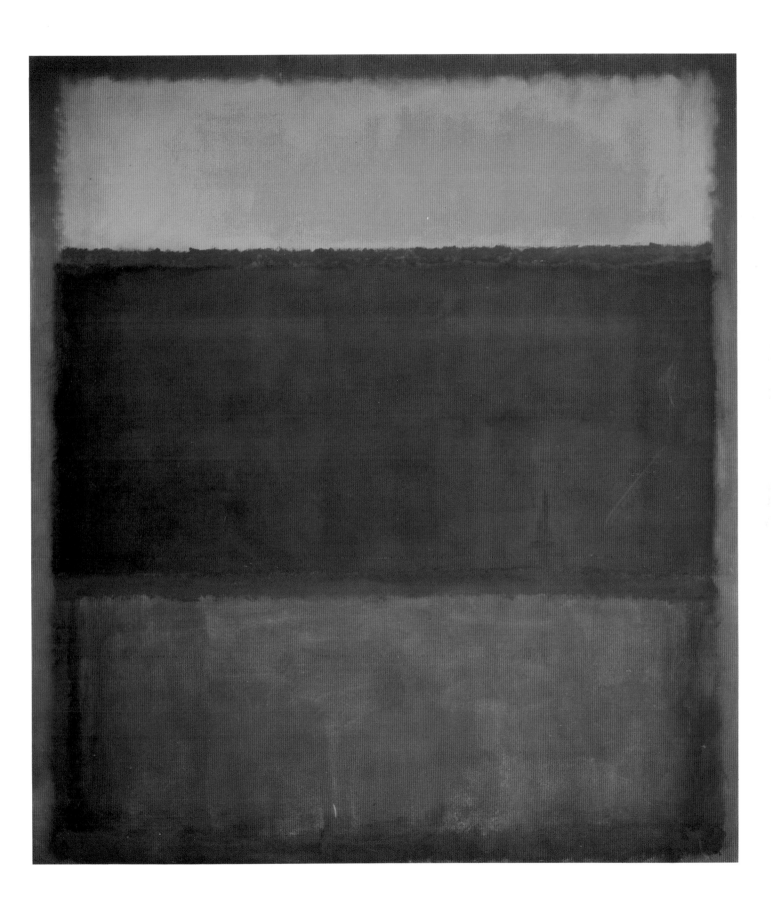

165. *Orange and Lilac over Ivory.* n.d.
Oil on canvas, 116 x 94"
Collection Dartmouth College Museum and Galleries,
Hanover, New Hampshire

166. *Orange, Wine, Grey on Plum.* 1961
Oil on canvas, 104½ x 92½"
Lent anonymously

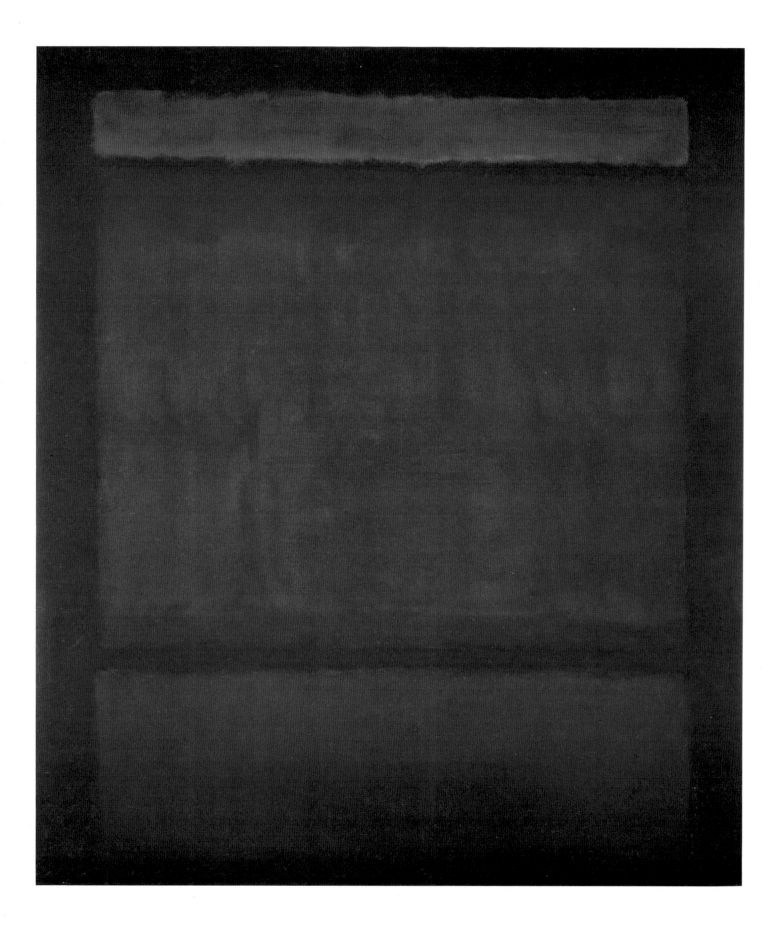

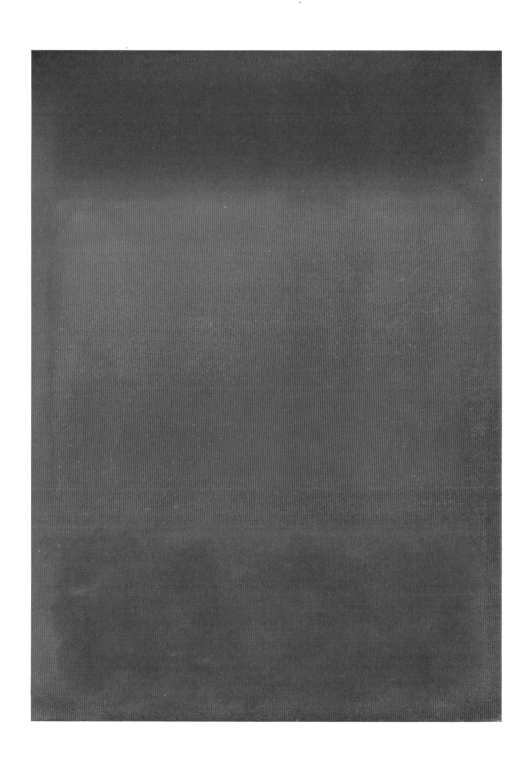

167. *Painting.* 1961
Oil on canvas, 93 x 80"
Collection The Museum of Fine Arts, Houston

168. *Untitled.* 1961
Oil on canvas, 69 x 50"
Collection Mr. and Mrs. Lee V. Eastman

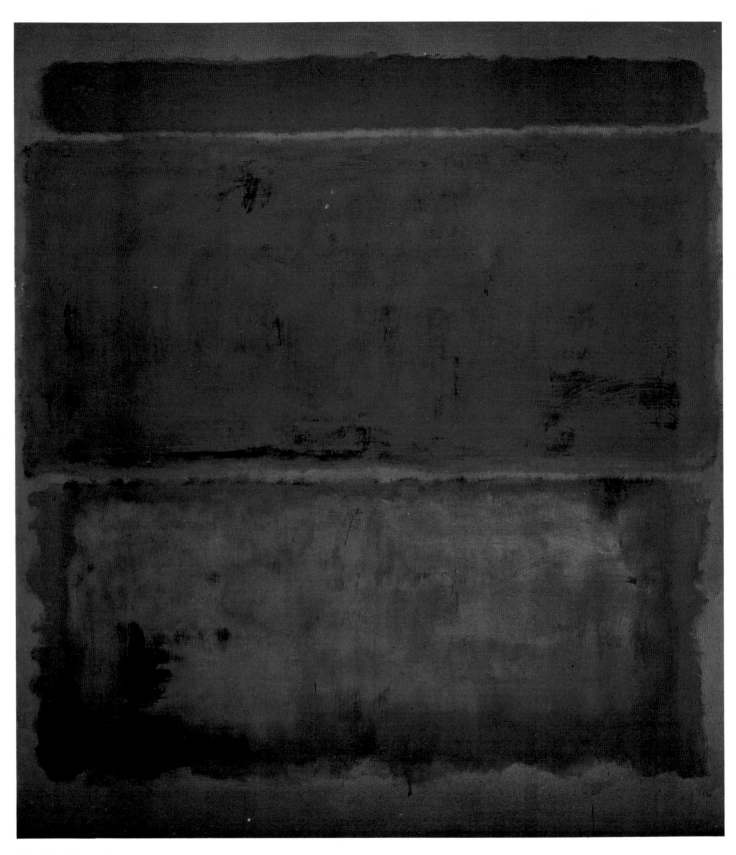

169. *Untitled.* 1961
Oil on canvas, 92½ x 81½"
Courtesy The Pace Gallery

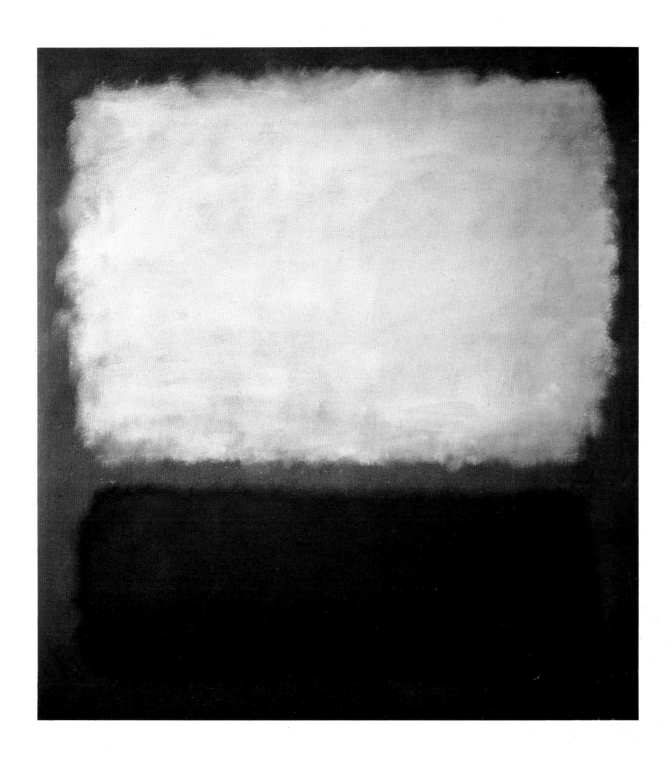

170. *Blue and Grey*. 1962
Oil on canvas, 79¼ x 69"
Frederick Weisman Family Collection

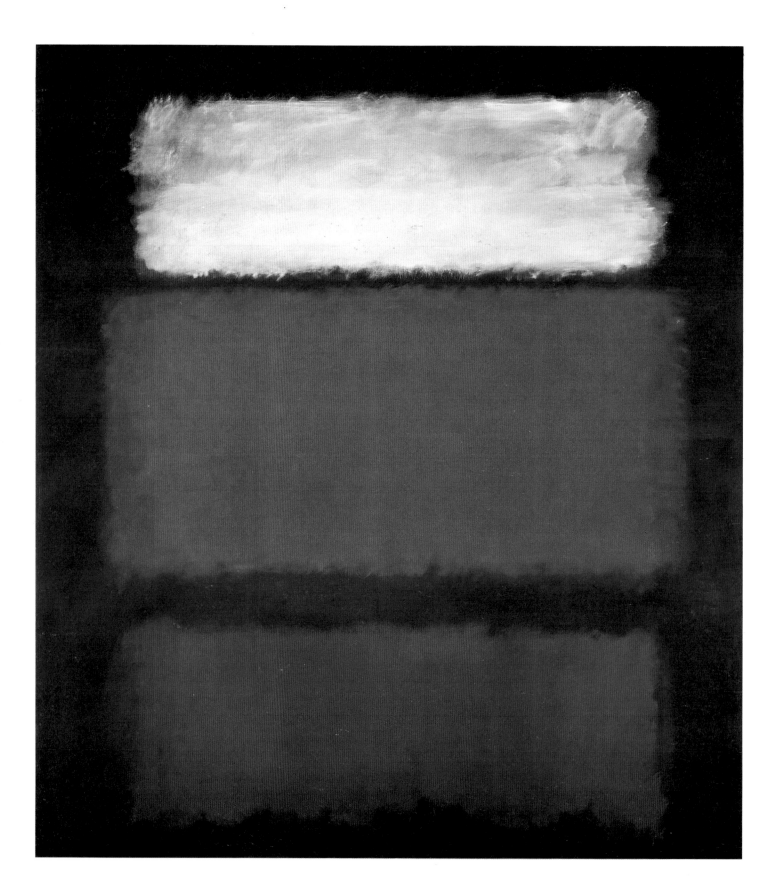

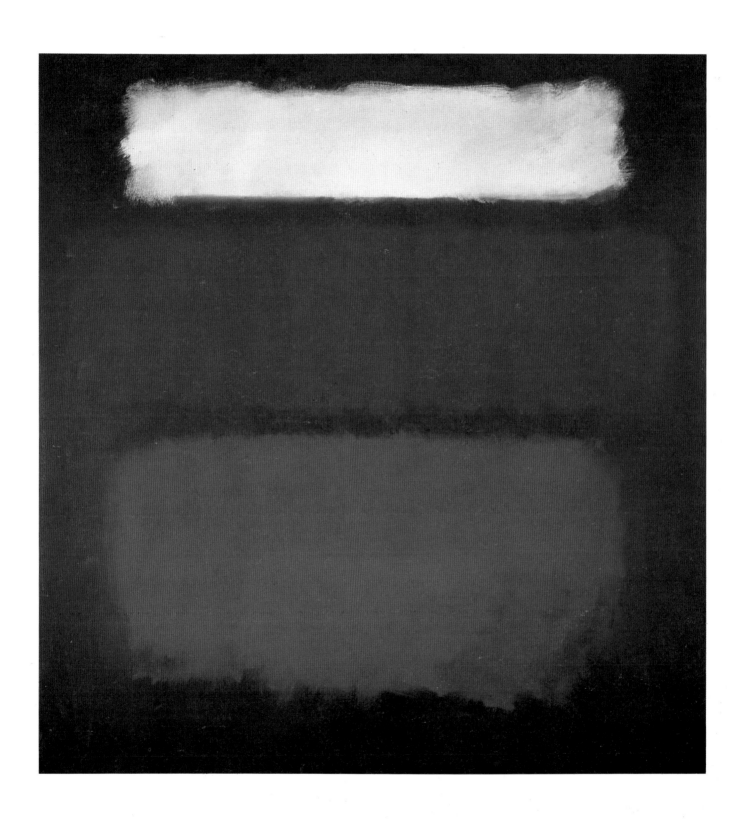

171. *Number 1, White and Red.* 1962
Oil on canvas, 102 x 90″
Collection Art Gallery of Ontario;
gift from the Women's Committee Fund, 1962

172. *Number 28.* 1962
Oil on canvas, 81 x 76⅜″
Estate of Mary Alice Rothko

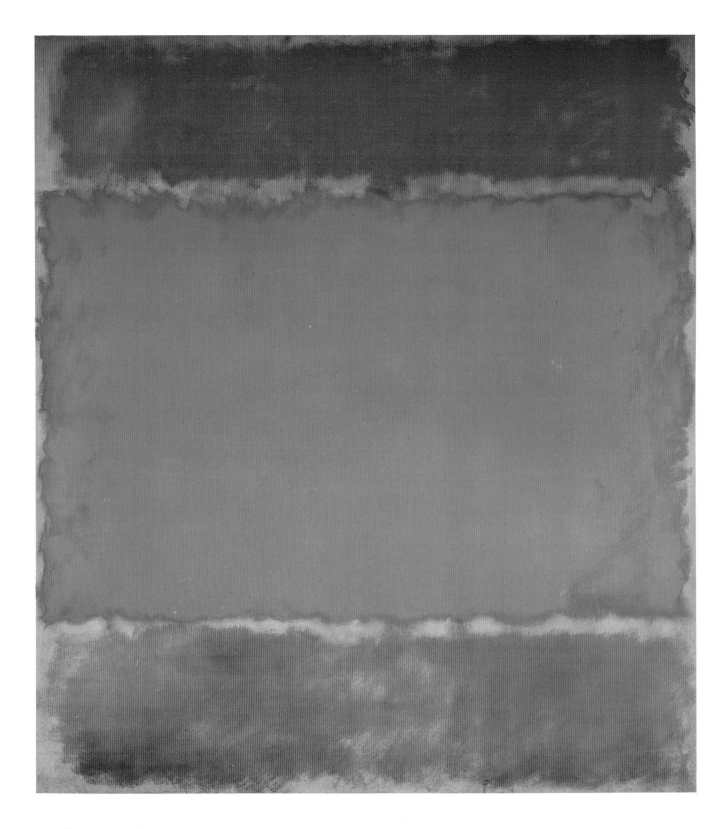

173. *Number 212*. 1962
 Oil on canvas, 69⅜ x 62″
 Estate of Mary Alice Rothko

174. *Red, Orange, Orange on Red*. 1962
 Oil on canvas, 92 x 80½″
 Collection The St. Louis Art Museum
 Purchase: funds given by
 the Shoenberg Foundation

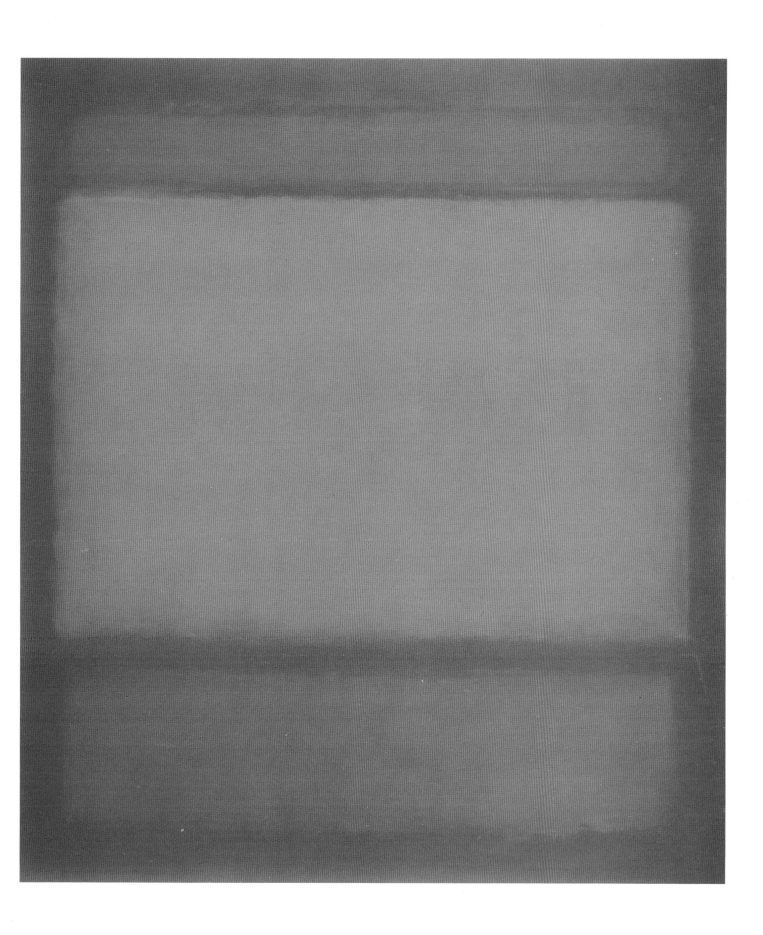

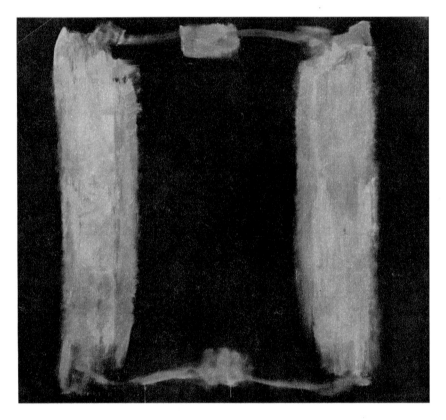
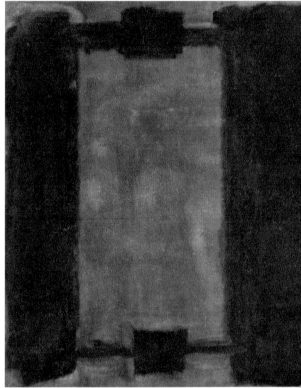

175-177. Triptych from *Harvard Murals*. 1962
Oil on canvas, left panel 104⅞ x 117″; central panel 104⅞ x 180½″; right panel 104⅞ x 96″
Courtesy of the President and Fellows of Harvard College

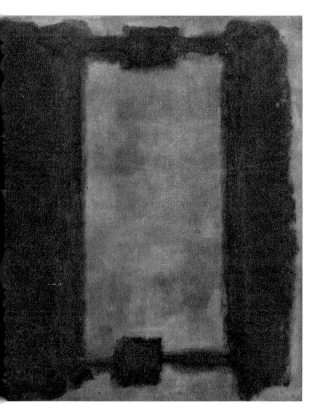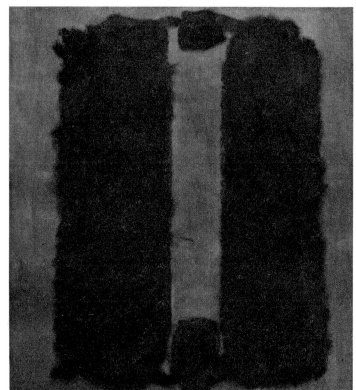

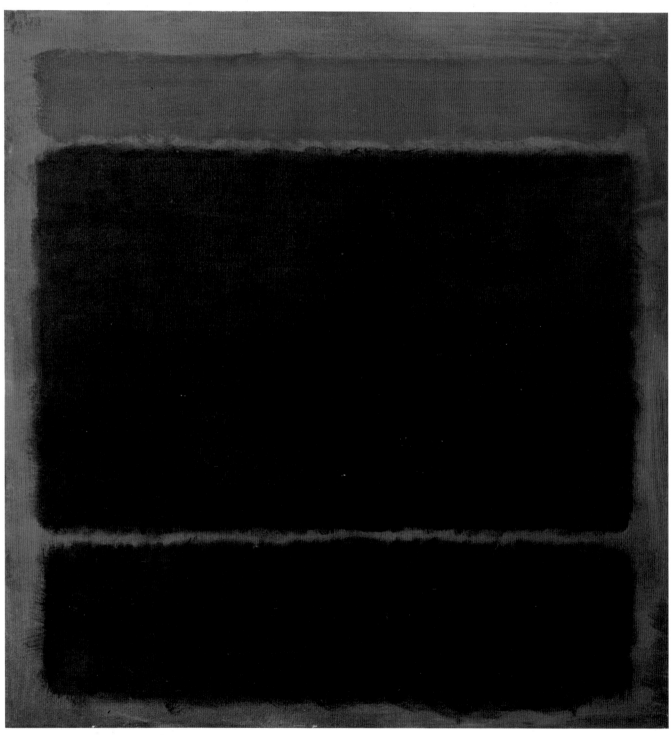

178. *Rust, Blacks on Plum.* 1962
Oil on canvas, 60 x 57"
Courtesy The Pace Gallery

179. *Dark Grey Tone on Maroon.* 1963
Oil on canvas, 134 x 72"
Estate of Mark Rothko

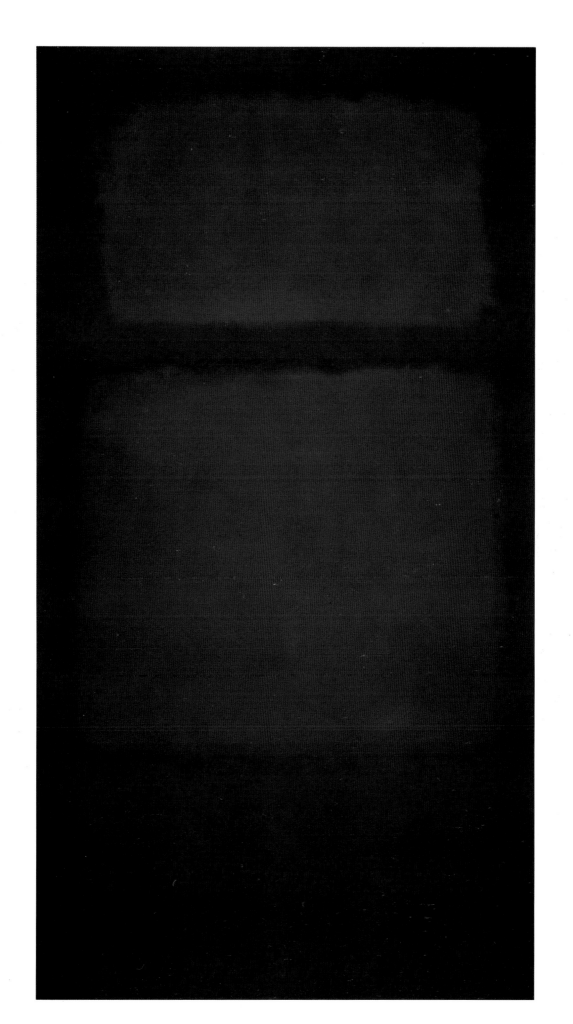

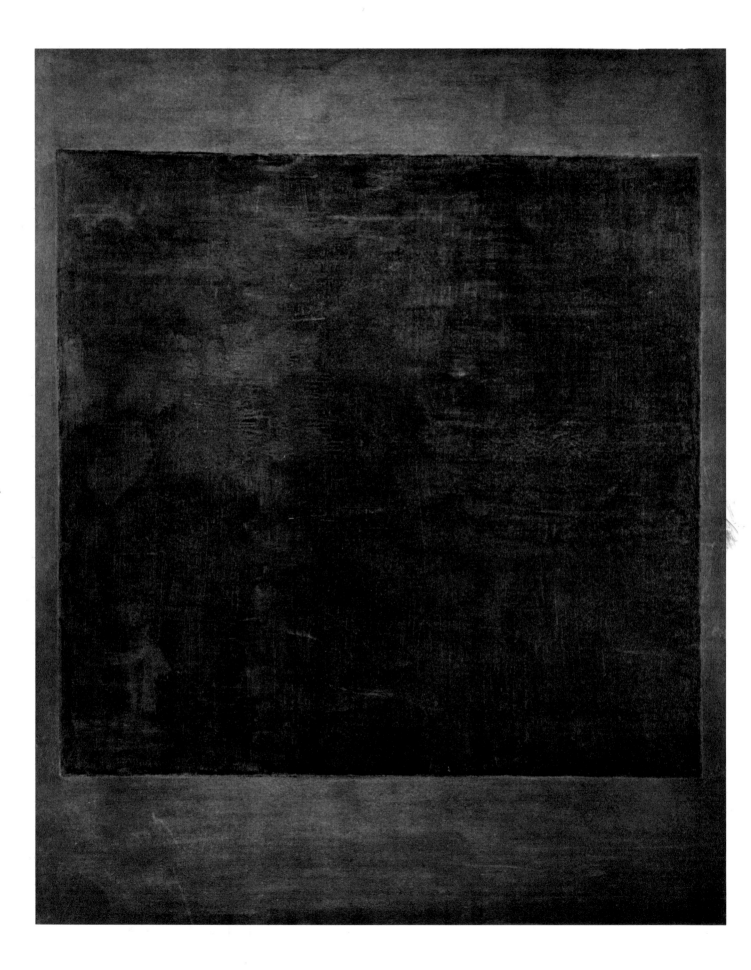

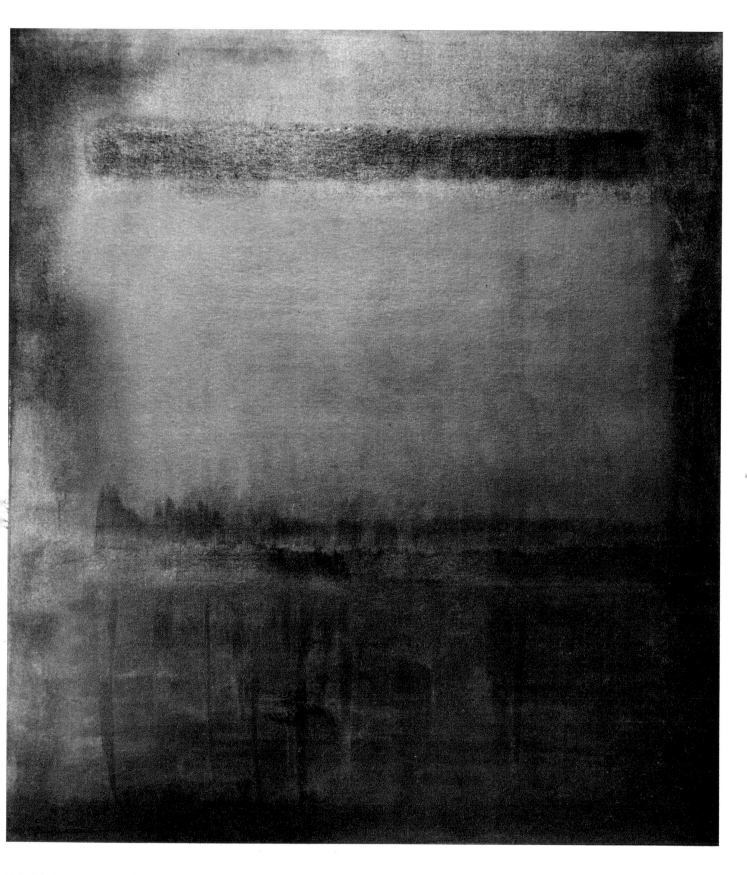

180. *Black on Dark Maroon.* 1964
Oil on canvas, 97 x 76"
Lent anonymously

181. *Brown, Green, Green-Grey on Deep Brown.* ca. 1965
Oil on canvas, 93¼ x 81½"
Collection Carter Burden, New York

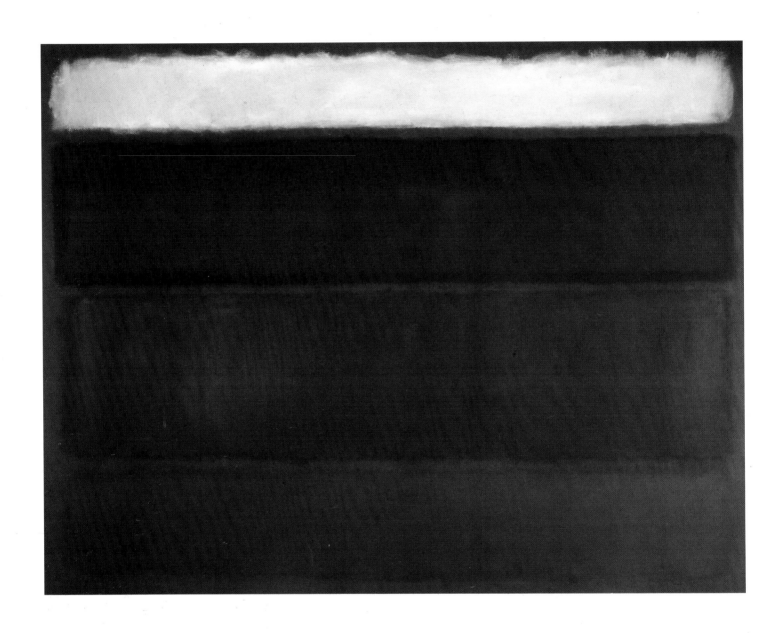

182. *Untitled*. 1963
 Oil on canvas, 69 x 90″
 Collection Mr. and Mrs. Richard E. Lang,
 Medina, Washington

183. *Untitled*. 1964
 Oil on canvas, 81 x 69″
 Collection Barbara and Donald Jonas

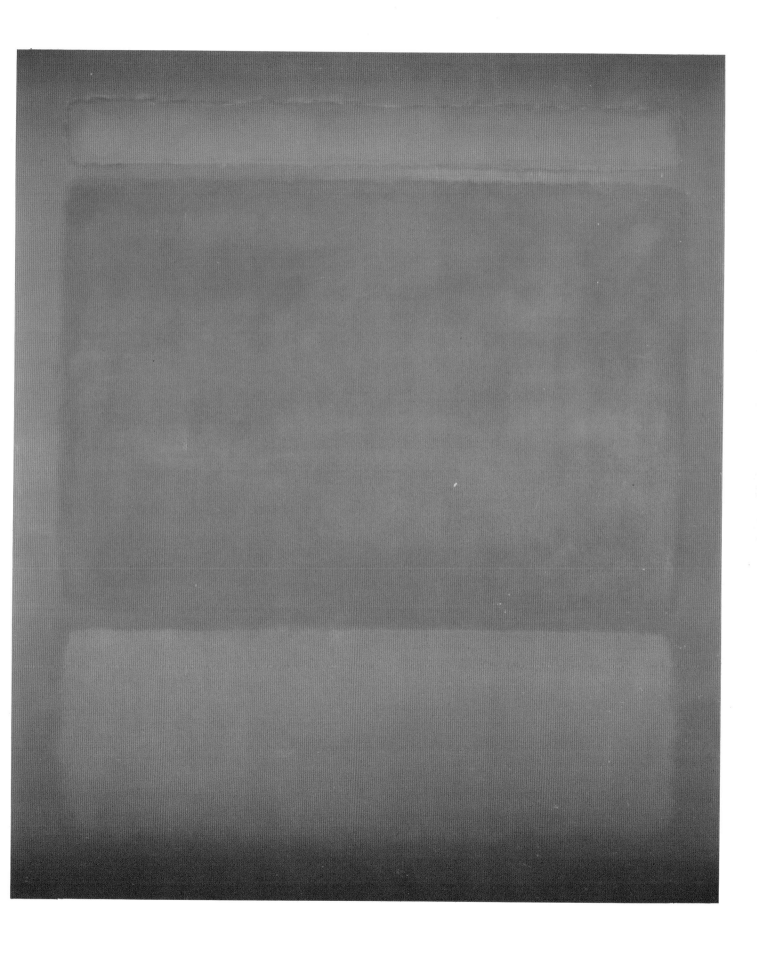

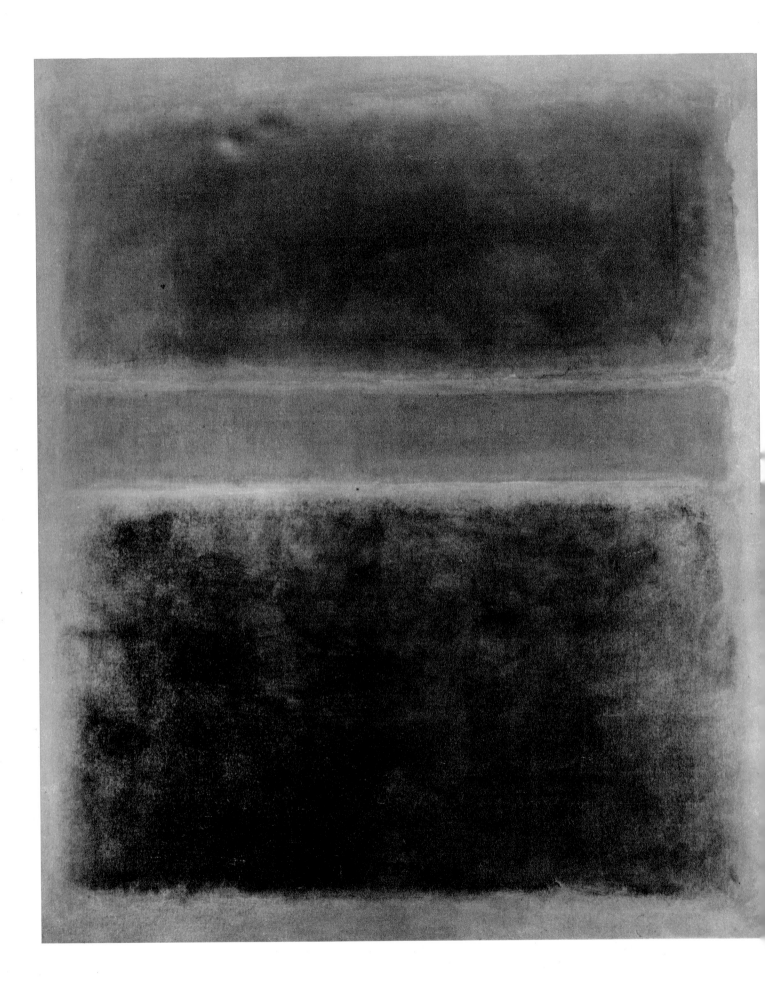

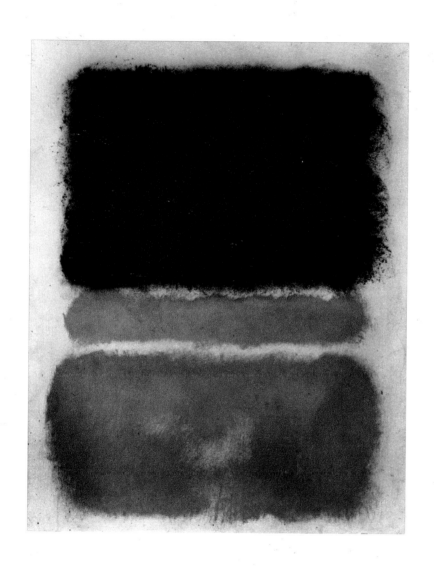

184. *Green, Black, Green.* 1966
Oil on canvas, 82 x 70″
Collection Dr. Paul Todd Makler

185. *Red.* 1968
Oil on paper mounted on canvas, 33 x 25¾″
Collection Mrs. Hannelore Schulhof

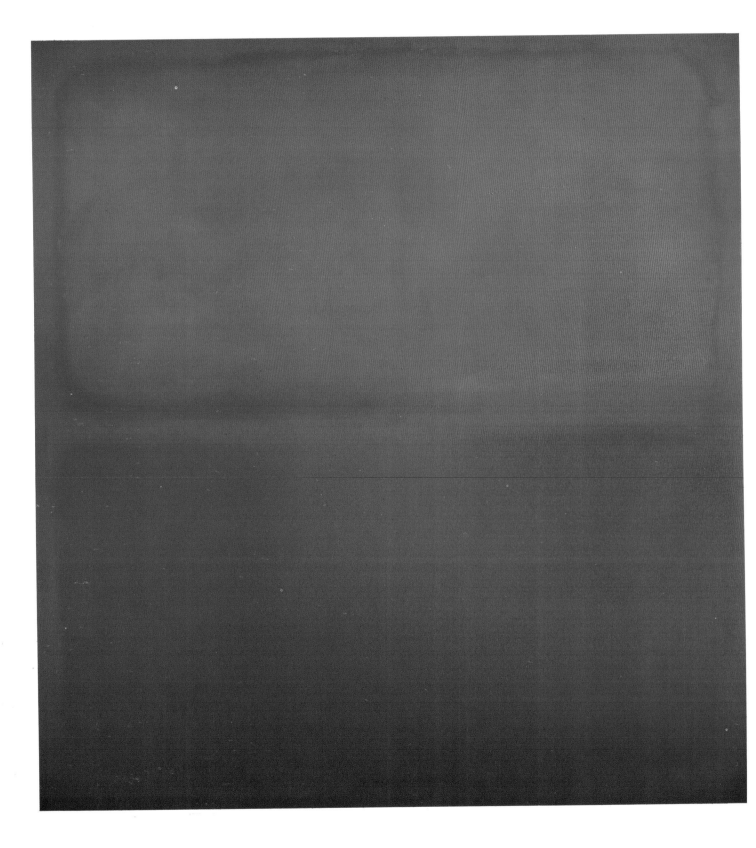

186. *Untitled*. 1967
Oil on canvas, 81 x 76″
Private Collection

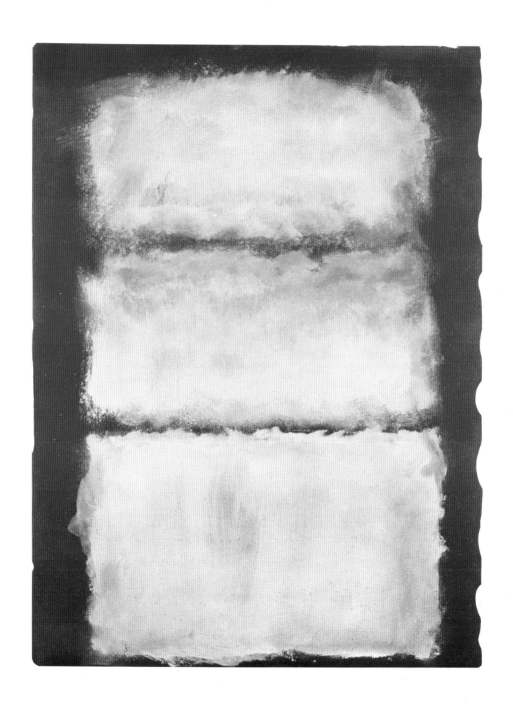

187. *Untitled.* 1968
 Acrylic on paper, 29 x 22″
 Estate of Mary Alice Rothko

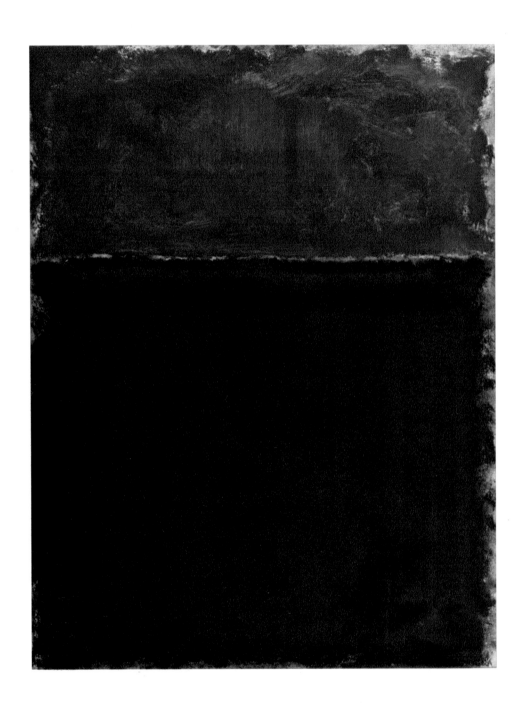

188. *Untitled.* 1968
Acrylic on paper, 32⅞ x 25″
Estate of Mark Rothko

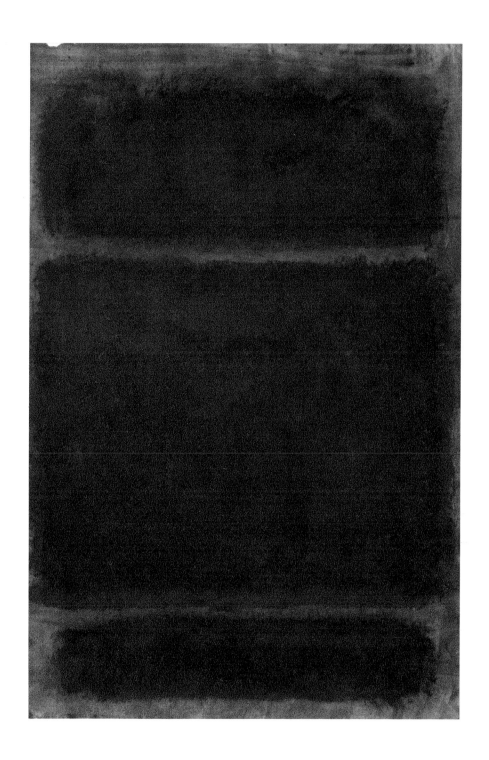

189. *Untitled.* 1968
 Acrylic on paper, 40½ x 27"
 Estate of Mark Rothko

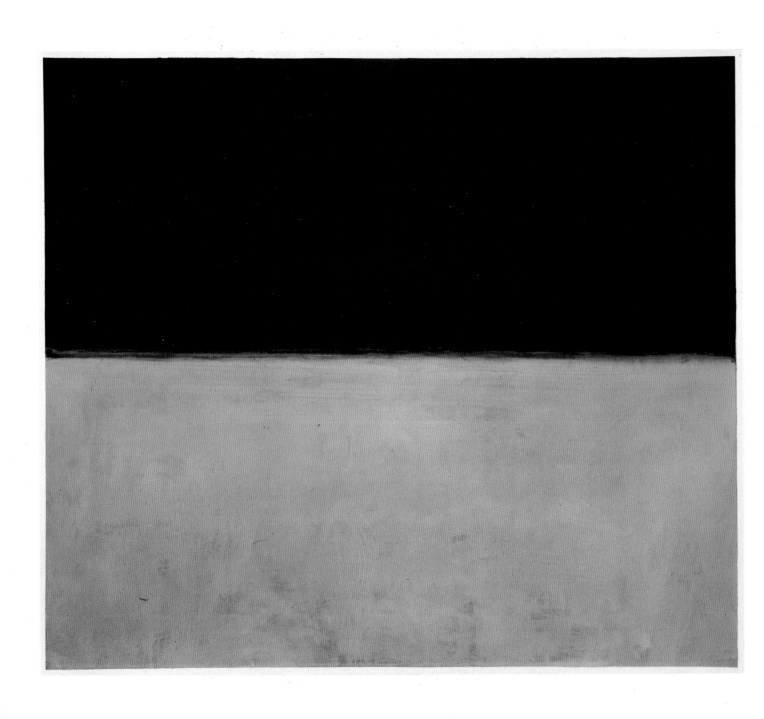

190. *Black on Grey.* 1969
Acrylic on canvas, 81¼ x 93¼"
Estate of Mark Rothko

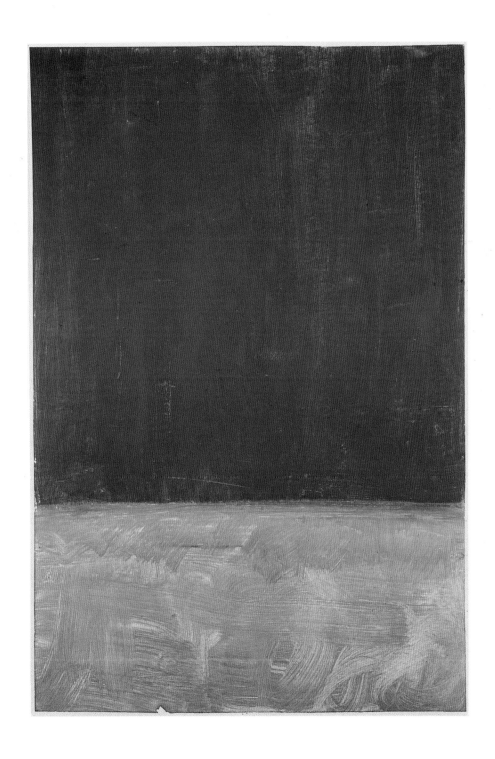

191. *Brown and Grey.* 1969
 Acrylic on paper, 72 x 48″
 Estate of Mark Rothko

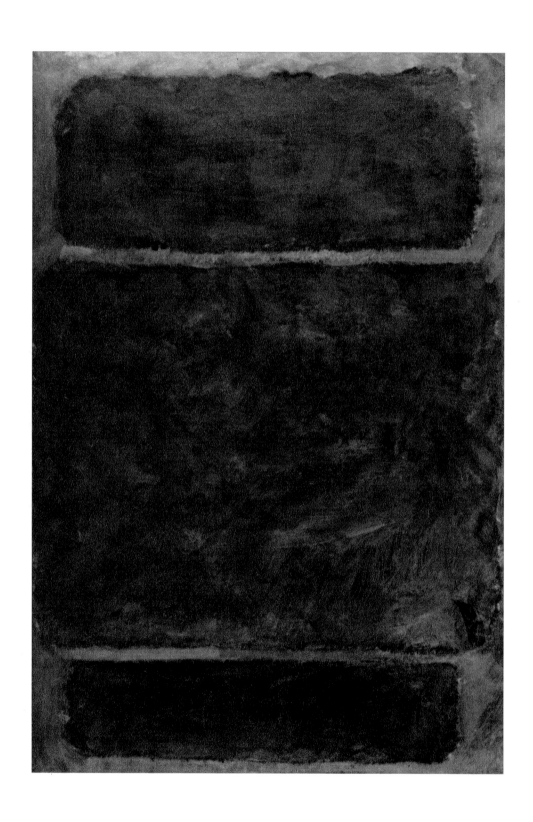

192. *Untitled.* 1968
Acrylic on paper, 58⅜ x 29¾"
Estate of Mark Rothko

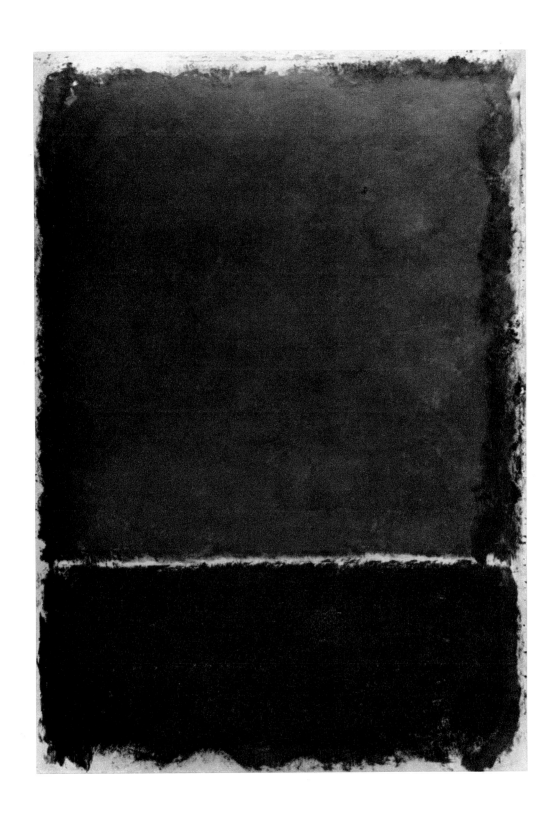

193. *Untitled.* 1968
 Acrylic on paper, 59⅞ x 42⅜″
 Lent anonymously

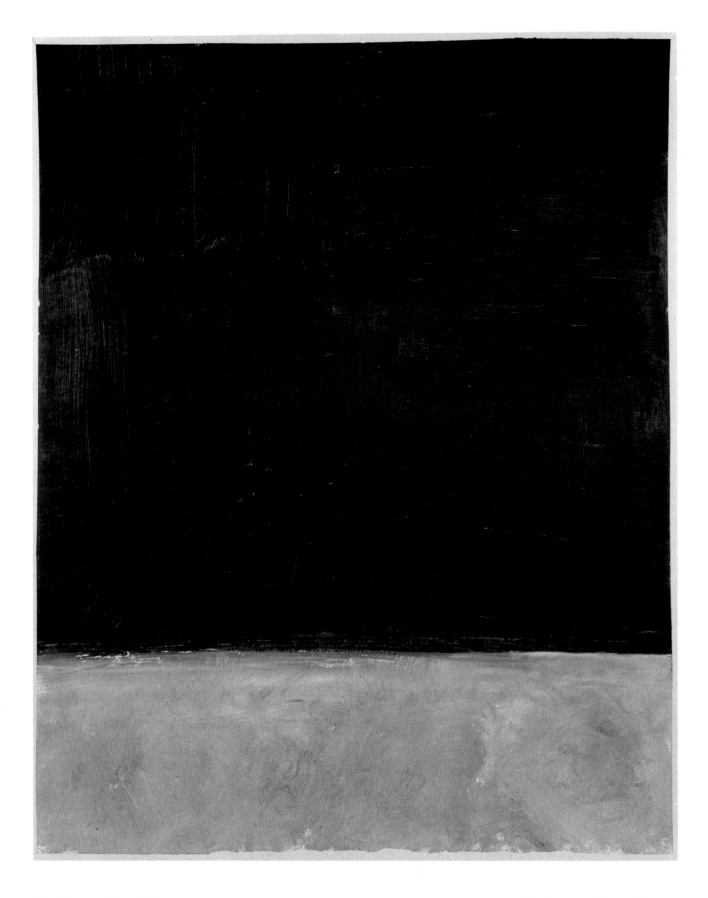

194. *Brown and Grey.* 1969
Acrylic on paper, 60¼ x 48¼"
Estate of Mark Rothko

195. *Brown and Grey.* 1969
Acrylic on paper, 62 x 48⅛"
Lent anonymously

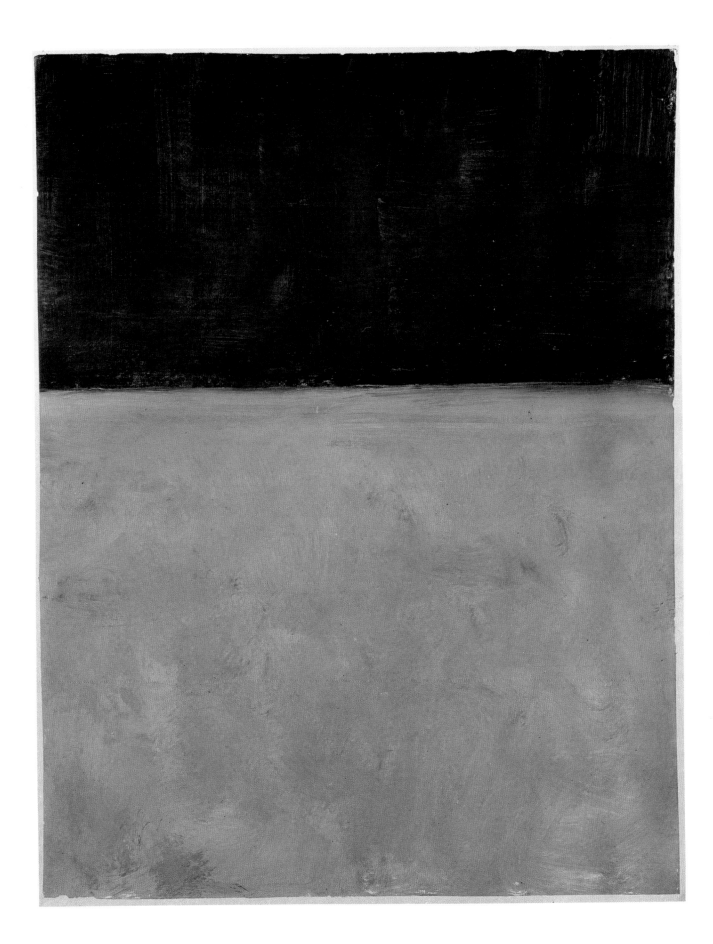

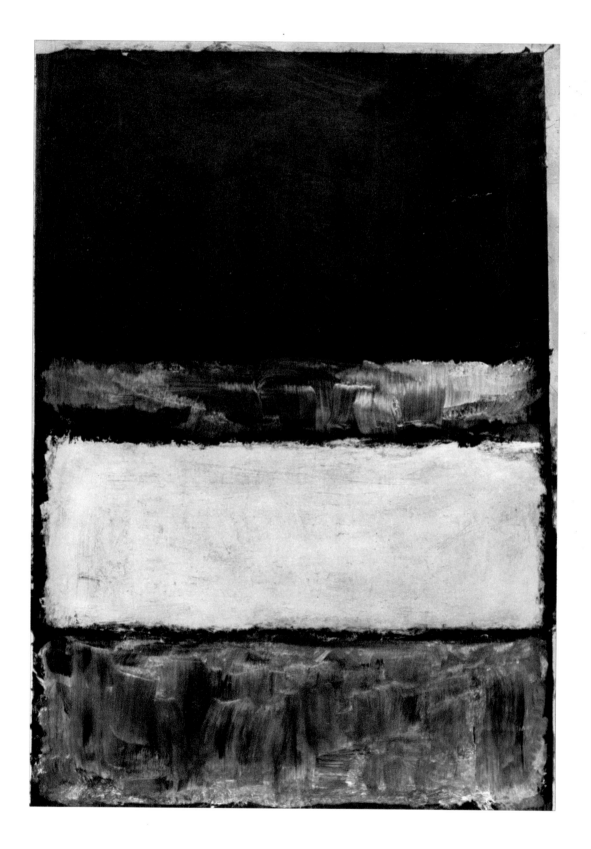

196. *Untitled.* 1968
 Acrylic on paper, 60 x 42¼"
 Lent anonymously

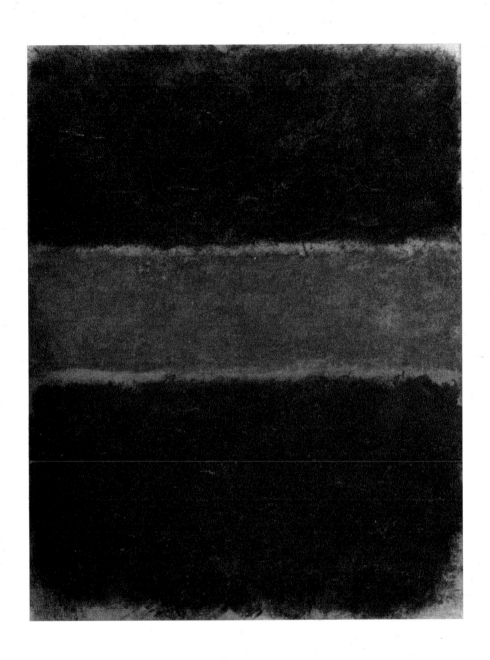

197. *Untitled.* 1968
 Acrylic on paper, 33¾ x 25⅝"
 Lent anonymously

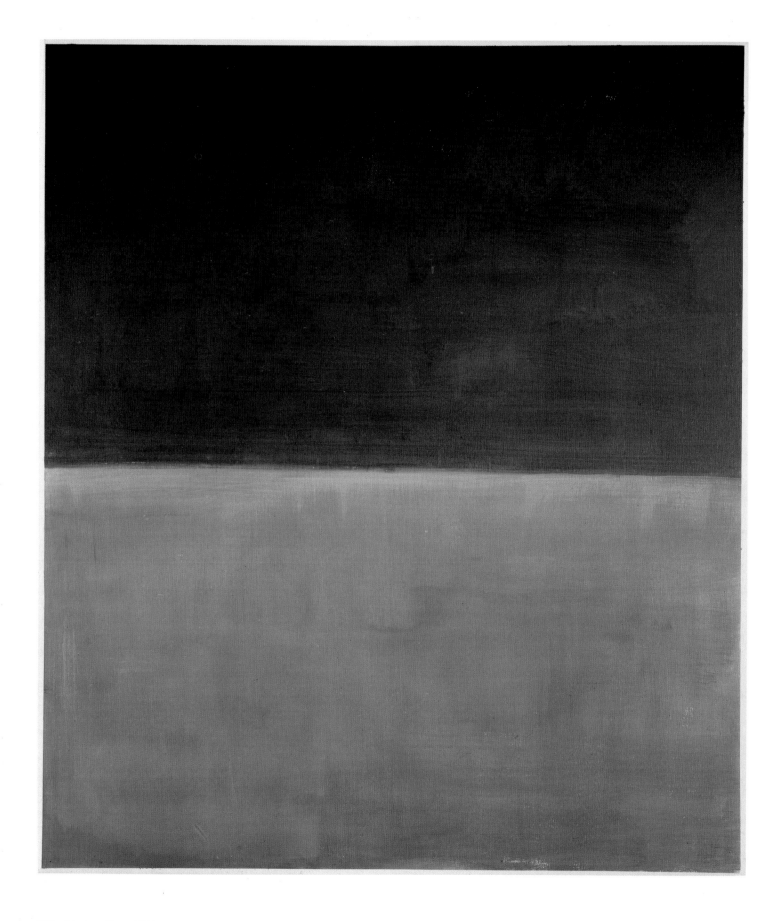

198. *Black on Grey*. 1970
Acrylic on canvas, 80¼ x 69"
Lent anonymously

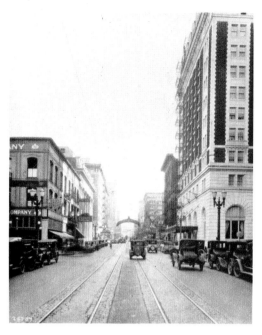

Downtown Portland, ca. 1915–20 Yale, ca. 1921–23 Rothko and Max Naimark, Yale 1921

Chronology

1903–1913

September 25 Marcus born in Dvinsk, Russia, to Jacob, a pharmacist, and Anna Goldin Rothkowitz. Youngest of four children: sister, Sonia, fourteen, brothers, Moise and Albert, eleven and eight respectively, at time of birth.

Attends Hebrew school, studies scriptures and Talmud.

1910 Jacob emigrates to United States, arrives Ellis Island. Travels to Portland, Oregon, where his brother, Samuel Weinstein, settled earlier.

1911 Albert and Moise arrive Portland, passage arranged by father.

1913

August 5 Marcus, mother and sister depart Libau, Russia, aboard S.S. *Czar*. Travel second-cabin.

August 17 Arrive New York, able to speak only Russian and Yiddish.

To New Haven; stay ten days with Weinstein cousins, proceed by train to Portland. Live at 538 Second Street, in Jewish neighborhood, southwest Portland.

Mother takes name Kate.

1914

March 27 Jacob dies.

Sonia, Albert and Moise go to work at New York Outfitting Company, Weinstein family mens' clothing business. Marcus becomes delivery boy, takes newspaper route.

1913–1921 Attends Shattuck Grade School and Lincoln High School. Completes high school in three years. Interested in literature, social studies, labor and radical causes. Loves music, plays mandolin, later piano. During high school, studies drawing at local art school, works in shipping department of Weinstein business.

1921–1923 Attends Yale University, New Haven, with Portland friends, also Russian emigrants, Aaron Harry Director and Max Naimark. Their scholarships cancelled after one year. Takes English, French, history, mathematics (in which he excels), physics, biology, economics and philosophy. Sketches often. Works at Yale student laundry and two cleaners.

Freshman year rooms with Naimark at 820 Howard Avenue, New Haven, home and office of Dr. Herman W. Grodzinski. Takes meals at Yale Commons, Lawrence Hall.

Sophomore year, with Director and another classmate, Simon Whitney, publishes short-lived weekly pamphlet *The Yale Saturday Evening Pest*. Progressive tone unusual for Yale at this time.

In 1922-23 lives at 161 Lawrence Hall, Yale University, with Director and another student.

Takes meals at Weinstein family home, 510 Howard Avenue.

Leaves Yale without receiving degree.

Moves to New York; takes odd jobs including work in garment district and as bookkeeper for

uncle, Samuel Nichtberger, C.P.A. and tax attorney.

1924

January–February | Begins taking anatomy courses with George Bridgman at Art Students League, New York.

Address on application is c/o Mrs. Goreff, 19 West 102nd Street. Uses this address until 1929.

Returns briefly to Portland, joins acting company there run by Josephine Dillon.

Addresses in Portland are: #C, Parkhurst Apartments, 635 Northrop Street and c/o Weinstein Brothers, Morgan Building.

1925 | Moves back to New York, which remains his home until his death.

October–December | Paints in Max Weber's class at Art Students League; studies still life and figure.

Meets Louis Harris in Weber's class.

Student work is in realist style; does urban scenes, still lifes and landscape.

Clyfford Still visits New York for first time; returns to Spokane, Washington, three months later.

Milton Avery moves to New York.

1926

March–May | Continues studies at Art Students League with Weber.

Influenced by Weber, experiments with expressionist style.

Becomes member of Art Students League, remains such until 1929, thereby entitled to take certain courses and vote on issues. (To qualify as member, student must be enrolled at League at least three months.)

1926–1927

November–January | Marcel Duchamp's *Large Glass* shown publicly for first time in *International Exhibition* at The Brooklyn Museum, New York.

Late 1920's | Draws maps for popularized biblical history book, *The Graphic Bible,* by Lewis Browne, retired Portland rabbi. Not credited for drawings, presses unsuccessful suit against Browne and Macmillan, publisher, for $20,000 and share of royalties.

1928

November 15–December 12 | Opportunity Galleries, New York. First group exhibition. Organized by Bernard Karfiol who chooses several of Rothkowitz's paintings. Other participants include Avery, Louis G. Ferstadt, Gela Forster, R. W. Gerbino, Harris, Olive Riley.

Becomes close friends with Avery and his wife

Sally. Avery's style important to his development.

1928–1929 | Clyfford Still in New York again; studies with Vaclav Vytlacil at Art Students League.

1929

November 8 | The Museum of Modern Art, New York, opens.

Begins teaching art to children part-time at Center Academy, Brooklyn Jewish Center. Keeps position until 1952.

Lives at 231 East 25th Street.

ca. 1929–1930 | Meets Adolph Gottlieb.

Continues to work in expressionist style; paints cityscapes, nudes, figure studies, domestic scenes.

1931

November 18 | Whitney Museum of American Art, New York, opens.

November | Wadsworth Atheneum, Hartford, *Newer Super-Realism.* First major Surrealist exhibition in United States.

1932

January 9–29 | Julien Levy Gallery, New York, *Surrealist Group Show.* Exhibition previously shown at Wadsworth Atheneum.

July 2 | While camping with Nathaniel Dirk at Hearthstone Camping Grounds, Lake George, New York, meets Edith Sachar.

Summer | Vacations with Averys and Gottliebs at Cape Ann, Massachusetts; does so again in 1934, 1935, 1936.

November 10 | Marries Edith Sachar, who makes costume jewelry to help sustain them.

Address is 137 West 72nd Street.

ca. 1932–1933 | Meets David Smith.

1933

Summer | Museum of Art, Portland, Oregon. First one-man exhibition. Shows drawings and watercolors with work of his students from Center Academy.

November 21–December 9 | Contemporary Arts Gallery, New York, *An Exhibition of Paintings by Marcus Rothkowitz.* First one-man exhibition in New York. Shows *Nude, Man Smoking, Portland, Riverside Drive,* among other oils, watercolors and drawings.

Hans Hofmann opens art school in New York.

Josef Albers becomes head of art department at Black Mountain College, Black Mountain, North Carolina.

1934 | Meets Joseph Solman at Avery's studio.

May 22– June 12	Uptown Gallery, New York, *Paintings by Selected Young Americans.* Rothkowitz shows *Sculptress, Woman and Cat, Lesson.*
June 12– July 2	Uptown Gallery, New York, *Group Exhibition.* Rothkowitz shows *The Pugilist.*
August 14– September 17	Uptown Gallery, New York, *Group Exhibition.* Rothkowitz shows *Mother and Child, The Sewing Lesson.*

Artists' Union formed in New York, with local chapters elsewhere, to agitate for creation of art projects for the unemployed. Rothkowitz among 200 members at inauguration. Similar organizations founded around same time are Artists' Committee of Action and Art Students' Council in New York.

November	*Art Front* begins publication, continues until December 1937. Sponsored jointly by Artists' Union and Artists' Committee of Action, edited by Stuart Davis. Becomes official organ of Artists' Union, advocates community involvement in arts, debates major aesthetic issues, reviews current exhibitions.
November 21– December 10	Julien Levy Gallery, New York, *Paintings by Salvador Dali.* Dali makes first visit to United States on this occasion.
December 15	Robert Godsoe opens Gallery Secession. Members include Ben-Zion, Ilya Bolotowsky, Gottlieb (probably brought to gallery by Harris and Rothko), Harris, Yankel Kufeld, Rothkowitz, Louis Schanker, Solman and Nahum Tschacbasov.
December	Julien Levy Gallery, New York. *Abstract Sculpture by Alberto Giacometti.* First one-man exhibition in United States.

1934–1935

December 15– January 15	Gallery Secession, New York, *Group Exhibition.* Rothkowitz shows *Duet.*

1935

January 10– February 9	Pierre Matisse Gallery, New York, *Joan Miró 1933–1934.*
January 15– February 5	Gallery Secession, New York, *Group Exhibition.* Rothkowitz shows *Nude.*

Above-mentioned members of Gallery Secession leave to form *The Ten:* group of independents has no declared program, but majority of members paint representationally in loose, flat manner yet are sympathic to abstract art, admire Expressionism. They protest conservative policies of art establishment; meet once a month at one another's studios. Group seldom numbers more than nine and is commonly referred to as "The Ten Who are Nine."

August	Works Progress Administration, Federal Art Project established, Holger Cahill, Director.

Most extensive of government-supported art programs during Depression. Consists of easel division, mural division, graphic division, sculpture division and supports creation of Index of American Design.

Pierre Matisse Gallery, New York [André Masson].

James Thrall Soby, *After Picasso,* published. First book primarily devoted to Surrealism to appear in United States.

Meets writer H. R. Hays.

Gottlieb begins to collect primitive art; Rothkowitz interested in archaic art of Aegean, African sculpture, art of Nineveh, Egypt and Mesopotamia but does not collect.

1935–1936

December 16– January 4	Montross Gallery, New York. *The Ten.* Group's first exhibition. Each of nine artists shows four paintings. Rothkowitz shows *Woman Sewing* (fig. 16, p. 32), *Subway.*

1936

January 7-18	Municipal Art Galleries, New York, *The Ten.* Group forms section of inaugural exhibition of Galleries. Joined for this show by Gottlieb's friend Edgar Levy. Rothkowitz shows *Crucifixion* (fig. 15, p. 32), *The Sea, Portrait.* Before opening, *The Ten,* several other artists threaten to withdraw work and picket unless Galleries rescind its Alien Clause, which stipulates that only citizens can exhibit there.
February 14	American Artists Congress holds inaugural session this Friday evening. It is "For Peace, For Democracy, For Cultural Progress." Rothkowitz belongs to this group.
Fall	Meets Annalee and Barnett Newman at breakfast given for them shortly after their marriage by Gottliebs; may have known Barnett previously.

American Abstract Artists founded in New York.

November 10-24	Galerie Bonaparte, Paris, *The Ten.* Group's only exhibition in Europe. Organized by Joseph Brummer. Pamphlet with text by Waldemar-George, who comments on Rothkowitz, nostalgia for Italian Trecento. Rothkowitz shows *Subway Scene, Crucifixion* (fig. 15, p. 32), *Woman Sewing* (fig. 16, p. 32).

Julien Levy publishes anthology, *Surrealism,* in New York.

Lives at 313 East 6th Street from now until 1940.

1936–1937

September 11– May 15	Employed by easel division of WPA in New

York; produces paintings for federal buildings. Earns $95.44 for sixty hours work per month.

Others on WPA at this time are William Baziotes, Arshile Gorky, Philip Guston, Willem de Kooning, Jackson Pollock, Ad Reinhardt, Jack Tworkov.

December 9-January 17	The Museum of Modern Art, New York, *Fantastic Art, Dada, Surrealism.* Organized by Alfred H. Barr, Jr.
December 14-January 2	Montross Gallery, New York, *The Ten.* Group joined for this show by Lee Gatch. Tschacbasov no longer member. Rothkowitz shows *Interior, Music,* among others.

Effect of Surrealism begins to be felt in New York art circles; automatic techniques will profoundly influence development of American art.

1937

April 26-May 8	Passedoit Gallery, New York, *The Ten.* Members include Ben-Zion, Bolotowsky, Gatch, Gottlieb, Harris, Kufeld, Rothkowitz, Schanker and Solman.

Gottlieb moves to desert near Tucson, where he remains until 1939.

John Graham's *System and Dialectics of Art* published in New York.

Artists' Union joins CIO as Local 60.

1938

February 21	Becomes United States citizen.
May 5-21	*Second Annual Membership Exhibition: American Artists Congress Inc.,* New York. Rothkowitz shows *Street Scene* (fig. 17, p.32) in Painting Section.
May 9-21	Passedoit Gallery, New York, *The Ten.* Group is now Ben-Zion, Bolotowsky, Gottlieb, Graham, Harris, Ralph Rosenborg, Rothkowitz, Schanker and Solman. Joined for this show by Karl Knaths.
November 5-26	Mercury Galleries, New York, *The Ten: Whitney Dissenters.* Group mounts exhibition as protest against Whitney's bias towards Regionalism and American Scene painting; joined for this show by Earl Kerkam. Rothkowitz shows *Conversation.*

Experiments with automatic drawing. Deeply interested in Oedipus myth. (Dore Ashton, *The New York School: A Cultural Reckoning,* New York, 1973, p. 98). Paints *Subway Scene, Antigone* (cat. nos. 22, 23). Interest in theater and early reading of Nietzsche's *The Birth of Tragedy,* perhaps influence a number of paintings of 1939-40 on mythological and dramatic themes. (William C. Seitz, *Abstract-Expressionist Painting in America: An Interpretation Based on the Work*

and Thought of Six Key Figures, unpublished Ph.D. dissertation, Princeton University, 1955, pp. 20-21.)

1939

June 1	Museum of Non-Objective Painting opens in New York; renamed The Solomon R. Guggenheim Museum in 1952.
October 23-November 4	Bonestell Gallery, New York, *The Ten.* Group joined for this show by David Burliuk.
November	Yves Tanguy arrives in New York.
	Matta moves to New York, where he remains until 1948.
	Perls Galleries, New York [Wifredo Lam].

1939–1940

November-January	The Museum of Modern Art, New York, *Picasso: Forty Years of His Art.*
1940	*The Ten* breaks up because members begin to show individually at various galleries.
January 8-27	Neumann-Willard Gallery, New York. *New Work by Marcel Gromaire, Mark Rothko, Joseph Solman.* Rothko shows *Entrance to Subway, Contemplation, The Party,* among others. First appearance of name Mark Rothko in announcement for this show; hereafter consistently uses this name in exhibitions, usually signs work Mark Rothko, although does not change name legally until 1959.
April 16-May 7	Julien Levy Galley, New York, *Matta.* First exhibition in New York.
April	Signs statement with Avery, Bolotowsky, Jose De Creeft, Gottlieb, Harris, Manfred Schwartz, among others, declaring secession from American Artists' Congress, because of its sanction of Russian invasion of Finland.
May 10	Federation of Modern Painters and Sculptors founded in New York by group that broke from American Artists' Congress. Among its members are: Avery, Baziotes, Bolotowsky, Gottlieb, Gatch, George L. K. Morris, Rothko, Schwartz, David Smith, Solman, Joseph Stella, Bradley Walker Tomlin, Ossip Zadkine. Rothko very active on Federation's Cultural Committee, which is concerned with politics as well as culture.
June 20-July 8	Rotunda of the American Art Today Building, New York World's Fair. Federation exhibits for first time.
September	First issue of *View,* Surrealist magazine, founded by Charles Henri Ford, published until 1947.
October	Piet Mondrian arrives in New York, remains until his death in 1944.

1941

March 9-23 Riverside Museum, New York, first annual Federation exhibition. Rothko shows *Portrait of Mary, Craftsman, Underground Fantasy, Subway*. Other participants include: Avery, Bolotowsky, George Constant, Morris Davidson, Gottlieb, Graham, Harris, Schwartz, Tomlin.

July Max Ernst emigrates to United States; marries Peggy Guggenheim in September. After brief stay in New York travels across country. Remains in America until 1953.

October-
November Special issue of *View* devoted to Surrealism.

André Breton emigrates to United States.

André Masson arrives in New York, where he continues to work until 1946.

Address at this time is 29 East 28th Street.

1941–1942 The Museum of Modern Art, New York, *2 Exhibitions: Paintings, Drawings, Prints—Joan Miró, Salvador Dali*.

1941–1943 Works closely with Gottlieb developing aesthetic based on interest in Graeco-Roman and Christian myth. Rothko's mythological paintings are stratified in composition, sometimes divided into sharply differentiated registers. Irrationally juxtaposed images disposed in orderly, geometric manner, at times segregated in zones. Imagery drawn from archaic sculpture, Northwest coast Indian art, also architectural motifs. Palette primarily pastel.

1942

January 5-26 R. H. Macy Department Store, New York [Group Exhibition]. Organized by Samuel Kootz. Rothko shows *Antigone*, 1938 (cat. no. 23) and *Oedipus*. Other participants include Avery, Gorky, Gottlieb, Graham, Karl Holty, Jan Matulka and George L. K. Morris.

January-
February Valentine-Dudensing Gallery, New York [Piet Mondrian]. First one-man exhibition in New York.

March 3-28 Pierre Matisse Gallery, New York. *Artists in Exile*. Breton, Ernst, Fernand Léger, Masson, Matta, Mondrian and Tanguy are among fourteen expatriates shown.

April Special issue of *View* devoted to Ernst.

May Special issue of *View* devoted to Tanguy.

June First issue of *VVV*, magazine, founded and edited by David Hare with Breton and Ernst as editorial advisers.

October 14-
November 7 451 Madison Avenue, New York, *First Papers of Surrealism*. Participants include Duchamp, Max Ernst, Paul Klee, Matta, Miró, Masson, Picasso and Tanguy, together with young Americans,

Artists in Exile, photograph taken on the occasion of an exhibition at Pierre Matisse Gallery, New York, March 1942. Bottom row, l. to r.: Matta Echaurren, Ossip Zadkine, Yves Tanguy, Max Ernst, Marc Chagall, Fernand Léger; second row: André Breton, Piet Mondrian, André Masson, Amédée Ozenfant, Jacques Lipchitz, Pavel Tchelitchew, Kurt Seligmann, Eugene Berman. Photo by George Platt Lynes

among whom are Robert Motherwell, Hare and Baziotes.

Peggy Guggenheim founds gallery, Art of This Century, New York; shows established modern artists, unknown Americans and her private collection of avant-garde art there. Jimmy Ernst is secretary. Closes in 1947 when Mrs. Guggenheim moves to Venice.

Introduced to Jimmy Ernst by Baziotes.

1943

June 3-26 Wildenstein and Co., New York, third annual Federation exhibition. Rothko shows *The Syrian Bull*, 1943 (cat. no. 28), Gottlieb's *Rape of Persephone*, 1943 (fig. 26, p. 42), is only other work with mythological title included.

June 7 With Gottlieb writes to Edward Alden Jewell, *The New York Times* art critic, in response to his negative review of Federation exhibition. Newman contributes to letter but does not sign it. Published in *The New York Times*, June 13, it articulates their commitment to use of simple flat shapes, belief in importance of mythic content, kinship with primitive art. Rothko gives *The Syrian Bull*, Gottlieb gives *Rape of Persephone* to Newman in appreciation for his collaboration on letter.

August Meets Buffie Johnson in Los Angeles; later in year in New York she introduces him to Howard

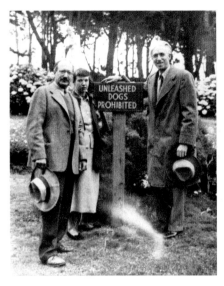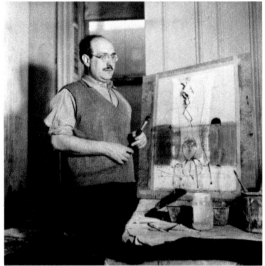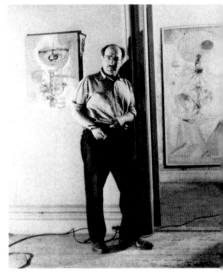

Mark and Mell Rothko with Clyfford Still, California, ca. 1946

1945–46

1945–46

	Putzel, Peggy Guggenheim's assistant from 1942-44.
October 11-November 3	The 460 Park Avenue Galleries, New York, *As We See Them*. Portraits by Federation members. Rothko shows *Leda*, 1943, Gottlieb shows *Oedipus*.
October 13	Rothko and Gottlieb discuss their aesthetic principles and theories on WNYC radio broadcast. Assert their interest in Jungian and eternal symbols, belief in power of myth, importance of archaism and of psychological content.

> Our presentation of these myths, however, must be in our own terms, which are at once more primitive and more modern than the myths themselves—more primitive because we seek the primeval and atavistic roots of the idea rather than their graceful classical version; more modern than the myths themselves because we must redescribe their implications through our own experience.

November 9-27	Art of This Century, New York, *Jackson Pollock: Paintings and Drawings*. First one-man exhibition.

Kootz publishes *New Frontiers in American Painting*. In it he says, if "the ultimate potential of Abstraction and Expressionism" were known, the future of art could be predicted.

Address is 165 East 31st Street.

1944

February 8-26	Artists' Gallery, New York [Ad Reinhardt]. First one-man exhibition.
October 3-21	Art of This Century, New York. *Paintings and Drawings by Baziotes*. First one-man exhibition.

October 24-November 11	Art of This Century, New York, *Robert Motherwell: Paintings, Papiers Collés, Drawings*. First one-man exhibition.
November	Sidney Janis, *Abstract and Surrealist Art in America*, published.
December 4-30	67 Gallery, New York, *Forty American Moderns*. Gallery opened in Fall by Putzel. Participants include I. Rice Pereira, Rothko, Kay Sage.

Peggy Guggenheim represents Rothko on Putzel's advice.

Meets Max Ernst.

Geometric curvilinear forms are flattened, juxtaposed against indeterminate opaque grounds which are sometimes divided into emphatic horizontal bands. Continues to use pastel palette, with accents of brighter or deeper color. Often works in watercolor from now until 1946. For example, *Horizontal Procession (Gyrations on Four Planes)*, *Poised Elements*, *Slow Swirl at the Edge of the Sea*, *Birth of Cephalopods*, all 1944 (cat. nos. 30, 31, 63, 37).

Meets Mary Alice Beistle (Mell), illustrator of children's books, through photographer Aaron Siskind.

Gottlieb elected head of Federation of Modern Painters and Sculptors, continues as such until 1945.

1945

January 9-February 4	Art of This Century, New York, *Mark Rothko Paintings*. First one-man exhibition at this gallery. Shows fifteen paintings including *Sacrifice of Iphigenia*, 1942, *The Syrian Bull*, 1943, *Birth*

of Cephalopods, Poised Elements, Slow Swirl at the Edge of the Sea, all 1944 (cat. nos. 29, 28, 37, 31, 63), Omens of Gods and Birds, 1945, Entombment I, Entombment II, both 1946 (cat. nos. 42, 43). Works reveal strong affinity to Surrealism, reflecting influence of Miró, Masson and Ernst.

February	David Porter Gallery, Washington, D.C., A Painting Prophecy—1950. Porter includes artists he feels may be forming a new tendency in painting, uniting the romantic and the abstract. Participants include Baziotes, Stuart Davis, Jimmy Ernst, Gottlieb, Knaths, Pollock, Richard Pousette-Dart and Rothko.
Spring	67 Gallery, New York, A Problem for Critics. Participants include Gorky, Gottlieb, Hofmann, Pollock and Rothko. Putzel asks critics to name the "new metamorphism" and states "I believe we see real American painting beginning now." (Published in Edward Alden Jewell, "Toward Abstract or Away," The New York Times, July 1, 1945, Section II, p. 2.)
March 13	Divorce from Edith Sachar granted.
March 31	Marries Mell in Linden, New Jersey.
March	Julien Levy Gallery, New York. Arshile Gorky.
	Special issue of View devoted to Duchamp.

1945–1946

November 27-January 10	Whitney Museum of American Art, New York, Annual Exhibition of Contemporary American Painting. Rothko shows Primeval Landscape, 1945 (cat. no. 66).
	Lives at 22 West 52nd Street.

1946

January 26-March 3	Pennsylvania Academy of Fine Arts, Philadelphia, The One Hundred and Forty-First Annual Exhibition. Rothko shows Landscape, 1945.
February 5-March 13	Whitney Museum of American Art, New York, Annual Exhibition of Contemporary American Sculpture, Watercolors and Drawings. Rothko shows Baptismal Scene, 1945.
February 12-March 7	Art of This Century, New York, Clyfford Still. First one-man exhibition at this gallery. Rothko writes catalogue text which Still later repudiates.
March 30	Robert M. Coates reviewing Hofmann show at Mortimer Brandt Gallery, New York, in The New Yorker, uses term "abstract expressionism" in discussing New York artists: "...he is certainly one of the most uncompromising representatives of what some people call the spatter-and-daub school of painting and I, more politely, have christened abstract Expressionism." Alfred H. Barr, Jr. had employed same term in relation to Kandinsky in 1936 in his book Cubism and Abstract Art.

April 22-May 4	Mortimer Brandt Gallery, New York, Mark Rothko: Watercolors. Shows Gethsemane, 1945 (cat. no. 65), Olympian Play, 1945, Tentacles of Memory, 1945-46, Geologic Reverie, 1946, among others.
Summer	Rents house in East Hampton, Long Island.
August 16-September 8	San Francisco Museum of Art. Oils and Watercolors by Mark Rothko. Travels in part to Santa Barbara. Shows Slow Swirl at the Edge of the Sea, Poised Elements, Ritual, Tiresias, Phalanx of the Mind, all 1944, Gethsemane, Primeval Landscape, both 1945, Prehistoric Memory, 1946 (cat. nos. 63, 31, 36, 34, 33, 65, 66, 60), among others.
September-November	Visits family in Portland. Spends time in California.
	Late in year Pollock begins all-over drip paintings.
	Still begins teaching at California School of Fine Arts, San Francisco; retains position until 1950.
	Figures and grounds begin to merge, forms lose definition. Influence of Gorky emerges in biomorphic shapes, of Still in abstract colorforms which suggest landscape.
	Becomes friendly with Motherwell.
	Address from now until 1954 is 1288 Sixth Avenue.

1946–1947

December 10-January 16	Whitney Museum of American Art, New York, Annual Exhibition of Contemporary American Painting. Rothko shows Room in Karnak.

1947

March 3-22	Betty Parsons Gallery, New York. Mark Rothko: Recent Paintings. First of five annual one-man exhibitions here. Shows Archaic Phantasy, Rites of Lilith, both 1945 (cat. nos. 35, 39), [Omens of?] Gods and Birds, 1945?, The Source, 1945-46 (cat. no. 57), Entombment, 1946, Astral Image, ca. 1946, Room in Karnak, Votive Figure, among others.
April 14-26	Betty Parsons Gallery. Clyfford Still: Recent Paintings.
April	While in New York, Still proposes to Douglas MacAgy and Rothko the creation of school for young artists taught by contemporary artists. School ultimately realized as The Subjects of the Artist.
Early Summer	Visits family in Portland before proceeding to teaching job.
June 23-August 1	Guest Instructor at California School of Fine Arts, San Francisco. Teaches ten hours a week: painting course restricted to artists and advanced students; contemporary art lecture series.

	Remains in San Francisco until end of August, lives at 2500 Leavenworth Street.
September 9-27	Wildenstein and Co. Inc., New York, seventh annual Federation exhibition. Rothko, who does not participate, sponsors Still as guest of member. Still shows *Apostate*.
December	With Mario Carreño, Herbert Ferber, Gottlieb, Boris Margo, Newman, Felipe Orlando, Theodoros Stamos, John Stephan and Hedda Sterne, contributes statement to *The Tiger's Eye*, general cultural magazine published from October 1947 until 1949, edited by Ruth Stephan, art editor John Stephan. Newman is an editor on second, third issues.
	Literary references and symbols, organic forms, automatic calligraphy largely disappear from work. Diffuse, rectangular patches of color, disposed vertically and horizontally, float in ambiguous space. Larger formats made of unsized duck used. Rejects watercolor for oils, which he applies in thin washes. For example, *Untitled, Number 26*, both 1947 (cat. nos. 74, 73). Begins to number some of his paintings.
1947–1948	
December 6- January 25	Whitney Museum of American Art, New York, *Annual Exhibition of Contemporary American Painting*. Rothko shows *Archaic Phantasy*, 1945 (cat. no. 35).
Winter	First and only issue of *Possibilities* appears. Editors are: Motherwell, art; Harold Rosenberg, writing; Pierre Chareau, architecture; John Cage, music. First magazine to deal exclusively with contemporary American art. It is published as first generation of Abstract Expressionists were abandoning Surrealist-inspired imagery and formulating their mature styles. Includes statement by Rothko.
1948	
January 31- March 21	Whitney Museum of American Art, New York, *Annual Exhibition of Contemporary American Sculpture, Watercolors and Drawings*. Rothko shows *Fantasy*.
March 8-27	Betty Parsons Gallery, New York, *Mark Rothko: Recent Paintings*. Shows *Poised Elements*, 1944, *Phalanx of the Mind*, 1945 (cat. nos. 31, 33), *Beginnings, Companionship, Dream Imagery*, among others.
June	Still, Baziotes and Motherwell meet in Rothko's apartment and discuss creation of a school. Still's notes of this meeting read: "A group of painters, each visiting the center one afternoon a week, each free to teach in whatever way he chose or free to stay away, every student free to work or remain away, attend every teacher's meeting or none." (Published in San Francisco Museum of Modern Art, *Clyfford Still*, January 9-March 14, 1976, p. 113.)

July 21	Gorky dies by suicide.
Fall	With Baziotes, David Hare and Motherwell, founds school, The Subjects of the Artist, at 35 East 8th Street. Name is Newman's suggestion; he joins faculty second semester. Still participates in initial planning stages but does not teach, as he returns to position at California School of Fine Arts. There are no formal courses but a "spontaneous investigation into the subjects of the modern artist — what his subjects are, how they are arrived at, methods of inspiration and transformation, moral attitudes, possibilities for further explorations...." (*Announcement for School, The Subjects of the Artist*, New York, 1948-49.) Approximately fifteen students attend school.
	Newman initiates Friday evening lectures open to public. Some of speakers are Jean Arp, John Cage, Joseph Cornell, Gottlieb, de Kooning and Reinhardt. Friday evening lectures at *Studio 35*, school started on premises of The Subjects of the Artist after it dissolves, and *The Club*, informal Abstract Expressionist group, grow out of this series.
December	In letter to Still, Rothko states that Newman proposes to carry on public relations, arrange lectures and seminars for The Subjects of the Artist. In later letter to Still, writes of being on eve of nervous breakdown, says he is withdrawing from participation in school. (San Francisco Museum of Modern Art, *Clyfford Still*, January 9-March 14, 1976, p. 113.)
	Configurations are simplified, reduced in number, colors intensified, canvases increase in size. Color and shape assume autonomy as mature style begins to emerge.
1949	
March 28- April 16	Betty Parsons Gallery, New York, *Mark Rothko*. Shows *Number 1-10, 23*.
April 2- May 8	Whitney Museum of American Art, New York, *Annual Exhibition of Contemporary American Sculpture, Watercolors and Drawings*. Rothko shows *Brown and Yellow*.
Spring	The Subjects of the Artist fails financially and closes.
July 5- August 12	Still recommends to MacAgy that Rothko again be invited to teach at California School of Fine Arts. He is made Guest Instructor, painting, philosophy and practice of painting today, open to artists and advanced students only. Also gives illustrated lectures on thoughts of contemporary artists and their work.
September 15- October 3	Samuel M. Kootz Gallery, New York, *The Intrasubjectives*. Reopening exhibition of gallery that had been closed since summer 1948, organized by Kootz and Rosenberg. Participants

are Baziotes, de Kooning, Gorky, Gottlieb, Graves, Hofmann, Motherwell, Pollock, Reinhardt, Rothko, Mark Tobey and Tomlin. Name is taken from José Ortega y Gasset.

November 18 Gives lecture, *My Point of View*, as part of series of forum talks on Contemporary Art at Studio 35.

Numbers most works; descriptive titles sometimes added later.

1949–
Winter 1950

December 16- Whitney Museum of American Art, New York,
February 5 *Annual Exhibition of Contemporary American Painting*. Rothko shows *Number 19*.

Mature style crystallizes. Frontal rectangles of varying sizes, aligned one above another, fill most of canvas. These seem to hover slightly above color field upon which they are juxtaposed. Thin washes of pigment saturate canvas; colors are disembodied, luminous, intense. For example, *Magenta, Black, Green on Orange* and *Violet, Black, Orange, Yellow on White and Red,* both 1949 (cat. nos. 92, 90).

1950

January 3-21 Betty Parsons Gallery, New York, *Mark Rothko.* Shows *Number 7, 10, 11, 14, 15,* among others.

January 23- Betty Parsons Gallery, New York, *Barnett*
February 11 *Newman.* First one-man exhibition.

Mother dies.

Spring Travels in England, France and Italy.

May 20 Open letter to Roland L. Redmond, President of The Metropolitan Museum of Art, New York, from eighteen avant-garde painters and ten sculptors, protesting national juried exhibition of contemporary American art, *American Painting Today 1950,* planned for December, which they felt would be prejudiced against advanced artists. Letter published in entirety in this summer's issue of *Art News*. Signatories include Baziotes, James Brooks, Fritz Bultman, Jimmy Ernst, Gottlieb, Hofmann, Weldon Kees, de Kooning, Rothko.

Fall Still moves to New York.

November 10- Whitney Museum of American Art, New York,
December 30 *Annual Exhibition of Contemporary American Painting*. Rothko shows *Number 7-A.*

December 30 Daughter, Kathy Lynn (Kate), is born.

Meets Alfred H. Barr, Jr. and Dorothy C. Miller.

1951

January 11- Frank Perls Gallery, Beverly Hills, *Seventeen*
February 7 *Modern American Painters.* Catalogue with text, "The School of New York," by Motherwell, in which he defines the characteristics of this group

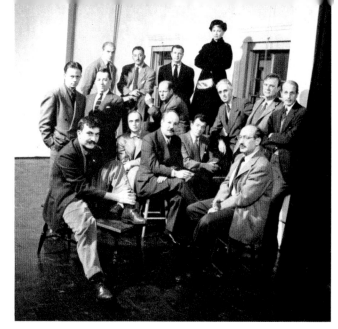

The Irascibles, 1950, photograph by Nina Leen which accompanied article in *Life,* January 15, 1951. Bottom row, l. to r.: Theodoros Stamos, Jimmy Ernst, Barnett Newman, James Brooks, Mark Rothko; second row: Richard Pousette-Dart, William Baziotes, Jackson Pollock, Clyfford Still, Robert Motherwell, Bradley Walker Tomlin; top row: Willem de Kooning, Adolph Gottlieb, Ad Reinhardt, Hedda Sterne. ©Time Inc.

273

and for first time identifies it in print as "School of New York." Participants include Baziotes, Gottlieb, de Kooning, Matta, Pollock, Reinhardt, Rothko, Still.

January 15 "Irascible Group of Advanced Artists Led Fight Against Show," *Life.* Publication with this caption of now famous Nina Leen photograph of group which, in May 1950, protested jury for The Metropolitan Museum of Art's exhibition of contemporary American painting (fig.).

late January- Studies printmaking for one week in Will Bar-
early February net's graphics class at Art Students League.

February 1 Appointed Assistant Professor, Department of Design, Brooklyn College. Retains position

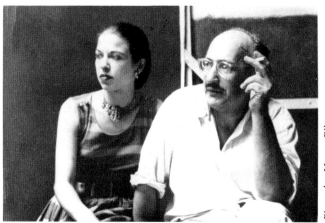

Mark and Mell Rothko, 1948–53

Photo by Henry Elkan

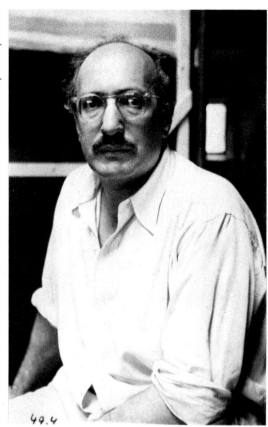

49.4

Early 1950's

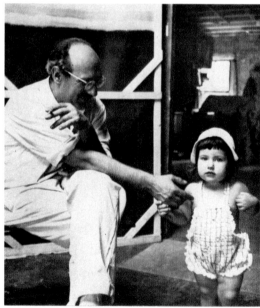

Mark Rothko and daughter, Kate, early 1950's

until June 30, 1954. Teaches contemporary art, theory of art, color, elements of drawing, graphic workshop. Reinhardt had been teaching there since 1947.

March 19	Participates in symposium on *How to combine architecture, painting and sculpture* at The Museum of Modern Art, New York. Statement reprinted in *Interiors*, May 1951.
April 2-12	Betty Parsons Gallery, New York, *Mark Rothko.* Shows *Number 1-16*.
June 2-July 12	Los Angeles County Museum, *1951 Annual Exhibition: Contemporary Painting in The United States*. Rothko shows *Number 11*, 1951.
	Meets Dore Ashton.
ca. 1951–1952	Meets Sally and William Scharf.

1952

March 13	Rothko invited by Joseph Fiore, Black Mountain College, Black Mountain, North Carolina, to teach painting there from June 25–August 22. Refuses offer.
March 25-June 11	The Museum of Modern Art, New York, *Fifteen Americans*. Organized by Dorothy C. Miller. Participants include Baziotes, Herbert Ferber, Frederick Kiesler, Pollock, Rothko, Still and Tomlin. Rothko and Still refuse to let their work travel, causing cancellation of plans to circulate exhibition in Europe.
December 20	Writes to Lloyd Goodrich, Associate Director of Whitney Museum of American Art, New York, regarding the acquisition and display of his work by museums:

> *Since I have a deep sense of responsibility for the life my pictures will lead out in the world, I will with gratitude accept any form of their exposition where their life and meaning can be maintained, and avoid all occasions where I feel that this cannot be done. . . . at least in my life, I must maintain a congruity between my actions and convictions, if I am to continue to function and do my work. And I do hope that I have here clarified my position.*

First and only issue of *Modern Artists in America*, which deals with abstract art and is edited by Motherwell and Reinhardt.

1952–1953	Clyfford Still teaches graphics at Brooklyn College.
	Studio at 106 West 53rd Street; continues to live on Sixth Avenue.

1953

May 11	Tomlin dies.

1954

October 18-December 31	The Art Institute of Chicago, *Recent Paintings by Mark Rothko*. Travels in part to Providence,

Rhode Island. Organized by Katharine Kuh. Shows *Number 12*, 1951, *Number 10*, 1952 (cat. nos. 99, 104), *Number 7*, 1953, *Number 1, Number 9*, both 1954, among others.

November 3 Henri Matisse dies.

From about this time uses both titles and numbers for his paintings, for example *Homage to Matisse, Light, Earth and Blue*, both 1954 (cat. nos. 107, 116).

1955

Spring Clement Greenberg in "American-Type' Painting," *Partisan Review*, discusses origins of Abstract Expressionism, noting importance to development of this movement of WPA, presence of emigré artists in New York during World War II, Hofmann and his school and early Kandinskys at Museum of Non-Objective Painting. Painters analyzed are Gorky, Gottlieb, Hofmann, Kline, de Kooning, Motherwell, Newman, Pollock, Rothko, Still, Tobey.

April 11-
May 14 Sidney Janis Gallery, New York. First of two one-man exhibitions there. Shows *Light, Earth and Blue*, 1954 (cat. no. 116), *Violet Center*, 1954, *Earth and Green*, 1955, *The Ochre, Yellow Expanse*, among others.

Summer Teaches for approximately ten weeks at University of Colorado, Boulder.

1956

February 20 "The Wild Ones," *Time*, includes discussion of Baziotes, Gorky, Gottlieb, Guston, de Kooning, Motherwell, Pollock and Rothko:
> *A cursory study of advance-guard painting gives rise to the conclusion that it consists, like the Mock Turtle's arithmetic of "Ambition, Distraction, Uglification and Derision." It is wild, woolly, willful. But nothing has only one side, and negatives cannot sum up America's newest painting. A good deal can be said for its positive qualities, once they have been set in the context of modern history....*

August 11 Pollock dies in car accident.

Address is 102 West 54th Street until 1961.

1957

February-
March Visiting Artist, Tulane University, New Orleans. Does not teach specific courses but gives series of talks and critiques and consults with faculty and students. While there, paints *White and Greens in Blue* and *Red, White and Brown;* he feels these constitute an important breakthrough for him. While at Tulane lives on Glendale Boulevard and Iona Street in Metairie, suburb of New Orleans.

April 1-20 Sidney Janis Gallery, New York, *8 Americans*. Rothko shows *The Black and The White*, 1956.

Early 1950's

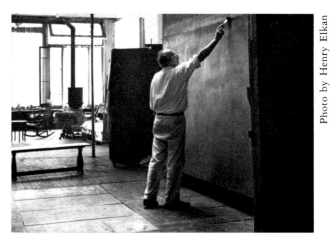

Early 1950's

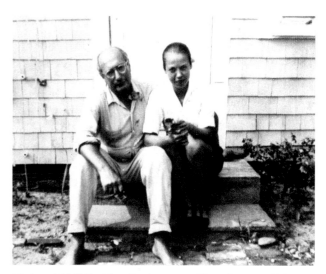

Mark and Mell Rothko, Provincetown, Massachusetts, 1957

December	In Letter to the Editor of *Art News*, Rothko refutes Elaine de Kooning's article, "Two Americans in Action," *Art News Annual*, 1958, which labels both Rothko and Kline as "action painters:" *I reject that aspect of the article which classifies my work as "Action Painting." An artist herself, the author must know that to classify is to embalm. Real identity is incompatible with schools and categories, except by mutilation. To allude to my work as Action Painting borders on the fantastic. No matter what modifications and adjustments are made to the meaning of the word action, Action Painting is antithetical to the very look and spirit of my work. The work must be the final arbiter.*

276

1958

June 14- October 19	Venice, *XXIX Esposizione Biennale Internazionale* d'Arte. Rothko shows *Black over Reds, Deep Red and Black, Two Whites, Two Reds, White and Greens in Blue*, all 1957, *Reds*, 1957-58, among others.
June	Buys cottage at 250 Bradford Street in Provincetown, Massachusetts.
	Moves studio to 222 Bowery, which had been YMCA gymnasium. Here starts his first commission, monumental canvases for Four Seasons restaurant, Seagram Building, ordered by Philip Johnson. Has never before worked in series. Employs horizontal formats with vertical elements for first time. Restricts palette in each panel to two colors. Makes three separate series of murals which become progressively darker, evolving from orange to deepest maroon and black. First set sold as separate paintings; second abandoned; third completed in 1959 but never delivered to restaurant, eventually given by Rothko to The Tate Gallery, London.
	Legally changes name to Mark Rothko; daughter's name legally changed to Kate.
June	Travels with Mell and Kate to England, France, Italy, Belgium and The Netherlands.
	Shortly after trip meets poet Stanley Kunitz.
October	Gives lecture at Pratt Institute, Brooklyn, in which he disassociates himself from Abstract Expressionist movement, discusses his development from figuration to abstraction and use of large scale.
	Meets Katharine Kuh when she moves to New York.
1958–1959	Begins to work on paper again.
October 22- February 23	The Solomon R. Guggenheim Museum, New York, *Guggenheim International Award 1958*. Miró receives $10,000 International Award for

his ceramic wall at UNESCO, Paris; Rothko refuses $1,000 United States National Section Award for *White and Greens in Blue*, 1957, and withdraws painting. "I look forward to the time when honors can be bestowed, simply, for the meaning of a man's life work—without enticing pictures into the competitive arena," he explains in letter to James Johnson Sweeney, Guggenheim Museum's Director.

1960

May 4-31	The Phillips Collection, Washington, D.C., *Paintings by Mark Rothko*. Small one-man exhibition. *Green and Maroon*, 1953, *Blue and Green*, 1957, *Green and Tangerine on Red*, 1956 (cat no. 131), *Orange and Red on Red*, 1957, included. Phillips purchases latter two.
November	The Phillips Collection opens new wing in which small room is designated to display their three Rothkos, two acquired in May and *Green and Maroon*, 1953, which had been purchased in 1957. *Ochre and Red on Red*, 1954 (cat. no. 118), is acquired in 1964 and added to room. Lives at 118 East 95th Street.

1961

January	Accepts invitation to participate in John F. Kennedy's inaugural activities.
January 18- March 12	The Museum of Modern Art, New York, *Mark Rothko*. Major one-man exhibition. Rothko directs installation. Shows *Baptismal Scene*, 1945, *Number 24*, 1947, *Number 20*, 1949, *Number 22*, 1949 (cat. no. 91), *Number 10*, 1953, *Homage to Matisse*, 1954 (cat. no. 107), *Number 9*, 1958 (cat. no. 149), *Number 22*, 1960, among fifty-four works. Circulated into January 1963 by The International Council of The Museum of Modern Art to London, Amsterdam, Basel, Rome, Paris.
October 13- December 31	The Solomon R. Guggenheim Museum, New York, *American Abstract Expressionists and Imagists*. Shows *Reds Number 22*, 1957. Begins mural panels commissioned by Professor Wassily Leontief, Chairman of the Society of Fellows and Henry Lee Professor of Economics, Harvard University, and John P. Coolidge, Director, Fogg Art Museum, Cambridge, Massachusetts. These were to be housed in penthouse of Holyoke Center, designed by José Luis Sert but are instead ultimately placed on permanent view in faculty dining room at Center.

1962

April 21- October 21	Seattle Fine Arts Pavilion, *Seattle World's Fair, Art Since 1950: American and International*. Travels in part to Waltham, Massachusetts, Boston.
May 13	Kline dies.
May	Attends state dinner celebrating the arts at White House.

Meets Dominique and John de Menil.

Completes Harvard Murals (cat. nos. 175-177). New formulation appears: in each of the five panels are two or three vertically oriented rectangles linked at top and bottom by horizontal lines and small, loosely brushed rectangles. He seeks to turn his "pictorial concepts into murals which would serve as an image for a public place." (Quoted in "Rothko Murals for Harvard," *College Art Journal*, vol. xxii, no. 4, Summer 1963, p. 254.)

1963

April 9-
June 2
The Solomon R. Guggenheim Museum, New York, *Five Mural Panels Executed for Harvard University by Mark Rothko.* Panels are shown there before they are sent to Cambridge.

June 4
Baziotes dies.

August 31
Son, Christopher Hall, born.

October 26
Dining room where murals are hung is used for the first time for meeting of directors of Harvard Alumni Association and Associated Harvard Clubs.

Joins Marlborough-Gerson Gallery, New York.

1964

Spring
Dominique and John de Menil visit Rothko in his studio; upon seeing Four Seasons panels there, commission him to make murals for chapel in Houston.

April 2-
June 28
The Tate Gallery, London, *Painting and Sculpture of a Decade 54–64.* Rothko shows *Light, Earth and Blue,* 1954 (cat. no. 116), *Black in Deep Red, Reds, Number 22,* both 1957, among others.

Summer
Rents summer cottage in Amagansett, Long Island.

Winter
Selects last studio, converted carriage house at 157 East 69th Street. Places parachute over skylight to keep studio relatively dark.

Starts work on Houston chapel murals.

1965

January 7
Delivers eulogy for Milton Avery, who died January 3, at New York Society for Ethical Culture.

Meets Ann and Bernard Malamud at Lyndon Johnson's inaugural activities.

March 28
Wins Medal Award of Brandeis University Creative Arts Awards.

May 24
David Smith dies in car accident.

June 14
Participates in The White House Festival of the Arts, shows *Ochre and Red on Red,* 1954 (cat. no. 118).

July 16-
August 1
Los Angeles County Museum of Art, *The New York School: The First Generation, Paintings of the*

Mark Rothko and son, Christopher, Summer 1964

277

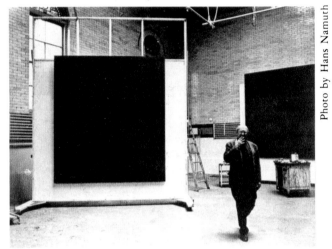

Ca. 1964–66

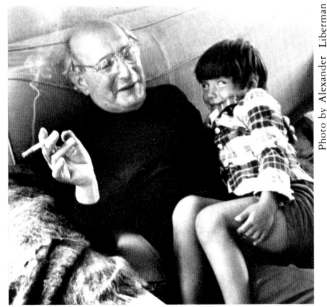

Mark Rothko and son, Christopher, August 30–September 2, 1968, Provincetown, Massachusetts

1940's and 1950's. Rothko shows *Number 26, 1947* (cat. no. 73), *Number 24*, 1948 (cat. no. 85), *Green on Blue*, 1956, *White Center*, 1957.

Ray Kelly becomes assistant, remains as such until 1968.

December
Roy Edwards becomes assistant, remains as such until August 1966

1966

June
Travels with family to Italy, France, The Netherlands, Belgium, London.

October 15-November 27
The International Council of The Museum of Modern Art organizes *Two Decades of American Painting*. Travels to Tokyo, Kyoto, New Delhi, Melbourne, Sydney. Rothko shows *Green on Blue*, 1956, *Black Stripe on Red*, 1958, *Number 10*, 1960–61.

1967

February-April
University of St. Thomas Art Department, Houston, *Six Painters*. Organized by Dominique de Menil. Participants are Mondrian, de Kooning, Guston, Kline, Pollock and Rothko. Rothko shows *Composition*, 1945, *Astral Image*, ca. 1946, *Green Stripe*, 1955, *Untitled*, 1960, *Untitled*, 1963, among others.

Summer
Teaches at University of California, Berkeley, at suggestion of Peter Selz. Meets Brian O'Doherty and Barbara Novak, who also teach there.

November 9-December 17
Stedelijk van Abbemuseum, Eindhoven, The Netherlands, *Kompass III*. Travels to Frankfurt.

Houston murals are basically complete, but Rothko continues to make minor changes on them.

1968

March 27-June 9
The Museum of Modern Art, New York, *Dada, Surrealism, and Their Heritage*. Travels to Los Angeles, Chicago. Rothko shows *Slow Swirl at the Edge of the Sea*, 1944 (cat. no. 63).

Spring
Suffers from aneurysm of aorta and is hospitalized for three weeks. Forced to stop working.

May 28
Together with Albers, Federico Castellon, Dorothea Greenbaum, William Gropper, Gyorgy Kepes, Louise Nevelson and Saul Steinberg is inducted into National Institute of Arts and Letters, Department of Art.

Summer
Rents house in Provincetown near Motherwell. Resumes work and within weeks does many small acrylics on rag paper. Their dimensions dictated by size of studio and available paper.

Starts to employ acrylics; able therefore to use water with medium in monumental paintings, spreads and soaks colors with wide brushes and sponges.

Winter
Begins to use larger paper; concerned about paper pieces' fragility, he mounts them on canvas.

Jonathan Ahearn becomes assistant, remains as such until February 1969.

1969

January 1
Leaves home and moves into East 69th Street studio. However, remains in constant touch with family.

February
Oliver Steindecker becomes assistant, remains until Rothko's death.

April 1-30
Gallery of Art, Washington University, St. Louis, *The Development of Modernist Painting: Jackson Pollock to the Present*. Rothko shows *Number 101*, 1961 (cat. no. 161).

June
Mark Rothko Foundation incorporated to provide financial assistance for older painters, sculptors, writers and composers.

June 9
Receives Honorary Degree, Doctor of Fine Arts, from Yale University. Kingman Brewster, President of Yale, says:

> As one of the few artists who can be counted among the founders of a new school of American painting, you have made an enduring place for yourself in the art of this century. Your paintings are marked by a simplicity of form and a magnificence of color. In them you have attained a visual and spiritual grandeur whose foundation is the tragic vein in an human existence. In admiration of your influence, which has nourished young artists throughout the world, Yale confers upon you the degree of Doctor of Fine Arts. (Reprinted in Yale University Art Gallery, New Haven, *Salute to Mark Rothko*, May 6-June 20, 1971.)

Donates Seagram murals to The Tate Gallery, London. Rothko stipulates that the nine canvases are to be placed in a room by themselves and are never to be shown with other paintings. "It seems to me that the heart of the matter is now to give this space you propose the greatest eloquence and poignancy of which my pictures are capable." (Quoted in Alastair Gordon, "In the Galleries: The Rothko Room," *The Connoisseur*, vol. 175, no. 706, December 1970, p. 303.)

1969–1970

October 16-February 1
The Metropolitan Museum of Art, *New York Painting and Sculpture: The First Generation*. Organized by Henry Geldzahler. Rothko shows *Vessels of Magic*, 1946, *Number 26*, 1947, *Number 10*, 1952 (cat. nos. 52, 73, 104, 155), *Reds, Number 16*, 1960.

Creates black and grey or brown series: canvases

Photo by Hans Namuth

Ca. 1964

comprised of two rectangles, black at top, grey or brown at bottom, framed by thin white band. They are stark, quiet, remote, somber.

1970

February 25 In studio, during early hours of morning, takes own life.

February 28 Buried in cemetery overlooking Shelter Island Sound.

May 29 Rothko room at The Tate Gallery, London, opens.

August 26 Mell dies.

1971

February 27,28 The Rothko Chapel, Houston, dedicated. Originally to be Roman Catholic and part of University of St. Thomas, then interdenominational at Rice University, is finally realized as interdenominational chapel affiliated with Institute of Religion and Human Development. Octagonal floor plan designed by Philip Johnson; the final design executed under supervision of Howard Barnstone and Eugene Aubrey.

Murals comprised of three triptychs, five single panels, four alternatives. Theme is Passion of Christ.

Two triptychs, one single panel composed of black hard-edged rectangles on maroon fields. One triptych, four single panels entirely black, veiled with maroon wash. Varied paint thicknesses produce nuances of color.

Rothko said of these murals: "I was always looking for something more." (*Quoted in Vogue,* vol. 157, no. 5, March 1, 1971, p. 111.)

Clair Zamoiski

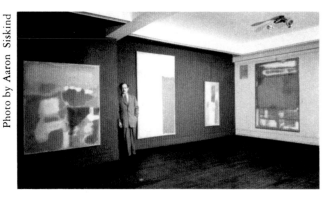

At Betty Parsons Gallery, New York, 1949

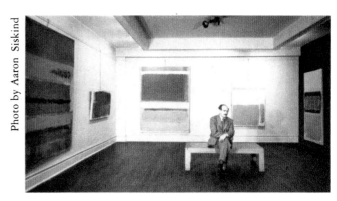

At Betty Parsons Gallery, New York, 1949

Exhibitions and Selected Reviews

I. Group

Opportunity Galleries, New York [Group Exhibition], November 15-December 12, 1928
Murdock Pemberton, "Marin and Others," *Creative Art*, vol. iii, no. vi, December 1928, pp. xlv—xlvi

Uptown Gallery, Continental Club, New York, *Paintings by Selected Young Americans*, May 22-June 12, 1934

Uptown Gallery, Continental Club, New York, *Group Exhibition*, June 12-July 2, 1934

Uptown Gallery, Continental Club, New York, *Group Exhibition: American Moderns*, August 14-September 17, 1934

Gallery Secession, New York, *Group Exhibition*, December 15, 1934-January 15, 1935
J[ane] S[chwartz], "Exhibitions in New York: Gallery Secession," *Art News*, vol. xxxiii, no. 12, December 12, 1934, p. 12

Gallery Secession, New York [Group Exhibition], January 15-February 5, 1935

Montross Gallery, New York, *The Ten*, December 16, 1935-January 4, 1936
"Exhibitions in New York: The Ten," *Art News*, vol. xxxiv, no. 12, December 21, 1935, p.8
Herbert Lawrence, "The Ten," *Art Front*, vol. 2, no. 3, February 1936, p. 12

Municipal Art Galleries, New York, *The Ten*, January 7-18, 1936
"A Municipal Adventure," *The New York Times*, January 12, 1936, Section 9, p. 9
"New York's New Municipal Gallery

Knows How to Forfend Trouble," *The Art Digest*, vol. x, no. 8, January 15, 1936, p. 6

Galerie Bonaparte, Paris, *The Ten*, November 10-24, 1936. Pamphlet with text by Waldemar-George

Montross Gallery, New York, *The Ten*, December 14, 1936-January 2, 1937
"The Nine That are 'Ten,'" *The Art Digest*, vol. xi, no. 6, December 15, 1936, p. 16
M.D., "A New Group Exhibition of Work by The Ten," *Art News*, vol. xxxv, no. 12, December 19, 1936, p. 18
"Solo Figures and Group Landings," *The New York Times*, December 20, 1936, Section II, p. 11
Jacob Kainen, "Our Expressionists," *Art Front*, vol. 3, no. 1, February 1937, pp. 14-15

Passedoit Gallery, New York, *The Ten*, April 26-May 8, 1937
"'The Ten' at Passedoit's," *The Art Digest*, vol. xi, no. 15, May 1, 1937, p. 23
H[oward] D[evree], "Five of the Current Group Shows," *The New York Times*, May 2, 1937, Section II, p. 90
J. L., "Versatility of Talent Exhibited by 'The Ten,'" *Art News*, vol. xxxv, no. 32, May 8, 1937, p. 17

Wanamaker's Picture Gallery, John Wanamaker, New York, *Second Annual Membership Exhibition: American Artists Congress Incorporated*, May 5-21, 1938

Passedoit Gallery, New York, *The Ten*, May 9-21, 1938
M.D., "New Experiments by 'The Ten' Group in its Seasonal Show,"
Art News, vol. xxxvi, no. 34, May 21, 1938, p. 16

Mercury Galleries, New York, *The Ten:*

Whitney Dissenters, November 5-26, 1938. Pamphlet with text by Bernard Braddon and Marcus Rothkowitz
J.L., "'Whitney Dissenters' Hold Their own Exhibition," *Art News*, vol. xxxviii, no. 7, November 12, 1938, p. 15
"Whitney Dissenters," *The Art Digest*, vol. xiii, no. 4, November 15, 1938, p. 9

Bonestell Gallery, New York, *The Ten*, October 23-November 4, 1939
J.L., "'The Ten:' a Substantial Showing," *Art News*, vol. xxxviii, no. 4, October 28, 1939, p. 16

Neumann-Willard Gallery, New York, *New Work by Marcel Gromaire, Mark Rothko, Joseph Solman*, January 8-27, 1940
J.L., "Three Moderns: Rothko, Gromaire and Solman," *Art News*, vol. xxxviii, no. 16, January 20, 1940, p. 12

Rotunda of the American Art Today Building, New York World's Fair, *The Federation of Modern Painters and Sculptors: The First Exhibition of Paintings and Sculpture*, June 20-July 8, 1940

Smith College Museum of Art, Northampton, Massachusetts, *American Art from the Federation of Modern Painters and Sculptors*, November 12-December 1, 1940

Riverside Museum, New York, *The First Annual Exhibition of the Federation of Modern Painters and Sculptors*, March 9-23, 1941

R.H. Macy Department Store, New York [Group Exhibition], January 5-26, 1942. Organized by Samuel Kootz
Edward Alden Jewell, "Mr. Kootz 'Discovers,'" *The New York Times*, January 11, 1942, Section 9, p. 9; reply by Samuel Kootz, "Letter to the Editor: Opinions under Postage," *The New York Times*,

January 18, 1942, Section 9, p. x9

Wildenstein and Co., Inc., Galleries, *The Federation of Modern Painters and Sculptors: Second Annual*, May 21-June 10, 1942. Catalogue

Wildenstein, New York, *The Federation of Modern Painters and Sculptors Inc.: Third Annual Exhibition*, June 3-26, 1943
Edward Alden Jewell, "End-Of-The-Season Melange," *The New York Times*, June 6, 1943, Section II, p. x9; reply by Marcus Rothko and Adolph Gottlieb with unacknowledged collaboration of Barnett Newman [letter], in Edward Alden Jewell, "The Realm of Art," *The New York Times*, June 13, 1943, p. x9

The 460 Park Avenue Galleries, New York, *As We See Them*, October 11-November 3, 1943

Abstract and Surrealist Art in the United States. Organized by Sidney Janis, circulated by San Francisco Museum of Art. Traveled to: Cincinnati Art Museum, February 8-March 12, 1944; The Denver Art Museum, March 26-April 3, 1944; The Santa Barbara Museum of Art, June-July 1944; San Francisco Museum of Art, July 1944. Catalogue with text by Sidney Janis. Traveled to Mortimer Brandt Gallery, New York, November 29-December 30, 1944. Separate catalogue published as Sidney Janis, *Abstract and Surrealist Art in America*, New York, 1944
M[aude] R[iley], "Whither Goes Abstract and Surrealist Art?" *The Art Digest*, vol. xix, no. 5, December 1, 1944, pp. 8, 31
Emily Genauer, "New Surrealist Show," *The New York World Telegram*, December 2, 1944, p. 9
Howard Devree, "Among the New Shows," *The New York Times*, December 3, 1944, Section II, p. x8

Art of This Century, New York, *First Exhibition in America of (twenty paintings) never shown in America Before* [sic], April 11-May 6, 1944

New Art Circle, New York, *Some Aspects of Modern Art*, closed October 23, 1944
Maude Riley, "Fifty-Seventh Street in Review," *The Art Digest*, vol. 19, no. 2, October 15, 1944, p. 17

67 Gallery, New York, *Forty American Moderns*, December 4-30, 1944
R.F. "Gifts for Dollars: A Fair Exchange," *Art News*, vol. xlii, no. 17, December 15-31, 1944, p. 18

David Porter Gallery, Washington, D.C., *A Painting Prophecy—1950*, February 1945. Catalogue with texts by Rothko and other participating artists

67 Gallery, New York, *A Problem for Critics*, May 14-July 7, 1945
Robert M. Coates, "The Art Galleries," *The New Yorker*, vol. xxi, no. 15, May 26, 1945, p. 68
Maude Riley, "Insufficient Evidence," *The Art Digest*, vol. 19, no. 17, June 1, 1945, p. 12
Clement Greenberg, "Art," *The Nation*, vol. clx, no. 23, June 9, 1945, pp. 657, 659
Edward Alden Jewell, "Toward Abstract or Away? A Problem for Critics," *The New York Times*, July 1, 1945, Section II, p. 2

California Palace of the Legion of Honor, San Francisco, *Contemporary American Painting*, May 17-June 17, 1945. Catalogue with text by Jermayne MacAgy

Wildenstein and Co., Inc., New York, *Fifth Anniversary Exhibition of Paintings and Sculpture by Members of the Federation of Modern Painters and Sculptors and guest artists*, September 12-29, 1945
"Unhampered Flow of Tradition..." *Limited Edition*, September 1945, p. 2

Art of This Century, New York, *Autumn Salon*, October 6-29, 1945
"The Passing Shows," *Art News*, vol. xliv, no. 13, October 15-31, 1945, p. 29

Whitney Museum of American Art, New York, *Annual Exhibition of Contemporary American Painting*, November 27, 1945-January 10, 1946. Catalogue
Alfred M. Frankfurter, "The Whitney Sets the Pace," *Art News*, vol. xliv, no. 16, December 1-14, 1945, pp. 13-15

Pennsylvania Academy of Fine Arts, Philadelphia, *The One Hundred and Forty-First Annual Exhibition of Painting and Sculpture*, January 26-March 3, 1946. Catalogue

Whitney Museum of American Art, New York, *Annual Exhibition of Contemporary American Sculpture, Watercolors and Drawings*, February 5-March 13, 1946. Catalogue
Thomas B. Hess, "The Whitney Draws Slowly to the Left," *Art News*, vol. xlv, no. 1, March 1946, pp. 29, 62

Charles Egan Gallery, New York, *12 Works of Distinction*, May 20-June 8, 1946
"Reviews and Previews," *Art News*, vol. xlv, no. 5, July 1946, pp. 48-49

Wildenstein and Co., Inc., New York, *Sixth Annual Exhibition of Paintings and Sculpture by Members of the Federation of Modern Painters and Sculptors and guest artists*, September 18-October 5, 1946. Traveled to: The Rochester Memorial Art Gallery, New York; The Saint Paul Gallery, Minnesota; M.H. de Young Memorial Museum, San Francisco; The Museum of Fine Arts, Houston; William Rockhill Nelson Gallery of Art, Kansas City, Missouri

Whitney Museum of American Art, New York, *Annual Exhibition of Contemporary American Painting*, December 10, 1946-January 16, 1947. Catalogue
Alfred M. Frankfurter, "What's Modern at the Whitney: Abstract Emphasis Builds Up the Naturalists," *Art News*, vol. xlv, no. 11, January 1947, pp. 18-19, 57

Betty Parsons Gallery, New York, *The Ideographic Picture*, January 20-February 8, 1947. Announcement with text by B[arnett] B. Newman
Edward Alden Jewell, "New Phase in Art Noted at Display," *The New York Times*, January 23, 1947, p. 21
Edward Alden Jewell, "By British Masters: 'The Ideographic Picture,'" *The New York Times*, January 26, 1947, p. x9
"Reviews and Previews," *Art News*, vol. xlv, no. 12, February 1947, p. 44

The Brooklyn Museum, *International Watercolor Exhibition, 14th Biennial*, April 16-June 8, 1947
Thomas B. Hess, "One World in Watercolor," *Art News*, vol. xlvi, no. 3, May 1947, pp. 25, 54-55

The Art Institute of Chicago, *Abstract and Surrealist American Art*, November 6, 1947-January 1, 1948. Catalogue with texts by Katharine Kuh and Frederick Sweet
Peyton Boswell, Jr., "Chicago Surveys the Abstract and Surrealist Art of America," *The Art Digest*, vol. 22, no. 4, November 15, 1947, pp. 9-10

Whitney Museum of American Art, New York, *Annual Exhibition of Contemporary American Painting*, December 6, 1947-January 25, 1948. Catalogue

Whitney Museum of American Art, New York, *Annual Exhibition of Contemporary American Sculpture, Watercolors and Drawings*, January 31-March 21, 1948. Catalogue.

Venice, *La XXIV Biennale di Venezia: La Collezione Peggy Guggenheim*, May 29-September 30, 1948. Catalogue with

281

texts by Bruno Alfieri and Peggy Guggenheim

Wildenstein and Co., New York, *Eighth Annual Exhibition of Paintings and Sculpture by Members of the Federation of Modern Painters and Sculptors*, September 14-October 2, 1948

Palazzo Strozzi, Florence, *La Collezione Guggenheim*, February 19-March 10, 1949. Catalogue with text by Peggy Guggenheim. Traveled to Palazzo Reale, Milan, June 1949. Separate catalogue with additional text by Franccsco Flora

National Arts Club, New York, *Federation of Modern Painters and Sculptors*, March 14-31, 1949

Whitney Museum of American Art, New York, *Annual Exhibition of Contemporary American Sculpture, Watercolors and Drawings*, April 2-May 8, 1949. Catalogue

San Francisco Museum of Art, *The Western Round Table on Modern Art*, April 8-10, 1949

Samuel M. Kootz Gallery, New York, *The Intrasubjectives*, September 15-October 3, 1949. Catalogue with text by Samuel Kootz
Margaret Breuning, "Kootz Re-opens," *The Art Digest*, vol. 23, no. 20, September 15, 1949, p. 15

Colorado Springs Fine Arts Center, *New Accessions, U.S.A., from Great Britain, The United States and France, with Sculpture from the United States*, November-December 1949

Whitney Museum of American Art, New York, *Annual Exhibition of Contemporary American Painting*, December 16, 1949-February 5, 1950. Catalogue

Lotos Club, New York, *Exhibition of Watercolors and Sculpture By the Members of the Federation of Modern Painters and Sculptors*, February 21-March 5, 1950

College of Fine and Applied Arts, Urbana, Illinois, *University of Illinois Exhibition of Contemporary American Painting*, February 26-April 2, 1950. Catalogue with text by Allen S. Weller

Virginia Museum of Fine Arts, Richmond, *American Painting 1950*, April 22-June 4, 1950. Catalogue with text by James Johnson Sweeney

Sidney Janis Gallery, New York, *Young Painters in U.S. and France*, October 22-

November 11, 1950
Belle Krasne, "Youth: France vs. U.S.," *The Art Digest*, vol. 25, no. 3, November 1, 1950, p. 17
R[obert] G[oodnough], "Reviews and Previews," *Art News*, vol. xlix, no. 7, November 1950, p. 47

Whitney Museum of American Art, New York, *Annual Exhibition of Contemporary American Painting*, November 10-December 31, 1950. Catalogue
Thomas B. Hess, "Invited Guests of the Whitney," *Art News*, vol. xlix, no. 8, December 1950, pp. 32-33, 63

Frank Perls Gallery, Beverly Hills, *Seventeen Modern American Painters*, January 11-February 7, 1951. Catalogue with text by Robert Motherwell

Stedelijk Museum, Amsterdam, *Surrealisme + Abstraction: Choix de la Collection Peggy Guggenheim/Surrealisme + Abstractie: Keuze uit de Verzameling Peggy Guggenheim*, January 19-February 26, 1951. Traveled to Palais des Beaux-Arts de Bruxelles, March 3-28, 1951. Catalogue in French and Dutch. Traveled to Kunsthaus Zürich, as *Moderne Kunst aus der Sammlung Peggy Guggenheim*, April-May 1951. Separate catalogue in German with text by Max Bill

The Museum of Modern Art, New York, *Abstract Painting and Sculpture in America*, January 23-March 25, 1951. Catalogue with text by Andrew Carnduff Ritchie
Belle Krasne, "The Modern Presents 37 Years of Abstraction in America," *The Art Digest*, vol. 25, no. 8, February 1, 1951, pp. 11, 21
Thomas B. Hess, "Is Abstraction Un-American?" *Art News*, vol. xlix, no. 10, February 1951, pp. 38-41

University Galleries, University of Nebraska, Lincoln, *Nebraska Art Association Sixty-First Annual Exhibition*, March 4-April 1, 1951. Catalogue
"Nebraska Shows Old and New," *The Art Digest*, vol. 25, no. 12, March 15, 1951, p. 11

College of Fine and Applied Arts, Urbana, Illinois, *University of Illinois Exhibition of Contemporary Painting*, March 4-April 15, 1951. Catalogue with text by Allen S. Weller

Los Angeles County Museum, *1951 Annual Exhibition: Contemporary Painting in the United States*, June 2-July 22, 1951. Catalogue with text by James B. Byrnes

University Gallery, University of Minnesota, Minneapolis, *40 American Painters, 1940-1950*, June 4-August 30, 1951. Catalogue with text by H.H. Arnason

The Museum of Modern Art, New York, *Selections from New York Private Collections*, Summer 1951. Catalogue

Rathaus Schönberg, Berlin, *Berliner Festwochen 1951: Amerikanische Malerei: Werden und Gegenwart*, September 20-October 5, 1951. Traveled to Schloss Charlottenburg, October 10-24, 1951. Catalogue

São Paulo, Brazil, *I Bienal do Museu de Arte Moderna de São Paulo*, October-December 1951. Catalogue

City Art Museum of Saint Louis, *Contemporary American Painting*, November 12-December 10, 1951. Catalogue

The Brooklyn Museum, New York, *Revolution and Tradition: An Exhibition of the Chief Movements in American Painting from 1900 to the Present*, November 15, 1951-January 6, 1952. Catalogue with text by John I.H. Baur
D[orothy] S[eckler], "The American Conflict: Rebel and Conformist," *Art News*, vol. 50, no. 8, December 1951, pp. 21, 58-59

The Museum of Modern Art, New York, *15 Americans*, March 25-June 11, 1952. Catalogue with reprinted and new texts by Rothko and other participating artists
James Fitzsimmons, "Fifteen More Questions Posed at the Modern Museum," *The Art Digest*, vol. 26, no. 15, May 1, 1952, pp. 11, 24

Sidney Janis Gallery, New York, *9 American Painters Today*, January 4-23, 1954

Joe and Emily Lowe Art Center, Syracuse University, *Painting and Sculpture from the Institute Collection*, February 9-28, 1954

Modern Art in the U.S.A. Organized by The International Council of The Museum of Modern Art, New York. Separate catalogue in language of each country with texts by some or all of following: Holger Cahill, Mildred Constantine, Greta Daniel, Arthur Drexler, Richard Griffith, Henry Russell Hitchcock, William S. Lieberman, Edward Steichen. Traveled to: Musée Nationale d'Art Moderne, Paris, as *Cinquante ans d'art aux Etats-Unis*, March 30-May 15, 1955; Kunsthaus Zürich, as *Moderne Kunst aus U.S.A.*, July

16-August 28, 1955; Museo de Arte Moderno, Barcelona, as *El Arte Moderno en el Estados Unidos* (architecture), and Palacio de la Virveina, Barcelona, as *3rd Bienal Hispano-Americano de Arte: El Arte Moderno en el Estados Unidos* (painting, sculpture, prints), September 24-October 24, 1955, with two catalogues; Haus des Deutschen Kunsthandwerks, Frankfurt, as *Moderne Kunst aus U.S.A.,* November 13-December 11, 1955; Tate Gallery, London, as *Modern Art in the United States,* January 5-February 12, 1956; Gemeente Museum, The Hague, as *50 jaar moderne kunst in de U.S.A.,* March 2-April 15, 1956; Wiener Secession Galerie (painting, sculpture, prints, architecture) and Neue Galerie, Vienna (photography), as *Moderne Kunst aus U.S.A.,* May 5-June 2, 1956, with one catalogue; Kalemagdan Pavilion (painting, sculpture), ULUS Gallery, (prints, photographs), Fresco Museum (architecture), Belgrade, as *Savremena utmetnost U.S.A.D.,* July 6-August 6, 1956, with one catalogue
Emily Genauer, "Bad Press for U.S. Art Show in Paris Examined," *New York Herald Tribune,* April 17, 1955, Section 6, p. 13
Lawrence Alloway, "U.S. Modern: Paintings," *Art News and Review,* vol. vii, no. 26, January 21, 1956, pp. 1, 9
Patrick Heron, "The Americans at the Tate Gallery," *Arts,* vol. 30, no. 6, March 1956, pp. 15-17

Milwaukee Art Institute, Wisconsin, *55 Americans,* September 9-October 23, 1955

Katonah Gallery, Katonah, New York, *American Watercolors from the Whitney Museum of American Art,* November 26, 1955 January 3, 1956

Betty Parsons Gallery, New York, *Ten Years,* December 19, 1955-January 14, 1956. Announcement with text by Clement Greenberg

Sidney Janis Gallery, New York, *Recent Paintings by 7 Americans,* September 24-October 20, 1956

The Phillips Collection, Washington, D.C., *Paintings by Mark Rothko, Bradley Tomlin and Kenzo Okada,* January 6-February 26, 1957

All India Arts & Crafts Society, New Delhi, *Third International Contemporary Art Exhibition,* February 23-March 7, 1957. Traveled to: Municipal Museum, Ahmedabad, closed March 31, 1957; In-dustrial Exhibition Grounds, Hyderabad, April 15-25, 1957; Calcutta, May 4-25, 1957

Sidney Janis Gallery, New York, *8 Americans,* April 1-20, 1957. Catalogue
J[ames] S[chuyler], "Reviews and Previews," *Art News,* vol. 56, no. 2, April 1957, p. 11

Albright Art Gallery, Buffalo, *Contemporary Art Acquisitions 1954-1957,* May 15, 1957-February 15, 1958. Catalogue

Gimpel Fils, Ltd., London, *Summer Exhibition,* July 16-August 24, 1957
Robert Melville, "Exhibitions," *Architectural Review,* vol. cxxii, no. 729, October 1957, pp. 269-271

Museum of Art, Pennsylvania State University, Hetzel Union Building, *An Exhibition in Tribute to Sidney Janis,* February 3-24, 1958

Institute of Contemporary Art, London, *Some Paintings from the E.J. Power Collection,* March 13-April 19, 1958. Catalogue with text by Lawrence Alloway
Patrick Heron, "London," *Arts,* vol. 32, no. 8, May 1958, pp. 22-23

The New American Painting. Organized by The International Council of The Museum of Modern Art, New York. Separate catalogue in language of each country with texts by Alfred H. Barr, Jr., Porter McCray, reprinted texts by Rothko and other participating artists. Traveled to: Kunsthalle Basel, as *Die neue amerikanische malerei,* April 19-May 26, 1958, with additional catalogue text by Arnold Rüdlinger; Galleria Civica d'Arte Moderna, Milan, as *La Nuova Pittura Americana,* June 1-29, 1958; Museo Nacional de Arte Contemporáneo, Madrid, as *La Nueva Pintura Americana,* July 16-August 11, 1958; Hochschule für Bildende Künste, Berlin, as *Die neue amerikanische malerei,* September 1-October 1, 1958; Stedelijk Museum, Amsterdam, as *Jong Amerika schildert,* October 17-November 24, 1958; Palais des Beaux-Arts de Bruxelles, as *La nouvelle peinture américaine,* December 6, 1958-January 4, 1959; Musée National d'Art Moderne, Paris, with additional exhibition as *Jackson Pollock et la nouvelle peinture américaine,* January 16-February 15, 1959, with additional catalogue texts by Sam Hunter on Pollock and by Jean Cassou; Tate Gallery, London, as *The New American Painting,* February 24-March 22, 1959, with additional catalogue text by Gabriel White; The Museum of Modern Art, New York, as *The New American Painting,* May 28-September 8, 1959. Traveled in part to Albany Institute of History and Art, New York, as *The New American Painting,* September 25-October 25, 1959
Emily Genauer, "Abstract Art that Toured Europe is Displayed Here," *The New York Herald Tribune,* May 28, 1959, p. 17
Hilton Kramer, "The End of Modern Painting," *The Reporter,* July 23, 1959, p. 42
Kenneth Rexroth, "Americans Seen Abroad," *Art News,* vol. 58, no. 4, Summer 1959, pp. 30-33, 52, 54
Lawrence Alloway, "The New American Painting," *Art International,* vol. 111, no. 3-4, 1959, pp. 21-29

Fieldston School Arts Center, New York, *American Art Today,* April 26-30, 1958

Venice, *XXIX Exposizione Biennale Internazionale d'Arte,* June 14-October 19, 1958. Catalogue with text on Rothko by Sam Hunter
Ettore Camesasca, "La Pittura Straniera," *Le Arti,* vol. vii, no. 4/5, May 5, 1958, pp. 4-5
Heinz Keller, "Ausstellungen: Venedig," *Werk,* jg. 45, heft 8, August 1958, pp. 153-156

Sidney Janis Gallery, New York, *X Years of Janis: 10th Anniversary Exhibition,* September 29-November 1, 1958

Root Art Center, Clinton, New York, *New Trends in 20th Century American Painting,* October 26-November 30, 1958

Department of Fine Arts, Carnegie Institute, Pittsburgh, *The 1958 Pittsburgh Bicentennial International Exhibition of Contemporary Painting and Sculpture,* December 5, 1958-February 8, 1959. Catalogue

Sidney Janis Gallery, New York, *8 American Painters,* January 5-31, 1959. Catalogue
J[ames] S[chuyler], "Reviews and Previews," *Art News,* vol. 57, no. 9, January 1959, p. 10

The Museum of Fine Arts, Houston, *New York and Paris: Painting in the Fifties,* January 16-February 8, 1959. Catalogue with texts by Dore Ashton and Bernard Dorival

Brooks Memorial Art Gallery, Memphis, *The Roy and Marie Neuberger Collection, 21 American Paintings: 1944-1956,* February 13-March 1, 1959

283

Kunstmuseum St. Gallen, Switzerland, *Neue Amerikanische Malerei*, March 14-April 26, 1959. Catalogue with texts by R. Hanhart, E. Naegeli and Hans Theler

Kassel, Germany, Museum Fridericianum, *II Documenta '59, Kunst nach 1945: Internationale Ausstellung*, July 11-October 11, 1959. Catalogue with text by Werner Haftmann
Lawrence Alloway, "Before and After 1945: Reflections on Documenta II," *Art International*, vol. 111, no. 7, 1959, pp. 29-36, 79

Sokolniki, Moscow, *American Painting and Sculpture: American National Exhibition in Moscow*, July 25-September 5, 1959. Organized by Archives of American Art, Detroit. Catalogue with text in English by Lloyd Goodrich

The Columbus Gallery of Fine Arts, Ohio, *Contemporary American Painting*, January 14-February 18, 1960. Catalogue with text by Tracy Atkinson

Modern American Painting 1930-1958. Organized by City Art Museum of St. Louis, circulated by United States Information Agency. Separate catalogue in language of each country with anonymous texts. Traveled to: Galleria Nazionale d'Arte Moderna, Rome, January 23-February 22, 1960; Permanente Gallery, Milan, as *25 Anni di Pittura Americana*, March 5-31, 1960; Amerika Haus, Berlin, April 15-May 15, 1960; Hessisches Landesmuseum Darmstadt, as *Moderne Amerikanische Malerei 1930-1958*, June 3-26, 1960; Göteborgs Konstmuseum, Göteborg, Sweden, as *Modernt Amerikanst Maleri 1932-1958*, July 15-August 7, 1960; City Art Gallery, York, England, mid-August-mid-September, 1960
J.A.S. Ingamells, "American Painting at York," *Museums Journal*, vol. 60, no. 6, October 1960, pp. 165-168

Galerie Neufville, Paris [Group Exhibition], February 23-March 22, 1960

University of California, Berkeley, *Art from Ingres to Pollock*, March 6-April 3, 1960. Catalogue with texts by Herschel B. Chipp and Grace Morley

Whitney Museum of American Art, New York, *Business Buys American Art*, March 17-April 24, 1960. Catalogue

Walker Art Center, Minneapolis, *60 American Painters 1960: Abstract Expressionist Painting of the '50's*, April 3-May 8, 1960. Catalogue with text by H.H. Arnason and

Herbert Read. Reprinted in *Art News*, May 1960, see Bibliography, General Articles, p. 293

Sidney Janis Gallery, New York, *9 American Painters*, April 4-23, 1960. Catalogue

Yale University Christian Association, New Haven, *Religious Perspectives in Post-1950 American Art*, April 18-29, 1960

Galleria dell'Ariete, Milan, *Undici Americani*, April 27-May 1960. Catalogue with text by Guido Ballo

San Francisco Museum of Art, *Paintings and Sculpture from the Collection of Mrs. John D. Rockefeller, III*, July 1-August 7, 1960

Cleveland Museum of Art, *Paths of Abstract Art*, October 4-November 13, 1960. Catalogue published as Edward B. Henning, *Paths of Abstract Art*, New York, 1960

Munson-Williams-Proctor Institute, Utica, New York, *Art Across America*, October 15-December 31, 1960. Catalogue with texts by Howard Mumford Jones and Richard B.K. McLanathan

Helmhaus Zürich, *Konkrete Kunst: 50 Jahre Entwicklung*, 1960

Kunstmuseum Basel, *Die Jubiläumsschenkung des Schweizerischen National-Versicherungs-Gesellschaft an das Basler Kunstmuseum*, 1960
Maria Netter, "Die Jubiläumsschenkung des Schweizerischen National-Versicherungs-Gesellschaft an das Basler Kunstmuseum," *Werk*, jg. 47, heft 5, May 1960, pp. 182-183

Städtisches Museum Leverkusen, West Germany, *Monochrome Malerei*, 1960

William Rockhill Nelson Gallery and Atkins Museum of Fine Arts, Kansas City, Missouri, *On the Logic of Modern Art*, January 19-February 26, 1961. Catalogue with text by Ralph T. Coe

Union College, Schenectady, New York, *New Trends in 20th Century American Painting*, March 5-26, 1961

John and Mable Ringling Museum of Art, Sarasota, Florida, *The Sidney Janis Painters*, April 8-May 7, 1961

Yale University Art Gallery, New Haven, *Paintings and Sculpture from the Albright Art Gallery*, April 26-September 4, 1961

Birmingham Museum of Art, Alabama, *Tenth Anniversary Exhibition*, April

28-May 31, 1961

Sidney Janis Gallery, New York, *10 American Painters*, May 8-June 3, 1961. Catalogue
I[rving] H. S[andler], "Reviews and Previews: Ten Americans," *Art News*, vol. 60, no. 4, Summer 1961, p. 10

Centro Internazionale delle Arti e del Costume, Palazzo Grassi, Venice, *Arte e Contemplazione*, July 7-October 18, 1961. Catalogue with text by Paolo Marinotti and poem by Willem Sandberg

Stedelijk Museum, Amsterdam, *Polariteit*, July 22-September 18, 1961. Catalogue with texts by Thomas Grochowiak and Annelise Schröder

Smolin Gallery, New York, *Paintings from the W.P.A.*, September 11-October 5, 1961
L[awrence] C[ampbell], "Reviews and Previews: Paintings from the W.P.A.," *Art News*, vol. 60, no. 5, September 1961, p. 14

San Francisco Museum of Art, *American Business and the Arts*, September 14-October 15, 1961

The Collection of Mr. and Mrs. Ben Heller. Organized by The Museum of Modern Art, New York. Traveled to: The Art Institute of Chicago, September 22-October 22, 1961; The Baltimore Museum of Art, December 3-31, 1961; Contemporary Arts Center, Cincinnati, January 22-February 25, 1962; The Cleveland Museum of Art, March 13-April 10, 1962; California Palace of the Legion of Honor, San Francisco, April 30-June 3, 1962; Portland Art Museum, Oregon, June 15-July 22, 1962; Los Angeles County Museum of Art, September 5-October 14, 1962. Catalogue with texts by Alfred H. Barr, Jr., Ben Heller and William Seitz
Henry Geldzahler, "Heller: New American-type collector," *Art News*, vol. 60, no. 5, September 1961, pp. 28-31, 58

The Solomon R. Guggenheim Museum, New York, *American Abstract Expressionists and Imagists*, October 13-December 31, 1961. Catalogue with text by H.H. Arnason
Jack Kroll, "American Painting and the Convertible Spiral," *Art News*, vol. 60, no. 7, November 1961, pp. 34-37, 66, 68-69
Lawrence Alloway, "Easel Painting at the Guggenheim," *Art International*, vol.

v, no. 10, Christmas 1961, pp. 26-34
Dore Ashton, "Art," *Arts & Architecture*, vol. 78, no. 12, December 1961, pp. 4-5

Vanguard American Painting. Organized by H. H. Arnason for United States Information Service. Separate catalogue in language of each country with text by H.H. Arnason. Traveled to: various cities, Yugoslavia, as *Savremena Amerika umenost 1961*; USIS Gallery, American Embassy, London, February 28-March 30, 1962; Hessischen Landesmuseum, Darmstadt, as *Abstrakte Amerikanische Malerei*, April 14-May 13, 1962; Salzburg, Zwerglgarten, as *Amerikanische Maler der Gegenwart*, July 10-August 3, 1962

Department of Fine Arts, Carnegie Institute, Pittsburgh, *The 1961 Pittsburgh International Exhibition of Contemporary Painting and Sculpture*, October 27, 1961-January 7, 1962. Catalogue with text by Gordon Bailet Washburn

Whitney Museum of American Art, New York, *American Art of our Century: 30th Anniversary Exhibition*, November 15-December 10, 1961. Catalogue with texts by John I.H. Baur and Lloyd Goodrich

Florida Union Social Room, University of Florida, *Painting and Sculpture in Florida Collections*, January 14-18, 1962

Whitney Museum of American Art, New York, *Masters of American Watercolor*, February 13-March 4, 1962
Dore Ashton, "New York Commentary: De Kooning's Verve," *Studio International*, vol. 163, no. 830, June 1962, p. 225

Gimpel Fils Ltd., London, *A Selection of East Coast & West Coast American Painters*, March 1962
J[asia] Reichardt, "Les Expositions à Londres: peinture américaine," *Aujourd'hui*, 6e année, no. 36, April 1962, p. 55

Wadsworth Atheneum, Hartford, *Continuity and Change: 45 American Abstract Painters and Sculptors*, April 12-May 27, 1962. Catalogue with text by Samuel Wagstaff, Jr.
Daniel Robbins, "Continuity and Change at Hartford," *Art International*, vol. vi, no. 8, October 25, 1962, pp. 59-65

Seattle Fine Arts Pavilion, *Seattle World's Fair, Art Since 1950: American and International*, April 21-October 21, 1962. Catalogue with text by Sam Hunter. Traveled in part to: Rose Art Museum,

Brandeis University, Waltham, Massachusetts, November 21-December 23, 1962; The Institute of Contemporary Art, Boston, as *American Art Since 1950*. Separate catalogue with text by Sam Hunter reprinted from Seattle catalogue

Sidney Janis Gallery, New York, *10 American Painters*, May 7-June 2, 1962. Catalogue

Haus am Waldsee, Berlin, *Gegenwart bis 1962*, June 1962. Catalogue with text by Manfred de Motte

Smolin Gallery, New York, *Art of the Thirties*, September 25-October 13, 1962

Oakland Art Museum, California, *Treasures from East Bay Collections*, September 28-November 2, 1962. Catalogue

University of Michigan Museum of Art, Ann Arbor, *Contemporary American Painting, Selections from the Collection of Mr. and Mrs. Roy R. Neuberger*, October 21-November 18, 1962

Dwan Gallery, Los Angeles [Group Exhibition], 1962
H[enry] T. H[opkins], "Reviews: Los Angeles," *Artforum*, vol. i, no. 6, November 1962, p. 48

Amon Carter Museum of Western Art, Fort Worth, Texas, *The Artist's Environment: The West Coast*, November 6-December 24, 1962. Traveled to: UCLA Art Galleries, Los Angeles, January 6-February 10, 1963; Oakland Art Museum, California, March 17-April 15, 1963

Galerie Müller, Stuttgart, *Sam Francis, Franz Kline, Joan Mitchell, Robert Motherwell, Marc Rothko*, January 19-February 15, 1963

Marlborough Fine Art, Ltd., London, *Aspects of 20th Century Art*, July-August 1963. Catalogue

Sidney Janis Gallery, New York, *11 Abstract Expressionist Painters*, October 7-November 2, 1963. Catalogue

The Minneapolis Institute of Arts, *Four Centuries of American Art*, November 27, 1963-January 19, 1964. Catalogue with text by Marshall B. Davidson

New Directions in American Painting. Organized by The Poses Institute of Fine Arts, Brandeis University, Waltham, Massachusetts. Catalogue with text by Sam Hunter. Traveled to: Munson-Williams-Proctor Institute, Utica, New

York, December 1, 1963-January 5, 1964; Isaac Delgado Museum of Art, New Orleans, February 7-March 8, 1964; Atlanta Art Association, March 18-April 22, 1964; J.B. Speed Art Museum, Louisville, May 4-June 7, 1964; Art Museum, Indiana University, Bloomington, June 22-September 20, 1964; Washington University, St. Louis, October 5-30, 1964; Detroit Institute of Arts, November 10-December 6, 1964

Danbury Scott—Fanton Museum and Historical Society, Inc., Danbury, Connecticut, *27 Contemporary American Artists*, January 9-25, 1964. Organized by Whitney Museum of American Art, New York

Galerie Jacques Benador, Geneva, *Artistes américaines*, February 14-late March 1964

Sidney Janis Gallery, New York, *2 Generations: Picasso to Pollock*, March 3-April 4, 1964

University Art Museum, University of Texas at Austin, *Recent American Paintings*, April 15-May 15, 1964. Catalogue

Fine Arts Gallery, Indiana University, Bloomington, *American Painting 1910-1960*, April 19-May 10, 1964. Catalogue with text by Henry R. Hope

The Tate Gallery, London, *Painting and Sculpture of a Decade: 54-64*, April 22-June 28, 1964. Organized by Alan Bowness, Lawrence Gowing and Philip James for Calouste Gulbenkian Foundation. Catalogue with unsigned text by Bowness, Gowing and James
Alan Bowness, "54/64 Painting & Sculpture of a Decade," *Studio International*, vol. 167, no. 853, May 1964, pp. 190-194

Adelphi University, Garden City, New York, *A Century of American Art, 1864-1964*, July 10-26, 1964

Milwaukee Art Center, *Wisconsin Collects*, September 24-October 25, 1964. Catalogue

Art Gallery, The University of New Mexico, Albuquerque, *Art Since 1889*, October 20-November 15, 1964. Catalogue

Sidney Janis Gallery, New York, *A Selection of 20th Century Art of 3 Generations*, November 24-December 26, 1964. Catalogue

The Tate Gallery, London, *The Peggy Guggenheim Collection*, December 31, 1964-March 7, 1965. Catalogue with text by Peggy Guggenheim

Institute of Contemporary Art, University of Pennsylvania, Philadelphia, *1943-1953: The Decisive Years*, January 14-March 1, 1965. Catalogue

Providence Art Club, Rhode Island, *1965 Kane Memorial Exhibition, Critic's Choice: Art Since World War II*, March 31-April 24, 1965. Catalogue with texts by Thomas B. Hess, Hilton Kramer and Harold Rosenberg

Vassar College Art Gallery, Poughkeepsie, New York, *Art Since 1923: An Exhibition in Honor of Agnes Rindge Claflin*, May 5-June 16, 1965

The White House, Washington, D.C., *The White House Festival of the Arts*, June 14, 1965

Los Angeles County Museum of Art, *The New York School: The First Generation, Paintings of the 1940's and 1950's*, July 16-August 1, 1965. Catalogue with excerpts from earlier texts by Lawrence Alloway, Robert Goldwater, Clement Greenberg, Harold Rosenberg, William Rubin and Meyer Schapiro and reprinted texts by Rothko and other participating artists

Philip Leider, "The New York School: The First Generation," *Artforum*, vol. iv, no. 1, September 1965, pp. 3-13

University of California, Berkeley, *The University Arts Center*, January 6-February 16, 1966

Williams College Museum of Art, Wesleyan, Massachusetts, *Williams-Vassar Exchange Exhibition*, February 28-March 18, 1966

The Larry Aldrich Museum, Ridgefield, Connecticut, *Brandeis University Creative Arts Awards, 1957-1966: Tenth Anniversary Exhibition*, April 17-June 26, 1966. Catalogue

Seven Decades, 1895-1965: Crosscurrents in Modern Art, April 26-May 21, 1966. Organized by Public Education Association, New York. Exhibition divided among New York galleries: Paul Rosenberg and Co., *1895-1904;* M. Knoedler & Co., Inc., *1905-1914;* Perls Galleries, E. V. Thaw & Co., *1915-1924;* Saidenberg Gallery, *1925-1934;* Stephen Hahn Gallery, *1925-1934;* Pierre Matisse Gallery, *1935-1944;* André Emmerich Gallery and Galleria Odyssia, *1945-1954;* Cordier and Ekstrom, Inc., *1955-1965*. Catalogue with text by Peter Selz

Cleveland Museum of Art, *Fifty Years of Modern Art 1916-1966*, June 14-July 31, 1966. Catalogue with text by Edward B. Henning

Whitney Museum of American Art, New York, *Art of the United States: 1670-1966*, September 28-November 27, 1966. Catalogue with text by Lloyd Goodrich

Barbara Rose, "The New Whitney: The Show," *Artforum*, vol. 5, no. 3, November 1966, pp. 51-55

Detroit Institute of Arts, *The W. Hawkins Ferry Collection*, October 11-November 20, 1966

Two Decades of American Painting. Organized by The International Council of The Museum of Modern Art, New York. Separate catalogue in English in each country with texts by Lucy R. Lippard, Waldo Rasmussen, Irving Sandler, G.R. Swenson. Traveled to: The National Museum of Modern Art, Tokyo, October 15-November 27, 1966, with catalogue with Japanese section; The National Museum of Modern Art, Kyoto, December 12, 1966-January 22, 1967, with catalogue with Japanese section; Lalit Kala Academy, New Delhi, March 25-April 15, 1967; National Gallery of Victoria, Melbourne, June 6-July 8, 1967; Art Gallery of New South Wales, Sydney, July 17-August 20, 1967

Columbus Gallery of Fine Arts, Ohio, *Two Generations of American Art: 1943-1965*, November 11-December, 1966

Moderna Museet, Stockholm, *Peggy Guggenheim samling fran Venedig*, November 26, 1966-January 8, 1967. Catalogue with text by Peggy Guggenheim

Sidney Janis Gallery, New York, *2 Generations: Picasso to Pollock*, January 3-27, 1967. Catalogue

University of St. Thomas Art Department, Houston, *Six Painters*, February-April 1967. Catalogue with texts by Morton Feldman, Thomas B. Hess and Dominique de Menil

Kurt von Meier, "Houston," *Artforum*, vol. v, no. 9, May 1967, pp. 59-60

Fondation Maeght, St. Paul de Vence, France, *Dix ans d'art vivant 1955-1965*, May 3-July 23, 1967. Catalogue with text by Francois Wehrlin

Washington Gallery of Modern Art, Washington, D.C., *Art for Embassies Selected from the Woodward Foundation Collection*, September 30-November 5, 1967. Catalogue with text by Henry Geldzahler

Institute of Contemporary Art, University of Pennsylvania, Philadelphia, *Selected Works from the Collection of Mr. and Mrs. H. Gates Lloyd*, October 18-November 19, 1967. Catalogue

M. Knoedler et Cie., Paris, *Six peintres américains: Gorky, Kline, de Kooning, Newman, Pollock, Rothko*, October 19-November 25, 1967. Catalogue with reprinted texts by Elaine de Kooning, Rothko and other participating artists

Stedelijk van Abbemuseum, Eindhoven, The Netherlands, *Kompass III: Schilderkunst na 1945 uit New York: Paintings after 1945 in New York*, November 9-December 17, 1967. Catalogue in Dutch and English with text by Jean Leering. Traveled to Frankfurter Kunstverein as *Kompass New York: Malerei nach 1945*, December 30, 1967-February 11, 1968. Separate catalogue in German and English with texts by Leering and E. Rathke

The Royal Dublin Society, *Rosc '67: The Poetry of Vision*, November 13, 1967-January 10, 1968. Catalogue

Clement Greenberg, "Poetry of Vision," *Artforum*, vol. vi, no. 8, April 1968, pp. 18-21

The Museum of Modern Art, New York, *The Sidney and Harriet Janis Collection*, January 17-March 4, 1968. Traveled to: The Minneapolis Institute of Arts, May 15-July 28, 1968; Portland Art Museum, Oregon, September 13-October 13, 1968; Pasadena Art Museum, November 11-December 15, 1968; San Francisco Museum of Art, January 13-February 16, 1969; Seattle Art Museum, March 12-April 13, 1969; Detroit Institute of Arts, July 14-August 17, 1969; Albright-Knox Art Gallery, Buffalo, September 15-October 19, 1969; Cleveland Museum of Art, November 18, 1969-January 4, 1970. Catalogue with text by Alfred H. Barr, Jr. Circulated further by The International Council of The Museum of Modern Art. Separate catalogue in language of each country. Traveled to: Kunsthalle Basel, February 28-March 30, 1970; The Institute of Contemporary Arts, London, May 1-31, 1970; Akademie der Künste, Berlin, June 12-August, 1970; Kunsthalle, Nürnberg, September 11-October 25, 1970; Württembergischer Kunstverein, Stuttgart, as *Von Surrealismus bis*

zur Pop Art, November 12-December 27, 1970; Palais des Beaux-Arts de Bruxelles, January 7-February 11, 1971, with no catalogue; Kunsthalle Köln, Von Picasso bis Warhol, March 5-April 18, 1971. Separate catalogue with text by Helmut R. Leppien

Art Gallery, University of California, Irvine, Twentieth-Century Works on Paper, January 30-February 25, 1968. Traveled to Memorial Union Art Gallery, University of California, Davis, March 26-April 20, 1968. Catalogue with text by James Monte

Finch College Museum of Art, New York, Betty Parsons' Private Collection, March 13-April 24, 1968. Catalogue with text by E.C. Goossen

J.B., "In the Museums: The Betty Parsons Collection," Arts Magazine, vol. 42, no. 5, March 1968, p. 54

Rosalind Constable, "The Betty Parsons Collection," Art News, vol. 67, no. 1, March 1968, pp. 48-49, 58-60

The Museum of Modern Art, New York, Dada, Surrealism, and Their Heritage, March 27-June 9, 1968. Traveled to: Los Angeles County Museum of Art, July 16-September 8, 1968; The Art Institute of Chicago, October 19-December 8, 1968. Catalogue with text by William Rubin

The National Gallery of Art, Washington, D.C., Paintings from the Albright-Knox Art Gallery, May 18-July 21, 1968

Whitney Museum of American Art, New York, Recent Acquisitions, May 23-July 7, 1968

The Museum of Modern Art, New York, The Art of the Real: USA 1948-1968, July 3-September 8, 1968. Catalogue with text by E.C. Goossen. Circulated by The International Council of The Museum of Modern Art. Separate catalogue in language of each country with text by Goossen. Traveled to: Centre National d'Art Contemporain, Paris, as L'Art du réel: USA 1948-1968, November 14-December 23, 1968; Kunsthaus Zürich, as Der Raum in der Amerikanischer Kunst 1948-1968, January 19-February 23, 1969, with catalogue with Goossen text in English, additional text by Felix Andreas Baumann; The Tate Gallery, London, as The Art of the Real: An Aspect of American Painting and Sculpture, 1948-1969, April 24-June 1, 1969

Hilton Kramer, "The Abstract and the Real, From Metaphysics to Visual Facts," The New York Times, July 21, 1969, Section II, p. D31

Philip Leider, "Art of the Real, Museum of Modern Art," Artforum, vol. vii. no. 1, September 1968, p. 65

"Laufen der Ausstellungen: Der Raum in der Amerikanischer Kunst 1948-1968," Werk, jg. 56, no. 1, January 1969, p. 71

Robert Melville, "Gallery: Minimalism," Architectural Review, vol. cxivi, no. 870, August 1969, pp. 146-148

Cranbrook Academy of Art, Bloomfield Hills, Michigan, Betty Parsons' Private Collection, September 22-October 20, 1968. Traveled to Brooks Memorial Art Gallery, Memphis, November 1-December 1, 1968. Catalogue with text by E.C. Goossen

Honolulu Academy of Arts, Hawaii, Signals in the Sixties, October 5-November 10, 1968. Catalogue with text by James Johnson Sweeney

Milwaukee Art Center, The Collection of Mrs. Harry Lynde Bradley, October 25, 1968-February 23, 1969. Catalogue with text by Tracy Atkinson

Städtische Kunsthalle Düsseldorf, Malerei des Zwanzigsten Jahrhunderts, 1968

The Solomon R. Guggenheim Museum, New York, Works of Art from the Peggy Guggenheim Foundation, January 16-March 23, 1969. Catalogue with text by Peggy Guggenheim

The Disappearance and Reappearance of the Image: Painting in the United States since 1945. Organized by International Art Program, National Collection of Fine Arts, Smithsonian Institution, Washington, D.C. Separate catalogue in language of each country with texts by Ruth Kaufman and John W. McCoubrey, and reprinted texts by Rothko and other participating artists. Traveled to: Sala Dalles, Bucharest, January 17-February 2, 1969; Museul Banatului, Timosoara, Romania, February 14-March 1, 1969; Galeria de Arta, Cluj, Romania, March 14-April 2, 1969; Slovenská Národná Galéria, Bratislava, Czechoslovakia, April 14-June 15, 1969; Národní Galerie, Prague, July 1-August 15, 1969; Palais des Beaux-Arts de Bruxelles, October 21-November 16, 1969

Rona Dobson, "Brussels: The Look of

American Art from 1945 to Now," International Herald Tribune, November 1-2, 1969, p. 7

Kunsthaus Zürich, American Art 1948-1968, January 20-February 23, 1969

Gallery of Art, Washington University, St. Louis, The Development of Modernist Painting: Jackson Pollock to the Present, April 1-30, 1969. Catalogue with text by Robert T. Buck, Jr.

The Museum of Modern Art, New York, The New American Painting and Sculpture: The First Generation, June 18-October 5, 1969

Whitney Museum of American Art New York, Seven Decades of 20th Century Art, July 3-September 28, 1969

Hudson River Museum, Yonkers, New York, Art in Westchester from Private Collections, September 28-November 2, 1969. Catalogue with text by Donald M. Haley

The Metropolitan Museum of Art, New York, New York Painting and Sculpture: 1940-1970, October 16, 1969-February 1, 1970. Catalogue with texts by Michael Fried, Henry Geldzahler, Clement Greenberg, Harold Rosenberg, Robert Rosenblum and William Rubin, reprinted or revised from earlier sources

Museo Naciónal de Bellas Artes, Buenos Aires, 109 Obras de Albright-Knox Art Gallery, October 23-November 30, 1969. Catalogue

Pasadena Art Museum, Painting in New York: 1944 to 1969, November 24, 1969-January 11, 1970. Catalogue with text by Alan R. Solomon

Palais des Beaux-Arts de Bruxelles, Peinture américaine depuis 1945, 1969

Santa Barbara Museum of Art, Trends in Twentieth Century Art: a loan exhibition from the San Francisco Museum of Art, January 6-February 15, 1970

The Katonah Gallery, Katonah, New York, Color, February 1-March 15, 1970. Catalogue with texts by Michael Fried and Clement Greenberg adapted in part from earlier sources

School of Fine & Applied Arts Gallery, Boston University School of Fine and Applied Arts, Centennial Exhibition: American Artists of the Nineteen Sixties, February 6-March 14, 1970. Catalogue with text by H.H. Arnason

Whitney Museum of American Art, New

287

York, *Recent Acquisitions*, July 9-19, 1970

Fondation Maeght, St. Paul de Vence, France, *Exposition l'art vivant aux Etats Unis*, July 16-September 30, 1970. Catalogue with text by Dore Ashton

Whitney Museum of American Art, New York, *Landmarks of American Art: 1900-1960*, July 24-September 13, 1970

Albright-Knox Art Gallery, Buffalo, *Color and Field: 1890-1970*, September 15-November 1, 1970. Traveled to: Dayton Art Institute, November 20, 1970-January 10, 1971; Cleveland Museum of Art, February 4-March 28, 1971. Catalogue with text by Priscilla Colt

Edward B. Henning, "Color and Field," *Art International*, vol. xv, no. 5, May 20, 1971, pp. 46-50

San Francisco Museum of Art, *Modern Masters in West Coast Collections*, October 18-November 27, 1970. Catalogue with text by George D. Culler

Kunsthaus Zürich, *Malerei des zwansigsten Jahrhunderts*, 1970

Whitney Museum of American Art, New York, *The Structure of Color*, February 25-April 18, 1971. Catalogue with text by Marcia Tucker and reprinted texts by Rothko and other participating artists

Northwood Institute, Cedar Hill, Dallas, *Selections from the Collection of Mrs. Harry Lynde Bradley*, March 21-April 30, 1971. Catalogue

Galerie Beyeler, Basel, *Art Fair 1971 Basel: America*, June 24-29, 1971

Louisiana Museum, Humlebaek, Denmark, *Louisiana—Revy: Amerikansk Kunst 1950-1970*, September 11-October 24, 1971. Catalogue with texts by Stig Brogger, David Galloway, Klaus Honnef, Niels Jensen, Gunnar Jespersen and Erik Thygesen, and texts by Mel Bochner, John Cage, Öyvind Fahlstrom, Alan Solomon and Rothko and other participating artists translated from earlier sources

Corcoran Gallery of Art, Washington, D.C., *Twentieth Century American Artists*, October 23-November 22, 1971

New Orleans Museum of Art, *New Orleans Collects*, November 14, 1971-January 9, 1972. Catalogue

Albright-Knox Art Gallery, Buffalo, *Abstract Expressionism: First and Second Generations in the Albright-Knox Art Gal-lery*, January 19-February 20, 1972. Catalogue

Peter Schjeldahl, "Down Memory Lane to the Fifties," *The New York Times*, February 6, 1972, Section II, p. 23

Mead Art Building, Amherst College, Amherst, Massachusetts, *Color Painting*, February 4-March 3, 1972. Catalogue with text by Carl N. Schmalz

Sidney Janis Gallery, New York, *Abstract Expressionism and Pop Art*, February 9-March 4, 1972

The University Art Museum, The University of Texas, Austin, *Color Forum*, February 27-April 16, 1972. Catalogue

Marlborough Gallery, New York, *Masters of the 19th and 20th Centuries*, April-May 1972

Des Moines Art Center, Iowa, *Twenty-Five Years of American Painting 1948-1973*, March 6-April 22, 1973. Catalogue with text by Max Kozloff

Cleveland Museum of Art, *Cleveland Collects Contemporary Art*, July 11-August 20, 1973. Catalogue with text by Edward B. Henning

Seattle Art Museum, *American Art Third Quarter Century*, August 22-October 14, 1973. Catalogue with text by Jan van der Marck

Whitney Museum of American Art, Downtown Branch, New York, *Beginnings: Direction in Twentieth-Century American Painting*, September-October 26, 1973

Oakland Museum, Art Department, California, *Period of Exploration*, September 4-November 4, 1973. Catalogue with text by Mary Fuller McChesney

Des Moines Art Center, Iowa, *The Kirsch Years: 1936-1958*, January 7-February 10, 1974. Traveled to University of Nebraska Art Galleries, Lincoln, February 25-March 31, 1974

The Museum of Fine Arts, Houston, *The Great Decade of American Abstraction: Modernist Art 1960-1970*, January 15-March 10, 1974. Catalogue with texts by E.A. Carmean, Jr. and Phillippe de Montebello and texts by Walter Darby Bannard, Kermit Champa, Jane Harrison Cone, Michael Fried, Clement Greenberg, Rosalind Krauss, Kenworth Moffet, Barbara Rose and William Rubin reprinted or revised from earlier sources

Pace Gallery, New York, *Selected American Painters of the Fifties*, February 9-March 19, 1974

Sidney Janis Gallery, New York, *25 Years of Janis: Part 2: From Pollock to Pop, Op and Sharp-Focus on Realism*, March 13-April 13, 1974

Fort Worth Art Center Museum, Texas, *Twentieth Century Art from Fort Worth Dallas Collections*, September 8-October 15, 1974. Catalogue with text by Henry T. Hopkins

The Tate Gallery, London, *Picasso to Lichtenstein: Masterpieces of Twentieth-Century Art from the Nordrhein-Westfalen Collection in Düsseldorf*, October 2-November 24, 1974. Catalogue

Orangerie des Tuileries, Paris, *Art du XXe siècle, Fondation Peggy Guggenheim, Venise*, November 30, 1974-March 3, 1975. Catalogue with text by Peggy Guggenheim

Whitney Museum of American Art, Downtown Branch, New York, *Subjects of the Artists: New York Painting 1941-1947*, April 22-May 28, 1975

Institute for the Arts, Rice University, Houston, *Marden, Novros, Rothko*, April-May 1975. Catalogue published as *Marden, Novros, Rothko: Painting in the Age of Actuality*, Houston, 1978, with text by Sheldon Nodelman

Cleveland Museum of Art, *Landscapes, Interior and Exterior: Avery, Rothko and Schueler*, July 9-August 31, 1975. Catalogue with text by Edward B. Henning

The Jewish Museum, New York, *Jewish Experience in the Art of the Twentieth Century*, October 16, 1975-January 25, 1976. Catalogue

Fort Worth Art Center Museum, Texas, *Selections from the Permanent Collection and Fort Worth Private Collections*, October 26-November 9, 1975

The Edmonton Art Galley, Edmonton, Canada, *The Collective Unconscious: American and Canadian Art: 1940-1950*, December 5, 1975-January 18, 1976. Catalogue with text by Karen Wilkin

The Columbus Gallery of Fine Arts, Ohio, *Aspects of Postwar Painting in America*, January 17-February 29, 1976. Organized by The Solomon R. Guggenheim Museum, New York. Catalogue. Traveled in revised and expanded form to The Sol-

omon R. Guggenheim Museum, New York, as *Acquisition Priorities: Aspects of Postwar Painting in America,* October 15, 1976-January 16, 1977. Separate catalogue

The Solomon R. Guggenheim Museum, New York, *Twentieth Century American Drawing: Three Avant-Garde Generations,* January 23-March 28, 1976. Catalogue with text by Diane Waldman. Traveled as *Amerikanische Zeichner des 20. Jahrhunderts—Drei Generationen von der Armory Show bis Heute,* to: Staatliche Kunsthalle Baden-Baden, May 26-July 11, 1976; Kunsthalle Bremen, July 18-August 29, 1976. Separate catalogue in German with text by Waldman, additional text by Hans Albert Peters

The Minneapolis Institute of Arts, *America Now,* February 20-May 2, 1976

Heritage and Horizon: American Painting 1776-1976. Organized by The Toledo Museum of Art, Ohio. Traveled to: Albright-Knox Art Gallery, Buffalo, March 6-April 11, 1976; Detroit Institute of Arts, May 5-June 13, 1976; The Toledo Museum of Art, Ohio, July 4-August 15, 1976; Cleveland Museum of Art, September 8-October 10, 1976. Catalogue with texts by Robert T. Buck, Frederick J. Cummings, Sherman E. Lee and Otto W. Wittmann

Miami-Dade Community College, South Campus, Florida, *Abstract Expressionism, Works from the Collection of the Whitney Museum of American Art,* March 8-April 1, 1976. Catalogue

Hirshhorn Museum and Sculpture Garden, Smithsonian Institution, Washington, D.C., *The Golden Door: Artist-Immigrants of America, 1876-1976,* May 20-October 20, 1976. Catalogue with texts by Daniel J. Boorstin and Cynthia Jaffee McCabe

Fort Worth Art Center Museum, Texas, *The Permanent Collection: A 75th Anniversary Retrospective,* June 6-October 31, 1976

Seibu Department Store Art Gallery, Tokyo, *Three Decades of American Art,* June 18-

July 20, 1976. Organized by Whitney Museum of American Art, New York

"American Moderns Fail to Stir Tokyo," *The New York Times,* July 15, 1976, p. 40

The Brooklyn Museum, New York, *American Watercolors and Pastels from the Museum Collection,* July 3-September 19, 1976

Musée d'Art et d'Histoire, Geneva, *Peinture américaine en Suisse: 1950-1965,* July 4-October 4, 1976. Catalogue with text by Charles Goerg

Guild Hall, East Hampton, New York, *Artists and East Hampton: A 100-Year Perspective,* August 14-October 3, 1976. Catalogue

The Museum of Modern Art, New York, *The Natural Paradise: Painting in America 1800-1950,* October 1-November 30, 1976. Catalogue with texts by Kynaston McShine, Barbara Novak, Robert Rosenblum and John Wilmerding

Milwaukee Art Center, *From Foreign Shores: Three Centuries of Art by Foreign Born American Masters,* October 15-November 28, 1976. Catalogue with text by I. Michael Danoff

Fort Worth Art Center Museum, Texas, *Selections and New Acquisitions from the Fort Worth Art Museum Permanent Collection,* January 9-February 20, 1977

Kunsthaus Zürich, *Aspekte Konstruktiver Kunst,* January 14-February 27, 1977. Catalogue

Rutgers University Art Gallery, New Brunswick, New Jersey, *Surrealism and American Art: 1931-1947,* March 5-April 24, 1977. Catalogue with texts by Jack J. Spector and Jeffrey Wechsler

South Dakota Memorial Art Center, Brookings, *The Calligraphic Statement,* March 20-April 24, 1977

Sidney Janis Gallery, New York, *Less is More,* April 7-May 7, 1977. Catalogue with text by S[idney] J[anis]

San Francisco Museum of Modern Art, *Col-*

lectors, Collecting, Collection, April 22-June 5, 1977

The Fitzwilliam Museum, Cambridge, England, *Jubilation: American Art During the Reign of Elizabeth II,* May 10-June 18, 1977. Catalogue

Palais des Beaux-Arts de Bruxelles, *American Art in Belgium,* May 25-August 28, 1977. Catalogue with texts by K.J. Geirlandt and G. Roque

American Embassy, London, *American Art at Home in Britain: The last four decades,* July 6-26, 1977. Organized by The Contemporary Art Society in cooperation with United States Information Service. Catalogue with text by Marina Vaizey

The Parrish Art Museum, Southampton, New York, *Twentieth Century American Paintings from the Metropolitan Museum of Art,* September 25-December 31, 1977. Catalogue with texts by Henry Geldzahler and Helen A. Harrison

The New York State Museum, Albany, *New York: The State of Art,* October 9-November 27, 1977. Catalogue with texts by Robert Bishop, William H. Gerdts and Thomas B. Hess

The San Jose Museum of Art, California, *America VIII: Post-war Modernism,* November 4-December 31, 1977. Catalogue

Grace Borgenicht Gallery, New York, *Milton Avery and His Friends,* January 28-February 24, 1978

Abstract Expressionism: The Formative Years. Organized by Herbert F. Johnson, Museum of Art, Ithaca, and Whitney Museum of American Art, New York. Traveled to: Herbert F. Johnson Museum of Art, Cornell University, Ithaca, New York, March 30-May 14, 1978; The Seibu Museum of Art, Tokyo, June 17-July 12, 1978; Whitney Museum of American Art, New York, October 5-December 3, 1978. Catalogue with texts by Robert Carleton Hobbs and Gail Levin

II. One-Man

Museum of Art, Portland, Oregon [Drawings and watercolors exhibited with work of the artist's students at Center School, Brooklyn], Summer 1933

Bulletin of the Museum of Art Portland, vol.

3, no. 1, November-December, 1933, n.p.

Contemporary Arts Gallery, New York, *An Exhibition of Paintings by Marcus Rothkowitz,* November 21-December 9,

1933

Jane Schwartz, "Around the Galleries," *Art News,* vol. xxxii, no. 9, December 2, 1933, p. 16

Art of This Century, New York, *Mark*

Rothko Paintings, January 9-February 4, 1945. Catalogue with anonymous text

Edward Alden Jewell, "Art: Diverse Shows," *The New York Times*, January 14, 1945, Section II, p. 8

"The Passing Shows," *Art News*, vol. xliii, no. 19, January 15-31, 1945, p. 27

Maude Riley, "The Mythical Rothko and His Myths," *The Art Digest*, vol. 19, no. 8, January 15, 1945, p. 15

Mortimer Brandt Gallery, New York, *Mark Rothko: Watercolors*, April 22-May 4, 1946

Edward Alden Jewell, "Art: Hither and Yon," *The New York Times*, April 28, 1946, Section II, p. 6

"Reviews and Previews," *Art News*, vol. xlv, no. 2, April 1946, p. 55

Ben Wolf, "Mark Rothko Watercolors," *The Art Digest*, vol. 20, no. 15, May 1, 1946, p. 19

San Francisco Museum of Art, *Oils and Watercolors by Mark Rothko*, August 13-September 8, 1946. Traveled in part to The Santa Barbara Museum of Art, September 1946

Donald Bear, "Rothko's Paintings High in Interest, But Far from Easy to Analyze," *Santa Barbara News Press*, September 25, 1946, p. B8

Betty Parsons Gallery, New York, *Mark Rothko: Recent Paintings*, March 3-22, 1947

Howard Devree, "Diverse New Shows," *The New York Times*, March 9, 1947, Section II, p. 7

M[argaret] B[reuning], "Fifty-seventh Street in Review: Subliminal Symbols," *The Art Digest*, vol. 21, no. 12, March 15, 1947, p. 18

"Reviews and Previews," *Art News*, vol. xlv, no. 13, March 1947, p. 42

Betty Parsons Gallery, New York, *Mark Rothko: Recent Paintings*, March 8-27, 1948

Sam Hunter, "Diverse Modernism," *The New York Times*, March 14, 1948, Section II, p. x8

"Reviews and Previews," *Art News*, vol. xlvii, no. 2, April 1948, p. 63

Betty Parsons Gallery, New York, *Mark Rothko*, March 28-April 16, 1949

M[argaret] B[reuning], "Fifty-seventh Street in Review: Mark Rothko at Parsons," *The Art Digest*, vol. 23, no. 14, April 15, 1949, p. 27

T[homas] B. H[ess], "Reviews and Previews," *Art News*, vol. xlviii, no. 2, April 1949, p. 48

Betty Parsons Gallery, New York, *Mark Rothko*, January 3-21, 1950

Howard Devree, "In New Directions," *The New York Times*, January 8, 1950, Section II, p. x10

Belle Krasne, "Mark of Rothko," *The Art Digest*, vol. 24, no. 8, January 15, 1950, p. 17

T[homas] B. H[ess], "Reviews and Previews," *Art News*, vol. xlviii, no. 10, February 1950, p. 46

Betty Parsons Gallery, New York, *Mark Rothko*, April 2-12, 1951

Carlyle Burrows, "Final Works by Beckmann and a Group of Americans," *New York Herald Tribune*, April 8, 1951, Section 4, p. 8

Stuart Preston, "Chiefly Abstract," *The New York Times*, April 8, 1951, Section II, p. x9

M[ary] C[ole], "Fifty-seventh Street in Review: Mark Rothko," *The Art Digest*, vol. 25, no. 14, April 15, 1951, p. 18

The Art Institute of Chicago, *Recent Paintings by Mark Rothko*, October 18-December 31, 1954. Traveled in part to Museum of Art, Rhode Island School of Design, Providence, as *Paintings by Mark Rothko*, January 19-February 13, 1955

Hubert Crehan, "Rothko's Wall of Light: A Show of his New Work at Chicago," *Arts Digest*, vol. 29, no. 3, November 1, 1954, pp. 5, 19

Katharine Kuh, "Mark Rothko," *The Art Institute of Chicago Quarterly*, vol. xlviii, no. 4, November 15, 1954, p. 68

Sidney Janis Gallery, New York, *New Paintings by Mark Rothko*, April 11-May 14, 1955

Robert M. Coates, "The Art Galleries," *The New Yorker*, vol. xxxi, no. 10, April 23, 1955, p. 84

L[averne] G[eorge], "Fortnight in Review," *Arts Digest*, vol. 29, no. 15, May 1, 1955, p. 23

T[homas] B. H[ess], "Reviews and Previews," *Art News*, vol. 54, no. 4, Summer 1955, p. 54

Contemporary Arts Museum, Houston, *Mark Rothko*, September 5-October 6, 1957. Catalogue with text by Elaine de

Kooning, excerpted from "Two Americans in Action," *Art News Annual 1958*, see Bibliography, Articles on Rothko, p. 295

Sidney Janis Gallery, New York, *New Paintings by Mark Rothko*, January 27-February 22, 1958

Dore Ashton, "Lettre de New York," *Cimaise*, série 5, no. 4, March-April 1958, pp. 30-31

Dore Ashton, "Art," *Arts & Architecture*, vol. 75, no. 4, April 1958, pp. 8, 29, 32

E.C. Goossen, "The End of Winter in New York," *Art International*, vol. ii, no. 2-3, 1958, p. 37

The Phillips Collection, Washington, D.C., *Paintings by Mark Rothko*, May 4-31, 1960

The Museum of Modern Art, New York, *Mark Rothko*, January 18-March 12, 1961. Catalogue with text by Peter Selz. Circulated by The International Council of The Museum of Modern Art. Separate catalogue in language of each country with text by Peter Selz and reprinted text by Robert Goldwater. Traveled to: Whitechapel Art Gallery, London, as *Mark Rothko: A Retrospective Exhibition Paintings 1945-1960*, October 10-November 12, 1961, with catalogue with additional text by Bryan Robertson; Stedelijk Museum, Amsterdam, November 24-December 27, 1961, with catalogue with additional text in French by Emilio Villa; Palais des Beaux-Arts de Bruxelles, January 6-29, 1962; Kunsthalle Basel, March 3-April 8, 1962, with catalogue in English and German; Galleria Nazionale d'Arte Moderna, Rome, April 27-May 20, 1962, with separate catalogue with text by Palma Bucarelli, none by Peter Selz; Musée d'Art Moderne de la Ville de Paris, December 5, 1962-January 13, 1963

John Canaday, "Is Less More and When for Whom?: Rothko Show Raises Questions About Painters, Critics and Audience," *The New York Times*, January 22, 1961, p. x17

Robert M. Coates, "The Art Galleries," *The New Yorker*, vol. xxxvi, no. 50, January 28, 1961, pp. 78-81

Irving Herschel Sandler, "New York Letter," *Art International*, vol. v, no. 2, March 1, 1961, pp. 40-41

Katharine Kuh, "The Fine Arts: Art Without Isms," *Saturday Review*, vol. xliv, no. 9, March 4, 1961, pp. 37, 145

Robert Goldwater, "Reflections on the Rothko Exhibition," *Arts*, vol. 35, no. 6,

March 1961, pp. 42-45

T[homas] B. H[ess], "Reviews and Previews," *Art News,* vol. 60, no. 1, March 1961, p. 10

M[ax] Kozloff, "Mark Rothko's New Retrospective," *Art Journal,* vol. xx, no. 3, Spring 1961, pp. 148-149

J. Harrison, "A Spiritual Experience: Paintings by Mark Rothko," *The Times,* London, October 13, 1961, p. 18

Alan Bowness, "Absolutely Abstract," *The Observer,* Sunday, October 15, 1961

John Russell, "A Grand Achievement of the Fifties," *The Sunday Times,* London, October 15, 1961, p. 39

Keith Sutton, "Art: Round the London Galleries," *The Listener,* vol. lxvi, no. 1699, October 19, 1961, p. 616

J. Harrison, "Mark Rothko," *The Arts Review,* vol. xiii, no. 20, October 21-November 4, 1961, pp. 2, 18

Michael Fried, "London: Visitors from America," *Arts,* vol. 36, no. 3, December 1961, pp. 38-39

Jasia Reichardt, "Les Expositions à L'Etranger: Londres," *Aujourd'hui,* 6e année, no. 34, December 1961, pp. 64-65

Maria Netter, "Austellungen," *Die Weltwoche,* Zürich, jg. 30, no. 1480, March 23, 1962, p. 26

Francesco Guerrieri, "Mostre Romane: Mark Rothko," *Auditorium,* vol. xi, no. 5-6, May-June 1962, pp. 20-21

Marcelin Pleynet, "Exposition Mark Rothko," *Tel Qual,* no. 12, Winter 1963, pp. 39-41

Rolf-Günter Dienst, "Pariser Kunstwinter," *Das Kunstwerk,* vol. xvi, no. 8, February 1963, p. 23

John Ashbery, "Paris Notes," *Art International,* vol. vii, no. 2, February 25, 1963, p. 72

The Solomon R. Guggenheim Museum, New York, *Five Mural Panels Executed for Harvard University by Mark Rothko,* April 9-June 2, 1963

Brian O'Doherty, "Art: Rothko Panels Seen," *The New York Times,* April 10, 1963, p. 36

Irving Sandler, "In the Art Galleries," *The New York Post,* April 21, 1963, Magazine, p. 14

D[onald] J[udd], "New York Exhibitions: In the Galleries," *Arts,* vol. 37, no. 10, September 1963, pp. 57-58

Marlborough New London Gallery, London, *Mark Rothko,* February-March 1964. Catalogue

Keith Roberts, "Current and Forthcoming Exhibitions," *Burlington Magazine,* vol. cvi, no. 733, April 1964, p. 194

Joseph Rykwert, "Mostre a Londra," *Domus,* no. 413, April 1964, p. 49

G. S. Whittet, "London Commentary: Fresh Facets in Mature Artist's Work," *Studio International,* vol. 167, no. 853, May 1964, p. 216

Galleria Nazionale d'Arte Moderna, Rome, *Mark Rothko,* 1965

Marlborough New London Gallery, London, *Mark Rothko, Winter 1965-66*

Pierre Rouve, "Rothko: Marlborough New London." *The Arts Review,* vol. xvi, no. 3, February 19, 1966, pp. 3, 17, 22

The Museum of Modern Art, New York, *Mark Rothko 1903-1970,* March 26-May 31, 1970

Museo d'Arte Moderna Ca'Pesaro, Venice, *Mark Rothko,* June 21-October 15, 1970. Organized under the auspices of *La XXXV Biennale Internazionale d'Arte di Venezia* with the collaboration of Marlborough Gallery, New York. Catalogue with text by Guido Perocco. Traveled to Marlborough Gallery, New York, as *Mark Rothko Paintings 1947-1970,* November 13-December 5, 1970

David L. Shirey, "Mark Rothko's Adaptable Rectangles," *The New York Times,* November 21, 1970, p. 24

Thomas B. Hess, "Rothko: A Venetian Souvenir," *Art News,* vol. 69, no. 7, November 1970, pp. 40-41, 72-74

J. Patrice Marandel, "Lettre de New York," *Art International,* vol. xv, no. 1, January 20, 1971, p. 45

Carter Ratcliff, "New York Letter," *Art International,* vol. xv, no. 1, January 20, 1971, p. 26

Kenneth Baker, "New York," *Artforum,* vol. ix, no. 5, January 1971, pp. 74-75

Willis Domingo, "Galleries," *Arts,* vol. 45, no. 4, February 1971, p. 55

Galleria Martano, Turin, *Mark Rothko,* March 17-April 20, 1971. Catalogue

Robert Kudielka, "Ausstellungen," *Das Kunstwerk,* vol. xxiv, no. 3, May 1971, pp. 51-52

Bergamo, Galleria Lorenzelli; *Mark Rothko,* March 1971. Catalogue with excerpts from reprinted texts by Marie-Claude Dane, Sam Hunter, Georgine Oeri, Peter Selz, Guido Perocco, Rothko and Peter Selz

Kunsthaus Zürich, *Mark Rothko,* March 21-May 9, 1971. Separate catalogue in language of each country with text by Donald McKinney and reprinted text by Rothko. Traveled to: Staatliche Museen Preussischer Kulturbesitz, Neue Nationalgalerie, Berlin, May 26-July 19, 1971; Städtische Kunsthalle Düsseldorf, as *Gemalde von Mark Rothko (1903-1970),* August 24-October 3, 1971; Museum Boymans van Beuningen, Rotterdam, November 20, 1971-January 2, 1972. Traveled in part to: Hayward Gallery, London, February 2-March 12, 1972; Musée National d'Art Moderne, Paris, March 23-May 8, 1972

James Burr, "London Galleries: Caliban and Calm," *Apollo,* vol. xcv, no. 120, February 1972, p. 139

Christopher Neve, "Pictures Must Be Miraculous: Rothko at the Hayward Gallery," *Country Life,* vol. cli, no. 3897, February 17, 1972, p. 391

Keith Roberts, "Current and Forthcoming Exhibitions," *The Burlington Magazine,* vol. cxiv, no. 828, March 1972, p. 190

Yale University Art Gallery, New Haven, *Salute to Mark Rothko,* May 6-June 20, 1971. Catalogue with text by Andrew Carnduff Ritchie

Newport Harbor Art Museum, Newport Beach, California, *10 Major Works: Mark Rothko,* January 30-March 10, 1974. Catalogue with texts by James B. Byrnes and Morton H. Levine

William Wilson, "A Window in the World of Mark Rothko," *The Los Angeles Times,* February 24, 1974

Mantua, Galleria Civica d'Arte Moderna, *Mark Rothko: Mostra didattica,* December 1977. Catalogue with text by Ida Panicelli

I. General Books

Sidney Janis, *Abstract and Surrealist Art in America*, New York, 1944, pp. 88, 118

John I. H. Baur, *Revolution and Tradition in Modern American Art*, Cambridge, Massachusetts, 1951, pp. 71, 72, 120

Thomas B. Hess, *Abstract Painting: Background and American Phase*, New York, 1951, pp. 145, 146, 150-152

William C. Seitz, *Abstract-Expressionist Painting in America: An Interpretation Based on the Work and Thought of Six Key Figures*, unpublished Ph.D dissertation, Princeton University, 1955, passim

Rudi Blesh, *Modern Art U.S.A.: Men, Rebellion, Conquest, 1900-1956*, New York, 1956, pp. 172, 226, 227, 234, 243, 247, 250, 264-266, 291

Selden Rodman, *Conversations with Artists*, New York, 1957, pp. 51, 55, 84, 92-96, 99, 108, 111, 114

Sam Hunter, "U.S.A." in *Art Since 1945*, Milton S. Fox, ed., New York, ca. 1958, pp. 283-348

Virgil Barker, *From Realism to Reality in Recent American Painting*, Lincoln, Nebraska, 1959, pp. 89-91

Clement Greenberg, *Art and Culture: Critical Essays*, Boston, 1961, pp. 125, 169, 219, 222, 225-226, 233, 234

Current Biography Yearbook, Charles Moritz, ed., New York, 1961, pp. 397-399

Dore Ashton, *The Unknown Shore: A View of Contemporary Art*, Boston, Toronto, 1962, pp. 25-26, 27, 42, 57, 59-60, 66, 71-78, 109, 170, 199, 226, 241-242, 249

Henry Geldzahler, *American Painting in the Twentieth Century*, New York, 1965, pp. 172, 188-189

Modern Art: From Fauvism to Abstract Expressionism, David Sylvester, ed., New York, 1965, pp. 112-113

Barbara Rose, *American Art Since 1900: A Critical History*, New York, 1967, pp. 126, 134, 163, 164, 167, 187, 189, 192, 194, 195, 196–197, 207, 208, 209, 224, 226, 233, 257; revised and enlarged, New York, Washington, D.C., 1975, pp.104, 112, 135, 138, 141, 159, 161, 163, 166–167, 168, 170, 177–179, 192, 194, 231–232, 258

Theories of Modern Art: A Source Book by Artists and Critics, Herschel B. Chipp, ed., Berkeley, Los Angeles, 1968, pp. 544–545, 548–549

Readings in American Art Since 1900: A Documentary Survey, Barbara Rose, ed., New York, 1968, pp. 143–145, 160; revised and enlarged as *Readings in American Art 1900–1975: A Documentary Survey*, New York, 1975, pp. 111–113, 134, 136–137, 160, 162, 198

H. H. Arnason, *History of Modern Art: Painting, Sculpture, Architecture*, New York, ca. 1968, pp. 432, 488, 508, 537, 621, 624; revised and enlarged, New York, 1977, pp. 436, 508, 533–534, 678, 683

Barbara Rose, *American Painting: The Twentieth Century*, Switzerland, 1969, pp. 36, 57, 63, 64, 70, 72, 73, 77, 80, 85–87, 90, 102, 103, 112

Ronald Alley, *Recent American Art*, London, 1969, p. 7

Dore Ashton, *A Reading of Modern Art*, Cleveland, London, 1969, pp. 25–31

Edward Lucie-Smith, *Late Modern: The Visual Arts Since 1945*, New York, Washington, D.C., 1969, pp. 38, 42

Harold Rosenberg, *Artworks and Packages*, New York, 1969, pp. 44, 101, 113, 116, 125, 126, 150, 158, 188, 191, 192, 222

Irving Sandler, *The Triumph of American Painting: A History of Abstract Expressionism*, New York, Washington, D.C., 1970, passim

Bernhard Kerber, *Amerikanische Kunst Seit 1945*, Stuttgart, 1971, pp. 10, 51–54, 56, 59, 65, 66–68, 85, 149, 207–208

Art Since Mid-Century: The New Internationalism, Greenwich, Connecticut, 1971, vol. I, *Abstract Art*, pp. 14, 50, 51, 52, 57–58, 62, 140, 150, 156, 231, 232, 244

Dore Ashton, *The New York School: A Cultural Reckoning*, New York, 1972, passim

Harold Rosenberg, *The De-Definition of Art*, New York, 1972, pp. 92, 96, 97, 100–107, 130, 193, 194, 218

Joseph Solman, 'The Easel Division of the WPA Federal Art Project," *The New Deal Art Projects: An Anthology of Memoirs*, Francis V. O'Connor, ed., Washington, D.C., 1972, pp. 115–130

Sam Hunter, *American Art of the 20th Century*, New York, ca. 1972, passim

Brian O'Doherty, *American Masters: The Voice and the Myth*, New York, ca. 1973, pp. 23, 24, 25, 88, 90, 105, 111, 120, 121, 150–187, 199, 232, 249, 257, 258, 274, 281, 282

Peter Plagens, *Sunshine Muse: Contemporary Art on the West Coast*, New York, Washington, D.C., 1974, pp. 23, 32, 35, 36, 37, 41, 42, 43, 46, 69, 75, 78, 132

Cor Blok, *Geschichte der Abstrakten Kunst 1900–1960*, Cologne, 1975, pp. 113, 114, 116, 117, 118, 122, 125, 127, 128, 145, 148, 154, 172, 174

Robert Rosenblum, *Modern Painting and the Northern Romantic Tradition: Friedrich to Rothko*, New York, Evanston, San Francisco, London, 1975, pp. 173–218

Paul Cummings, *A Dictionary of Contemporary American Artists*, New York, London, 1977, third edition, pp. 418–419

II. *General Articles*

Jules Langsner, "More About the School of New York," *Arts and Architecture*, vol. 68, no. 5, May 1951, pp. 20,46

B. H. Friedman, "The New Baroque," *Arts Digest*, vol. 28, no. 20, September 15, 1954, pp. 12–13

Clement Greenberg, "'American-Type' Painting," *Partisan Review*, vol. xxii, no. 2, Spring 1955, pp. 179–196. Reprinted in Greenberg, *Art and Culture*, 1961, see General Books, p. 292

Meyer Schapiro, "The Younger American Painters of Today," *The Listener*, vol. lv, no. 1402, January 26, 1956, pp. 146–147

Hubert Crehan, "Is there a California School?" *Art News*, vol. 54, no. 9, January 1956, pp. 32–35, 64

"Art: The Wild Ones," *Time*, vol. lxxii, no. 8, February 20, 1956, pp. 70–75

Herbert Read, "An Art of Internal Necessity," *Quadrum*, no. 1, May 1956, pp.7–22

Dore Ashton, "L'Apport artistique des Etats-Unis," *XXe Siècle*, nouvelle série, no. 7, June 1956, pp.69–72

Clement Greenberg, "New York painting only yesterday," *Art News*, vol. 56, no. 4, Summer 1957, pp. 58–59, 84–86

Lawrence Alloway, "6. Background to Action: The Words," *Art News and Review*, vol. ix, no. 26, January 18, 1958, pp. 3–4

William Rubin, "The New York School—Then and Now, Part II," *Art International*, vol. ii, no. 4–5, May–June 1958, pp. 19–22

Robert Rosenblum, "Unité et divergences de la peinture américaine: La peinture américaine depuis la seconde guerre mondiale," *Aujourd'hui: art et architecture*, 3 année, no. 18, July 1958, pp. 12–18

Lawrence Alloway, "Art in New York Today," *The Listener*, vol. lx, no. 1543, October 23, 1958, pp. 647–648

E. C. Goossen, "The Big Canvas," *Art International*, vol. 2, no. 8, November 1958, pp. 45–47. Reprinted in *The New Art: A Critical Anthology*, Gregory Battcock, ed., New York, 1966, pp. 48–56

Dorothy Seiberling, "Part I, Baffling U.S. Art: What It Is About," *Life*, vol. 47, no. 19, November 9, 1959, pp.68–80; "Part II, The Varied Art of Four Pioneers," no. 20, November 16, 1959, pp. 74–86

Herbert Read and H. Harvard Arnason, "Dialogue on Modern U.S. Painting," *Art News*, vol. 59, no. 3, May 1960, pp. 33–36

Dore Ashton, "Perspective de la peinture américaine," *Cahiers d'Art*, années 33–35, 1960, pp. 203–221

Robert Goldwater, "Reflections on the New York School, *Quadrum*, no. viii, 1960, pp. 17–36

Robert Rosenblum, "The Abstract Sublime," *Art News*, vol. 59, no. 10, February 1961, pp. 38–41, 56, 58. Reprinted in The Metropolitan Museum of Art, New York, *New York Painting and Sculpture*, 1969, see Group Exhibitions, p. 287

Rachel Jacobs, "L'idéologie de la peinture américaine," *Aujourd'hui: art et architecture*, 6e année, no. 37, June 1962, pp. 6–19

Clement Greenberg, "After Abstract Expressionism," *Art International*, vol. vi, no. 8, October 25, 1962, pp. 24–32. Reprinted in The Metropolitan Museum of Art, New York, *New York Painting and Sculpture*, 1969, see Group Exhibitions, p. 287

Lawrence Alloway, "The American Sublime," *Living Arts*, vol. i, no. 2, June 1963, pp. 11–22

Max Kozloff, "A Letter to the Editor: An Answer to Clement Greenberg's Article 'After Abstract Expressionism,'" *Art International*, vol. vii, no. 6, June 25, 1963, pp. 88–92

Edward B. Henning, "In Pursuit of Content," *The Bulletin of the Cleveland Museum of Art*, vol. 50, no. 8, October 1963, pp. 218–239

Dore Ashton, "La Voix du tourbillon dans l'Amérique de Kafka," *XXe Siècle*, nouvelle série, xxvie année, no. 23, May 1964, pp. 92–96

Thomas B. Hess, "Private faces in public places," *Art News*, vol. 63, no. 10, February 1965, pp. 36–38, 62

Lawrence Alloway, "The Biomorphic Forties," *Artforum*, vol. iv, no. 1, September 1965, pp. 18–22

Barnett Newman interviewed by Neil A. Levine, "The New York School Question," *Art News*, vol. 64, no. 5, September 1965, pp. 38–41, 55–56

Matthew Baigell, "American abstract expressionism and hard edge: some comparisons," *studio international*, vol. 171, no. 873, January 1966, pp. 10–15

Marcelin Pleynet, "De la peinture américaine (III)," *Les Lettres françaises*, no. 1177, April 6–12, 1967, pp. 31–32

Irving Sandler, "Dada, Surrealism and Their Heritage: 2. The Surrealist Emigres in New York," *Artforum*, vol. vi, no. 9, May 1968, pp. 24–31

Bernhard Kerber, "Der Ausdruck des Sublimen in der amerikanischen Kunst," *Art Internatinal*, vol. xiii, no. 10, Christmas 1969, pp. 31–36

Lawrence Alloway, "The Spectrum of Monochrome," *Arts Magazine*, December–January 1971, vol. 45, no. 3, pp. 30–33

John Chandler, "The colors of monochrome: An introduction to the seduction of reduction," *artscanada*, vol. xxviii, no. 160/161, October/November 1971, pp. 18–31

Donald B. Kuspit, "The Illusion of the Absolute in Abstract Art," *Art Journal*, vol. xxxi, no. 1, Fall 1971, pp. 26–30

Edward M. Levine, "Abstract Expressionism: The Mystical Experience," *Art Journal*, vol. xxxi, no. 1, Fall 1971, pp. 22–25

Morton Feldman, "After Modernism," *Art in America*, vol. 59, no. six, November–December 1971, pp. 68–77

Barbara Rose, "Mondrian in New York," *Artforum*, vol. x, no. 4, December 1971, pp. 54–63

Charles Harrison, "Abstract Expressionism II," *Studio International*, vol. 185, no. 952, February 1973, pp. 53–60

Lawrence Alloway, "Residual Sign Systems in Abstract Expressionism," *Artforum*, vol. xii, no. 3, November 1973, pp. 36–42

Les Levine, "Lone Star Four," *Arts Magazine*, vol. 48, no. 6, March 1974, pp. 30–39

Janet Kutner, "Brice Marden, David Novros, Mark Rothko: The Urge to Communicate Through Non-Imagistic Painting," *Arts Magazine*, vol. 50, no. 1, September 1975, pp. 61–63

Jeremy Gilbert-Rolfe, "Appreciating Ryman," *Arts Magazine*, vol. 50, no. 4, December 1975, pp. 70–73

Amy Goldin, "Abstract Expressionism, No Man's Landscape," *Art in America*, vol. 64, no. one, January–February 1976, pp. 77–79

Harry Rand, "Adolph Gottlieb in Context," *Arts Magazine*, vol. 51, no. 6, February 1976, 112–135

Donald B. Kuspit, "Symbolic Pregnance in Mark Rothko and Clyfford Still," *Arts Magazine*, vol. 52, no. 7, March 1978, pp. 120–125

III. *Articles on Rothko*

"Brown Belittles Drawings in Book," *The New York Times*, January 5, 1929

O[scar] C[ollier], "Mark Rothko, *The New Iconograph*, no. 4, Fall 1947, pp. 41–44

Douglas MacAgy, "Mark Rothko," *Magazine of Art*, vol. 42, no. 1, January 1949, pp. 20–21

Dore Ashton, "Mark Rothko," *Arts & Architecture*, vol. 74, no. 8, August 1957, pp. 8, 31

Dore Ashton, "Art: Lecture by Rothko," *The New York Times*, October 31, 1958, p. 26

Dore Ashton, "L'Automne à New York: Letter from New York," *Cimaise*, série vi, no. 2, December 1958, pp. 37–40

Elaine de Kooning, "Two Americans in Action: Franz Kline and Mark Rothko," *Art News Annual*, vol. xxvii, 1958, pp. 86–97, 174–179

Gabriella Drudi, "Mark Rothko," *Appia*, vol. 2, January 1960, n.p.

Emilio Villa, "Idée de Rothko," *Appia*, vol. 2, January 1960, n.p.

Georgine Oeri, "Tobey and Rothko," *Baltimore Museum of Art News Quarterly*, vol. xxiii, no. 2, Winter 1960, pp. 2–8

E. C. Goossen, "Rothko: The Omnibus Image," *Art News*, vol. 59, no. 9, January 1961, pp. 38–40, 60–61

L. Picard, "Mark Rothko," *Das Kunstwerk*, vol. xiv, no. 10–11, April/May 1961, pp. 33–40

Georgine Oeri, "Mark Rothko," *Quadrum*, no. x, 1961, pp. 65–74

Lawrence Alloway, "Notes on Rothko," *Art International*, vol. 6, no. 5–6, 1962, pp. 90–94

José-Augusto França, "Mark Rothko et l'espace continu," *aujourd'hui: art et architecture*, 7e année, no. 40, January 1963, pp. 10–11

Dora Vallier, "Rothko ou l'absence de thème devenue thème," *XXe Siècle*, xxve année, no. 21, May 1963, pp. 53–56. Reprinted in *XXe Siècle*, nouvelle série, xxxve année, no. 40, June 1973, pp. 98–103

Philippe Sollers, "Le Mur du Sens," *Art de France*, vol. 4, 1964, pp. 239–251

Max Kozloff, "The Problem of Color-Light in Rothko," *Artforum*, vol. iv, no. 1, September 1965, pp. 38–44

"Mark Rothko, Artist, a Suicide Here at 66," *The New York Times*, February 26, 1970, pp. 1, 39

Hilton Kramer, "A Pure Abstractionist: Rothko's Work in Color, Conveyed Luminosity Yet an Extreme Serenity," *The New York Times*, February 26, 1970, p. 39

Maria Netter, "Ende einer Pionierarbeit: Zum Tode des Malers Mark Rothko," *Die Weltwoche*, jg. 38, vol. 10, March 6, 1970, p. 35

William Rubin, "Mark Rothko 1903–70, *The New York Times*, March 8, 1970, pp. 21, 22

Harold Rosenberg, "The Art World: Rothko," *The New Yorker*, vol. xlvi, no. 6, March 28, 1970, pp. 90–95

Robert Olmos, "Mrs. Allen About Her Brother," *Northwest Magazine*, March 29, 1970, p. 21

T[homas] B. H[ess], "Editorial: Mark Rothko, 1903–1970," *Art News*, vol. 69, no. 2, April 1970, pp. 29, 66, 67

Max Kozloff, "Mark Rothko (1903–1970)," *Artforum*, vol. viii, no. 8, April 1970, pp. 88–89

John Fischer, "Mark Rothko: portrait of the artist as an angry man," *Harper's*, vol. 241, no. 1442, July 1970, pp. 16–23

R. C. Kenedy, "Mark Rothko," *Art International*, vol. xiv, no. 8, October 20, 1970, pp. 45–49

Brian O'Doherty, "Rothko," *Art International*, vol. xiv, no. 8, October 20, 1970, pp. 30–44

Alastair Gordon, "In the Galleries: The Rothko Room," *The Connoisseur*, vol. 175, no. 706, December 1970, p. 303

Mrs. John de Menil, "Address given in The Rothko Chapel," February 26, 1971. Transcript on deposit in Rothko file, Whitney Museum of American Art, New York

"Celebration of Genius at the Rothko Chapel," *Vogue*, vol. 157, no. 5, March 1, 1971, pp. 109–111

Lawrence Alloway, "Art," *The Nation*, vol. 212, no. 11, March 15, 1971, pp. 349–350

Robert Goldwater, "Rothko's Black Paintings," *Art in America,* vol. 59, no. two, March–April 1971, pp. 58–63

Katharine Kuh, "The Fine Arts: A Maximum of Poignancy," *Saturday Review,* vol. liv, no. 16, April 17, 1971, pp. 52, 81

T[homas] B. H[ess], "Editorial: Can Art Be Used?" *Art News,* vol. 70, no. 2, April 1971, p. 33

Jean-Patrice Marandel, "Une chapelle oecuménique au Texas," *L'Oeil,* no. 197, May 1971, pp. 16–19

Dominique de Menil, "The Rothko Chapel," *Art Journal,* vol. xxx, no. 3, Spring 1971, pp. 249–251

Dore Ashton, "The Rothko Chapel in Houston," *Studio,* vol. 181, no. 934, June 1971, pp. 273–275

Andrew Causey, "Rothko through his paintings," *Studio International,* vol. 183, no. 943, April 1972, pp. 149–155

Brian O'Doherty, "The Rothko Chapel," *Art in America,* vol. 61, no. one, January–February 1973, pp. 14–18, 20

Wallace Putnam, "Mark Rothko Told Me," *Arts Magazine,* vol. 48, no. 7, April 1974, pp. 44–45

Brian O'Doherty, "Rothko: Failure was His Success," *The New York Post,* July 27, 1974, p. 34

Harold Rosenberg, "The Art World: Death and the Artist," *The New Yorker,* vol. li, no. 5, March 24, 1975, pp. 69–75

Ann Holmes, "The Rothko Chapel Six Years Later," *Art News,* vol. 75, no. 10, December 1976, pp. 35–37

Dore Ashton, "Oranges and Lemons, An Adjustment," *Arts Magazine,* vol. 51, no. 6, February 1977, p. 142

Russell E. Bowman, *A New Acquisition by Mark Rothko,* The David and Alfred Smart Gallery, University of Chicago, 1977

Robert F. Phillips, "Abstract Expressionists: Mark Rothko 1903–1970," *Museum News,* The Toledo Museum of Art, vol. 19, no. 4, 1977, pp. 98–101

George Dennison, "The Painting of Mark Rothko," unpublished, n.d. On deposit in Rothko file, The Museum of Modern Art, New York

Joseph Liss, "Portrait by Rothko," unpublished, n.d. On deposit in Rothko file, Whitney Museum of American Art, New York

IV. By Rothko

Marcus Rothkowitz and Bernard Bradden [Statement], in Mercury Galleries, New York, *The Ten: Whitney Dissenters,* November 5–26, 1938

Marcus Rothko and Adolph Gottlieb with unacknowledged collaboration of Barnett Newman [Letter], in Edward Alden Jewell, "The Realm of Art: A New Platform and Other Matters: 'Globalism' Pops into View," *The New York Times,* June 13, 1943, p. x9. Reprinted in part in Hess, *Abstract Painting,* 1951; Blesh, *Modern Art U.S.A.,* 1956; Ashton, *The Unknown Shore,* 1962; Chipp, *Theories in Modern Art,* 1968; Sandler, *The Triumph of American Painting,* 1970, see General Books, p. 292

Mark Rothko and Adolph Gottlieb, "The Portrait and the Modern Artist," WNYC *Art in New York* broadcast, October 13, 1943. Excerpts from transcript in Los Angeles County Museum of Art, *The New York School,* 1965, see Group Exhibitions, p. 286; Sandler, *The Triumph of American Painting,* 1970, see General Books, p. 292

"Personal Statement" in David Porter Gallery, Washington, D.C., *A Painting Prophecy–1950,* February 1945. Reprinted in part in Los Angeles County Museum of Art, *The New York School,* 1965, see Group Exhibitions, p. 286; in full in *Readings in American Art 1900–1975,* 1975, see General Books, p. 292

"Clyfford Still" in Art of This Century, New York, *Clyfford Still,* February 12–March 7, 1946. Reprinted in part in Sandler, *The Triumph of American Painting,* 1970, see General Books, p. 292

"The Ides of Art: The Attitudes of 10 Artists on their Art and Contemporaneousness," *The Tiger's Eye,* vol. 1, no. 2, December 1947, p. 44. Reprinted in The Museum of Modern Art, New York, *15 Americans,* 1952, Los Angeles County Museum of Art, *The New York School,* 1965, see Group Exhibitions, pp. 283, 286

"The Romantics Were Prompted," *Possibilities 1,* Winter 1947/8, p. 84. Reprinted in Kunsthaus Zürich, *Mark Rothko,* 1971, see One-Man Exhibitions, p. 291; *Theories of Modern Art,* 1968, *Readings in American Art Since 1900,* 1968, revised edition, 1975, see General Books, p. 292

"Statement on his Attitude in Painting," *The Tiger's Eye,* vol. 1, no. 9, October 1949, p. 114. Reprinted in The Museum of Modern Art, New York, *15 Americans,* 1952; *The New American Painting,* 1958, Knoedler, Paris, *Six peintres américains,* 1967, see Group Exhibitions, pp. 283, 286; *Readings in American Art Since 1900,* 1968, revised edition, 1975, see General Books, p. 292

"A Symposium on How to Combine Architecture, Painting and Sculpture," *Interiors,* vol. cx, no. 10, May 1951, p. 104. Reprinted in part in Los Angeles County Museum of Art, *The New York School,* 1965, see Group Exhibitions, p. 286; *Readings in American Art Since 1900,* 1968, revised edition, 1975; *Art Since Mid-Century,* 1971, vol. 1, see General Books, p. 292

Unpublished letter to Lloyd Goodrich, Director, Whitney Museum of American Art, New York, December 20, 1952. On deposit in Rothko file, Whitney Museum of American Art, New York

Unpublished letter to Rosalind Irvine, Whitney Museum of American Art, New York, April 9, 1957. On deposit in Rothko file, Whitney Museum of American Art, New York

"Editor's Letters," *Art News,* vol. 56, no. 8, December 1957, p. 6

[Interview with Rothko] in Selden Rodman, *Conversations with Artists,* New York, 1957, pp. 93, 94

[Lecture] delivered Fall 1958, Pratt Institute, Brooklyn. Excerpts from transcript in Los Angeles County Museum of Art, *The New York School,* 1965, see Group Exhibitions, p. 286; Dore Ashton, "Art: Lecture by Rothko," *The New York Times,* October 31, 1958, p. 26, Dore Ashton, "Letter from New York," *Cimaise,* no. 6, December 1958, pp. 37–40, see articles on Rothko, p. 294; *Art Since Mid-Century,* 1971, vol. 1, see General Books, p. 292

Eulogy for Milton Avery, delivered January 7, 1965, New York Society for Ethical Culture, New York. Transcript published in National Collection of Fine Arts, Smithsonian Institution, Washington, D.C., *Milton Avery,* December 12, 1969–January 25, 1970

Photographic Credits

Works in the exhibition

Color

Courtesy Albright-Knox Art Gallery, Buffalo: cat. no. 132
Courtesy University Art Museum, University of California
Berkeley: cat. no. 164
Henry B. Beville: cat. nos. 118, 131
Lee Boltin: cat. no. 95
Will Brown: cat. no. 112
Courtesy The Art Institute of Chicago: cat. no. 88
Courtesy Dartmouth Art Galleries and Collections, New Hampshire: cat. no. 165
Courtesy Gimpel and Hanover Galerie, Zürich: cat. no. 127
Courtesy Arnold and Milly Glimcher: cat. no. 154
Courtesy Graham Gund: cat. nos. 103, 122
Bruce C. Jones: cat. nos. 114, 115, 134, 159, 168, 183
Courtesy Kunstsammlung Nordrhein-Westfalen, Düsseldorf:
cat. no. 163
Courtesy Mr. and Mrs. Richard E. Lang: cat. no. 182
Paul M. Macapia, Seattle Art Museum: cat. no. 104
Aida and Bob Mates: cat. nos. 121, 150
Robert E. Mates and Mary Donlon: cat. nos. 19, 22, 31, 34, 62–
70, 74, 86, 87, 89, 90, 92, 93, 99, 110, 111, 113, 117, 119,
123, 125, 128, 135, 138, 142, 145, 146, 149, 153, 157,
158, 160, 162, 166, 169, 172, 173, 178, 179, 186, 187,
190, 191, 194, 195, 198
Courtesy The Mayor Gallery, London: cat. no. 116
Courtesy McCrory Corporation, New York: cat. no. 107
Courtesy David McKee Gallery, New York: cat. no. 139
Allen Mewbourn: cat. no. 167
Courtesy The Museum of Modern Art, New York: cat. no. 91
Courtesy Munson-Williams-Proctor Institute, Utica, New York:
cat. no. 100
Courtesy Art Gallery of Ontario: cat. no. 171
Courtesy The Pace Gallery, New York: cat. no. 136
Courtesy Count Panza di Biumo: cat. nos. 108, 137
Courtesy The Parrish Art Museum, Southampton, New York:
cat. no. 73
Courtesy Mr. and Mrs. Joseph Pulitzer, Jr.: cat. no. 161
Courtesy Museum of Art, Rhode Island School of Design, Providence: cat. no. 120
Courtesy The St. Louis Art Museum: cat. no. 174
Elton Schnellbacher: cat. no. 124
F. J. Thomas: cat. nos. 140, 170
Malcolm Varon: cat. no. 96
Herbert Vose: cat. no. 77

Black and white

Courtesy Acquavella Contemporary Art, Inc., New York: cat.
no. 148
Courtesy Galerie Beyeler, Basel: cat. no. 101
Courtesy Bradley Family Foundation, Inc., Milwaukee: cat.
no. 130
Courtesy Olive Bragazzi Fine Arts Service; photo by Charles Uht:
cat. no. 181
Courtesy The Brooklyn Museum: cat. no. 52
Courtesy Gerald S. Elliott, Chicago; photo by Jonas Dovydenas:
cat. no. 143
Courtesy The Fort Worth Art Museum: cat. no. 151
Phillip Galgiani: cat. no. 43
Robert E. Mates and Mary Donlon: cat. nos. 1–18, 20, 21, 23–
30, 32, 33, 35–41, 44–51, 53–61, 71, 72, 75, 76, 78–84,
94, 97, 102, 106, 109, 133, 180, 188, 189, 192, 193, 196, 197

Courtesy The Metropolitan Museum of Art, New York: cat.
no. 155
Courtesy The Museum of Modern Art, New York: cat. nos.
98, 152
Courtesy The Museum of Modern Art, New York; photo by
Rudolph Burckhardt: cat. no. 144
Courtesy The Museum of Modern Art, New York: photo by
Geoffrey Clements: cat. no. 85
O. E. Nelson: cat. no. 185
Courtesy The Pace Gallery, New York: cat. no. 184
Courtesy Count Panza di Biumo; photo by Gian Sinigaglia: cat.
no. 129
Quiriconi-Tropea: cat. no. 147
Courtesy Tehran Museum of Contemporary Art: cat. no. 126
Courtesy The Toledo Museum of Art: cat. no. 156
Courtesy Mr. and Mrs. Burton Tremaine: cat. no. 105
Courtesy Whitney Museum of American Art, New York: cat.
no. 42

Supplementary illustrations and figures in the text

Courtesy Albright-Knox Art Gallery, Buffalo, New York: figs.
34, 39
Jörg P. Anders: fig. 51
Courtesy Archives of American Art, Smithsonian Institution,
George Platt Lynes Photograph Collection: p. 269
Courtesy The Baltimore Museum of Art: fig. 8
Regina Bogat: frontispiece
Courtesy Mrs. Adolph Gottlieb, New York: fig. 24
Courtesy Adolph and Esther Gottlieb Foundation Inc.: figs.
25, 27
Hickey & Robertson, Houston: figs. 49, 50
Bruce C. Jones: fig. 12
Consuelo Kanaga: p. 14 top, p. 17
Walter Klein, Düsseldorf: fig. 19
Nina Leen, Life Magazine © Time Inc.: p. 273 top
Alexander Liberman: p. 14 bottom, p. 71, p. 277 bottom
Courtesy University of Maryland Art Gallery, College Park;
photo by Jack D. Teemer, Jr.: fig. 23
Robert E. Mates and Mary Donlon: figs. 28, 35, 37
Courtesy The Metropolitan Museum of Art, New York: figs.
6, 22
Courtesy The Museum of Modern Art, New York: figs. 14, 18,
29, 36, 42, 44
Courtesy The Museum of Modern Art, New York; photo by
Soichi Sunami: figs. 7, 43, 46
Courtesy Dr. Max Naimark: fig. 4, p. 265 right
Hans Namuth: p. 277 top and middle, p. 279
Courtesy Oregon Historical Society, Portland: figs. 2, 3, p. 265
left
Courtesy Philadelphia Museum of Art: fig. 45
David Preston: fig. 26
Courtesy Rheinisches Bildarchiv: fig. 32
Courtesy Kate Rothko Prizel: p. 11, p. 265 middle, p. 270 all,
p. 273 bottom, p. 275 bottom, p. 277 top
Courtesy Museum of Art, Rhode Island School of Design, Providence: fig. 10
Courtesy Estate of Mary Alice Rothko: figs. 15, 16, 17, 30
Courtesy Estate of Mary Alice Rothko; photo by Henry Elkan:
p. 274 top and bottom, p. 275 top and bottom
Courtesy The St. Louis Art Museum: fig. 9
Courtesy San Francisco Museum of Modern Art: fig. 38
Aaron Siskind: p. 280 left and right
Courtesy The Tate Gallery, London: figs. 47, 48
Courtesy The Tel Aviv Museum: fig. 21
Courtesy Whitney Museum of American Art, New York; photo
by Geoffrey Clements: figs. 5, 13